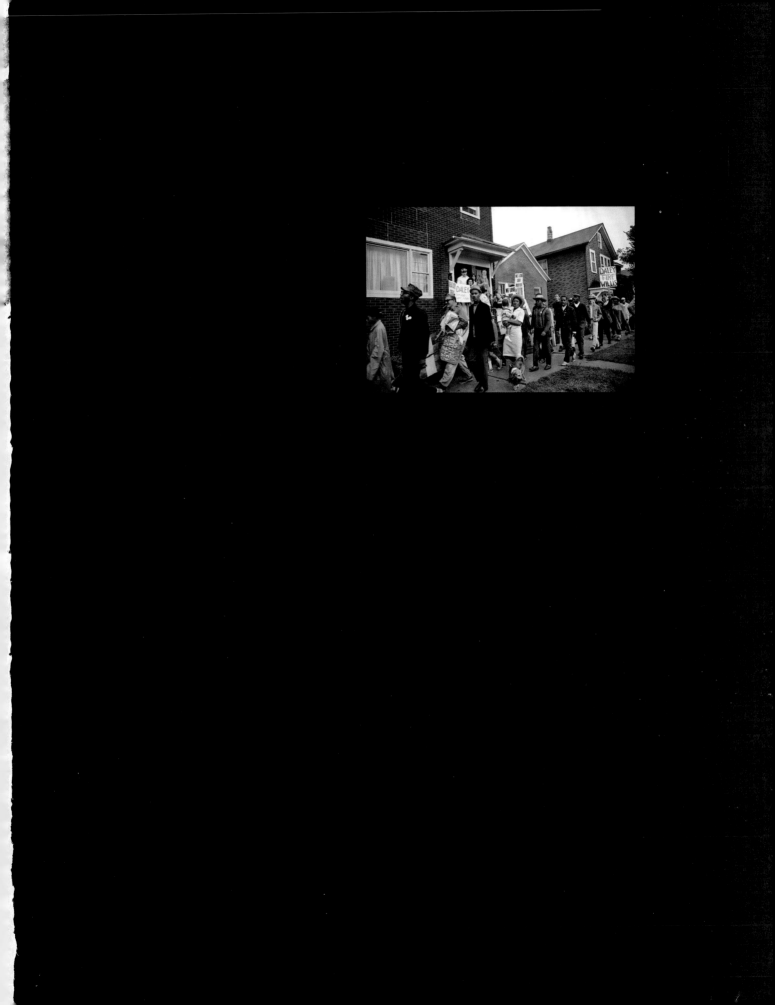

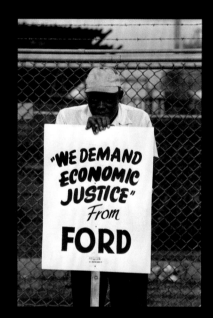

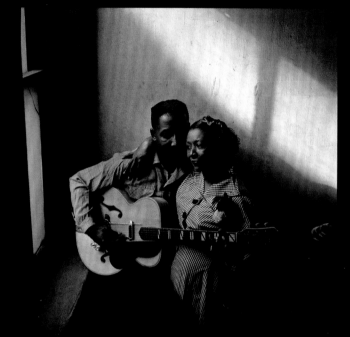

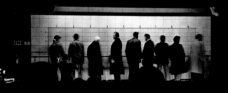

TROUBLEMAKERS

Chicago Freedom Struggles through the Lens of Art Shay

Erik S. Gellman

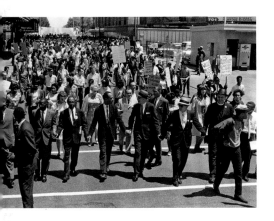

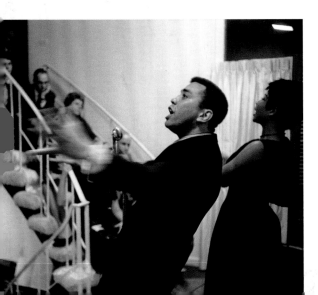

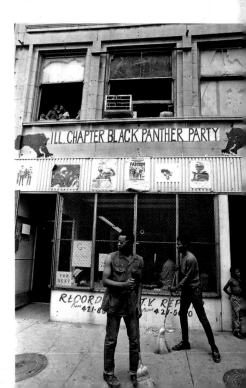

The University of Chicago Press
Chicago and London

The University of Chicago Press, Chicago 60637
The University of Chicago Press, Ltd., London
© 2020 by The University of Chicago
Photographs © Art Shay Projects, LLC
Published 2020
Printed in China

29 28 27 26 25 24 23 22 21 20 1 2 3 4 5

ISBN-13: 978-0-226-60392-6 (cloth)
ISBN-13: 978-0-226-60408-4 (e-book)
DOI: https://doi.org/10.7208/chicago/9780226604084.001.0001

This book has been made possible in part by the National Endowment for the Humanities: Exploring the human endeavor; Roosevelt University's Gage Gallery; and the UNC at Chapel Hill Office of the Vice Chancellor for Research.

Library of Congress Cataloging-in-Publication Data

Names: Gellman, Erik S., author. | Container of (expression): Shay, Arthur. Photographs. Selections.
Title: Troublemakers: Chicago freedom struggles through the lens of Art Shay / Erik S. Gellman.
Description: Chicago: The University of Chicago Press, 2020. | Includes bibliographical references and index.
Identifiers: LCCN 2019009719 | ISBN 9780226603926 (cloth) | ISBN 9780226604084 (ebook)
Subjects: LCSH: Social conflict—Illinois—Chicago. | Civil rights movements—Illinois—Chicago. | Chicago (Ill.)—Race relations—History—20th century. | Social conflict—Illinois—Chicago—Pictorial works. | Civil rights movements—Illinois—Chicago—Pictorial works. | Chicago (Ill.)—Race relations—History—20th century—Pictorial works. | Shay, Arthur. | Documentary photography—Illinois—Chicago.
Classification: LCC HN80.C55 G45 2019 | DDC 305.8009773/11—dc23
LC record available at https://lccn.loc.gov/2019009719

♾ This paper meets the requirements of ANSI/NISO Z39.48-1992 (Permanence of Paper).

CONTENTS

INTRODUCTION

When do people have the right to make trouble? This question defined postwar Chicago, the nation's "social laboratory," where residents tested new forms of protest and social control. By the 1968 Democratic Convention—when demonstrators chanted, "The whole world is watching"—they understood that other cities looked to Chicago as their residents dealt with similar currents of dissent and urban crisis in an era of rising prosperity and growing inequality.[1]

Chicago's postwar social movements advanced ambitious visions of a democratic society that drew swift retaliation from city authorities. These activists created new solidarities as they traversed the labor, civil rights, peace, and Black Power movements, whose neat boundaries only make sense in retrospect. They confronted the politicians, officials, and power brokers, who feared that conflict stymied development and damaged Chicago's fragile reputation as the "Second City." Demanding a form of civility that masked inequalities, these elites disparaged protestors as "outsiders," insisting that real Chicagoans supported the city's efficient Democratic "organization."[2] This system helped those willing to profess their loyalty and left everyone else behind.

On both sides of these confrontations over urban democracy, Chicagoans pointed to each other as the real "troublemakers." Indeed, the city's scrappy reputation was hard-earned. *Chicago: City on the Make*, Nelson Algren's 1951 prose-poem, profiled the "hustlers" and "Do-Gooders" whose clashes animated city life while warning that these identities were easily traded.[3] The same was true several decades later. Power struggles in postwar Chicago involved a carnival of street actors, reactors, and bystanders who took pragmatic approaches to securing their place in the postwar city.

This book fuses history and photography to capture these dynamics. Historians often stud

their texts with images to illustrate people or places.[4] But they rarely analyze photographs as primary sources in their own right or center them in their narratives. Meanwhile, photography books rarely engage historical analysis beyond an introductory essay and a list of captions. Separated from their context, photographs may evoke a visceral emotional reaction while accomplishing little else. "Harrowing photographs alone do not inevitably lose their power to shock," theorist Susan Sontag concluded, "but they don't help us much to understand." Thus, images can deceive even as they inform, serving as both artifact and artifice.[5] Interweaving photographs and historical analysis—using each piece to inform the other—brings a new narrative of postwar Chicago into focus.

The photographs in the pages that follow are the work of Art Shay. He grew up in the Bronx's large Eastern European Jewish immigrant community during the Great Depression, served with distinction as a U.S. Air Force navigator during World War II, and then landed a job in California as a journalist for *Life* magazine. "Going on assignments with the magazine's ace cameramen," a reporter later wrote, "gave Shay a photo education unequaled at any school." But Shay wanted to explore photography on his own, both as a career and an art form. Shortly after his 1948 move to Chicago, he became a new kind of "free lance" photographer—a difficult but enticing lifestyle that required him to "live off his wits" while allowing for more creative autonomy.[6] Shay sold work to *Life*, *Ebony*, *Fortune*, the *Saturday Evening Post*, and a host of other major periodicals, but he also wandered Chicago photographing whatever caught his eye. His curiosity about the city's diverse people and neighborhoods pulled him across the invisible yet palpable lines of racial and class segregation. He documented decades of the city's hidden history as it unfolded.

Shay's archive surpasses the boundaries of published photography and photojournalism. Photography was an elite medium when it emerged in the late nineteenth century, but it had begun to democratize by the 1930s, when Shay was coming of age. That expansion was pushed along by the leftist cultural front, the sponsorship of the federal government—especially New Deal projects—and the new accessibility of camera and darkroom equipment. A postwar groundswell of popular demand for photographs gave rise to photography sections in newspapers as well as pictorial magazines. The yearning for "the weight of words" and "the shock of photos," as one such publication advertised itself, grounded activist efforts to sway public opinion, even as publishers helped determine what constituted a worthy photograph.[7] This editorial process made its subjects more digestible and honed a consensus approach to the poor and working class, and especially racial minorities. For example, as new movements coalesced in the mid-1960s, many press outlets hewed to tried-and-true depictions of Black activists as violent and criminal, and antiwar demonstrators as spoiled white teenagers. Shay's body of work included photos he could sell and many more that fell outside of these conventions.

Shay's photographs offer a new perspective on the struggles over rights, space, and power in mid-twentieth-century Chicago. Thus, while this book is not about Shay, his photographs define it.[8] "I believe the camera is something more than an extension of the photographer's eye," he told an interviewer in 1955. "It is rather an extension of his opinions. He reveals himself when he takes pictures."[9] Shay did not consider himself an activist; he rarely took part in the conflicts he witnessed. He was sometimes cynical about the efficacy of protests and the earnestness of protestors. But in turning his keen eye to democratic protest activity against all forms of fascism, Shay revealed himself. He adopted a brazen yet sometimes humorous approach as he foregrounded concerns and grassroots actors that are often overlooked, then and now. His images convey the volatile and contingent energy that activists generated by making trouble. At the same time, they show the enormous effort that went into containing that trouble in order to perpetuate power imbalances and entrenched corruption.

The freedom moments and movements Shay captured did not transform Chicago into the "open city" many activists demanded, but not because they lacked strength or vision. Instead, this outcome was created in contests that fractured and refractured its residents along class, racial, political, and spatial lines—contests that produced the problems that continue to plague Chicago and the rest of urban America.

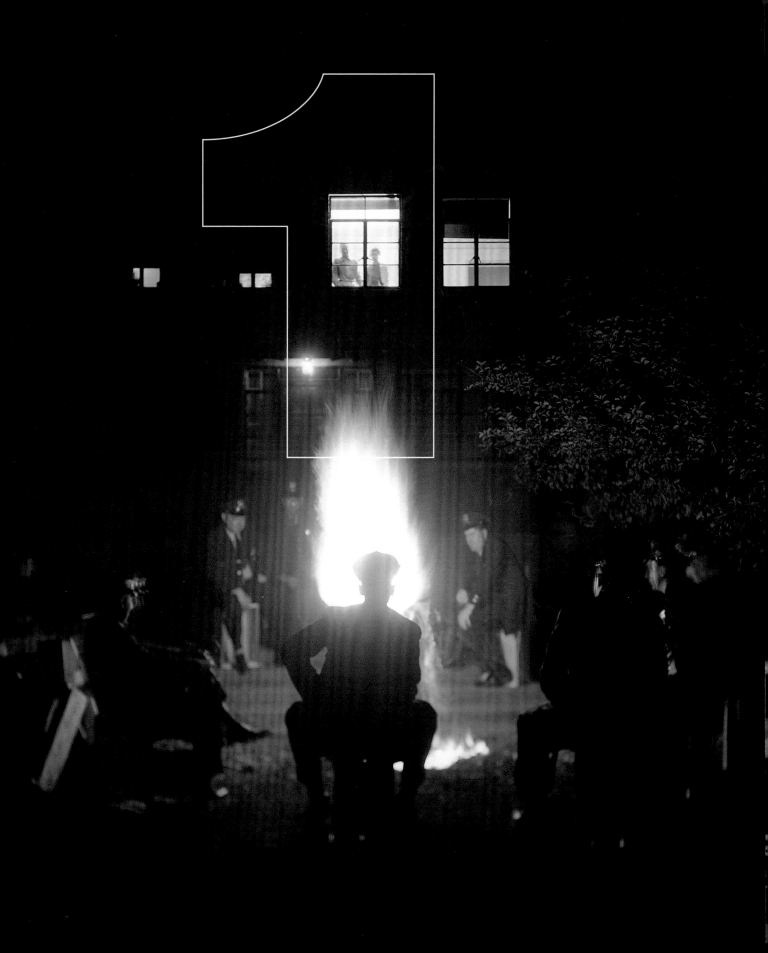

DEMOCRATIC DREAMS DEFERRED

After the United States defeated fascism abroad in the Second World War, Chicagoans sought to interpret this human triumph and tragedy for their own lives. Art Shay became one of these Chicagoans when he moved to the city from the West Coast in 1948. He soon parted ways with his employer, *Life* magazine, to work for himself. What Shay captured on the streets of Chicago in his first years revealed residents' wide-ranging aspirations for the postwar American city. His photographs of protestors—especially those who were working class—show that many in the labor movement hoped to realize the dream deferred from the 1930s for a new, more democratic class and race alignment. But Shay also documented forms of street activity and urban culture that suggested shifting yet hardening lines of color and class and the persistence of Depression-like conditions in a supposed era of prosperity. Shay captured these freedom dreams as well as the sobering realities of a new Cold War climate in Chicago's neighborhoods, workplaces, and other contested spaces.

African Americans, perhaps more than any other group of Chicagoans, knew that democratizing the city would require more than superficial changes. On the one hand, Black Chicagoans often acted as "hardheaded realists" when it came to the city's structural racism. As St. Clair Drake and Horace R. Cayton concluded in *Black Metropolis*, their 1945 study of Chicago, many African Americans saw "democracy as something granted to Negroes on the basis of political expediency rather than as a right." But many Black institutions and leaders also thought collectively in the postwar years, speaking of "advancing the race" rather than advancing themselves alone.[1] It would take sustained effort to transform the Black ghetto into the Black Metropolis—an attack upon the many forces that stymied African Americans' access to housing, jobs, and other city resources.

Such activism was more urgent than ever because the war had triggered a second Great Migration from the South that increased the Black presence in Chicago by one-half million residents. "Apart from the introduction of automobiles," one scholar of this exodus concluded, "it would be hard to think of anything that more dramatically reshaped America's big cities in the twentieth century than the relocation of the nation's black population."[2] This wave of migrants doubled the number of Black Chicagoans twice over by 1960, increasing their proportion of the city's residents from 8 to 22 percent.

Many Chicagoans were unsettled by this influx of southerners. University of Chicago sociologists concluded that the migrants' rural backgrounds rendered them maladjusted to the patterns of urban life.[3] Contemporary press accounts compounded these academic conclusions, stressing southerners' difficulty in making the "transition to sophisticated, industrial Chicago." A *Chicago Tribune* story noted that "heroic efforts to teach them are being made by many Negro organizations," but other "Negro leaders are bitter in their denunciation of 'black trash.'"[4] Black journalist Roi Ottley captured critics' concerns about these newcomers in a 1956 series of *Tribune* articles on migration. Their lack of familiarity with "urban ways ... produced problems of adjustment and assimilation," Ottley wrote; in particular, their "family life ... has completely collapsed."[5] Shay captured the living conditions on the city's West Side that led so many Chicagoans to such conclusions—conclusions that remained unchallenged among those who never got to know the new urbanites who resisted these circumstances.

Other evidence suggests that these southern migrants combated assumptions about their backwardness and inability to adjust to the city. One Black domestic worker responded

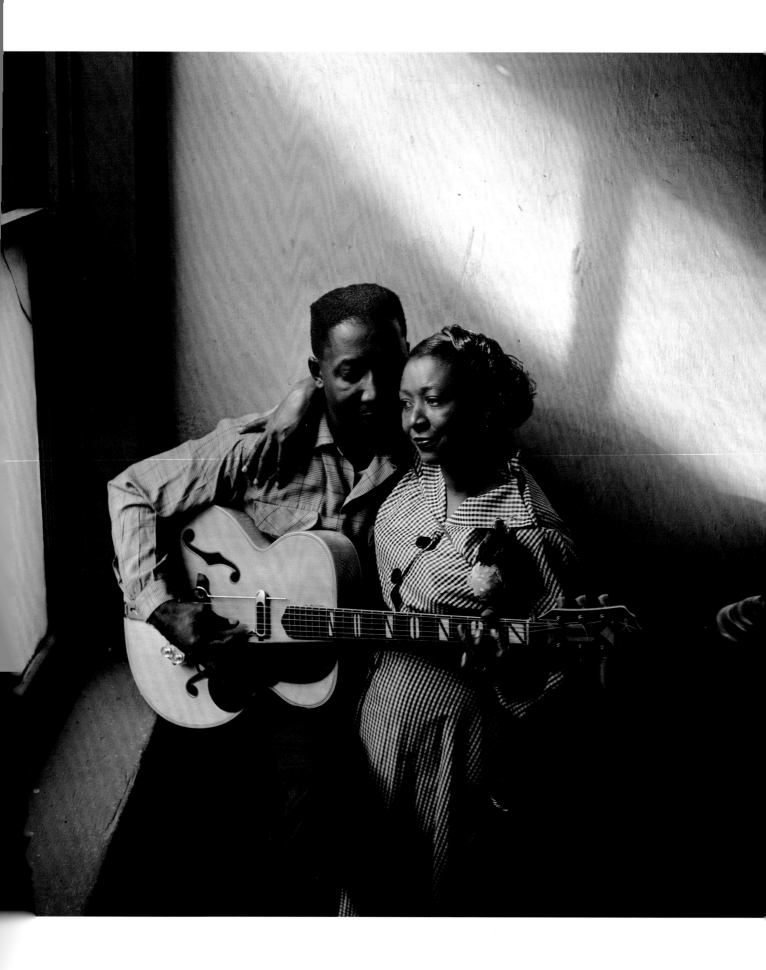

to Ottley's articles that she resented being called "bottom class. I am speaking for myself and many others," she wrote, that "we are not the least of race, as we are making an honest living [and] live Christian lives."[6] Statistics bear out her rebuttal. Black migrants earned higher wages than African Americans already in Chicago, even though that pay was approximately 80 percent of what white southern migrants earned up North. Black migrants also maintained more two-parent households and relied less on welfare than their northern-born counterparts.[7]

Shay's portrait of blues musician Muddy Waters and his wife, Geneva, highlighted these newcomers' deeper humanity. Like many other migrants, Waters came from Mississippi. After he arrived in 1943, he moved in with a cousin on the West Side. His initial experiences in Chicago did not reflect his later success. Waters worked in a container factory, drove trucks, and sold venetian blinds door-to-door. When he played his music for next to nothing in bars or on the street, listeners, especially Black South Siders, mocked it as primitive. Perhaps that's why one of his earliest recordings was titled "Feel Like Going Home." But Waters, like many other migrants, stayed. He knew that life in Chicago held the potential for freedom that did not exist in Mississippi. Indeed, wages in the city were on average four times higher by 1950 than they were back home.[8]

Waters was not an activist or, in his words, "not up on a platform preaching," but he saw his music as a form of agitation. To Waters, the blues could be defined "in one word: TROUBLE." The music was "an expression of trouble in mind, trouble in body, trouble in soul," he explained in a 1950s interview. "When a man has trouble," Waters claimed, "it helps him to express it." When Waters first came to Chicago, he recalled that migrants like him had not wanted to openly resist the injustice they met. "My people who had left the South," he said, "even though they weren't really free, wanted to run off in a corner and escape their troubles."[9] But eventually they opened up to both his music and to collective resistance. A flourishing Mississippi diaspora culture came to inform old and new forms of civil rights struggles in the 1940s and 1950s.

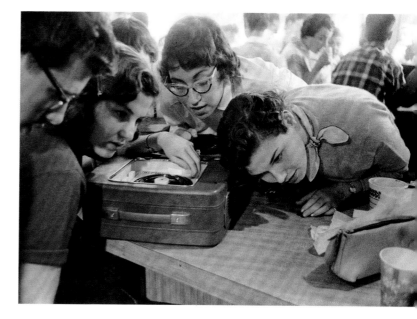

New technologies and business developments amplified Waters's music. His surprising success with Chess Records built him a solid reputation as a recording artist. Due to the lifting of the war-time ban on new recordings and the mass distribution of jukeboxes and portable turntables, a new audience began to hear his music. Blues singles—including one dozen Muddy Waters songs released between 1950 and 1955—rose to the top of the rhythm and blues charts for *Billboard* and *Cash Box*, traversing boundaries and consumed by a new "teen-ager" market—a dynamic explored further in the next chapter.[10]

As music wafted across the color lines dividing postwar Chicago, so, too, did many workers, who became less racially divided than they had been in previous decades. Through hard-fought organizing campaigns, workers in the Congress of Industrial Organizations (CIO) built interracial industrial unions in the late 1930s and solidified them during the war years. After the war, many workers in these progressive labor organizations hoped to realize their vision of a more democratic city by fighting for economic and social justice.

Perhaps the most significant of these local unions was the United Packinghouse Workers of America (UPWA).[11] By war's end, as many as one-quarter of all Black workers in Chicago labored for the meatpacking industry. Notably, the hiring

of Black women increased fivefold over that same decade.[12] The UPWA emerged from the war in good shape. As the union won consistent wage increases throughout the 1950s, its members fought to keep Black women's foothold in its ranks. The union pursued racially integrated departments more vigorously than it sought to erode gendered job classifications. A successful 1950 lawsuit against Swift & Co., for example, forced it and other major packinghouses to stop interviewing white women for positions it refused to advertise to Black women.[13] Five years later, Addie Wyatt and other Chicago UPWA leaders confronted the city's packinghouses with federal Executive Order 10557, a provision that banned government contractors from practicing race-based discrimination in employment. This leverage opened up the packinghouses' white-collar jobs, boosting Black women into clerk, typist, and secretary positions.[14]

Workers demanded fair wages, for example, by "Refus[ing] to Be Frozen in Poverty" and calling for "Equal Pay for Women." Such efforts did help many of Chicago's blue-collar workers win

middle-class wages. But racial tensions and Cold War government policies nearly snuffed out much of the previous decade's progressive civil rights unionism. The UPWA's members overrode the leadership to launch a massive strike in 1948, but it largely failed; the settlement they accepted was no better than the offer that had been on the table before the strike, and many of the most activist participants were fired.[15] The U.S. House Un-American Activities Committee (HUAC) created further trouble for the city's workers. The 1952 hearings brought "all the usual intimidations … against Chicago's union militants: screaming red-scare headlines, lists of fingered workers in the papers, fear of loss of jobs, threats of contempt citations, etc.," a labor reporter detailed. The hearings had never been intended to root out Chicago Communists. As *March of Labor* magazine concluded, congressmen had meant for them to target the city's prominent union activists and disrupt their momentum.[16]

Leading anti-Communists held Chicago in their sights. In 1954 Republican Senator Joseph

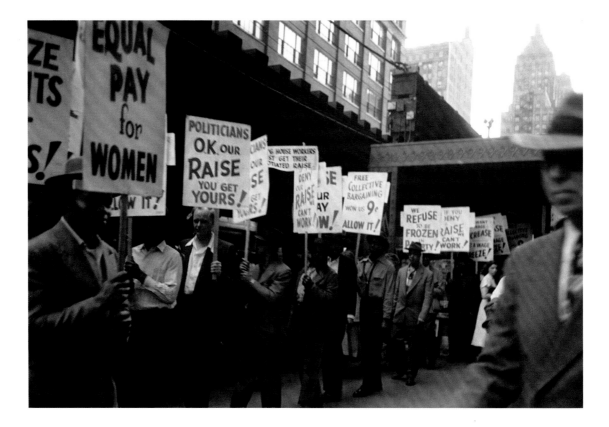

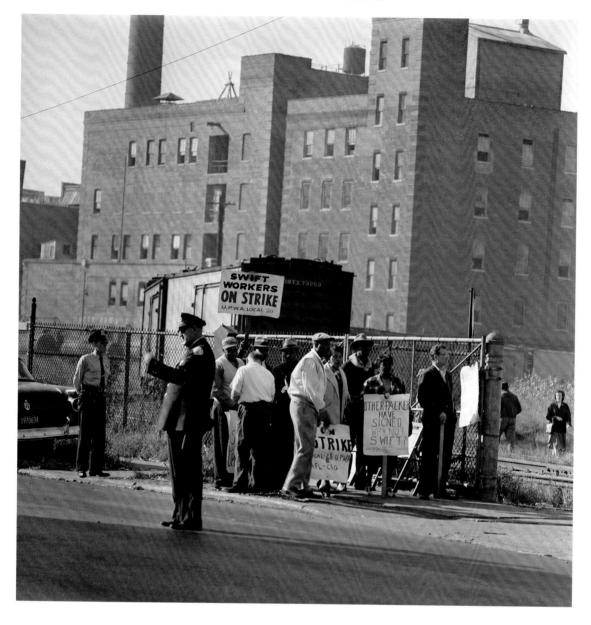

McCarthy—the namesake of McCarthyism—addressed an audience of 1,500 members of the Irish Fellowship Club on St. Patrick's Day at the downtown Palmer House hotel. McCarthy mused that he was tempted to "review the history of the Irish race" and highlight "how much they have contributed to the civilization of the world." But even on St. Patrick's Day, he told his largely Irish American audience, there was a more pressing imperative: "a war ... we are not winning" against "a brutalitarian power to enslave not only the minds but the bodies of all the people of the world." McCarthy defended HUAC's tactics—calling witnesses to testify and name others who were "fellow travelers" and "deluded liberals"—by concluding that "traitors are not gentlemen." He proclaimed his "high honor of manning the watchtowers of this nation ... regardless how rough the fight may get."[17] McCarthy's reception from the largely Democratic crowd was polite rather than enthusiastic, but his fellow Irish Catholics had been leaders of the bipartisan denunciation of

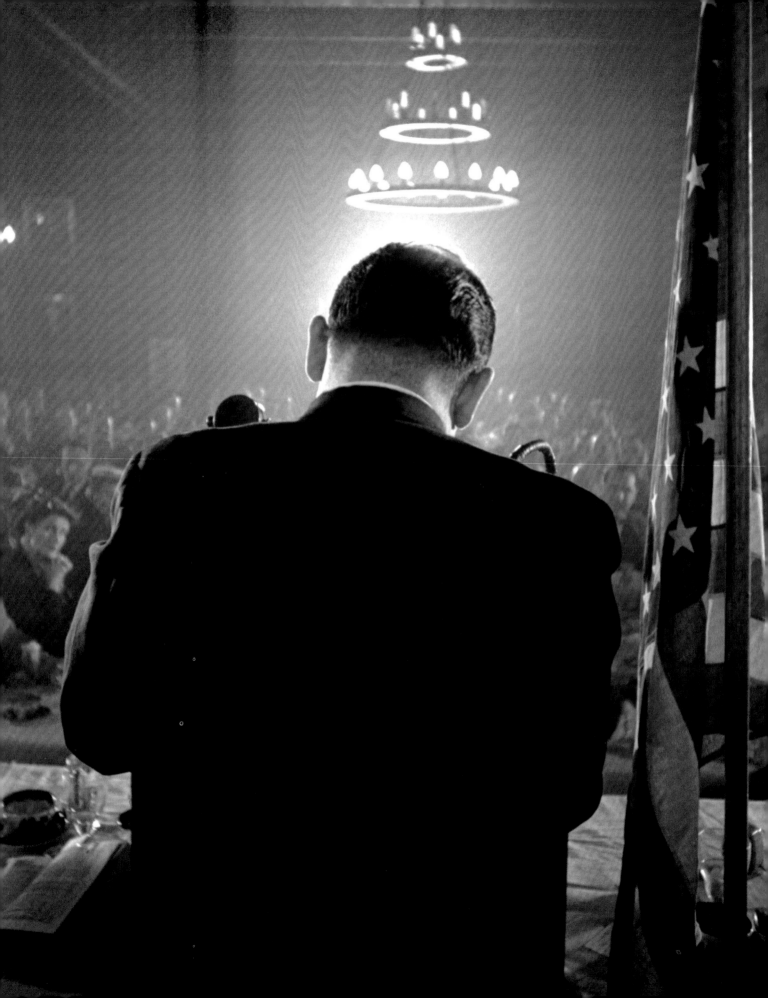

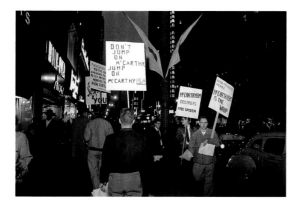

Communism. Many supported his efforts to cast a wide net in blacklisting anti-racist, feminist, and labor activists.

Covering McCarthy's 1954 speech, Shay satirized the senator, making a political point with his camera. Spotting the candelabra above McCarthy's head, Shay angled upward at him to capture his hubris in a halo of lights. Shay's friend and confidant, the writer Nelson Algren, shared this critique of the angels "manning the watchtower" to preserve American freedom in his 1951 book, *Chicago: City on the Make*. "However do senators get so close to God?" Algren asked. "How is it that front-office men never conspire? ... Or that winners never pitch in a bill to the price of their victory?" Chicago might be a Hustlertown, but punishment for such crimes seemed to be meted out against working-class people rather than those who built their careers by denouncing others as un-American. Indeed, as McCarthy stepped off the raised stage that night, he leaned down and grabbed Shay to steady himself. Shay told him, "That's the only support you'll ever get from me, Senator."[18]

Shay also made sure to capture the activists gathered outside. Their signs compared McCarthy to Hitler and Stalin, accusing him of stoking fear to "whip" people—especially "union members"—into surrendering their rights to free speech and peaceful protest. By the end of 1954, more and more Americans shared Shay's take on McCarthy. But the larger Cold War climate, evidenced by the sign that read "Don't Jump on McCarthy; Jump on McCarthy<u>ism</u>," continued to squeeze Chicago protest politics into a narrow framework.

In response to McCarthyism and other new forms of conservatism, a union liberalism coalesced. Although it accepted anti-Communism, this liberalism pursued cross-class and interracial organizing and nominally supported civil rights. It also sought to adjust the political economy to the benefit of working people. In October 1954, for example, two opposing groups greeted Charles Wilson, the former head of General Motors (GM) and Republican President Dwight Eisenhower's new secretary of defense. One group welcomed him off his United Airlines flight with messages such as "Peace with Prosperity: Vote Republican." A larger group chided him for disrespecting the unemployed at the height of an economic recession. Wilson had recently slammed the jobless as "kennel dogs," distinguishing them from employed "bird dogs." The latter, he said, would rather "hunt for food rather than sit on their fannies and yell." Drawing from this rhetoric, workers brought their own dogs to greet Wilson. They mocked and confronted him: "I'm a KENNEL DOG: DON'T FENCE ME IN!" and "Unemployed Workers ARE PEOPLE."

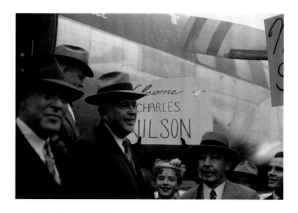

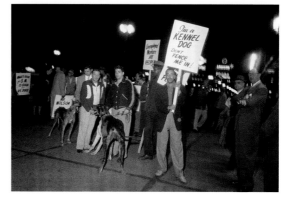

These workers' signs also challenged mainstream assumptions about the overall economy. They evoked Wilson's previous famous, if misquoted, comment tying GM's fortune to America's overall prosperity with signs such as "WHAT'S GOOD FOR G.M., IS GOOD FOR US DOGS." They further questioned the former CEO turned defense secretary's motives with signs such as "G.M. Brought me here to WORK[,] NOW Tells Me to 'GO SOUTH.'" That sign referenced the Great Migration that brought many African Americans to the city, only to face the problem of businesses that fled to the anti-union suburbs as well as to the western and southern regions of America.[19]

These workers were denouncing a new pro-business climate that was starting to cross party lines. It seemed to invite companies to relocate their factories and automate their production, shedding workers along the way. While these workers did not, as Wilson suggested, "sit on their fannies," they did yell in protest. Shay captured this dynamic during a short June 1955 strike of Ford workers. That Far South Side assembly plant employed 2,000 workers. The UAW strikers demanded a "guaranteed annual wage," or "GAW," to reset labor-management relations to the "proper scale of moral values which puts people above property, men above machines," in the words of union head Walter Reuther. When Ford representatives called these demands "unreasonable," workers denounced the company's offer as "5 YEARS OF SLAVERY." But Ford and other automakers, battered by strikes such as the ones by Locals 471 and 551 in Chicago while hamstrung by high demand, did agree to a modified annual wage. If these unions had lost the dream of changing the structure of capitalism, they reasoned, at the very least they could share the fruits of 1950s prosperity.[20]

The new local and national pro-business climate changed Chicago's political economy, but in the opposite way many unionists had desired. Right when African Americans and women moved into leadership positions and advocated for racial and gender equality, the industries themselves transformed to undermine union strength. By the mid-1950s, automation and runaway shops

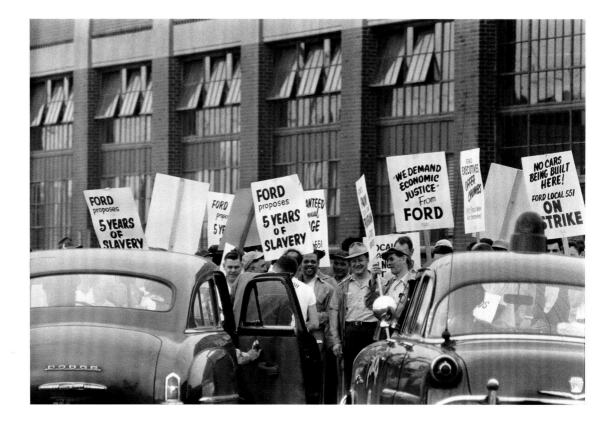

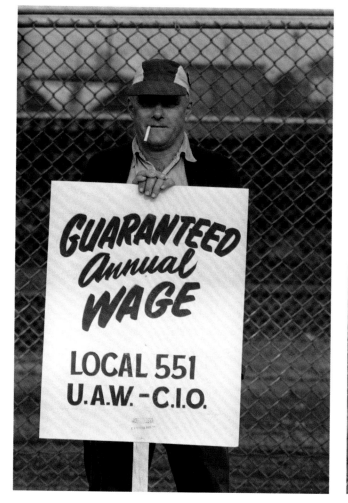

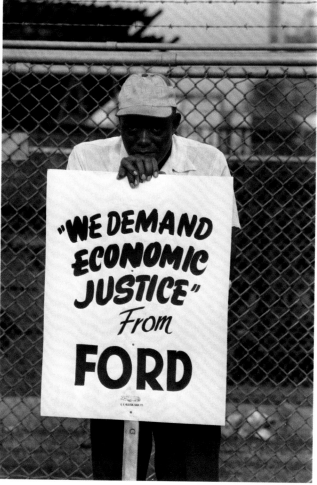

had put Chicago's workforce on a steady decline. In addition, the CIO merged with the American Federation of Labor, a more conservative labor organization that tended to mute appeals for structural economic changes and racial justice. As a result, the aggressive social democratic and civil rights unionism diminished just as union membership dwindled. In Chicago's packinghouses and stockyards, for example, employment dropped from its peak of 50,000 during World War I to only 2,500 meat-processing jobs by 1965.[21]

Beyond industrial workers and unions, another method of racial activism on economic issues emphasized consumerism and Black nationalism. African Americans in the Negro Labor Relations League (NLRL) targeted companies that did business in or with Chicago's South Side Black

Belt neighborhoods but failed to employ any African Americans.[22] As its membership crossed class lines within Black enclaves, this cooperation sparked tensions. Middle-class professionals complained about "entanglements with unsavory elements," aggressive tactics, and donations from "shady" Black labor racketeers willing to exploit the neighborhood's workers. The NLRL leadership boasted its use of "boys who lived in and out of jail" on its picket lines. It took donations from underworld and respectable businessmen alike, even as it claimed that its efforts yielded hundreds of jobs for community members.[23] In the postwar era, the NLRL maintained a visible presence with sound trucks, protest posters, and pickets with uneven success. Its members also expanded its campaigns beyond milk and bakery workers and

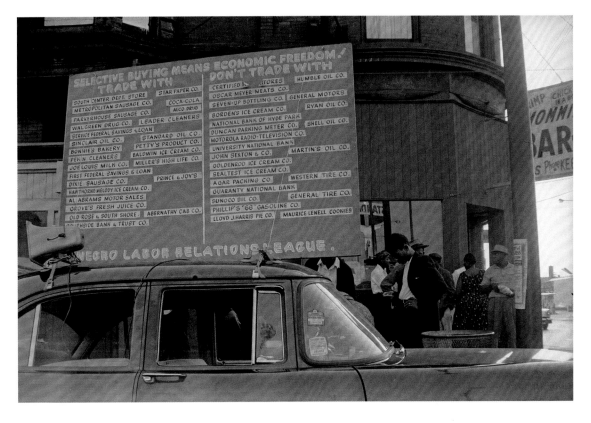

theater employees in the neighborhood to target discrimination in municipal subcontracts and banks in downtown Chicago.[24] But some African American South Siders decried the group as "too radical" in its tactics, and it faced formal criminal charges of extortion from companies it threatened to put on the "Don't Trade With" side of its boycott board.[25]

Black consumer boycotters made economic arguments about segregated spaces because there were very few places where they encountered other Chicagoans. Those locations where people of different races did interact were sites of consumption and leisure such as public parks and beaches. Located on Chicago's Northwest Side, the Riverview amusement park had long admitted African Americans, but prior to the 1960s young white kids attacked Black patrons "for their refusal to submit to white authority," according to one historian.[26] Nonetheless, African Americans sought out this urban space because there were so few opportunities for recreation in their own

South and West Side neighborhoods. Those children also wanted to ride the old-fashioned Ferris wheel, try the new space ride with "capsule cars sailing over the length of the park," and play the carnival games.[27]

The park's managers admitted Black patrons to all of its facilities starting in the mid-1930s, but they also continued to confirm white control over its space—especially in one notorious game called the "African Dip."[28] In it, a player paid a dime (later a quarter) for three balls to try to hit a target attached to a dunk tank where a person—typically a young Black park worker—would fall into a pool of water. The carnival game's owner welcomed "integration" as white men staffed the counter to take patrons' money and "colored boys" sat in cages "just like monkeys."[29] The Black employees were trained to antagonize potential customers, and white men in particular, by making comments about their girlfriends and wives, thus provoking them to play the game and dunk them in the water to demonstrate their manhood and racial superi-

ority.[30] White patrons may have found the game innocuous, but it expressed a message of racial dominance and control. African American patrons had long complained about the "Dip" as a "contemptible" spectacle that "foments antagonism and ridicules the Negro," as one group wrote to the *Chicago Defender* in 1950.[31] But it was not until 1964 that fear of a boycott and a column by the white Chicago journalist Mike Royko succeeded in getting the game removed, even if it also took the jobs of those Black workers.[32]

The most common issue of racial contestation in the postwar era, however, was housing. With the end of the war and the ongoing Second Great Migration, Chicago grew in population but not in available housing units. A Chicago Urban League report, titled "Fog Over Chicago," laid out the massive housing problem that had grown in the past decade. Between 1948 and 1958, at least 100,000 new homes were needed to accommodate the influx of more than 400,000 African Americans in Chicago. Only 22,500 new units had become available, and most of these had been created

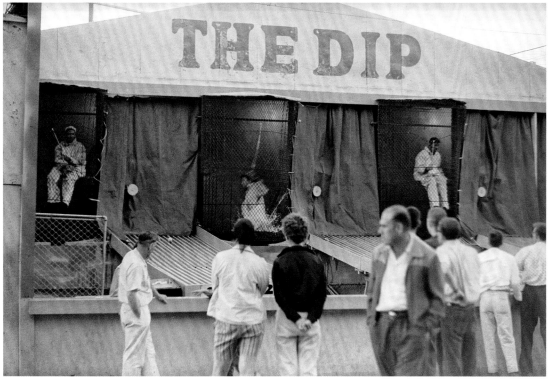

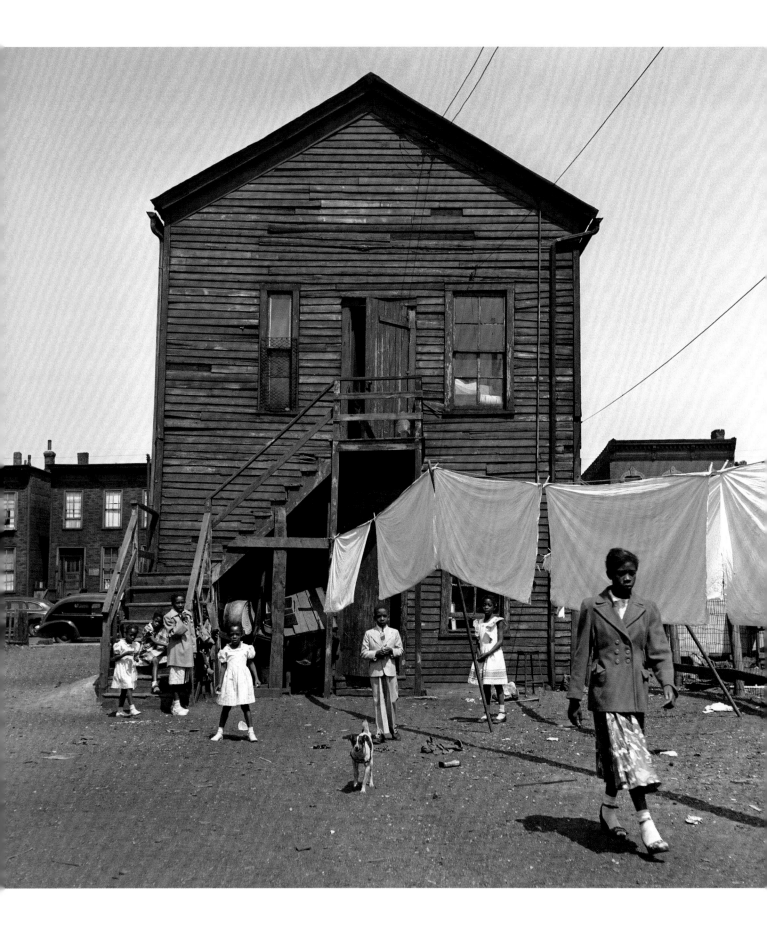

by subdividing existing dwellings rather than
building new ones. Moreover, urban renewal
and "slum clearance" projects displaced 86,000
people, 67 percent of whom were Black. This prob-
lem of housing overcrowding, the Urban League
explained, would continue as long as African
Americans could not access "normal selection and
financing" for homes. Persistent segregation lim-
ited Black renters to the 9 percent of "artificially
restricted" units in the "ghetto"; the suburbs
barred them altogether.[33]

Other observers described the problem as
well. Without government intervention, the private
housing market would continue to encourage
segregation that permitted African Americans'
financial exploitation. In 1953 the director of
the all-white Chicago Real Estate Board blamed
the migrants themselves for the overcrowding,
saying that "the urbanization process will take
some time for the colored rural people who are
coming to Chicago." Another report noted that
"few Negro realtors talk about integration" because
they "find the expansion of the Negro segregated
area to be the most profitable area of opera-
tion."[34] As the Urban League and independent
analysts concluded, "two separate Chicagos" had
developed: "the geographic white Chicago ... in
which the population is shrinking" and the "geo-
graphic Negro Chicago ... in which the population
is growing fast." City leaders had created a "fog"
over these problems, purposely obscuring rather
than trying to fix them.[35]

This housing-related "fog" lifted for a while
in September 1953, when the coroner of Cook
County demanded a public inquest into "fire
trap" housing. The tragedy that prompted this
investigation was a horrific blaze that ruined
an entire apartment building at 3616 South State
Street, in the heart of the residential Bronzeville
neighborhood. This building had numerous un-
addressed and unreported building code violations,
including faulty wiring and a lack of fire escapes.
Negligence had killed eighteen people. Coroner
Walter McCarron hoped that this tragedy would
prompt a public investigation into the more than
sixty deaths that had occurred in the previous
six months. He pointed out that violations had

been reported in hundreds of other buildings,
primarily in areas where African American and
Mexican migrants lived. McCarron's inquest made
headlines, and the city council formed a blue-
ribbon panel and moved the hearings to City Hall
to redress this issue. James Downs, the mayor's
housing coordinator, testified that "the slum oper-
ators are today's white slavers." Roy Christensen,
the building commissioner, said he was so dis-
traught by what he heard that he was "unable to
sleep for weeks" or "take solid food for days."[36]

But anger and empathy did not lead to sub-
stantial reform. One fire commissioner accused

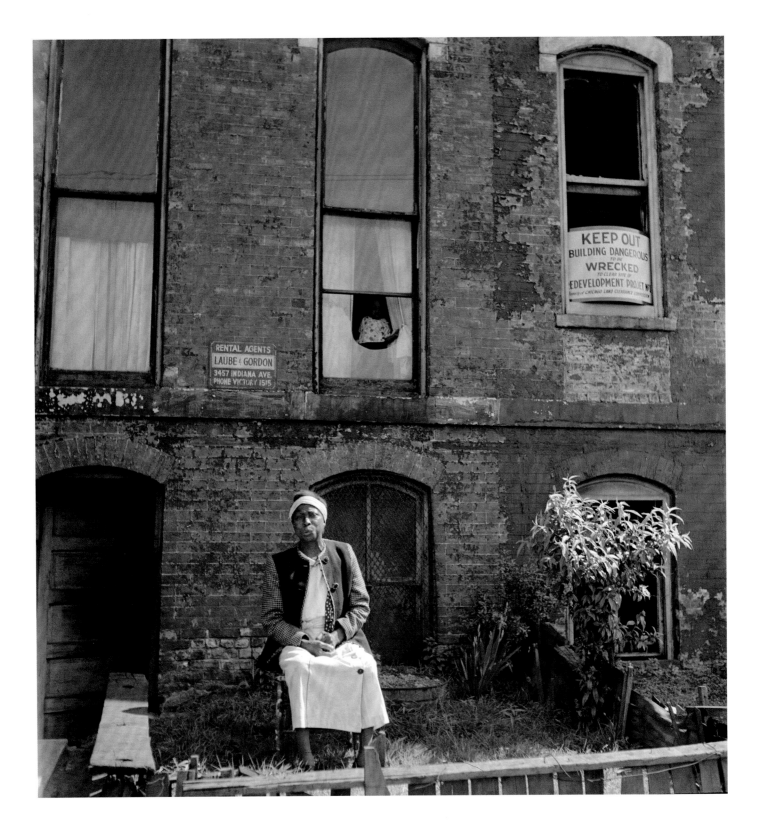

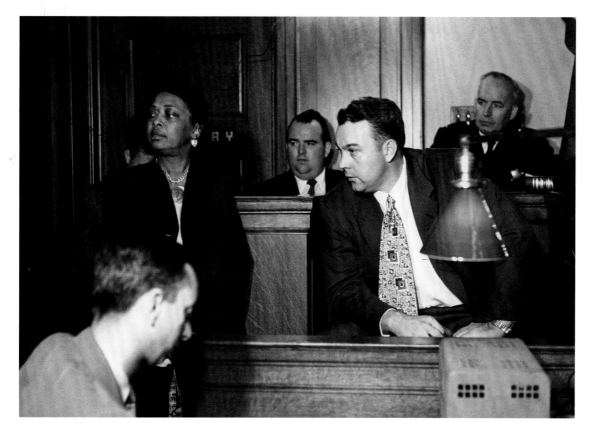

McCarron of "playing politics" (since he was a Republican); another report conceded that he "irritated the city administration"; and a closed-door meeting with the Democratic Mayor Martin Kennelly led McCarron to abandon his plan to subpoena the mayor to testify. The city council passed three ordinances for better enforcement, but the aldermen rejected a proposal to shift that enforcement from the ineffective city building department to a new conservation board. This led to charges that it was a "phony" and "long deferred program of reform." And while the Republican *Tribune* took some glee in reporting the lack of city code enforcement and municipal court decisions of Democratic officials to punish exploitative landlords, its editorial also blamed rent-control laws and the tenants themselves as having "primary responsibility."[37]

African Americans' search for adequate housing led many to white neighborhoods—not necessarily as civil rights activists, but as people desperate for a decent place to live. As Mrs. Porcher, a resident

of Chicago Public Housing, explained, "We've lived in rooming houses, garages, and places you can't imagine, so you know I appreciate this place." She reflected, "It doesn't matter if I don't make friends here."[38] On the latter point, she and other Black "pioneers" knew well that the feeling was at best mutual. White residents often met new Black residents with rocks, bricks, fists, and fire—though this postwar period became an "era of hidden violence" because the Chicago Commission on Human Relations warned the press that coverage of these incidents would only increase their frequency.[39] But in July 1953, when Betty Howard, a light-skinned Black woman, applied and was accidentally admitted into the all-white Trumbull Park housing project on the city's Far South Side neighborhood of South Deering, racial clashes over housing became national and international news.

By that fall, three more Black families moved into the Trumbull Park apartments, and *Life* magazine commissioned Art Shay to photograph the racial drama. The resulting photographic story

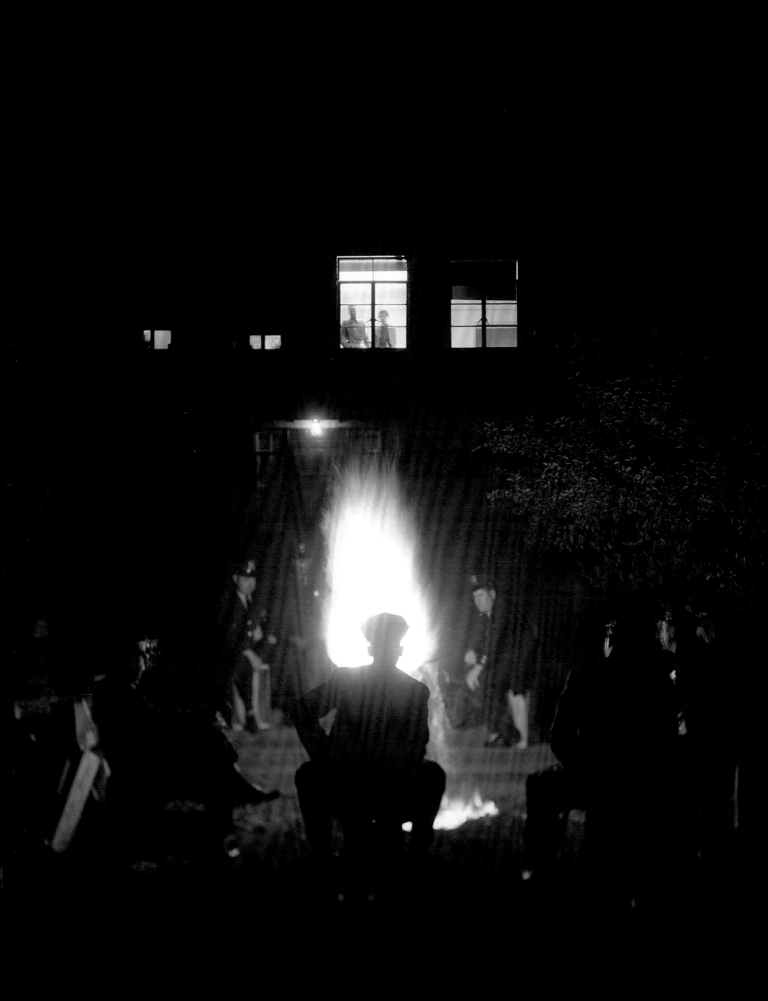

with captions, "Night Watch: It Guards Negroes in a Chicago Housing Project against Violence," emphasized the police presence and spotlighted the Black families who remained confined to their apartments under threat of violence. The photographic narrative began with a full-page color photograph of police around a bonfire, where "from the window of their apartment Mr. and Mrs. Edward Johnson look down at [a] night shift of a continuous police watch over them," and then it moved from photographs of a phalanx of officers at roll call to a photograph (not taken by Shay) that suggested white violence, with the caption: "Woman at right carries stone and stick" and another "woman with camera was a riot leader." The last page featured close-up portraits of three of the Black families that emphasized their confinement. The Howard family "put plywood in [a] window after brick crashed glass"; the King family "moved into the project from [a] crowded apartment where three children had to sleep in one room"; and the Johnson family "fearfully keep their living room blinds drawn." Each caption mentioned the residents' employment—"part-time mail man," "hospital attendant," and "state of Illinois clerk, and his wife, a university graduate"—to counteract stereotypes of Black families in public housing as lazy and jobless. Shay's images in *Life* emphasized respectable families as imprisoned victims, guarded by police in their own homes.[40]

By focusing on Black victimization at the hands of unruly white mobs, *Life*'s essay captured the nation's attention while narrowing the story. An important Black counter-narrative to the one of victimhood emerged in the writings of Frank London Brown, whose family was among the African Americans who moved into the public housing apartments in Trumbull Park. When the Brown family moved in April 1954, Frank worked as the program coordinator for Chicago's District 1 of the United Packinghouse Workers of America. He explored his own literary aspirations in his 1959 book *Trumbull Park*. The novel emphasized how Black families transformed their racial shame and fear into pride and boldness. In particular, it highlighted Black residents' humiliation at riding locked in the back of police wagons between home and work. Looking through the wagon's

grating at a white onlooker, Brown's narrator remarked, "Even he was grinning at the monkey in the cage," not unlike the symbolic shame produced by the "Dip" at Riverview Park. But these Black families gradually became emboldened to resist their confinement through collective action. At the end of Brown's novel, some Black residents "walked with our chests stuck out, and our heads way up in the air," while singing a blues song: "Every day, every day … Well, it ain't nobody worried, and it ain't nobody cryin'!"[41]

This final scene, while not entirely accurate, highlighted the community resistance that developed in Trumbull Park. In the novel's account,

Deering Improvement Association's campaign of racial terror. And while the Black families of Trumbull Park were "all very proud" that Brown had published a novel about them, some of his neighbors resented that he had "quit on them" when he moved his family out of the neighborhood. At least one white resident objected that "whites" in the book "were treated as a faceless mob."[42]

Just as Brown's novel emphasized African American collective resistance, media accounts depicted a monolithic white racist response in South Deering. A more detailed look at the families in the Trumbull Park homes and surrounding South Deering neighborhood helps to explain Shay's unpublished photos, such as an innocuous image of police playing baseball with neighborhood children. In this baseball game, the intergenerational bond was one of whiteness, but politics, ethnicity, and religion also mattered.

In the 1950s, Chicago's police force was made up of white ethnics—Irish, Polish, Italian, and Greek. These men owed their jobs, and thus their allegiance, to the precinct captains in Chicago's fifty political wards, which matched its police areas. In addition, the police force was largely Catholic, and most of its officers belonged to the St. Jude Police League, a powerful fraternal organization with its own ministers and rituals that bonded policemen through religion.[43] Paralleling the ethnic and religious solidarities of the police, much of the white neighborhood resistance came from similar Italian, Yugoslavian, and other white ethnics in South Deering. Many of these residents were also Catholic and belonged to St. Kevin's parish. Its membership overlapped with the South Deering Improvement Association, the organization that openly opposed Black residents and whose bulletin reprinted articles from the White Citizens' Councils in the South. Most of these Catholics rented or owned the neighborhood's houses, evincing higher incomes and class status than their neighbors in public housing. But they nonetheless expressed economic anxiety in racialized terms through a violent defense of parish boundaries. Such outbursts embarrassed other middle-class Catholics in the city, who forged interracial alliances with civil rights groups, but

Black residents formed their "Walk and Pray" group in the spring of 1957 that rejected police escorts. Together, they moved freely throughout the housing project and the surrounding South Deering neighborhood. The novel thus emphasized Black residents' ambivalence toward interracial forms of struggle in the Cold War 1950s. In reality, "Walk and Pray" was created through an alliance between the Black families and a young white minister, David Fison, and his Methodist church, which rejected the South

whose impact on their fellow Catholics in South Deering was negligible.[44]

By contrast, many of the white families who moved into the Trumbull Park apartments from outside the neighborhood—including a few southern transplants—quietly tolerated or even supported its limited desegregation. The local Methodist church, an outspoken supporter of desegregation, suffered five years of arson and bombings. While the conflicts at Trumbull Park drew violence that inspired comparisons to southern confrontations, whiteness was not monolithic. The city's racial formation was shaped by the city's particular religious, ethnic, and class characteristics.[45]

By 1960 Black residents of Trumbull Park had kept their place in the public housing complex. A report that year noted that major incidents of violence had decreased since the Calumet Park riots during the summer of 1957 that had spilled over into South Deering. Forty Black students had enrolled in the neighborhood's elementary school. The community center and Methodist church had become interracial spaces of community gathering. By contrast, the South Deering Improvement Association's meetings dwindled, with its propaganda bulletin devolving from a free weekly to a monthly subscriber-only newsletter. Perhaps the strongest sign that tensions had cooled was a series of interracial baseball games in the summer of 1958 that took place without incident on the prairie land next to the housing project.[46] Methodist Reverend Fison reflected that cameras, not more violent weapons, had been essential to pacifying the neighborhood. "I have found that harassers keep their distance when I carry my camera," he wrote, and "the presence of cameras will do much to keep troublemakers at bay." But he also understood the limits of his camera as a tool of exposure, writing that people should only use this weapon "when one is in a group" and to help police identify and arrest lawbreakers.[47]

The sustained occupation of Trumbull Park reflected some citywide gains but also revealed the city's failure to fight housing segregation. In 1940 most African Americans occupied a small section of urban space on the South Side of the

city. Two decades later, they had stretched this area threefold to encompass a huge new West Side enclave.[48] But even as African Americans' available living space expanded, institutional racism became more entrenched. Trumbull Park residents noticed that when vacancies occurred in the project, the Chicago Housing Authority was slow to fill them despite the waiting list of 20,000. Black families desperate for affordable and decent housing made up 85 percent of that list. Trumbull Park housed twenty-nine families in 1955—a figure that soon dropped but held steady at nineteen. The CHA blamed this decline and token level of desegregation on Black applicants who did not want to move there because of its violent history. Residents and housing equality activists knew otherwise. Despite recent city provisions requiring that "families shall not be segregated" and "granting the applicant first in order of the list of choice," Mayor Kennelly and the Democratic machine fired Elizabeth Wood from the CHA. She had been the agency's last champion of limited desegregation. By early 1958 Wood's replacement, Alvin Rose, backed away from desegregation policies in a speech at the City Club of Chicago. "We are not going to use public housing as a wedge," he declared, adding, "Our role must be one of a friend to the community." In practical terms, this new policy meant that city officials would protect the racial status quo. As one historian explains, this policy "turned the CHA into a bulwark of segregation in

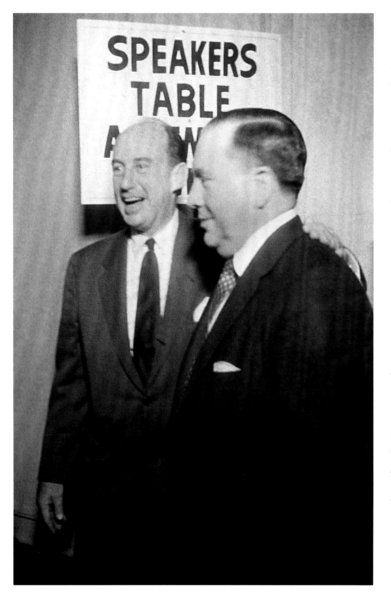

a time. And while Kennelly's tenure saw widespread yet localized housing-related skirmishes in South Deering and other Chicago neighborhoods, these whites resorted to violence because they felt they could not rely on city officials to preserve their racial privilege in the 1950s.

Enter Daley, who, as Cook County clerk, quietly co-opted the Democratic machine and created the illusion that he had been drafted to run as a reformer. In the "chill of winter" of 1955, *Life* magazine reported on the "hot fight to choose a mayor," telling a national audience that the Democratic machine had "unceremoniously shoved Mayor Martin Kennelly out" in favor of "Richard Daley, an honest politician of unquestioned party loyalty." Daley defended the Democratic machine (or "organization," as he put it) against charges of bossism and corruption. It was a "community service" for ordinary local people, he explained. In a speech that February at Chicago's City Club, he joked, "Sometimes I think the newspapers have just discovered that elections for public office are conducted by political parties." Daley capitalized on the negative press and racial animosity created by Chicago housing struggles to foster pragmatic alliances with national Democratic Party figures who had reform records. Chief among these was Adlai Stevenson, who had served as governor of Illinois and had run as the Democratic nominee for president in 1952. "The Chicago machine had launched Stevenson's political career," Daley's biographers explained, "and he would need its backing when he sought the 1956 Democratic nomination for president." As such, Stevenson broke from his rule against primary election endorsement to join forces with Daley, allowing the mayoral machine leader to "wrap himself in the mantle of reform." Art Shay photographed the two men as they stood together, over the caption, "From Adlai Stevenson came a pat on the back and a sharp denunciation of Daley's critics."[50]

In addition to publicly allying with liberals, Daley's campaign pitched him as a defender of local pride—a man who would battle the outsiders and elites attempting to besmirch the city's reputation. In one of his "Go Forward" campaign pamphlets, for example, Daley framed the city as

Chicago," aligning it with an equally racially segregated and exploitative private housing market.[49]

These housing policy shifts paved the way for Democratic Committee of Cook County chairman Richard J. Daley to rise to the mayor's office as a reform candidate in 1955. While Mayor Kennelly had hardly championed desegregated housing, he did change many of the Democratic machine's patronage jobs into civil service positions. This shift most notably allowed Elizabeth Wood and others to run a somewhat independent CHA for

a victim of its own success. He wrote, "The city's historical role as a mid-continental migration center" had spurred "rapid and tremendous development" that "has brought problems with it, like housing and off-street parking and race and crime—like everywhere else." But he appealed for a "re-evaluation of Chicago's great stature," blaming outsiders for minimizing the city's greatness by overemphasizing its problems. Daley's strategy downplayed the city's growing inequalities and elevated him as a defender of ordinary Chicagoans' "justifiable civic pride." This strategy of trying to be "the poor man's friend," one person advised, should be "hammer[ed] … home until you are nauseated by it."[51]

Daley accomplished this through coded language that linked race and crime. In another statement, Daley wrote that his opponents had "unduly *blackened* the reputation of our essentially well-ordered, cultural, esthetic, attractive metropolis." Deliberately or not, this statement paralleled another central focus of his local campaign—framing his home neighborhood of Bridgeport as an emblematic Chicago neighborhood. As a campaign slogan, Daley often said, "When I walk down the streets of my neighborhood, I see the streets of every neighborhood. When I go to my church, I see churches of every faith. When I greet my children, I see the children of every family."[52] Shay captured these politics of the local "civic pride" in photographs of an evening rally in February that crossed Daley's neighborhood. This carefully staged march presented Daley as a local champion, spotlighting the support of housewives ("'Mom' Likes Daley") and children. Daley's campaign also made sure the crowd demonstrated its support for Stanley Nowakowski, the Polish alderman of the Eleventh Ward vetted by Daley and the machine in 1947 to solidify an alliance between Bridgeport's Irish and Polish residents.[53] The people of Bridgeport performed and displayed the Daley campaign's aspirations for Shay's camera and to Chicago at large.

Daley's television advertisements—then a relatively new political tool—included footage of his Bridgeport marches and speeches. His campaign designed these ads to change unfavorable opinions of Daley's "low and restrained voice" and ap-parent lack of confidence that one advisor deemed not "too effective for the medium of television."[54] Instead, Daley's advertisers commingled flattering scripts with footage of neighborhood supporters. "Many of these people have known Richard Daley since his boyhood," one read. "They are enthusiastic ~~workers~~ neighbors of Daley for mayor and their banners, hatbands, and signs leave no doubt about their feelings. They want the rest of Chicago to share their enthusiasm."[55] These accounts of Daley emphasized his modest home at 3536 South Lowe Avenue in Bridgeport, his loving wife, and his seven children. In replacing "workers" with "neighbors," the ad sought to convey Daley's supporters' genuine love for him and suggest that the rest of Chicago should know and love him too. This television-advertising writer thus repackaged people who no doubt had machine patronage ties into plucky volunteer supporters.

The campaign theme of Bridgeport neighbors may have convinced some Chicagoans, but labor unions lined up for Daley due to their disdain for the incumbent Kennelly. The local American Federation of Labor endorsed Daley in a special edition of its *Federation News* accompanied by his handwritten letter "explaining his person-to-person style and his plans." The more politically and racially progressive Cook County Industrial Union Council of the CIO supported him as well, making available prominent union leaders to speak out on behalf of the campaign.[56] Labor leader Ernest DeMaio—president of District 11 of the United Electrical Workers, one of the few left-wing unions remaining in 1955—spoke for many when he denounced Kennelly's "inept and reactionary leadership." Beyond Kennelly's personal style, DeMaio criticized the very premise of his political narrative. Daley's opponents spoke of Chicago politics as a dichotomy between "clean government" and the "machine." But the supposedly "clean" coalition included the "GOP, the West Side Syndicate bloc, the city's anti-labor employers, the employer's anti-labor specialist [Police] Captain [George] Barnes, and such race violence advocates as the Chicago Tribune." As such, the Republican Party's criminal and anti-labor coalition did not seem like a "clean" alternative for the city's working class.

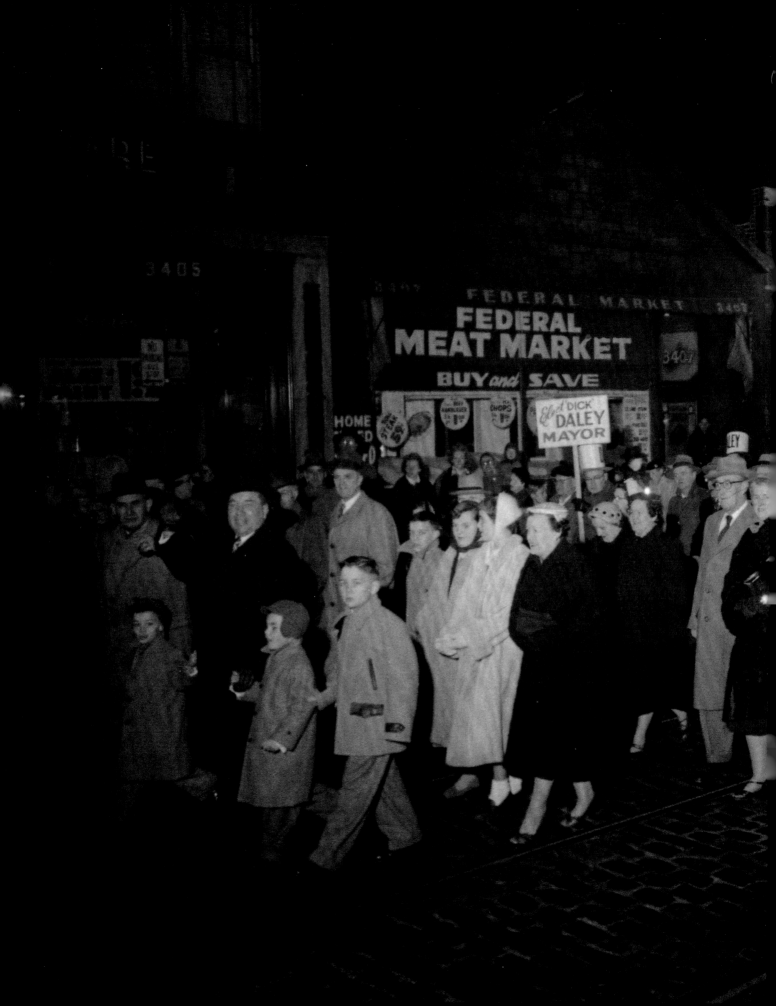

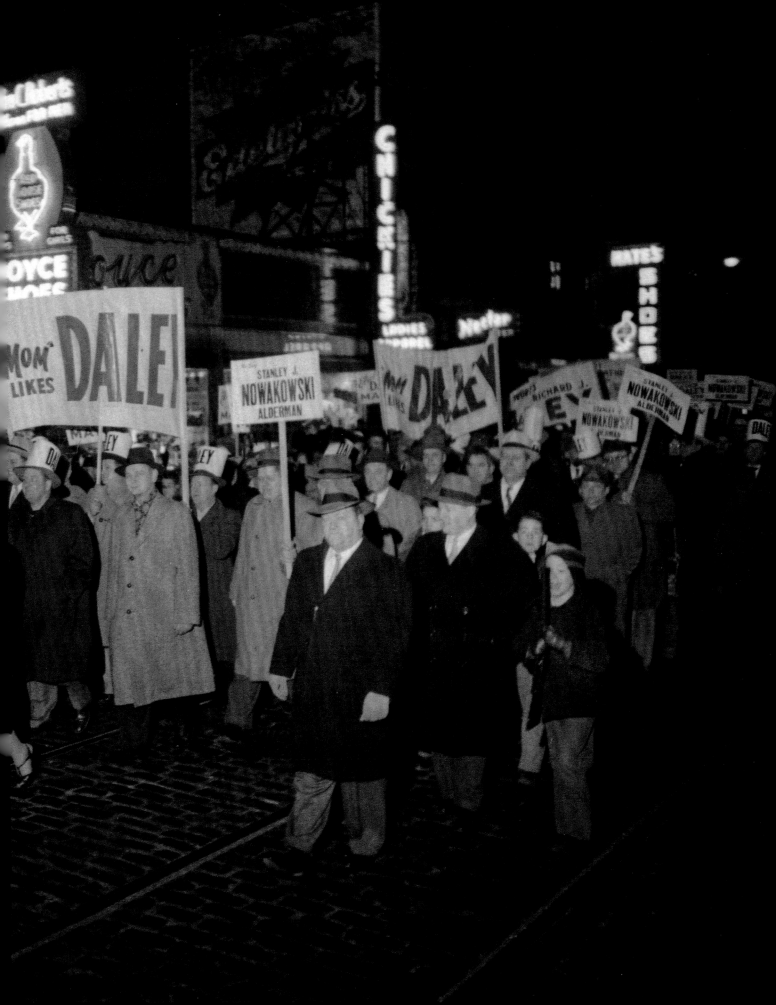

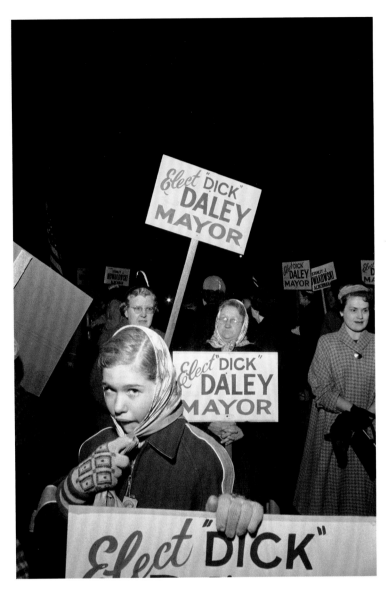

Black newspaper, endorsed him too. But advocates of segregation such as the South Deering Improvement Association also thought Daley was their man. The machine he controlled fused old-fashioned machine patronage politics with deceptive practices such as circulating flyers in white neighborhoods claiming that the fictional "American Negro Civic Association" endorsed his opponent. Daley's machine ran a Janus-faced campaign that succeeded in both the primary and general elections. He evaded questions about the future of public housing and racial justice while earning endorsements from progressive labor and civil rights groups. Daley won the general election by the narrow margin of 55 percent of the vote, including several critical Black wards. Few of these diverse supporters, hopeful that a vote for Daley would return power to average Chicagoans, could have known that they had just elected a mayor who would consolidate his control for the next two decades.[58]

This chapter opened with Muddy Waters as a representative of the struggles and possibilities Chicago held out to the newcomers of the Second Great Migration. It concludes with a similar emblematic musician, Mahalia Jackson. She came to Chicago as a sixteen-year-old from New Orleans in 1928, at the tail end of the first wave of the Great Migration. This first group of migrants had been in Chicago longer, and, as such, they fostered different forms of politics and culture that worked in tandem and in tension with that of later migrants, even though both groups met similar racial restrictions. Living with her aunt Hannah in Chicago, Jackson had planned to study nursing, but economic necessity led her to work as a domestic, a hotel maid, and in a packing company. By 1939 she had scraped together enough money from these jobs and her singing in churches to open her own beauty parlor, Mahalia's Beauty Salon, at 3252 South Indiana Avenue, in the heart of the South Side Black community. But Jackson's legendary performances at Greater Salem Baptist, Pilgrim Baptist, and other local churches made her into a career musician. When she first arrived in Chicago, she recalled, ministers railed against gospel music as not "dignified" because of its jazz

But most important, DeMaio could not support a mayor "who sits silent while Negroes live in terror under siege at Trumbull Park homes." DeMaio urged Daley to champion reforms that would benefit average Chicagoans: to push low-cost housing, tax real estate interests, end double-shift and overcrowded schools, raise unemployment benefits, elect judges democratically, and arrest those responsible for racial violence and discrimination in Chicago's neighborhoods.[57]

Prominent African American organizations supported Daley for similar reasons. The NAACP and the *Chicago Defender*, the city's influential

elements and "hand clapping and the stompin'," but eventually the community and churches came to accept it as "serving God." It was "the same good old church music," Jackson said, "but with a little bounce." Outside of church, Jackson's 1948 rendition of "Move on Up a Little Higher" made her a national star, thanks to a recording contract with Apollo Records and radio play from disc jockeys like the South Side's Al Benson.[59]

Jackson's experiences in this postwar era were shaped by the hope she and others held out for a better society as well as by the shifting protest politics in Cold War Chicago. In April 1948 she and blues musician Big Bill Broonzy performed at a Chicago South Side fund-raiser and rally for the national Progressive Party. The gathering featured left-wing unionists, activists, and politicians. But just four years later, Jackson threatened to sue leftist organizers of a "Peace Rally" in New York for using her name without permission. "I believe in peace but I also believe in God," she said, echoing a common refrain about Communism as godless. "You can't truly believe in one without the other," she told the press, and people who claimed otherwise were "false and disloyal." This change of politics paralleled the larger civil rights movement's shift toward a Cold War liberalism that refused to endorse anything connected to Communism. Beginning in the late 1940s, Jackson reaffirmed her commitment to the Democratic Party, which also meant she stumped for candidates from William Dawson's Black submachine organization in the 1950s. But she did risk her career when she "crash[ed] television's glass curtain," insisting in 1955 that her longtime radio scriptwriter, Studs Terkel, be retained for her new television show even though his name appeared on the entertainment industry's anti-Communist blacklist.[60]

Jackson also came to realize her newfound celebrity did not change her relationship to Chicago's color line. "The attention I was getting from white people from my singing sort of confused me,"

she said. "It took me some time to understand they still didn't want me as a neighbor." When she tried to find a house outside the Black Belt, agents and homeowners refused to sell to her. Through an agent, she finally found a willing seller and bought a large house in Chatham (at 8358 South Indiana Avenue) in 1956. But "people almost went crazy" soon thereafter. Jackson joked, "You'd have thought the atomic bomb was coming instead of me." Threatening phone calls followed; vandals shot bullets and pellets through her windows. The *Chicago Defender* blamed the *Chatham Fields Bulletin*, a segregationist newspaper that "stoked violence" among white residents in the neighborhood. A police detail remained for a year to protect her and the few other Black professionals there, and by the late 1950s the neighborhood had become majority Black. This white flight also surprised Jackson. She recalled that whites "swore" that Blacks would make it "a slum overnight," but, she noted, "the grass is still green" and "the same birds are still in the trees."[61]

Shay photographed her singing-in-motion in the basement of this house in the late 1950s. His images capture Jackson's dynamic approach to music as a form of personal liberation. "Gospel and spiritual music," she said, "brings the people where I want them to be—in the presence of God." Undeterred by threats from whites, Jackson sang at a Chicago rally for the southern civil rights movement a month later, traveled down to Montgomery, Alabama, in support of the bus boycott there, endorsed the sit-in movement of the younger generation, and became a key cultural leader of the 1960s civil rights movement, both in the South and Chicago.[62] But this 1960s reemergence of Chicagoans' grassroots resistance was preceded by an era without much democratic activism. It was shaped instead by an increasingly powerful and punitive criminal justice system.

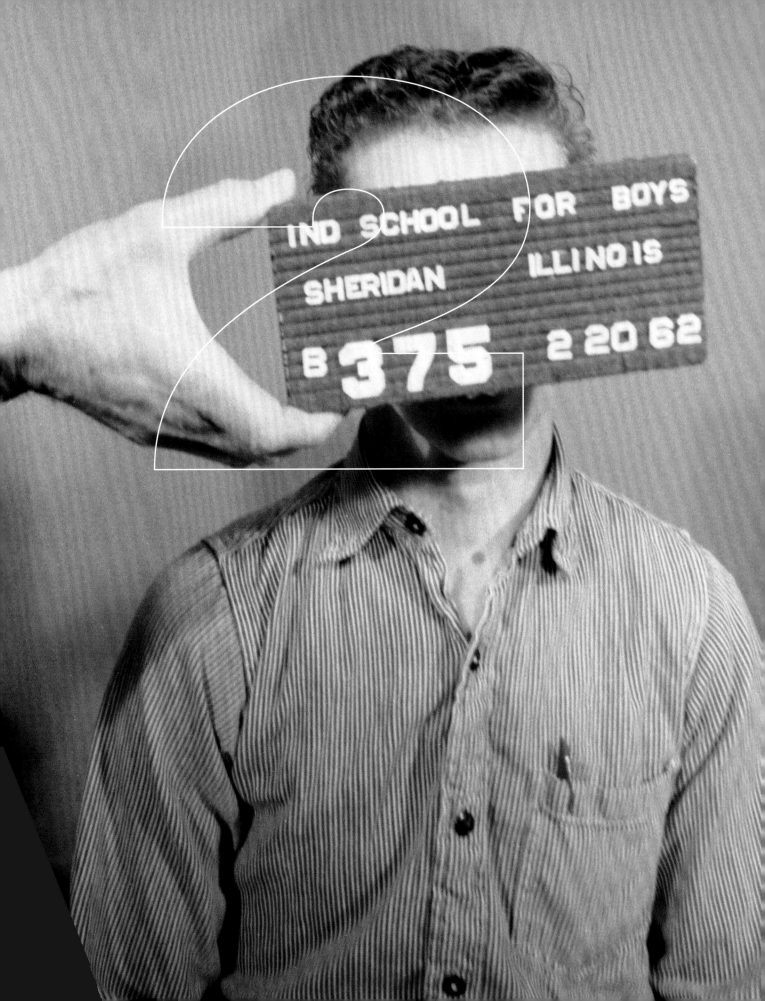

WINDY CITY
JUSTICE

Chicago in the 1950s was a city defined by racial and class inequality but described as a place of affluence and progress. At the end of the decade, a confidential report noted that "the demoralized and rotting areas of the city we call slums have grown alarmingly," and as a result, "Chicago has been moving steadily to becoming a city of the rich and poor with its middle class living in the suburbs." Instead of trying to improve their environment, residents seemed apathetic. "None of the important organizations pleading for an end to segregation," the report concluded, "have faith in their own platform. Off the record, they admit they can think of no practical way of getting what they want." The criminal justice system played a central role in silencing democratic troublemakers at midcentury. The police, courts, and jails targeted, arrested, convicted, and locked away more Chicagoans than ever before. Rather than attempting to rehabilitate incarcerated troublemakers, city officials removed and contained them. It especially targeted "teen-agers," a group that was largely denied the privileges and spoils of the city's Democratic machine.

To expose the hidden workings of Chicago's criminal justice system, Art Shay wandered what he called "the lower depths" of the city with his artistic collaborator and friend, the writer Nelson Algren. Shay explored the urban spaces that nobody wanted outsiders to see in order to expose the injustices that made the city work. When Shay's press card as a Time, Inc., photographer could not get him access, he recalled that a "discreet five-dollar bill" was "never turned down" by the police officer or bailiff on duty. Such petty bribery could buy access to hidden spaces such as the courts and jails at Eleventh Street and State Street and Twenty-Sixth Street and California Avenue. There, one could witness what Shay called the "further oppression of the already oppressed."[1] Some Chicagoans, signified by a photograph of a well-dressed man painting a sign that read "Smiling-Criminals. Polite-Hypocrites," understood that the city's boosters worked to hide its problems. They, like Shay and Algren, produced a message that flipped the usual script about progress, poverty, and criminality in 1950s Chicago.

Shay and Algren spotlighted the downtrodden that others ignored, exposing the forces that sought to control them. This collaboration embarrassed Chicago's boosters and power brokers. In October 1951, *Holiday* magazine published an issue on Chicago with an Algren essay accompanied by Shay's photographs. If the magazine intended to draw people to visit its featured destinations, this article likely had the opposite impact. "It isn't hard to love a town for its broad and bending boulevards, its lamplit parks or its endowed opera," Algren wrote. "But you never truly love a place till you love it for its alleys too." In alleys and other dark corners, Algren found the hustlers of Chicago. One hardworking nightclub entertainer, an African American man in women's attire, explained to a judge, "Female impersonation isn't just a silly hobby with me. It's my bread and butter." Beyond the city's station houses, courts, and jail cells, they even got access to its spaces of death—the morgue and the electric chair. The chair was located in the basement of the Cook County Jail, the nation's only jail that carried out the death penalty on inmates in its own facility. Although Shay's most morbid photographs did not run in the article, Algren ended by highlighting "the adolescent who paused his gum chewing, upon hearing the sentence of death by electrocution put upon him, to reminisce: 'I knew I'd never get to twenty-one anyhow.'" To Algren and Shay, this figure embodied Chicago, a city whose hustler mentality devoured even its own young.[2]

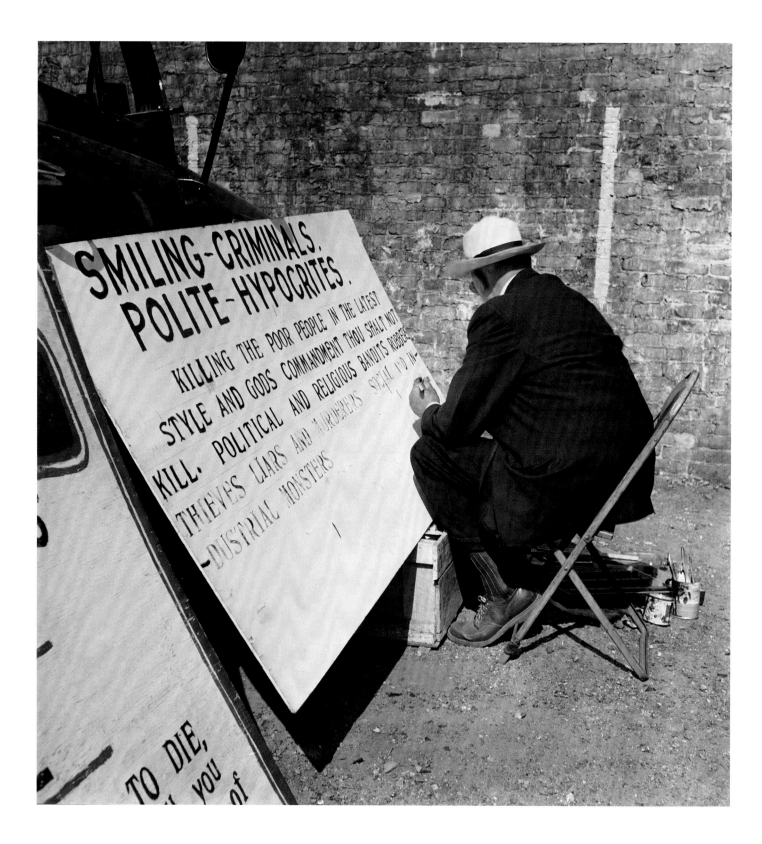

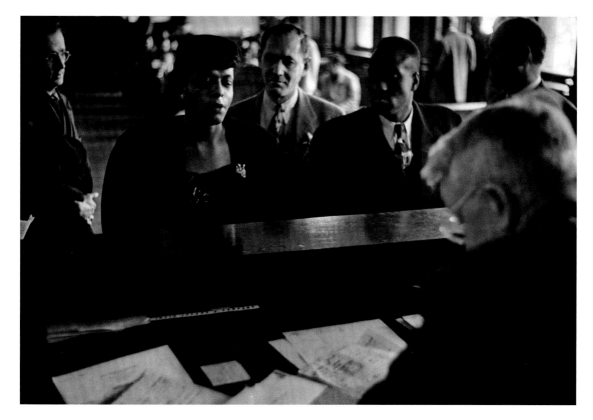

Chicago's media and many of its citizens objected to Algren's article as well as his book-length adaptation, *Chicago: City on the Make*. In fact, anticipating a backlash, much to Algren's chagrin, *Holiday*'s staff heavily edited his text and titled the article "One Man's Chicago," to emphasize that it was his interpretation. *Tribune* reviewer Alfred Ames took up this theme. He found the article and subsequent book to have a "distorted, partial, unenviable slant" by a man "who purports to be characterizing a city." The book, he concluded, would be "unlikely to please any who are not masochists, and is definitely an ugly highly scented object." Local readers piled on. Mrs. Helene Washer wrote, "I've lived here all my life," and "what comforts me is I, too, have my parts of the city." Her Chicago was characterized by the "landscape along the Outer Drive" and Michigan Avenue's Orchestra Hall and Art Institute, and the people who "go to work and return to nice, pleasant residential neighborhoods." But in admitting to having never seen the "back alleys or honkey tonks," she acknowledged that Algren's Chicago did exist, though she did not

care to see it. The city's criminal justice system, bolstering race and class segregation and fueled by political patronage, was designed to ensure that residents like her could ignore it. The local critics with blinders seemed to win out; Algren was increasingly a local pariah after writing *Chicago: City on the Make*. He became more celebrated in cities other than in his hometown.[3]

Algren's characterization of Chicago came to seem justified, however, as it preceded an auspicious "wave of public indignation." This

outcry was prompted by the brazen 1952 murder of Charles Gross, a Republican committeeman who had dared to defy the Mafia-influenced "West Side Bloc" of politicians and patronage workers. This syndicate controlled nine city wards at both the city and state level. Public outcry about Gross's murder prompted the creation of the city council's Emergency Crime Investigating Committee. Although it had been created to investigate and bring Gross's murderers to justice, the committee soon expanded its focus to include "seek[ing] out links between crime and politics." Backed by a new civic watchdog group called the "Big 19," the committee's aldermen led investigations that threatened to expose how the city's entire criminal justice system was corrupted by machine politics. Shay captured one of the more volatile hearings in February 1953. An "anti-administration minority" on the committee gained temporary control of the proceedings and demanded that Police Captain Redmond Gibbons disclose his personal income statements. He had previously refused to do so, even after the *Sun-Times* got ahold of his "little red book" listing payoffs. Further, the committee demanded that all Chicago Police Department (CPD) captains and lieutenants submit to lie-detector tests about whether they had accepted similar bribes.[4]

The committee attracted publicity but accomplished few reforms. Police officers "painted a rosy picture" of the department, stating under oath that the CPD was free from political influence. As proof of recent efficiency in fighting crime, officers cited over 400 gambling and 10,000 narcotics arrests in recent years. Notably, these had largely resulted from Mayor Kennelly's uneven crackdown against vice in African American neighborhoods. But the police department stonewalled the committee on lie-detector tests and income disclosure, with the committee itself usually voting along party lines against compelling such testimony. After three years and $220,000 spent on its investigations, and the resignation of three chief counsels (including one who publicly said he "didn't want to be a party to a whitewash"), the committee in October 1955 "prepared . . . to

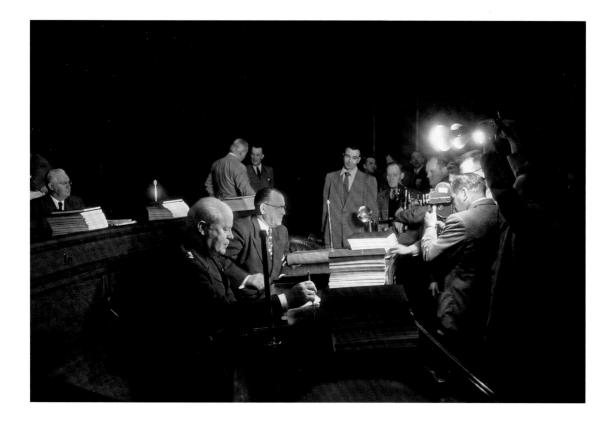

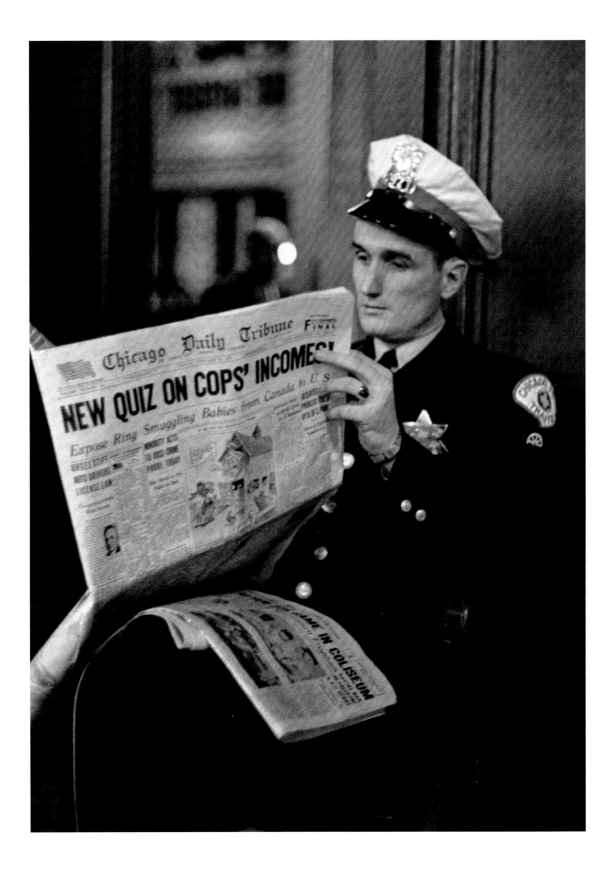

quietly drop out of existence." The corruption investigation prompted the Republicans to clean house by firing thirty-eight corrupted officials, but the Democratic Party, Cook County's dominant power broker, never bothered. The committee failed at its own stated goals: it did not force Police Commissioner Timothy O'Connor to resign or initiate an independent investigation committee within the CPD, and, most symbolically, nobody was ever brought to trial for the murder of Charles Gross.[5] Further, its plodding pace seemed to exhaust Chicagoans and inure them to corruption. Longtime local journalist Mike Royko described the local atmosphere: "Most Chicagoans considered dishonesty of the police as part of the natural environment. The Chicago River is polluted, the factories belch smoke, the Cubs are the North Side team, the Sox are the South Side team, [and] the cops are crooked—so what else was new?"[6]

By 1955 Chicago police corruption had become such a well-worn national narrative that *Life* magazine found a story about a single honest officer more newsworthy. Editors assigned journalist Dora Jane Hamblin and Art Shay to look into the celebrity of traffic officer Jack Muller. Titled "Chicago's Traffic Terror" (with an alternate title in the table of contents of "Troublemaking in Chicago"), the story revealed Muller's earnest, uphill battle to "enforce the laws and help all of the people, not just the privileged few." A World War II veteran who grew up on the city's West Side, Muller first made a name for himself in 1949, when he responded to a call of an officer shot, taking a bullet that hit the insignia on his cap and left fragments in his skull. But he became "better known to the average citizen than the police commissioner himself" when he was transferred to the traffic division and started to ticket automobiles. Muller issued an average of 15,000 citations each year rather than the 1,040 average of others on a similar traffic detail. What accounted for the difference? Other officers lobbied local machine politicians for the traffic detail assignment to line their own pockets, whereas Muller refused and even arrested motorists for attempted bribery. Muller wrote up *all* lawbreakers, which included aldermen, businessmen, and even the wife of Mafia leader Tony Accardo.[7]

The best-known example of Muller's "incorrupt-ible, indefatigable" approach to law enforcement came in 1954 with the "Epstein affair." On a hot August day, Muller pulled over the "political boss" and Superior Court Judge Samuel B. Epstein and his wife for illegally and dangerously driving their Cadillac across an intersection near Oak Street and Michigan Avenue, then a popular nightclub district. Muller testified that Lottie Epstein slapped him, threw his ticket book on the ground, and kicked him in the shins. Mrs. Epstein (falsely) counter-charged that Muller had struck her, ren-dering her hysterical. But the real fireworks ex-ploded when Muller brought the couple to the sta-tion, where "more brass than almost any occasion" assembled in sympathy with the judge. Muller did not yield, and because of the interest of the local press around the case, the CPD could not fix the ticket and drop the matter. Epstein had to pay the $6 traffic fine, and Muller's approach seemed to win the day.[8]

But the media's fascination with Muller stemmed as much from joking about him as ad-miring him. The hundreds of local stories about the "Oak Street Commando" and letters to the ed-itor about him became a diversion from an other-wise entrenched network of corruption throughout the city's criminal justice system. The CPD also retaliated against Muller by what he called the "Chinese water torture" method. They replaced his motorcycle with a slower three-wheel variety, switched him to the night shift, transferred him to the "Siberia" of Trumbull Park for foot patrol (as photographed sympathetically by Shay in a follow-up article), and on several occasions put him under a gag order for his attempts to talk about CPD corruption. After becoming mayor in 1956, Daley seemed to have special ire for him. The mayor, "reporters have noted, drums the edge of his desk with his fingers when discussing something distasteful"; he did so at a "frenzied clip" when reporters asked him about Muller. But Daley knew that Muller was more a pest then a real challenge. Neither political party supported Muller when he ran for sheriff in 1958; he received only 8 percent of the vote. Throughout the 1960s, Muller levied credible charges against the CPD and its internal investigations unit. Top brass responded by mak-ing him the subject of investigation himself, first for defaming the CPD by making allegations, and then on fantastic charges that he "was a hired killer for the Chicago crime syndicate."[9]

If police officers, much like the city's elites, thought themselves above the law, young people became particularly vulnerable to it. Illinois's treat-ment of juveniles was originally meant to protect young lawbreakers by emphasizing "causative factors" in their criminal behavior and the pursuit of "remedial solution[s]." But police officers and judges used this discretion as a weapon in the 1950s. As one report suggested, the Illinois law allowed for a "wide range of ... behavior in its defi-nition of delinquency." Offenses for those under eighteen years old included "knowingly associ-at[ing] with thieves, vicious, or immoral persons"; "wander[ing] about in the streets in the night"; using "indecent language in a public place"; and "patroniz[ing] or visit[ing] any public pool room or bucket shop." Illustrating the latter charge, Shay photographed one young man in the early 1950s in a pool hall. In framing his subject, Shay made sure to capture him standing in front of the MEN sign on the restroom door. Beyond the explicitly listed violations, the police could detain a young person for being simply "incorrigible."[10] This use of the law led to an alarming 70 percent increase in the total number of juvenile offenders referred to Family Court between 1949 and 1955 and another 100 percent increase from 1956 to 1961.[11]

Heightened policing of young people in the 1950s emerged alongside a newly defined age group: "teen-agers." While the word "teen-ager" first appeared during the Second World War, it became widespread by the early 1950s and largely pejorative by mid-decade. Shay set out to capture teenagers' energy. In 1955 he discovered Bob's Grill and Soda Fountain in the Northwest Side's Irving Park neighborhood. The Tribune had lauded the nearby Carl Schurz High School as a rebuke to the "doubting Thomases who hold that a teen-ager necessarily must be irresponsible, immature, and reckless," and quoted its principal, who claimed that "less than 1 per cent of the 3,100 students ... ever gets into any kind of trouble." This school represented a model for all Chicago,

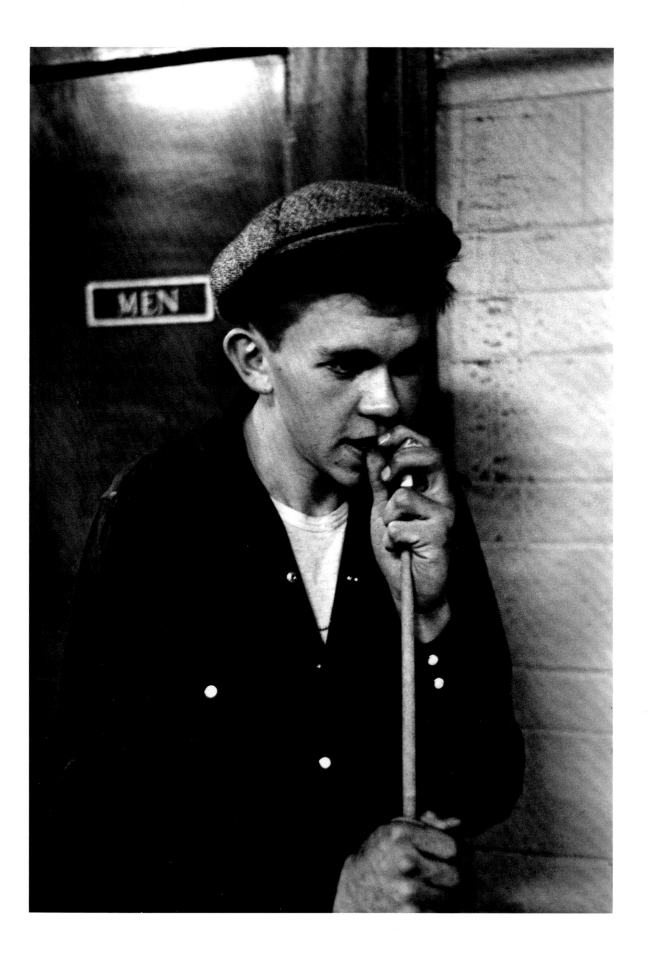

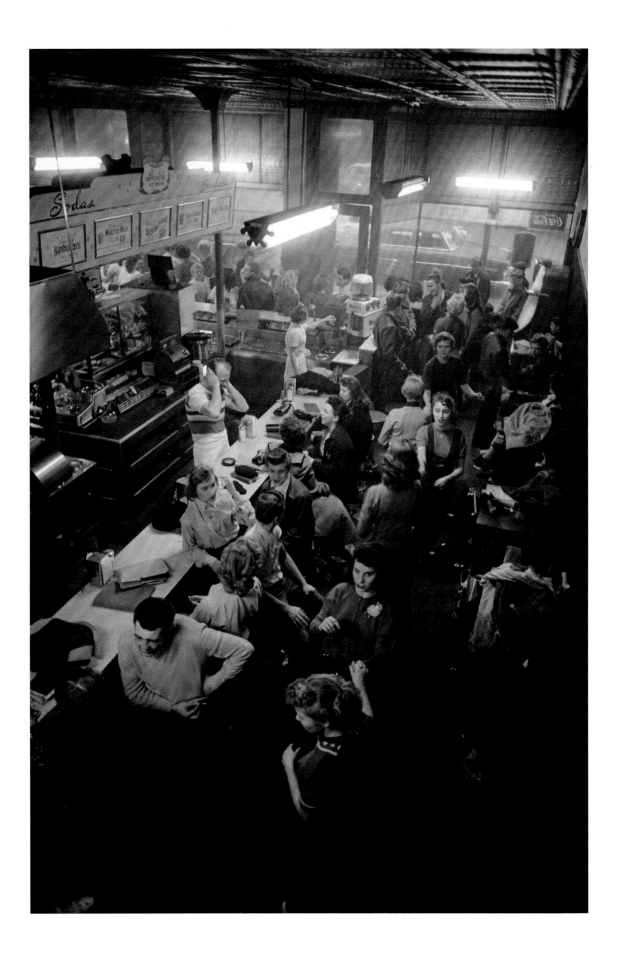

the article asserted, because "stability" of the "predominantly Scandinavian and German" residents "has changed little in the past 40 years."[12] In other words, this neighborhood, unlike others, did not face a challenge to its ethnic homogeneity and color line. Shay's photographs confirm the all-white student population and innocent interaction of young people as they packed the space after school to eat, study, dance, flirt, and scrap with each other. But these photographs also depicted new hairstyles, fashion, and interests—visual signifiers that sparked increased scrutiny and concern about teenagers.

Take, for example, the photo of the stack of books, with the novel *Forever Amber*, featuring an alluring blond woman on its Signet mass-market cover. Kathleen Winsor published the novel in 1944 to critical and popular acclaim, but the plot—which featured protagonist Amber St. Clare, who in seventeenth-century England elevated her class status by having sex with a series of men—was disavowed by the Catholic Church and banned as pornography by several states. In fact, even the U.S. Post Office banned it as "obscene" for a time.[13] Chicago did not ban this book or others like it due to pressure from civil liberties groups. But Mayor Daley did propose a successful city council ordinance in late 1956 that prohibited the sale of literature that had the "dominant effect of substantially arousing sexual desires in persons under the age of 17 years." The Chicago Youth Commission supported an even wider ban, positing a direct link between young people's consumption of literature and entertainment and their propensity to commit crime.[14] This echoed a national debate that began in the mid-1950s about teenagers and delinquency that often conflated the two categories. Or as a 1956 series of articles in the *Tribune* framed it, there was a dichotomy between "Good and Bad Teen-Agers," and parents needed to keep their children from joining the latter category.[15] Young people themselves understood this dichotomy, often playing one role or the other. As one girl's note left on the soda fountain's cash register explained, "I.O.U. 10¢"—a promise the shopkeeper should trust because "I am a good girl."

As teenagers and adults debated what made good and bad "teen-agers," the police and other

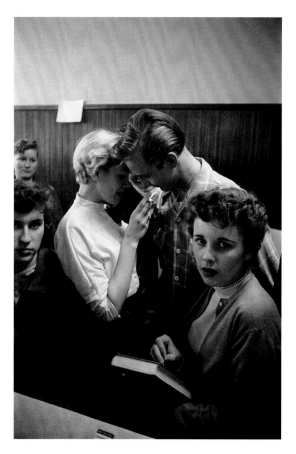

authorities established distinct ways of handling youth in different sections of the city. In the all-white Irving Park neighborhood, occasional reports surfaced about auto thefts, drunk driving, and assault.[16] The *Tribune* was especially concerned about "the growing group of delinquents who are no longer confined to any social class" across Chicago. It profiled "Buddy," "a chubby-cheeked, well-dressed lad, [who] couldn't possibly be a teen-age hoodlum, but he is."[17] No doubt young men (and some women) engaged in criminal activities in all Chicago neighborhoods in the postwar era.[18] One scholar called this phenomenon "the revenge of the lower class," implying that working-class themes in music (the blues and rock 'n' roll) and film (such as *The Wild One* and *Blackboard Jungle*) targeted the new teenage market across class and racial lines.[19]

But few of these "teen-agers" were ever branded as delinquents and sent through the criminal justice system. Most notably, young whites'

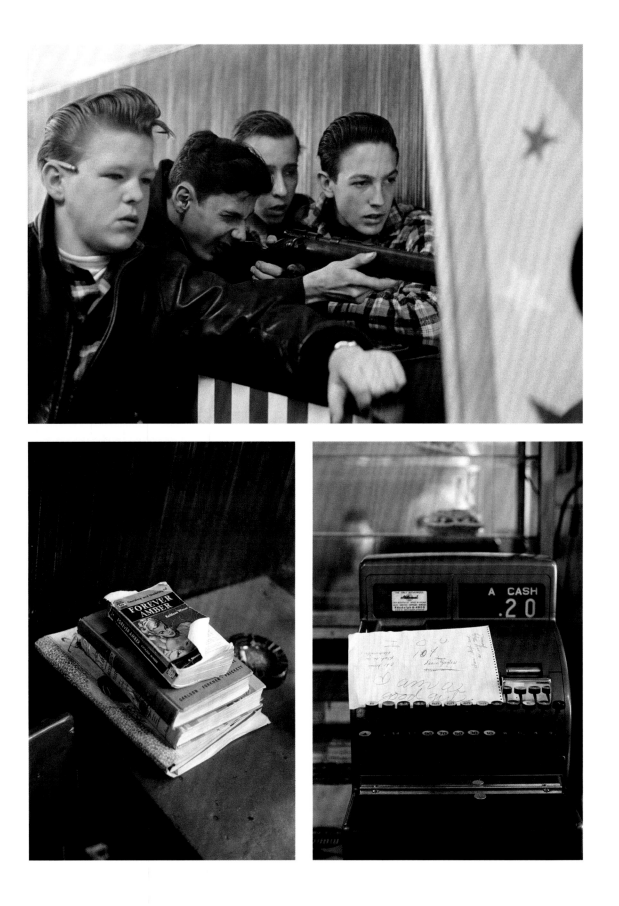

racist violence was rarely treated as a crime. Even as white-on-Black assaults reached an "all-time high" during the first months of 1946, these offenders were mostly "from good homes and not delinquent in the traditional sense," according to the director of the Mayor's Conference on Human Relations. Scholars have shown how groups of young white men terrorized African Americans who moved into previously segregated South and West Side neighborhoods in the 1950s. The police arrested these offenders only when pressured. Even then, courts imposed lenient sentences, such as when ninety of those arrested during the 1947 riot in the Fernwood neighborhood were sentenced to "compulsory group therapy" rather than a juvenile detention facility or jail.[20]

If not North Side whites or anti-Black vigilantes on the South and West Sides, who then accounted for the large increase of young people arrested, convicted, and confined for juvenile delinquency and adult crimes in 1950s Chicago? The answer is embedded in the 1955 testimony of Reverend Archibald Carey Jr., a prominent African American Republican in Chicago, before a U.S. Senate subcommittee on crime. Carey claimed that racism "spawns hatreds that result in violence." To do an "effective job of eliminating juvenile delinquency," he contended, the Senate committee on juveniles should "look to the banishment of those conditions of segregation and discrimination."[21] But Carey also blamed the problem of delinquency on "the demand for freedom [that] has ignored the fact that discipline is necessary." "Instead of self-expression," he explained, "we now have self-explosion." Chicago's criminal justice system ignored Carey's first claim and concentrated on his second. By defining racism as individual, psychological, and aberrant social behavior rather than collective, structural, and economic in nature, authorities could choose to ignore anti-Black violence while targeting young people of color and others expressing freedom in 1950s Chicago.[22] In fact, such expressions by young people were easily redefined as incorrigible behavior and therefore delinquency. Evidence from both before and especially after Daley became mayor shows that political forces within the criminal justice system in Chicago exploited widespread concern about

"teen-agers" in order to contain young people's political activism, thereby reinforcing the city's color and class lines.

Shay's images humanized this racialized turn. In the mid-1950s, he talked his way into a police station's holding cell to photograph a fourteen-year-old held on murder charges. This photograph of one prisoner symbolized officers' assertive tactics to ensnare more and more young Black men. First, the police used local station facilities to detain suspects for days to coerce confessions. An American Civil Liberties Union report found that in 1956 police illegally held at least 3,000 people "in violation of their civil rights," noting that stations "in areas heavily populated by Negroes have a specially bad record" of brutality, illegal search and seizure, and more. Judges and prosecuting attorneys, beholden to the Democratic machine and police cooperation, were complicit. As one Sun-Times editorial concluded about the attorney: "He fears that if he tries to crack down on the police they will not cooperate with him in criminal investigations," and therefore "blinds himself to the barbarisms and other illegalities that police indulge in." The Chicago Defender's discovery and subsequent promotion of such widespread abuse led to a 1958 federal grand jury where three youths and a social worker testified against police brutality. These practices were especially common at the Fillmore Police Station in Black Chicago, where one youth explained he was held for three days without charges, beaten, and ordered to sign a confession for a recent murder.[23]

To address these problems, the newly elected Richard J. Daley established a Mayor's Advisory Committee on Youth Welfare in 1956. "Giving our children happy and healthy lives, and guiding them to become responsible, constructive members of our community," he claimed, "is our most important job."[24] The committee was charged to reduce the incidence of delinquency and to suggest more effective treatment. Overall it did little to reduce young people's entry into the criminal justice system. The city council, now under Daley's centralized rule, revised the curfew ordinance of 1923 so that it applied to anyone under eighteen rather than sixteen years old. This adjustment led to 3,569 more infractions in just the

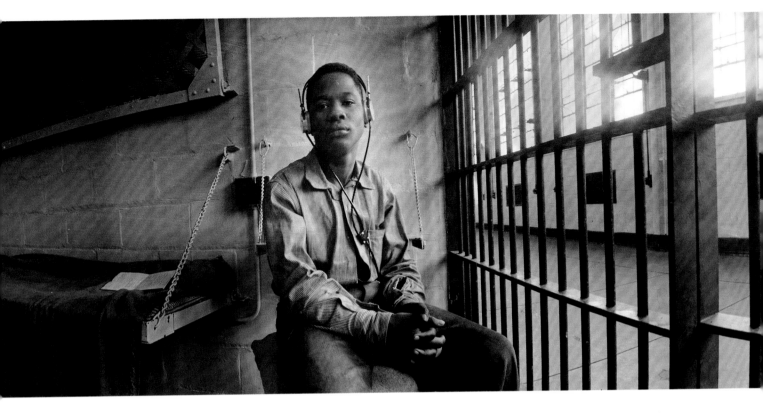

first few months.[25] In addition, Chicagoans who had hoped Daley, upon his election, would replace Police Commissioner Timothy O'Connor were disappointed in 1956 and again in 1958 during a federal grand jury into police misconduct when the mayor had "no comment" except that he retained "complete confidence" in his police chief.[26]

A 1950s surge in juvenile arrests made the previous years seem benign by comparison. Studying statistics of juvenile arrests through 1960, Chicago criminologist Hans Mattick concluded, "There has been a general tendency in all districts, increasing with time, to deal more and more severely with juvenile offenders." He also noted the ineptitude of the police, including their "bewilderment . . . in the face of a numerical growing and complex problem" and their desire to "shift the responsibility to other agencies" to escape negative press attention.[27] In 1960 another U.S. Senate investigation of juvenile delinquency complimented the city's recent efforts but also quoted one local project administrator who confided, "We haven't succeeded by and large in appreciably reducing the volume of delinquency in Chicago." The report

also suggested that earlier methods might no longer work because "the population which is presently moving into the areas serviced by the project does not have the same cultural characteristics as the previous groups."[28] The population he referred to here was African American. If putting more resources into programs to help juvenile delinquents would be ineffective, the only way to deal with these troublemakers, policy makers reasoned, was to lock them up. Mattick lamented this approach even as he confirmed its existence. After analyzing the statistics neighborhood-by-neighborhood, he concluded: "Police are enforcing the law differentially in the interest of 'holding the color line.'"[29]

One way the law was unevenly enforced was through "roving squad" units of officers who swooped into particular neighborhoods to make arrests. The CPD introduced this policy in 1946. Under the Kennelly administration, these officers cracked down on previously tolerated gambling and other forms of vice in African American neighborhoods while leaving similar operations untouched in white areas. Even though this policy contributed to Kennelly's downfall and Black

voters gave Daley crucial support in his 1956 and 1960 electoral victories, the new mayor expanded the roving squads' budget and size (11-man squads and 225 total officers) as the renamed "Task Force." These police officers had no neighborhood allegiances, though they were clustered in African American areas of the city. Black Chicagoans certainly felt their presence. When the *Chicago Defender* in 1957 asked a dozen of its Black readers about the police, responses were mixed save for near-universal condemnation of the Task Force. One resident called its stop-and-frisk policies "humiliating"; another deemed it a "flagrant violation of the Constitution"; and another complained that the "'flying squad' has got to go" because "people can't sleep at night with them around." This reader highlighted the Task Force's selective practices: "The only place you'll find them is in Negro neighborhoods," adding, "I have never seen them search a white man's car."[30]

Apart from the district-less Task Force, the CPD made thousands of new arrests, especially of young people of color, by targeting drug sellers and users. In the 1950s, heroin use escalated citywide; most of these addicts were between the ages of seventeen and twenty-five. Academic experts indirectly supported CPD efforts to arrest and jail drug users, offering no alternative solution. A 1953 report co-issued by the Illinois Institute for Juvenile Research and the Chicago Area Project concluded that heroin use was a dead end. "Reliable procedures for the treatment and cure of opiate addiction are not known at the present time." Notably, the report conflated heroin-related arrests with usage in suggesting that heroin sellers and users alike were irredeemable. Its authors seemed to confirm the CPD's policy of targeting only a few neighborhoods for drug busts, concluding that out of seventy-five total community areas, the majority of users came from only five West and South Side locations. These areas were largely Black residential neighborhoods. Shay's photograph of the docket of charges levied in the Circuit Court of Chicago captured this racialized enforcement of drug-related crimes. By the mid-1950s, drug arrests congested the court system.

New sentencing guidelines clogged jails as well, allowing judges to issue harsher sentences of three to five years for juvenile users in particular. Other than larceny, more people were incarcerated for drug possession than any other crime in the Cook County Jail by 1955. This rate continued to grow, packing that jail and other detention facilities.[31]

More arrests and longer sentences meant more Chicagoans in jail—a development that particularly affected the city's youth. Illinois law held that offenders as young as ten could be tried in circuit or criminal court. If convicted, they could be sent to one of two local adult jails, Cook County or the City Jail (known as Bridewell). Cook County in 1956 had over 1,000 more inmates than its antiquated 1929 design was meant to accommodate, and young people were 15 percent of the population of approximately 2,000. Bridewell, right next door, was similarly overcrowded and understaffed. It had 1,181 detainees under twenty-

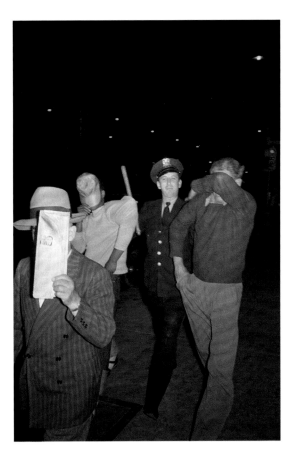

one in 1956, 65 percent of whom were non-white. Designed to temporarily hold petty thieves and debtors and used as a drunk tank into the war years, Bridewell's population changed dramatically in the 1950s. The jail began detaining Chicagoans for months and even years under terrible conditions. This shift in Bridewell's population made a bad situation much worse. As one investigator remarked, this "House of Correction is not a house and doubtfully correctional."[32] Other young people arrested in Chicago were sent to the Family Court, where judges and the Illinois Youth Commission meted out sentences to juvenile facilities such as the special public school (deemed "parental school" because these youth remained with their guardians) or the Arthur J. Audy Home. These institutions were also overcrowded, and the Audy Home faced special scrutiny for its high operating costs. As a result, judges and the Youth Commission increasingly chose facilities in other counties, figuratively sending youth downstream with the refuse in the Chicago River. These regional options included a facility in St. Charles (for boys) and Geneva (for girls), while the notorious Illinois Industrial School for Boys at Sheridan was reserved for "the larger, more sophisticated, more aggressive boys." These "schools" confined young people from all 436 counties in Illinois, but over 80 percent of those committed by the Illinois Youth Commission came from Cook County.[33]

To capture this political and cultural shift in the juvenile justice system, Shay drove sixty-five miles southwest of Chicago to visit the Sheridan facility. This "Industrial School," located in LaSalle County about five miles outside of the town of Sheridan, took up twenty buildings on 320 acres of rural property. And while it had plenty of outdoor spaces for inmates to roam, by 1956 it had 15 percent more inmates than it was meant to house. Many young men were confined to windowless cells, even though "penologists agree it is unnecessary for any except perhaps the most desperate criminals." It had a system of mirrors that "prevents any kind of privacy," one report concluded, which was a "serious obstacle to any rehabilitation." Still, few people seemed to care what occurred inside Sheridan except for the mothers of those confined there. South

Side resident Mrs. Doramai Allent wrote an open letter to the Sheridan superintendent detailing the conditions. "I was shocked beyond belief that in 1956 in the second largest city of the United States that they allow torture of boys," she wrote. She described a system of physical punishment and confinement where any staff member could order a boy to "the hole" (an internal cell) for ten days without clothing or a mattress and limited to a diet of bread and milk. She explained that one boy had spent several weeks in "the hole" and died of an epileptic fit even though the staff knew of his condition. While her child had been there several months, the "school" was "not doing a single thing to rehabilitate."[34] Officials ignored Allent's letter, but a similar accusation from a resident of rural Madison County garnered more attention. Mrs. Cleadous Ramsey accused Sheridan guards of beating her son and three others. The state began a laggard investigation.[35] But in the meantime, the facility experienced a "riot" in 1960 when several boys captured and beat a guard, holding him hostage for several hours to demand their release.[36] The following year, the state committee's scathing report and recommendations caught the attention of Republican Governor William Stratton. The report confirmed beatings by guards and windowless isolation rooms where inmates spent as many as twenty-nine days without clothing and with limited food. Four top officials and three guards were dismissed.[37]

Sheridan officials granted Shay complete access during the winter of 1962, no doubt as part of a publicity campaign by new staffers eager to show how much the Industrial School had changed. On a similar tour, a security guard named William Golden visited the facility and wrote a sympathetic article. He referenced "those circulation-raising headlines in the Chicago newspapers," such as "Guards Treat Inmates Like Animals," but assured his readers not to be alarmed because "punishments are just and sometimes harsh" and locking up these juveniles will "keep society safe."[38] Some of Shay's photographs depict this new look, highlighting the medical clinic and expansive grounds where inmates could exercise. But Shay also took the opportunity to show how little had changed, photographing

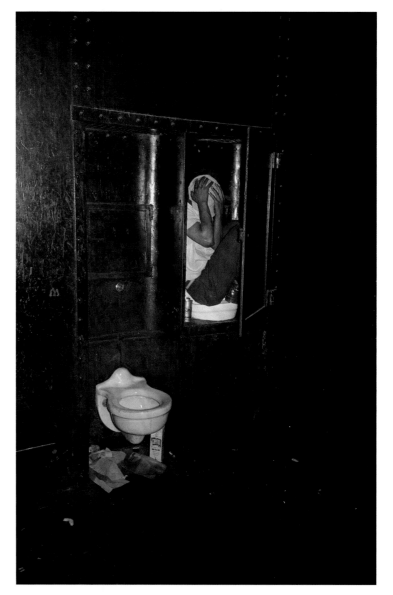

young men confined in dark and isolated conditions. The new superintendent, Arthur Wright, admitted that the previous staff had sacrificed rehabilitation for punishment. But he also confirmed that the facilities continued to be overcrowded and expressed his belief that "discipline is vital." Wright stood firm of the use of "the hole" (interior cells), noting that those inmates now had rubber mats for sleeping and jumpers to wear. In addition, Raymond Farber, one of the fired administrators and cousin of the dismissed superintendent, won his job back through a civil service appeal.[39]

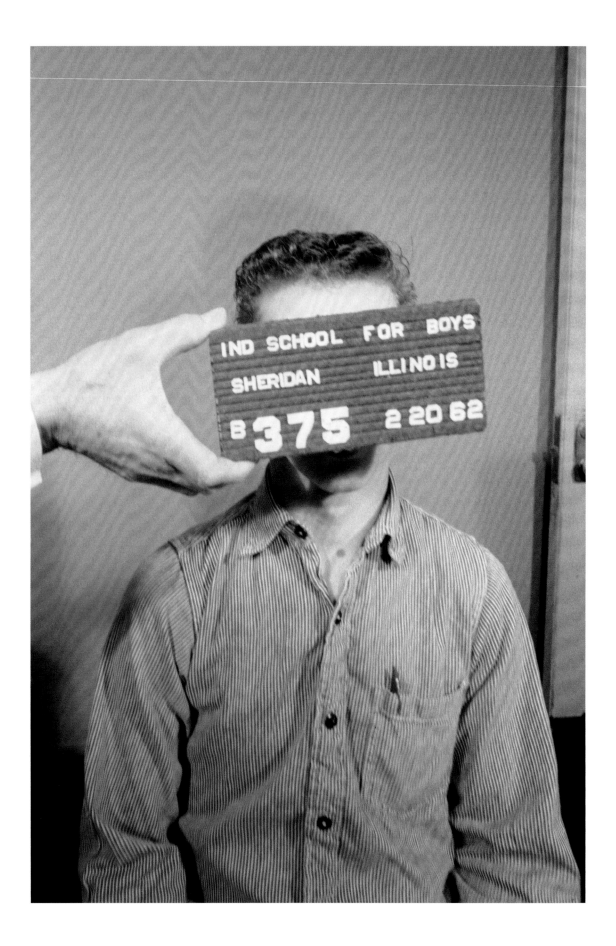

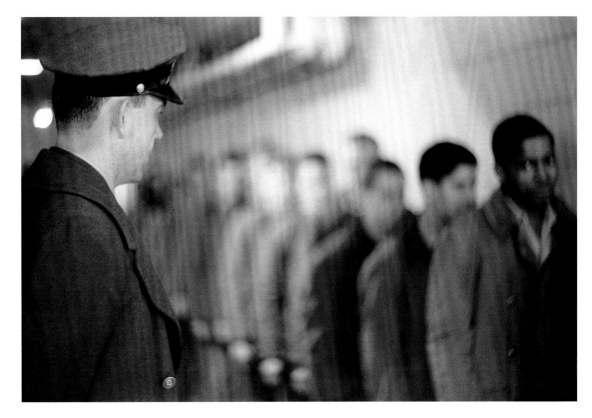

Shay's rare photos of the inside of Sheridan were to accompany a story by famed journalist John Bartlow Martin in the *Saturday Evening Post*. Martin's manuscript detailed the eight-year "illusion of progress" that had begun with the 1953 law that created the Illinois Youth Commission. His investigation revealed a "woefully inadequate" statewide professional staff that included at least 20 percent who were hired through political patronage and with scant qualifications. This patronage may have sounded familiar to Chicagoans as typical Democratic politics, but Martin noted that the commission's first six commissioners were all Republicans. "Most of them only spend six or eight hours a week at the institutions," he wrote. "At least two of them operate private businesses, and they draw combined salaries and expenses of about $50,000 a year." Martin detailed the history of harsh treatment and brutality that made Sheridan not a "reformatory" but a "maximum security prison for teen-age felons," and went a step further than other reports. He provided evidence that guards gave some of the best

fighters in the boxing club privileged assignments that included beating other kids and that widespread "homosexuality" took place that amounted to "big boys forc[ing] small ones to submit sexually." Martin then detailed how the subsequent investigation became a "whitewash" and explained that the commissioner-turned-whistleblower, Oliver Keller, was thanked by getting his budget slashed by $2 million and then "asked to resign" by Democratic Governor Otto Kerner. Martin ended the 35-page article by quoting an "expert" who confided, "This is an unpopular cause. People don't want to spend money on these places." Instead, these people concluded, "'Lock 'em up, they're bad, the hell with them,'" but the inmates "are released—released worse than they entered."

Tellingly, the *Saturday Evening Post* must have agreed about the subject's unpopularity; it never published the article or Shay's photographs.[40]

Complaints against Chicago's discriminatory criminal justice system mounted and were muted throughout the 1950s, but it was the discovery of a burglary ring on the city's largely white North Side that led to substantive police reform in 1960. This scandal had begun several years earlier when twenty-three-year-old convicted thief Richard Morrison left prison for the Edgewater neighborhood. Working as a pizza deliveryman, Morrison befriended several police officers at the nearby Summerdale Station. He and at least eight officers built a burglary ring of local businesses. The officers' motive was simple: greed. No doubt they

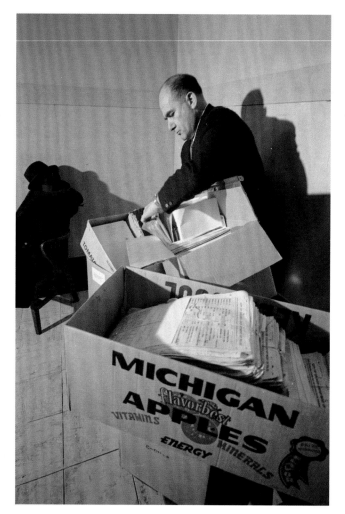

not spend much time in the dismal Cook County Jail before offering information on police corruption to Cook County State's Attorney Benjamin Adamowski. Morrison's 77-page confession spelled out the range of illegal activities he and policemen coordinated out of the Summerdale Station. The officers' trials dragged on for several years, but Shay captured the scandal as it was still breaking, with the convening of the grand jury. The media emphasized Morrison's dramatic confession, but Shay's photographs captured high-ranking CPD officers scheming to separate themselves from yet another scandal. These officers included the new Summerdale Station Captain Maurice Berger. He had diligently followed orders to remove station files by piling disorganized stacks into Michigan apple boxes. Perhaps recalling the earlier scandals when key evidence went missing and witnesses went mute, Shay also documented the latest lie-detector technology that might make it possible to convict the officers. He managed to access the 23rd-floor suite of the downtown Hilton Hotel, where he photographed Fred Inbau, a Northwestern University law professor, and Richard Arther, a supposedly independent expert from New York, who would administer the lie-detector tests there on the arrested officers and other CPD leaders.[42]

The CPD once again tried to save its reputation. Early on, Democratic leaders used the age-old strategy of dismissing the charges as partisan politics. When reporters asked Mayor Daley whether he would submit to a lie-detector test to address whether ward committeemen chose and controlled the city's police captains, he sneered, "It is obvious the campaign for state's attorney has started early." No doubt Republican State's Attorney Adamowski did seek to leverage the scandal in his reelection campaign. But these allegations contained too much truth to be dismissed as party politics. Daley soon realized that he needed to distance himself from the scandal. He deferred questions to O'Connor. "Ask the police commissioner" became his stock response, because "he's running the police department, and has been since the day of my inauguration." Soon thereafter, Daley forced O'Connor to resign and then demanded that the CPD make changes "all the way to the top."[43]

grew tired of hearing about other higher-ranked officers living in "lavish" homes, buying fancy automobiles, and taking regular vacations. And they seemed to grow rich from corruption without consequences, as the rise and fall of the "Big Nine" committee hearings made clear. Meanwhile, ordinary patrolmen in the CPD had to purchase their own uniforms. Their pay was so low that many took second jobs, even though it was against department regulations. These corrupt police officers and Morrison were responsible for the 48 percent increase in burglaries in 1959. At least eighty of these crimes took place in the first six months of the year.[41]

This burglary ring was disrupted by two honest detectives who arrested Morrison in late July 1959 for a theft of his own. Morrison did

Daley drafted an outsider as the new CPD head. This was a savvy move he hoped would also seem democratic. Daley's blue-ribbon search committee included a few key machine loyalists and other local notables. It was headed by Orlando Wilson, a noted police reform expert. Once the mayor's committee was in place, he ensured that its search would fail, instead pressing key committeemen to draft Wilson himself for the job. Wilson accepted, but only after negotiating his independence from the mayor's office and a three-year contract at a salary of $30,000. "I felt I owed it to the whole police profession," he recalled, to reform "one of the wickedest" departments in the nation. Daley announced the decision in late February, and the city council rubber-stamped it two weeks later, affirming that the mayor somehow was both in control and above reproach.[44] As Alderman Seymour Simon remembered, "The amazing thing about the police scandal" was "the way Daley turned it to his own advantage" and "wound up being treated as a hero and reformer."[45]

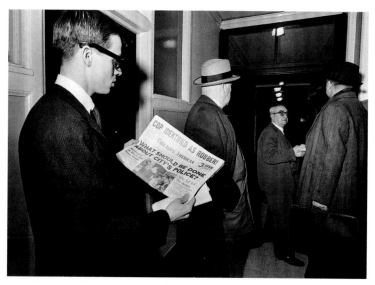

While Daley should certainly be credited for what one scholar called his "political deftness," his administration could also thank its lack of opposition and classic voter fraud in overcoming the police corruption affair. The Republican *Tribune* deemed this scandal and the string of others before it the "Price of One Party Rule." But even as its editors lambasted the machine's power, they praised the person at the helm. "We believe he is personally honest and he is doing the best for the welfare of Chicago," one editorial stated, but "the job of maintaining decent civic standards is too much for Mr. Daley."[46] This statement reflected the energy Daley had devoted to building relationships with local businessmen. When the Republican paper had the chance to push for Daley's resignation, its editors balked. Moreover, State's Attorney Adamowski's words came back to haunt him when, in the midst of the scandal, Adamowski said, "No one should ever ask me to stop talking about things like this. If people and the judges don't like it, they should beat me at the polls."[47] The Democratic machine did just that in November's election, which made Daley into a national political figure for helping to elect Democrat presidential nominee John F. Kennedy. Adamowski

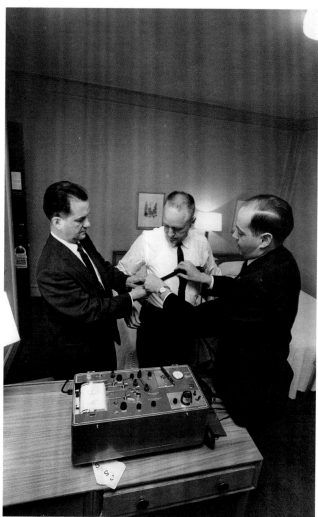

cried foul, prompting a special prosecutor for fraud and a recount that continued to narrow his margin of defeat. But the national GOP lost interest when the election results for its presidential candidate, Richard M. Nixon, were unchanged. As journalist Mike Royko wrote, Adamowski "didn't have the money" to pay the $600-a-day recount cost, "so he had to give up."[48]

Despite Daley's recovery and triumph, the CPD's fate under an independent and earnest reformer was uncertain. Shay pondered this question, juxtaposing a portrait of Wilson at police headquarters in 1960 with a photograph of the display of badges of police killed in the line of duty. Would Wilson respect the CPD's checkered history or chart a different course? Alderman Leon Despres, a perennial critic of the machine and police brutality, hoped the scandal would finally render the Chicago police a modern crime-fighting force. Wilson did make some big changes. He moved his superintendent's office from City Hall to the remodeled police headquarters. He also opened a new communications center and installed a new data filing system; the days of carting disorganized files in apple boxes were over. Finally, he restructured the chain of command. By reducing the number of police districts from thirty-eight to twenty-one, he broke up the overlap between ward and police boundaries. Further, he formed an Internal Investigations Department (IID) and hired 500 new Black patrolmen. "Under O. W. Wilson," one historian of the CPD concluded, the "[d]epartment was forced to break from its historic nineteenth-century roots." Instead, "the period of modernity had at last begun."[49]

Less apparent to Chicagoans was Wilson's penchant for rigorous law enforcement. Wilson received praise as the former head of police in Wichita, Kansas, but the city's mayor also noted that he had been "too damned efficient." And before he was offered the job, Wilson got a strong endorsement from the head of the Chicago House of Corrections, who commended his tough, even aggressive approach.[50] Throughout his tenure in Chicago, from 1960 to 1967, Wilson resisted the national movement toward respecting suspects' civil liberties. Despite Wilson's own admission

that Chicago crime was on the decline, his new, more accurate record-keeping system created the illusion that it was rising. Wilson seized upon this phantom spike to justify a massive increase in the CPD's budget and officers.[51]

Wilson's reforms, which drew more resources to the CPD, led to more efficient racial and youth profiling and policing in particular neighborhoods. Officers effectively occupied those neighborhoods

rather than "serving and protecting" their residents. Several statistics reveal the results of Wilson's policies. Arrest rates for African Americans in Chicago rose 65 percent, transforming the incarcerated population. In Cook County Jail, for example, the inmate population in the mid-1950s was evenly split between whites and Blacks, even though Blacks made up 14 percent of Chicago's population. By the middle of the 1960s, Blacks vastly outnumbered whites in every tier of the jail.[52] Wilson's aggressive efficiency stressed a criminal justice system already bursting at the seams. Reformers' efforts to ease this burden through rehabilitation and parole lost out to policies that caged more people for longer durations.

The mix of violence, police, and politics that framed Charles Gross's 1952 assassination re-emerged eleven years later when African American Chicago Alderman Benjamin Lewis was murdered. Lewis had been born in Georgia and brought to Chicago as an infant. He grew up on the West Side and attended Richard T. Crane Prep High School and Crane Junior College. After serving as an army lieutenant during World War II, Lewis worked as a Chicago Transit Authority driver, union organizer, and clerk at the Employment Service office. He also rose as an African American political representative in the otherwise Italian and Jewish West Side Bloc machine. Lewis even learned to speak Yiddish in his seventeen years as a Democratic Party precinct captain.[53] For decades, the West Side machine had been controlled by white politicians who neglected their own wards as African Americans moved there in large numbers. Some did not even live there. West Side politicians came to believe that at least one token Black politician should represent the one-half million Black voters there. Lewis seemed the ideal choice. A seasoned veteran of local politics, he presumably grasped the patronage, corruption, and even Mafia involvement within the West Side Bloc. Machine insiders bet that Lewis would remain loyal to the power brokers that allowed white real estate, insurance, and other exploitative but profitable businesses to flourish. Lewis was the first African American to become alderman of the Twenty-Fourth Ward (the Lawndale neighborhood). He won in 1959 with a 12–1 margin. He was reelected four years later by an even larger margin and seemed to many like a new machine operator on the West Side.[54]

Lewis was executed just two days after his landslide reelection. Police discovered him in his ward office on Roosevelt Road, handcuffed and shot three times in the back of the head. A lit cigarette still burned in his hand. Shay was in the massive crowd of Chicagoans who attended Lewis's funeral, with 1,500 packed into Lawndale's Galilee Missionary Baptist Church and another 5,000 people lining the street. Shay captured scenes of ordinary West Siders mingling with politicians, police, and presumably some organized crime figures. Mayor Daley was among the dignitaries. Shay photographed him outside the church whispering under his hat to an unidentified man, and then inside, doing his political due diligence by paying his respects to the slain Democratic politician. Oratory was never Daley's strong suit, and the mayor concluded his short remarks with the ominous comment, "He gave us everything he had." Outside, a *Defender* reporter captured some of the conversation between Black mourners at the church. All viewed Lewis as much more than a token machine politician. "He did so much for his people," one woman said. Another was more specific: "We have lost a valuable man in our attempt to move forward as first class citizens." A sixteen-year-old perceived the loss in more personal terms: "Mr. Lewis was our best friend. He took us to picnics and saw that we stayed out of trouble." The mourners also shared a sense of indignation and hope. "This big crowd," one man summarized, "is a message to the mob or whoever did this to Ben, that the people are with him or any one else who tries to do as much for the people as he did. This looks like a new day."[55]

Chicagoans reflected and speculated on what the tragedy meant for their city. The *Daily News* sold an extra 15,000 papers on the day of the murder, and the *Defender* issued an unprecedented second run of the weekend edition. The immediate coverage summarized available facts about Lewis's murder, but follow-up articles were wider-ranging. Some praised Lewis as a selfless politician who

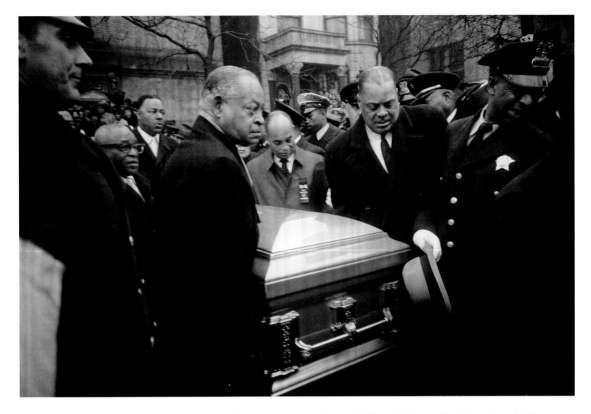

lived for his West Side constituents, while more critical coverage took up rumors about marital infidelity and his business associations "with hoodlums and racketeers."[56] The *Defender* captured this ambivalence with the front-page headline "Two Sides to Ben Lewis: Good Outweighed Bad." The *Defender* perhaps exaggerated in suggesting that Lewis had "a dual personality," but its editors sought to capture the pragmatism that had allowed him to navigate West Side politics. Lewis had not tried to buck the machine, but he had sought to make it benefit his constituents by reassigning patronage jobs from whites to Black ward residents. Lewis had been quick to profess his loyalty to Daley, but he had also made earnest attempts to reduce crime and privately boasted (with Daley's blessing) that he was building a West Side political organization that would do more for its people than its South Side equivalent. No single narrative of the Lewis assassination emerged. Some Chicagoans tried to forget it and move on, others tried to sweep it under the rug, while still others hoped his ghost would haunt the streets of the West Side and City Hall for years to come.[57]

Beyond the salacious details and varied impressions of the Lewis murder mystery, the event reflected several truths about policing and governance in mid-century Chicago. First, the political machine was strengthened in the wake of Lewis's assassination. None of the Black aldermen who eulogized Lewis supported an independent investigation. Republican Alderman John Hoellen sought to read a list of probable culprits, but the city council's Democrats shouted him down, so Hoellen "could scarcely be heard."[58] One month after Lewis's death, nearly every West Side resident interviewed by a *Defender* reporter believed that Lewis's murder would never be solved. They were correct; nobody was ever arrested, let alone tried or convicted.[59] And once again, Mayor Daley avoided blame, at least in terms of political fallout. That April, Black voters, and in particular Lewis's Twenty-Fourth Ward, provided the margin in Daley's slimmer 1963 reelection victory against his old nemesis, the prosecutor Ben Adamowski.[60]

Adamowski had done everything in his power to expose the machine as corrupt and beneficial to only a minority of connected Chicagoans,

including the businessmen who were supposedly in his own party. Indeed, Republican businessmen gave anemic financial support to Adamowski's campaign, signified by Shay's sly portrait of the candidate featuring his party's own elephant poised to stomp on him from behind. Even without business support, white voters agreed with Adamowski's calls for less favoritism and lower taxes; they cast 51 percent of their ballots for Adamowski. Daley still won by a margin of 138,792, but this marked the narrowest re-election of his tenure as mayor, with Black voters providing the margin of victory.[61] Daley won Black Chicagoans' loyalty even as their recent encounters with police, courts, and jails left them doubting that the city would ever reform its criminal justice system. He did not receive these votes through reform. Instead, the Democratic Party of Cook County, in part through its criminal justice policies, fostered disorganization in these wards. This allowed its own machine to retain a monopoly of physical and political control over these urban spaces, votes included.

But not all Black Chicagoans accepted this version of Windy City justice. A group of young West Side activists called the Friends of Ben Lewis drew from the alderman's memory to create new forms of protest politics. Their tactics were more militant than anything Lewis himself would have endorsed. The lesson they drew from his murder was that working within the machine was less productive than revolting against it. The Friends of Ben Lewis picketed the Fillmore Police Station for its discriminatory practices and protested in front of the Twenty-Fourth Ward office for retaining white patronage

workers from outside the neighborhood. They also began to link local problems to struggles making headlines in the South, connecting with civil rights organizations such as the Congress of Racial Equality and self-defense organizations such as the Deacons for Defense and Justice.[62] These networks would envision and create the Chicago Freedom Movement. They would usher in a new era of democratic troublemaking to end the stifling 1950s.

SUBURBAN CIVILITY

In 1961 Art Shay encountered the African American writer and intellectual James Baldwin at a neighbor's home in suburban Deerfield, Illinois. Baldwin was visiting the lily-white suburb because it had recently drawn international attention for its stand against residential racial integration. He attended the house party on behalf of the American Freedom of Residence Fund, a national organization of liberal integrationists that supported the beleaguered local group, the Deerfield Citizens for Human Rights. Shay captured Baldwin seated, smoking a cigarette, and hiding away in the kitchen. As he looks back at the camera, Baldwin seems to ponder the absurdity of his environment in Deerfield, where residents seemed so scared of having a dark-skinned neighbor like him.[1]

Baldwin recounted an incident from this or a similar trip to Chicago in *The Fire Next Time*. "I and two Negro acquaintances, all of us well past thirty, and looking it, were in the bar of Chicago's O'Hare airport." The bartender refused to serve them, claiming they seemed too young. The bar manager defended the decision "on the ground that he was 'new' and had not yet, presumably, learned to distinguish between a Negro boy of twenty and a Negro 'boy' of thirty-seven." Baldwin was eventually served, but what really bothered him and his friends was that not a single white customer in the bar did anything to intervene. A stranger later struck up a conversation with Baldwin's friend, a Korean War veteran, who told him, "The fight we had been having in the bar was his fight too." The man replied, "I lost my conscience a long time ago." To Baldwin, this man's stance seemed "typical" of whites in early 1960s America. "A few years ago, I would have hated these people with all my heart," he concluded, but "now I pitied them, pitied them in order not to despise them. And this is not the happiest way to feel to one's countrymen."[2]

Many observers of the conflict in Deerfield shared Baldwin's mixture of anger and pity because the town's battle over race and housing seemed to spotlight white middle-class America's lack of conscience. Northern cities like Chicago often described their racial politics in upbeat terms, quick to define themselves against southern areas. But when they were confronted with the possibility of proximity to African Americans, many individual whites chose to relocate or resist even as they appealed to civility and race-neutral motives.

In the 1940s and 1950s, more than one million white Chicagoans moved to the suburbs. Some, like Art Shay, did so for economic reasons, using the GI Bill and other incentives to buy spacious homes with yards. Others, however, moved to the suburbs to escape what they described as an increasingly crime-ridden city.[3] As the last chapter detailed, these appeals to urban disorder were often coded references to fears of African American neighbors. When Shay moved his young family to Deerfield in 1958, he could not have known that the suburb would become embroiled in a national news story the following year. This coincidence allowed him to capture, from a personal angle, suburban whites' mostly hidden resistance to the burgeoning northern civil rights movement.

Deerfield came to be known as the "Little Rock of housing" in the North, but its residents' racial fears were emblematic of other suburban whites' across the region. "Condemnations of property and manipulations of zoning designations to prevent African Americans from building," one historian recently concluded, "occurred almost routinely in the 1950s and 1960s."[4] What set Deerfield apart was its self-professed openness, which convinced developers that residents would embrace or at least tolerate a few African Americans among them. They were proven wrong. But rather than

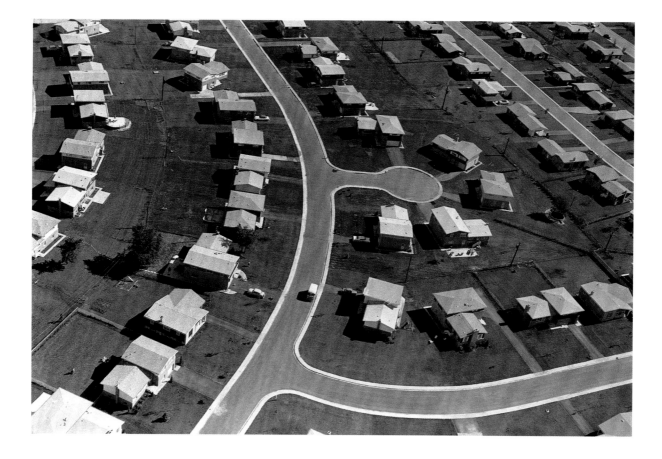

letting segregationists, as in hundreds of other suburbs, quietly win—through polite manipulations of the town's zoning laws and other means—the developers took their fight public and all the way to the White House and the Supreme Court.

But the history of the development of suburbs like Deerfield also reveals something important yet less explored about those who fought for desegregation there. They, too, believed in civility but differed from their segregationist neighbors in that they thought American institutions would ensure fair play and equality of opportunity. Many of them also had faith that the free market would ultimately allow those who could afford to buy homes to do so, regardless of race. Their vision of civil rights ended with the integration of a few upper-middle-class Black neighbors, not with a restructuring of the naturalized urban-suburban policies that were accelerating the urban crisis. As such, their ideas, tactics, and actions reveal key elements of postwar northern liberalism and new American suburban identities.

Plans for the Floral Park housing project began in 1957 through coordination with interracial housing specialist Morris Milgram. A group of Chicago Quakers and Unitarians asked the housing developer to help them plan an integrated development somewhere in the Chicago suburbs. Milgram had gained national acclaim as an expert in integrated housing through his previous projects with the Princeton, New Jersey–based company Modern Community Developers (MCD). The son of Jewish immigrant garment workers, Milgram was raised steeped in the Jewish Left. He took part in New Deal–era radical Socialist activism, most notably in the New Jersey branch of the Workers Defense League, which fought for economic justice and civil rights causes. But he was among the Socialists who refashioned themselves into liberal Democrats in the early Cold War. Liberals like Milgram pursued democratic reforms through the American political and capitalist system, including racial integration. Milgram joined his father-in-law's construction firm outside of Philadelphia. He wanted to learn the business, but also to develop "open occupancy" housing. His first such project began in 1954 in Concord Park, Pennsylvania, and opened four years later as a successful interracial housing

development. A handful of other East Coast developments followed suit, opening interracial housing complexes in Princeton, New Jersey, and outside of Philadelphia, where Milgram lived with his own family.[5]

After evaluating different Chicago suburbs, Milgram's MCD and the local Progress Development Corporation (PDC) chose Deerfield because it resembled the sites of other successful projects in its distance from downtown and its proximity to trains and highways. Deerfield incorporated in 1904, but it did not change much from its "early days" of "virgin woods, open fields, and Indian paths" until after the Second World War. The population tripled between 1950 and 1960 to 12,000 residents. This growth was due in part to new transit routes that made the town a convenient haven for the many junior executives who commuted to Chicago for work. The North Shore Line ran at least ten trains a day, and the Chicago, Milwaukee, St. Paul & Pacific Railroad Company offered forty-three "fast electric" trains. More important, the developers noted the soon-to-be-completed extension of the highway system from Chicago to Deerfield. The local housing market was also favorable. The developers obtained a price list for another Deerfield housing project listing new homes for $25,000, with down payments of $2,800 for veterans and $4,200 for others. These prices marked Deerfield as a suburban enclave that was desired but not upper class. Last, the developers saw Deerfield's distant location—about thirty miles from Chicago—as ideal. The town did not border any areas of "white flight" that could cause the community to change from all-white to all-Black. And this distance was important to the developers and allied groups such as the Quakers' American Friends Service Committee (AFSC), who wanted to convince segregationists that "so-called 'safe' areas are no longer so" and "integration is inevitable."[6]

Despite the developers' careful planning, conflict broke out in Deerfield in November 1959. While Deerfield's town motto was "To Live With Will Unfettered," the next three years would see many accusations of fettering. The unrest began when a local minister, ahead of the developer's publicity schedule, angered some residents when he leaked word that the Floral Park development would be

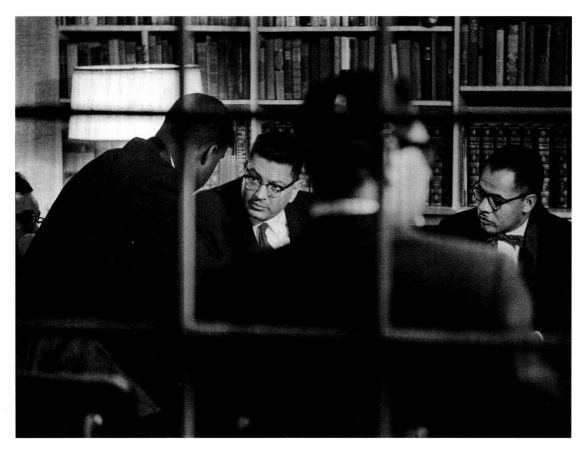

interracial. At that early stage, builder Max Weinrib had only the frames of the two model homes completed, and no African Americans had even committed to moving there. Thus, while developers planned to sell a dozen of Floral Park's fifty-one homes to Black families, this drama's cast of characters was almost exclusively white. Further, its closeness to the Thanksgiving and Christmas holidays made the white middle-class residents' reaction seem like a drama for a Hollywood (or even Frank Capra) screenplay. "Merry Christmas to the bigots of Deerfield," one South Side Chicagoan wrote to the *Defender*. "Was there no room in the Inn when Joseph sought lodging for the sainted Virgin that holy night so long ago? Or were Joseph and Mary turned away because their faces might have been a different hue?"[7]

Shay ostensibly photographed this dramatic situation for a *Life* magazine story, but this assignment also merged his professional and personal commitments. In a November 25, 1959, Teletype,

Life's Chicago editor provided annotations for several rolls of Shay's photographs. Shay first attended a "meeting of some of the pro integrationists, all Deerfield residents" at the home of his neighbor John E. "Jack" Lemmon, making clear whose side he was on. This small group included Reverend Russell Bletzer, pastor of the North Shore Unitarian Church, the first religious leader in Deerfield to come out prominently for

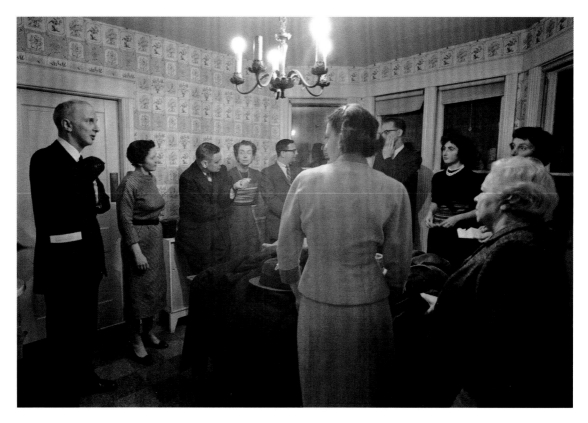

integration. Bletzer had told his congregation, "The coming of integrated housing to Deerfield would be our opportunity as citizens to put into action our highest principles of American idealism." This group discussed "last minute tactics" before heading out to the local elementary school for a town meeting about the housing project.[8]

Deerfield residents flocked to the elementary school gymnasium on November 24, 1959, for a tense and dramatic forum on the Floral Park project. After all 400 seats quickly filled, residents lined the aisles, and the town's employees set up loud-speakers so that the overflow crowd could hear the proceedings from where they stood in the school's halls, stairwells, and even outside in the frigid eighteen-degree weather.[9] Inside, Village Manager Norris Stilphen attempted to hush the crowd before summoning a range of town residents to address the audience. Above the microphone, the white men on Deefield's board of trustees sat on a raised stage. Behind the trustees hung the school's world map. Press officials could not help framing the hearing in its global Cold War context. "It is fair

to point out," one *Sun-Times* editorial stated, that "the alienation of friends we need among the non-whites of Asia and Africa" might result from them condemning Deerfield, and therefore the United States, as discriminatory toward people of color.[10]

The hearing amplified Floral Park's formidable opposition. The first Deerfield-area resident to speak, the Chicago investment banker Harold Lewis, tried to dodge accusations of racial bigotry. He argued that he and his soon-to-form group, the North Shore Residents Association, did not want to be "lured into the position of debating integration." Indeed, they were "prepared to accept it when it comes naturally," but they resented "the manner in which this has been brought forth." Lewis thus appealed to many white suburbanites' shared view that integration was either organic or "unnatural."[11] This claim gave Lewis and his supporters a seem-ingly race-neutral way to oppose Floral Park, but it also reveals postwar suburbanites' common assumptions. Most Deerfield residents saw buying a home in their selected suburb as a personal deci-sion. The net outcome of these individual choices,

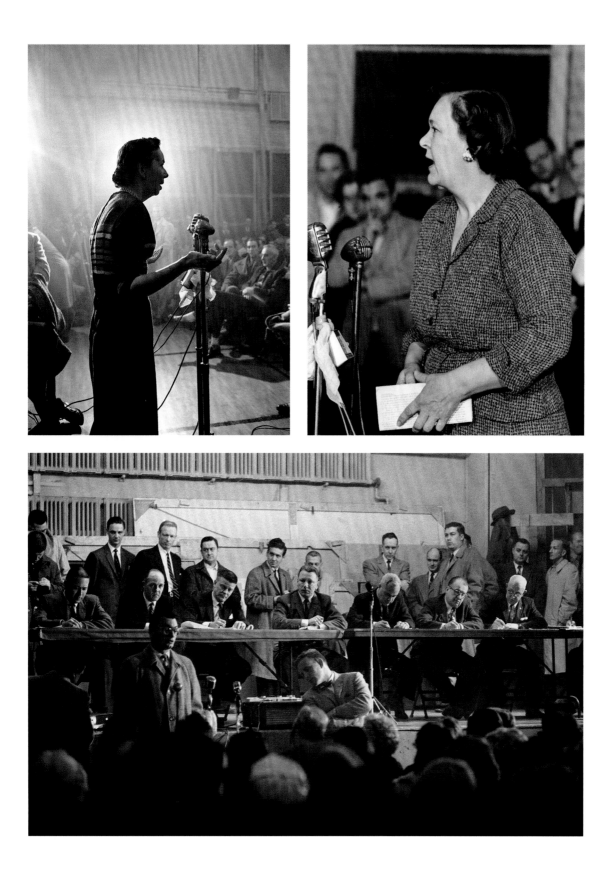

then, was a community whose residents shared an appreciation for green spaces, ample parking, and especially quality schools and safe streets for their children.

These allegedly "natural" preferences were shaped by Cold War cultural ideals that prized suburban home ownership by heterosexual nuclear families. White middle-class men were the principal beneficiaries of postwar economic prosperity—a prosperity that was made possible by generous government welfare programs. These included Federal Housing Administration mortgages, the $95 billion GI Bill of Rights, and highway and other transit construction that spurred suburban growth. These federal policies were racially discriminatory, channeling governmental support to whites, who interpreted it as their individual achievement of the American Dream.[12] This understanding of suburban life led Lewis and other opponents of the Floral Park housing project to distinguish between their personal decisions to live in certain kinds of suburbs and the intentions of Morris Milgram, an East Coast outsider, who wanted to "force" integration upon them.

Other speakers against the project echoed Lewis and more clearly revealed their assumptions about race and politics. Mrs. Robert Hyde drew applause when she declared herself to be against Floral Park, but not against integration per se. Like Lewis, she described the developers as having "force[d] this issue on us." Instead, she explained, each race should have "their own schools and their own stores like they have done in the South and it has worked just beautifully to the advantage of the colored and the white." Perhaps referring to the notorious anti-Communist Elizabeth Dilling, who literally stood in solidarity at the back of the gymnasium, Mrs. Hyde added, "I feel that there has been information that these developers are connected with the Communist party.... They have no love for the Negroes. They have no love for anyone."[13] Opponents like Hyde saw segregation as self-selecting and mutually beneficial, claiming that integrationists had other nefarious motives.

The presence of the anti-Communist Dilling sent important signals to Deerfield residents. After a trip to the Soviet Union in the 1930s, Dilling had become a notorious Chicago Red-baiter, falsely

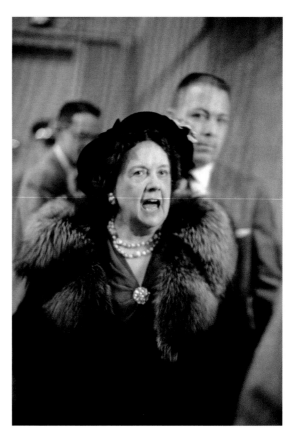

claiming to have single-handedly compelled the Dies Committee (the House Un-American Activities Committee) to investigate Communism. Her numerous publications, including *Red Channels*, named and sought to discredit celebrities, politicians, and others for supporting anything related to civil rights, which she framed as a Communist conspiracy. Dilling created the mimeographed bulletin "The Red Hand Over Deerfield." Residents such as Mrs. Hyde drew from its insinuations to dismiss Milgram and others as "Red." Milgram must have found this ironic given that his 1930s Socialism had often attacked the Communist Party.[14] Few people stopped to talk with Dilling after the hearing, and only about thirty residents attended a later house meeting with her. One AFSC activist concluded that Dilling "largely defeats her own purpose by her manner of presentation using innuendo, guilt by association, etc."[15] But her presence buttressed more moderate segregationists' cause because they could distance themselves from her, portraying themselves as sensible opponents to the housing project.

Beyond linking housing integration to Communism, a final argument of Floral Park's opponents drew from an assumption about the relationship between race and property. Real estate businessman William Reynolds, for example, stoked fears at the town meeting by claiming that African Americans' presence would inevitably depress property values. If African Americans moved into Floral Park, he claimed, nearby homes "will lose the[ir] entire equity." Four thousand homes would be thus affected, he estimated. Following Reynolds was a man named Jim Crowe (that led the Chicago *Life* editor to write, "Next, Jim Crowe, Repeat, Crowe," in disbelief back to the New York office). Crowe testified that he had seen other communities that experienced "forced integration" where "property values went down." He did not want this fate to happen to the people of Deerfield, he claimed, and then he called for an impromptu show of hands. He asked who else considered this an "invasion," pressuring everyone in the gymnasium to display their opinions. Hands shot up in the air, showing the vast majority of people in the gym agreed with Jim Crowe and Jim Crow.[16]

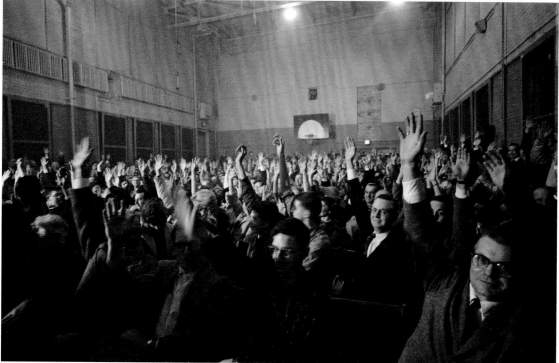

The argument that race affected property values allowed Deerfield residents to claim—and even to believe—that they opposed the project for economic rather than racial reasons. At the town meeting, PDC attorney John Hunt presented evidence from Milgram's other housing projects that showed no decrease in property values; the audience shouted him down. Local newspapers began to conduct their own surveys of real estate agencies, printing the positive results in which agents reported a "good December" so far in both the number and price of home sales in Deerfield.[17] But such evidence could not sway those who were opposed. Many suburbanites remained steadfast that a few African American neighbors would harm their property values. They saw themselves as savvy investors, not racial haters.

The liberal integrationists who attended the town meeting may not have anticipated the opposition they encountered, but they nonetheless spoke in favor of Floral Park. Most built upon the premise that racial discrimination was anathema to American values. One of the earliest supporters to speak, Mrs. Bennie Simon, conceded the property values argument of the opposition, saying, "I would hate to see our property value go down." But she "would hate even more to lose the values I have." This stirred the crowd, but it was Theodor Repsholdt, a thirty-seven-year-old local high school history, English, and classics teacher, whose comments led the audience to boo, hiss, and jeer. He framed his words as a "declaration of conscience," exclaiming that he not only favored integration but that he would move into the housing project if he could afford it. Some shouted, "Fire him," and booed in reply, though he drew some applause, too. Later in the evening, Mrs. Rose Lemon evoked the Second World War against fascism as a prime reason to support integration. "I had three sons in the last war and they all fought for this sort of thing and I'm going to fight for it too." A handful of others spoke in support, but the last among them was the most memorable. The previous speaker had drawn from religious ideology in framing her opposition: "God made the bluebird and the blackbird but you don't see them in the same nest." This prompted Mariellen Sabato ("Mari, Repeat, Mari," the *Life*

editor wrote in reference to the Virgin Mary), to rise in rebuttal. She remarked, "God does let them live in the same tree. There are other ways of feeling...." Sabato was interrupted by catcalls and boos. She broke down crying, abandoned the microphone, and continued "sobbing hysterically" against the wall of the gymnasium. This moment summed up the evening for many in attendance. The town seemed divided into two emotionally charged sides: a large bullying opposition and a small embattled liberal group.[18]

Between Thanksgiving and Christmas, Deerfield residents lobbied their neighbors. Unlike the public partisanship in Chicago and the state capital, Springfield, most residents of Deerfield probably did not know their neighbors' attitudes until the Floral Park issue caused them to choose a side. Town board members, for example, did not have political party affiliations; they served in addition to their full-time jobs. And although some suburbs in the 1950s became known as

liberal or conservative destinations, most were more like Deerfield, communities where apolitical neighborliness and civility dominated the public sphere.[19] The shift from private politics within the home to public lobbying around integration transformed the town spirit and created feuds that lasted decades, including one between Art Shay and his neighbor. One Sunday morning Shay answered a knock on his door from a neighbor who lived two houses down. Shay did not know him well but had previously respected him because he had also served in the Eighth Air Force during the war. This neighbor appeared with his young children dressed for church and asked Shay to join the North Shore Residents Association (NSRA), which sought to keep Deerfield a white community. Shay politely declined but then lost his temper when he noticed one of this man's kids held a protest sign with the word "nigger" on it. He angrily confronted him, "Why the hell do you think we fought the war?" They never talked again.[20]

Groups like the NSRA, fearing a racist stain on the town's reputation, began to craft a more civil approach. Right after the town meeting, a group of lawyers convened a meeting at the local American Legion Hall. Unlike the school hearing, this gathering of about 200 people was meant only for opponents of the Floral Park housing project. Shay attended, and when he started to take photographs, someone identified him as a *Life* photographer who happened to live in Deerfield. This drew cries of "Throw him out" and talk of going "underground" because "there were too many spies." Appealing to civility rather than making a scene, the group let him stay, but several people obscured their faces from Shay's camera. This group determined to invalidate the housing project by designating the land as needed for a public park. Others agreed, but some asked whether more parks would raise taxes. On this question, resident Carl Bagge replied, "This is the price I am willing to pay." Over the next few weeks, the NSRA quietly and successfully lobbied for a vote on a park referendum, which they were granted on the Monday before Christmas. But in the meantime, they also wanted to shape public opinion of themselves as democratic and respectable. They polled Deerfield residents house to house over

the second weekend in December, emphasizing their neutrality while using the visits to lobby their neighbors (and skipping over people who were known to oppose them). After a long weekend of canvassing, they gathered at the Jewett Park field house to count ballots. They announced that out of 4,023 responses, 3,507 opposed the Floral Park project.[21]

Other events that December cast the NSRA in a less favorable light. Chief among these were the public comments of Harold Lewis, the opposition's self-declared spokesman. Lewis tried to avoid direct discussion of race, but he conceded in a debate, "I wouldn't be telling the truth if I didn't admit that having Negroes is one of the basic issues." Lewis had also written to the explicitly racist White Citizens' Councils (WCC) of Mississippi to ask for assistance. "I would imagine that determined resistance would be easier to maintain in the South than in the North, although the consequences of defeat would be far more devastating," he wrote. "At least you do not have to fight your political leaders and ministers and newspapers to the extent we do up here." The WCC leaked the letter to the press, urging Lewis and his allies not to "give an inch." Some southern newspapers commended Lewis, whereas the northern press pointed out that his letter seemed to substantiate rumors of a direct alliance between Deerfield residents and southern white supremacists.

Indeed, the opponents' covert actions seemed drawn from the Citizens' Council playbook. In early December, the Deerfield Citizens for Human Rights received an eviction notice that gave them a few weeks to vacate their office. Soon thereafter, outspoken DCHR members and employees of the PDC and MCD development companies began receiving harassing phone calls that threatened their families. These threats became more real when Deerfield resident Bernard Scotch discovered a charred "Klan-style" cross on his lawn and when vandals "axed" parts of the two Floral Park model homes. Similar to the WCC in the South, the NSRA disavowed any involvement. Police and the press blamed "irresponsible juveniles" or "adult delinquents with juvenile minds" by contrast to the "good people of Deerfield [who] won't tolerate violence."[22]

The Deerfield Citizens for Human Rights, while on the defensive, remained optimistic. The group continued to meet locally while coordinating with two dozen Illinois human relations groups and the Philadelphia-based MCD. Speaking for the MCD, Milgram dismissed the Deerfield residents' vote. "Human rights exist regardless of any poll," he said, and he expressed hope that Deerfield residents would realize this and "abandon hysteria."[23] Believing itself to be on the right side of history, the DCHR deemed the poll biased and concentrated on convincing the town to vote against the park referendum. In an "Open Letter to Deerfield Voters," they explained the motive as "aimed at stopping integration," noting that town residents had previously voted down similar park referendums. They also framed the referendum as unlawful and expensive. While claiming that the law "protects all citizens' rights," they also urged residents who were not persuaded by the legal argument to vote with their pocketbooks. The parks would cost $550,000 and even more tax dollars would be spent in legal fees when its "subterfuge" was challenged in court. The DCHR ended its plea with perhaps its most cogent argument, striking at the heart of their suburban identity: class status. The vote offered Deerfield the opportunity to "regain its reputation and self-respect" and "its status as a fine community in the eyes of America." For all of these reasons, they urged residents, "when you are alone in the voting booth" to "VOTE NO" with "your conscience."[24]

These "VOTE NO" appeals failed to persuade the majority of Deerfieldians. On December 21, 1959, 85 percent of the town's 4,500 voters cast ballots on the park referendum, approving it by 2,635 to 1,207. The DCHR had narrowed the gap found by the Home Owners Association's poll from an 8:1 to a 2:1 margin, but it was still soundly rejected. "We are saddened by the defeat of morality, justice, and reason by the organized power of prejudice," the group's statement read, but "will continue to urge that integration be accepted peacefully and lawfully when it comes to Deerfield, as it surely will." High-placed allies and civil rights leaders shared this optimism. The DCHR mentioned that it had received a letter from E. Frederic Morrow, Administrative Officer for Special Projects

and the first African American to hold an executive position in the White House. Morrow wrote that President Eisenhower found it "encouraging" that "you and others have concerned yourselves with and are protecting the basic American principal of fair dealing"; he vowed to look into the housing situation there. But even more uplifting, they received an endorsement from Martin Luther King Jr., who was in Chicago that month to speak at several churches about the southern civil rights movement. Dr. King wrote that while the Deerfield conflict revealed that "integration is not a sectional problem," he remained hopeful. King called for more "righteous pressure," assuring his Chicago audience, "I have no doubt that integration will work in Deerfield."[25]

Following the referendum vote, the immediate drama subsided, but both sides dug in for a long legal battle. The day after the park vote, the Progress Development Corporation made good on its promise to litigate. The group sued the Village of Deerfield, its Park Board, and NSRA for $750,000 in civil rights damages. Residents responded by raising more than $25,000 in door-to-door appeals for the named defendants' legal costs. The defendants' attorney George Christensen framed them as victims. He argued that Floral Park's developers had engaged in race discrimination by using a quota to set the number of African American and white families (12 out of 51) in the project. Milgram responded, "This is the last refuge of a debater—to try to turn the facts upside down." If other developers also sold homes to all citizens, he reasoned, "it wouldn't be necessary to sell homes on a gradual basis." But Christensen's strategy, even if used to defend segregation, was not baseless. As the trial unfolded, the Chicago-based *Ebony* magazine weighed "The Pros and Cons of Quotas." The African American editors understood Milgram's good intentions, but they nonetheless concluded, "Even 'nice' Negroes aren't flattered by a plan which rations them out like portions of poison, which when taken in small doses is more curative than killing." This editorial insinuated that the developers had over-managed their integration plan by imposing quotas that might be illegal. But it also suggested that a victory for integration would

only result in tokenism, which sent a message that *Ebony* argued "still smells of discrimination." It seemed that certain white liberals wanted a select few Black neighbors, and they understood integration to mean Black families adopting white middle-class values. Contrary to this assumption about assimilation, a late 1950s survey indicated that between 45 and 65 percent of African American home seekers in the late 1950s preferred a neighborhood that was at least one-half Black.[26]

The question of quota-driven "controlled occupancy" raised a deep issue, but one that turned out to be less important in this case because of the judge's ruling. Initially, the PDC was encouraged that Judge Joseph Sam Perry deemed the case within his federal jurisdiction, but the judge's personal background caused concern. Hailing from rural Alabama, Perry was referred to as the "cracker barrel" judge by some attorneys. One reporter deemed him to be "as southern as a steaming skillet of hominy grits." Appointed by

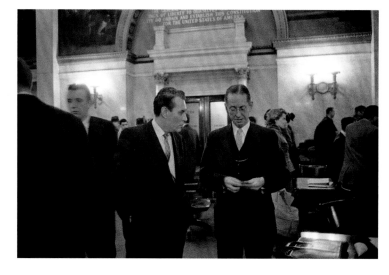

President Truman to the federal bench in 1951, Perry declared himself to be just as "fundamentalist" in interpreting federal law as his father, a Holiness preacher, was in interpreting the Bible. In March those concerns proved prescient when Perry ruled against the plaintiffs and then some. He not only dismissed the civil rights charges, but "went several steps further than he needed to" by contrasting Deerfield with Little Rock. Breaking from judicial custom, Perry invited reporters into his chambers for his off-the-cuff remarks. If the housing company "was really interested in integrated housing," he reasoned, "I do not think they would have built $30,000–40,000 homes 30 miles from the city." The "whole thing smacks of a money-making scheme," Perry declared, even though the defense attorney never even made this claim in court. AFSC allies were "discouraged by the decision," fearing that Perry's reactionary opinion "could be a model for other communities to prevent integrated housing."[27]

Over the next two years, as appeals wound their way through the courts, the DCHR struggled to keep Deerfield in the public eye. In early 1960, one leader reported that the group was "bewildered as to how to proceed." Its members tried to organize a "Brotherhood Week," inviting Republican then–Vice President Richard Nixon, who declined. Meanwhile, reprisals continued without much public notice. When a young Harvard-trained Deerfield attorney admitted to his "respectable" Chicago firm that "he stood for integration," he

was promptly fired. Worse yet, when vandals damaged the model homes and arsonists tried to bomb and set fire to DCHR leader Jack Lemmon's home, the local police insinuated that the victims did this themselves to generate publicity.[28]

The press reported these incidents but seemed to lose interest. In 1961 the *Chicago Defender* remarked upon the "conspiracy of silence by some media" and the challenge of sustaining the fight when "local legal machinery is aggravatingly too slow." Its editor noted that the courts needed to "feel the full brunt of the social action that respon-

sible citizens are stirring to widen the frontier of democracy."[29] This editorial revealed the dangers of putting so much faith in the legal system. Shay's assignment for *Life* confirmed this problem. As southern civil rights activists knew all too well, dramatic confrontation, not civility, created publicity. When Shay's initial "assignment" was bumped in November (a common occurrence at the magazine, with so many international stories vying for print space), editors assured him that it would run once the drama was resolved. Shay remained "on open and continuing assignment," photographing "almost every facet of the story." But *Life* never published a story on Deerfield because by that time "it was no longer, from their point of view, news."[30]

Shay began photographing housing market stories that ended with the voluntary yet sometimes reluctant arrival of new suburban neighbors. In the spring and summer of 1962, for example, he collaborated with journalist Alfred Balk by photographing Chicago neighborhoods that were transitioning from white to Black, exposing this process of "white flight" as anything but natural. One photograph showed three white housewives keeping a hawkish watch from a balcony near West Eighty-Ninth Street and South Normal Avenue on the Southeast Side of Chicago. These women tailed and heckled real estate agents and complained of "unethical practices" to the state's Department of Education and Registration, demanding that the "licenses of these men" be revoked. In his notes, Shay admired their resolve but also indicated that their block "has just begun to 'crumble.'"[31]

The subsequent article included this photograph and was framed as a first-person "Confession of a Block-Buster," in which the pseudonymous Norris Vitchek described his business of "beating down prices I pay to white owners by stimulating their fear of what is to come." This included paying Black people to drive and walk around the neighborhood to suggest they lived there and promptly placing "sold signs" on newly purchased property to induce fear to sell before prices dropped further. Then, Vitchek sold "to the eager Negroes at inflated prices" because they were desperate to find decent housing outside

of overcrowded neighborhoods. He would profit a third time by "financing these purchases at what amounts to a high rate of interest" because African Americans could not get traditional mortgages due to government and bank red-lining of neighborhoods as "high risk" for loans. The resulting high payments, he explained, led new Black residents to "overcrowd and overuse their buildings by renting out part of them, or to skimp over maintenance, starting the neighborhood on the way to blight." Intended to raise the ire of the largely white middle-class readership of the *Saturday Evening Post* against this "vulture," the confessor then turned on his reader. "Why should I feel guilty?" he asked. These real estate transactions were not only legal but were supported by policies of the local and federal government, the Chicago Real Estate Board, banks, and many agents who made these deals in the city and lived in the suburbs. "Whatever my faults and whatever the social stigma I endure, I don't believe I am hypocritical about all this," he wrote. "Can you honestly say the same?"[32]

To redress these and other exploitative racial housing practices, as well as to cover the "accumulating astronomical costs" of the Deerfield legal case, Milgram and his allies created the American Freedom of Residence Fund (AFRF). Its board and sponsors included prominent civil rights leaders, artists, and liberal political figures—from Martin Luther King Jr., to NAACP leader Roy Wilkins, to Major League Baseball's Jackie Robinson, to the writer Saul Bellow, to the local musical artist Oscar Brown Jr. This group solicited contributions for the Deerfield case in the *New Republic* and other liberal journals. Its ads asked readers to "Help Fight for the Right to Live Anywhere You Please." The AFRF held house-party fund-raisers in several cities, but the most noteworthy was its spring 1961 "Golden Key Award" dinner, a $25 per-plate affair held at the Morrison Hotel in downtown Chicago. The dinner featured a long list of notables—including James Baldwin—and ended with a keynote address by honorary co-chair Eleanor Roosevelt. Roosevelt's speech highlighted her former leadership position in the United Nations. "What happened in Deerfield

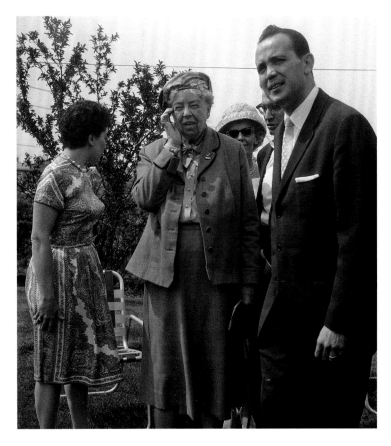

carries over to our foreign relations," she warned. "We, in this country, have to face the fact that in this world white people are in a minority."[33] Shay did not document this dinner, but he did photograph Mrs. Roosevelt when she visited Deerfield on the same trip.

Public events like the Golden Key dinner raised funds and publicity, but they did not really confront the forces that produced and profited from housing discrimination; instead, it was young people's activism that sustained the civil rights cause in Deerfield. When the controversy first broke out there, it seemed to be a debate among adults. But at least one reporter discovered that "teenagers are taking the integration issue to school with them." These young people include Shay's daughter, Jane Shay, whose schoolmate Kathy Hyde told her that the Shays were referred to as "nigger-lovers" in her home. "That was a very bad and terrible word and should never be used," Jane responded, "plus I didn't even know any Negroes,

and neither did she."³⁴ While many white high
schoolers resisted having African American class-
mates, others called for integration. They appealed
to equality of opportunity and rejected appeals to
property values and their parents' values more gen-
erally. "I'm for [integration]," one girl said, laughing.
"My mother is from the South and she has a fit
every time it's brought up." In the meantime, teen-
agers learned about the sit-in movement that broke
out across the South in the first months of 1960.³⁵

In December an interracial group of young peo-
ple organized their own action in Deerfield. Just be-
fore Christmas, about forty people gathered at the
home of DCHR leader Jack Lemmon on a Sunday
morning, then made impromptu visits to local
churches. They next held a "kneel in" and sang
holiday carols and civil rights anthems outside the
two model homes in Floral Park. They claimed that
one of these was being unjustly used by Deerfield
Village Manager Norris Stilphen as his personal
residence. Shay photographed these actions, which
drew a reaction from Stilphen, who declared "the
singing" to have been "in bad taste." He also

insisted Deerfield churches had never been seg-
regated, pointing out that "Negro maids ... attend
village churches as a matter of course." Despite
this publicity, Deerfield's demonstrators still
favored politeness over confrontation. Lemmon
meant to compliment them in stating that "there
were no harsh words and no trouble whatsoever."
That is probably why the local *Waukegan News-
Sun* was one of the few newspapers that found
this polite suburban activism to be newsworthy.³⁶

By spring 1963, the legal battle over integrating
Deerfield had reached the nation's capital. After
two years of legal wrangling, the Illinois Supreme
Court had effectively decided that the park dis-
trict's use of community hostility based on race
was lawful because its intent was not race-based.
Shaken but not defeated, Milgram and his allies
held out hope that the courts would ultimately rule
in their favor. They called in every possible political
favor in their efforts to convince the U.S. Supreme
Court to overturn the case. They also believed that
they had the access and power to influence peo-
ple in high places. A long list of well-connected

political and civil rights leaders sent telegrams to Attorney General Robert Kennedy. When his office did not intervene, the Deerfield activists' new attorney, Joe Rauh, sent a delegation from the Americans for Democratic Action to the White House to demand that President John F. Kennedy reconsider. President Kennedy admitted in the meeting that "perhaps the administration made a mistake," writing a note about it and putting it in his pocket to later discuss with his advisors. But ultimately, the Kennedys balked, and the Supreme Court voted unanimously against the writ of certiorari to hear the case. This decision seemed like a betrayal to Milgram and his allies. Rauh summed up their anger, telling the press that "Bobby Kennedy sold out to white suburbia." Beyond killing the Deerfield case, this outcome established the dangerous precedent that any town's majority could impose its will on a minority by manipulating zoning laws.[37]

While the adults seemed to surrender, young Deerfieldians tried to integrate their town on their own terms. In the midst of these last appeals in

May 1963, two members of CORE—an African American reverend named Alton Cox from High Point, North Carolina, and white public relations representative Jack Harkins from Chicago—pitched tents on Deerfield's newest public park site, vowing to remain there indefinitely. Village Manager Stilphen initially ordered to have them arrested, but he changed his mind when a local church offered them sanctuary if they were kicked out of the park. Over the next few days, curious Deerfieldians visited the park to ask questions, discuss civil rights, and take pamphlets. A few confronted them. "Am most impressed by the young men from CORE who surprised us all," Deerfield resident and activist Ethel Untermyer wrote to Milgram. When some "big boys" challenged Reverend Cox and asked what he would do if they hit him, he replied, "Say, haven't you heard of a thing called love?"

This direct action inspired a larger campaign that saw young people in Deerfield link up with Chicago-based civil rights activists for a freedom rally to "Protest Segregation: North and South." On May 20, 1963, between fifty and one hundred

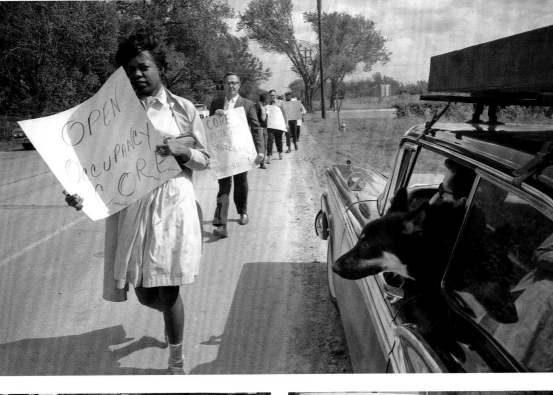

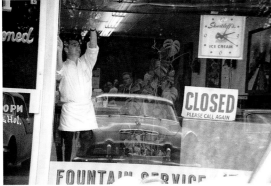

people marched from Village Hall down Waukegan Road, turned west on Wilmot Road, and finally entered the park. Shay was there to capture the activists. Among them was his daughter Jane. He also photographed the opposition, which included at least one restaurant owner who shut his diner when he saw the marchers coming. Once in the park, Shay documented them demonstrating and singing. One photo captured the generational dynamics at play as two young people, high atop

the baseball backstop, hovered above each shoulder of one of the local ministers. As night fell, Shay photographed the group holding hands in a circle and then sleeping over in the park. He also took shots of the next morning's "Outdoor Religious Service." With 45 percent of Deerfield's population under eighteen years old by 1964, these young people provided hope despite what their elders, the courts, or the Kennedys had decided on their behalf.[38]

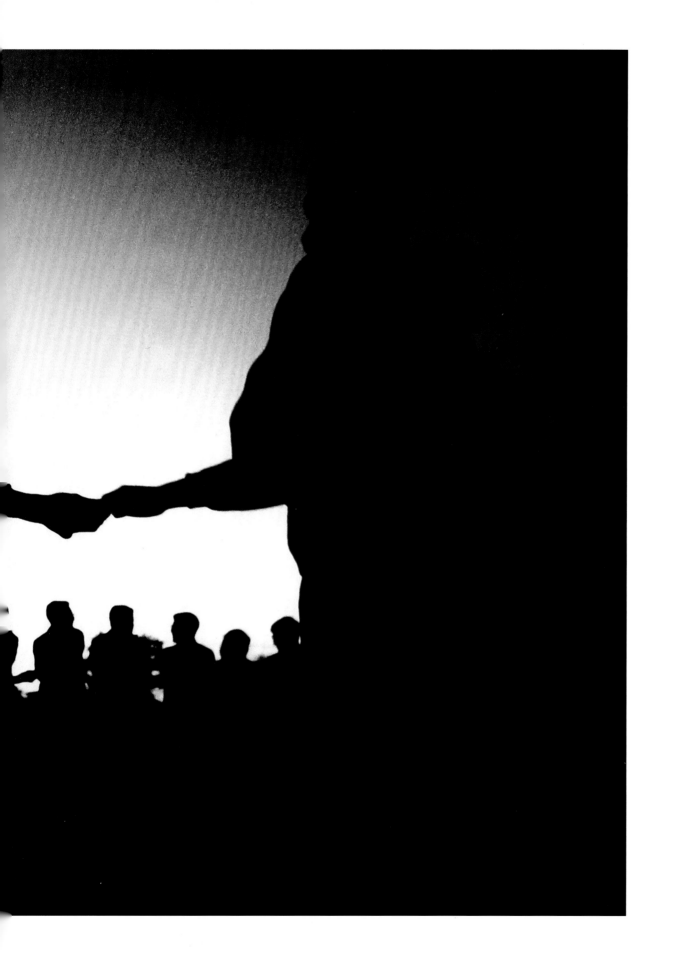

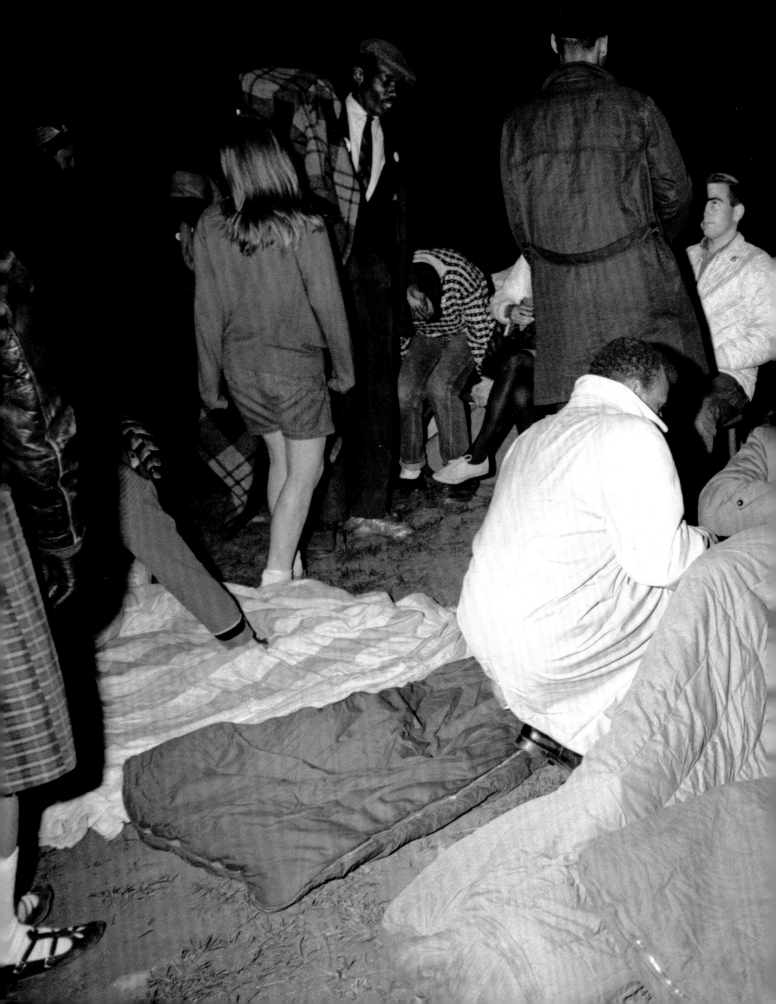

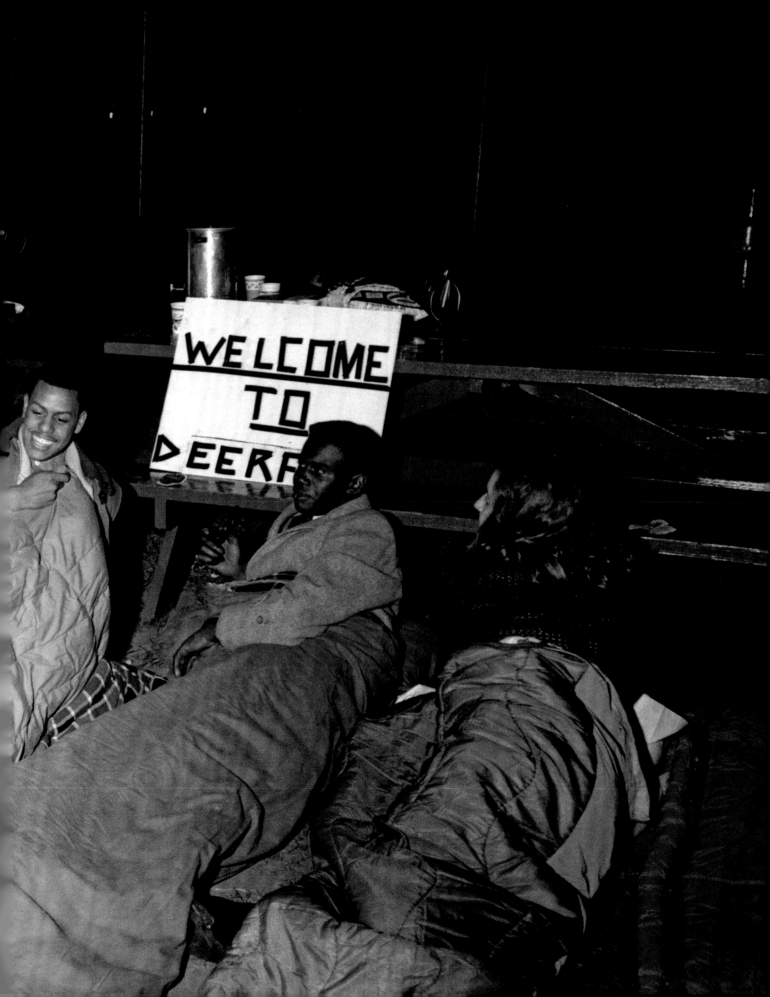

want another Deerfield here." In 1960–61 nearby Park Forest and Skokie accepted racial integration to avoid the expense, time, and "scars" that Deerfield had endured. Deerfield "dramatized the problem of discrimination in housing in the North," Weston concluded, and "without question the coming of the first Negro families in several other Chicago suburbs ... was made easier because of Deerfield."[40] By 1963 the AFSC boasted that in the past two and a half years it had helped eleven African American families move into six previously all-white Chicago suburbs. And Deerfield finally became one of these suburbs when, in 1967, Sherman and Eve Beverly moved into their Deerfield home without opposition.[41]

Even with these silver linings, the outcome in Deerfield revealed blind spots baked into postwar suburban identities. During the controversy and even decades after it, many Deerfieldians denied that race was relevant to their opposition to the project. Proponents of integration found their neighbors' denials ridiculous, but the two groups did share a common suburban outlook. Residents of Deerfield and hundreds of other suburbs tended to understand their residential choices as individual, erasing the host of state-sponsored entitlements that perpetuated racial and class inequalities. The cost of highways, low-interest home loans, and other public policies drained Chicago's population, tax dollars, and jobs, but middle-class social norms obscured this process. In the initial town meeting, a member of the Deerfield town board berated people in the gymnasium for their "catcalls" and other interruptions. He accused them of not being "a part of Deerfield." The town's residents, he claimed, had "always been the kind that were polite and considerate." Similarly, an ally of the DCHR wrote in the North Shore Human Relations newsletter, "Regardless of your feelings on integrated housing in general, or on this project in particular, it is important that an atmosphere be created in which calm and rational discussion of the issue becomes possible." Even at a commemoration event forty years later, an audience member who had lived in Deerfield in 1959 explained to the younger audience, "There were no bad people in this story"; it was "just sad that it happened."[42]

Perhaps inspired by their youthful allies, liberal proponents of the integrated project believed that some good had come from their three-year campaign. "MCD took a financial beating in Deerfield," Milgram concluded, "but we have weathered it." His lesson from the campaign was that there were "safer and quicker ways" to integrate housing. For example, he pledged to buy existing apartment complexes and houses and open them to all.[39] Further, Deerfield had drawn the national and international publicity that others sought to avoid. Jane Weston, an AFSC staff member who coordinated with the DCHR in the Chicago region, often heard other suburbanites reasoning, "We don't

This same emphasis on civility gave way to complete amnesia just a year after the final court decision. A reporter noted in 1964 that residents "don't like to talk about what happened in 1959," and that "it's a rare Deerfielder, present or past, who can recall the Village with anything but happy impressions." Neither side seemed interested in reflecting back; they wanted to move on and erase their hometown's embarrassing moniker as the "Little Rock of the North."[43]

Civility also prevailed over confrontation for those who sought racial equality. Instead of turning to other forms of protest politics, the PDC and MCD stuck with litigation. Throughout the appeals process, they expressed great optimism that American institutions would protect equal opportunity and "fair play." When these institutions wavered, suburban liberals believed that their class status would yield political influence to make justice prevail. When institutions and influence failed them, some felt betrayed and admitted the mistake of relying so much on litigation. But even where racial justice advocates won, as was the case in the early 1960s for several other suburbs, their victories seemed hollow. For example, a 1958 Urban League study concluded that 400,000 African Americans could not find adequate housing in Chicagoland. Solving the housing problem required 100,000 homes, not a dozen. In particular, it would mean removing what the U.S. Civil Rights Commission termed the "white noose around the city."[44] While one group sought to maintain and even tighten the noose, the other sought to loosen

it a little, prompting some to question the stakes of the battle itself. African American allies such as James Baldwin came to understand by 1963 that these inequalities required much broader collective, structural solutions. Some in Deerfield, such as the Shay and Untermyer families, shared his critique. But as a group, suburbanites did not join Baldwin in becoming more radical (or re-radicalized in the case of the former Socialist Morris Milgram) because it would have required a fundamental revision of their liberal suburban identities.

In 1960 Milgram told a reporter that he "wanted to find out whether idealism can be applied to business." The Deerfield experience provided an answer, but he and others nonetheless continued to seek individualist, "free market" solutions to societal inequalities even as massive capitalist enterprises made great profit by promoting racial discrimination through suburbanization within the same capitalist system. This kind of activism allowed suburban liberals to both portray their fight as moral and overlook the larger regional processes that generated basic inequalities.[45] As such, while these suburban liberals certainly held more egalitarian values than their neighbors, they may have publicly rejected, yet privately agreed with, the anonymous opponent of the Floral Park housing project who told *Time* magazine, "We just can't afford to be democratic."[46] It is precisely this suburban liberal identity and its parallels to urban liberalism that civil rights activists took on in 1963, the subject of the chapter that follows.

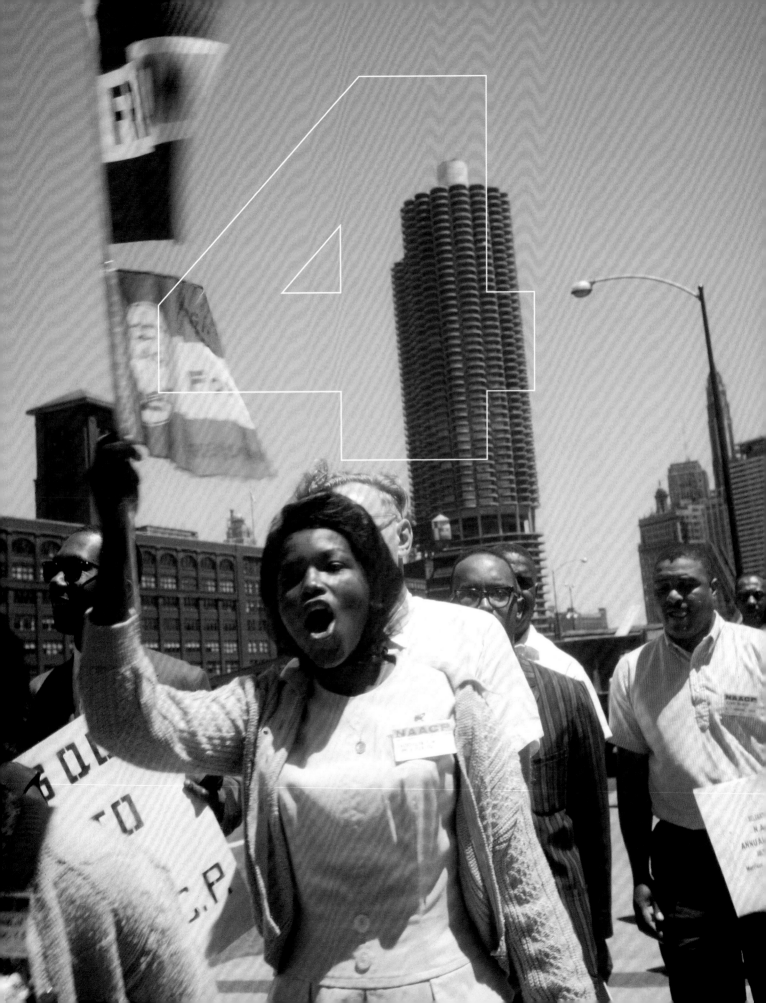

CHICAGO'S OWN
CIVIL RIGHTS
MOVEMENT

Many Chicagoans watched on television as civil rights activism spread across the South in 1960, comparing it to their own northern situation. Oscar Brown Jr. was one. Born into a prominent South Side African American family, Brown came of age during the 1930s Black Chicago Renaissance. That movement's artists infused their creative work with their resistance to racial and class inequalities.[1] Adopting this spirit for his generation, Brown dove into many postwar activist endeavors, including stints in the Communist Party, Progressive Party, U.S. Army, and the United Packinghouse Workers of America. Cast out of all them, he turned to radio. Brown hosted his own program, *Negro Newsfront*, and performed many roles on *Destination Freedom*, his fellow activist Richard Durham's Black history program.[2] But Brown's career really took off as a singer-songwriter when Lorraine Hansberry, the successful playwright of *A Raisin in the Sun*, and her husband, Bob Nemiroff, took an interest. Nemiroff was a New York music writer and producer, and he invited Brown to record some demos, then helped him record an album on Columbia Records. Soon thereafter the great gospel singer Mahalia Jackson recorded his song "Brown Baby." This notoriety convinced Brown to become an artist full-time. He sat down at a typewriter in a loft at his father's real estate office at 4649 South Cottage Grove Avenue and began to write the musical he would come to call *Kicks & Co.* And when the student sit-in movement broke out in Greensboro, North Carolina, in February 1960, Brown had found the perfect setting for its first acts: a historically Black southern college campus in the midst of the Black Freedom Movement.[3]

Kicks & Co. was a musical amalgam of Brown's activist experiences in Chicago. Based loosely on a German Faustian folktale, the character Mr. Kicks resembled a modern-day Mephistopheles, who, trapped in his own hell as an agent of the devil, tried to seduce others to join him in a quest to corrupt morals and debase humanity. Kicks "was afraid that if this spirit of love were to jump the color line," Brown explained, "it would be bad for his business."[4] The musical numbers pitted the strident demands of the student sit-ins against its characters' temptations to fulfill their hedonistic desires. As Kicks sang in the opening scene: "I teach a course in ruination from the devil's text / For fools who can't stand temptation / Step right up you're next." This song of seduction threatened the student activists' worthy cause, as laid out in the number "Opportunity, Please Knock." In this song, a student sang: "Don't fly through my window / Like a house brick or rock / Opportunity, just knock." Demanding access to all of the rights of American citizenship, the student continued, "Knock and then enter / You'll be more than welcome here / Show me a chance that's just halfway fair / And let me take it from there."[5] Brown's musical delved into racism, consumerism, misogyny, violence, and even miscegenation. The two main characters ended up in Chicago, where one sold out as a rock-and-roll musician and the other became the first Black centerfold for "*Orgy* magazine," a thinly disguised nod to the Chicago-based *Playboy*. In the end, another character was seduced into debauchery, but the two main students had a change of heart. They defied their temptation for "Kicks" and instead returned to their southern campus, reengaging with the freedom movement there.[6]

Kicks & Co. was one of the most anticipated musicals of 1961, its rise seeming to parallel that of the civil rights movement. Before its opening, Brown toured major cities to promote it, performing several of the characters' songs alongside Zabeth Wilde, who sang the female parts. The two were a huge hit at venues including popular jazz clubs like New York's Village Vanguard and Chicago's Birdhouse, but more often at house party fund-raisers hosted by liberal civil rights

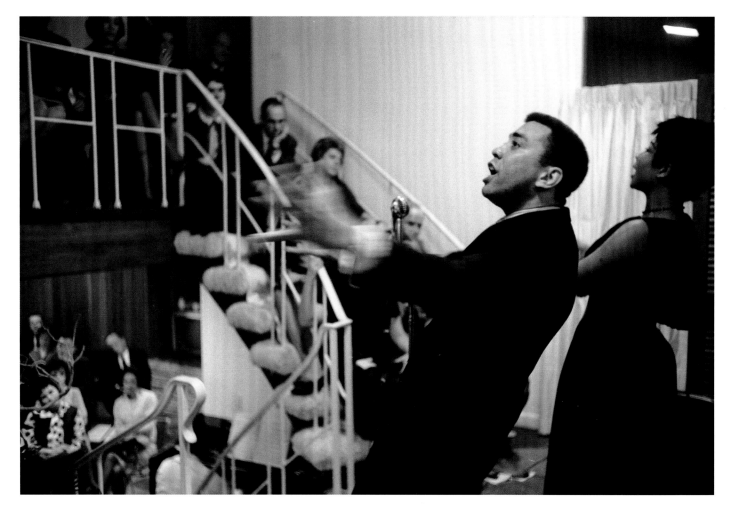

movement supporters.[7] Art Shay captured them in action at one such gathering in Chicagoland. At another late 1960 preview performance hosted by Nemiroff, who signed on to produce, and Hansberry, who later became the musical's director, Brown won over a new admirer: Dr. Martin Luther King Jr. "Rarely has there come upon the American scene a work which so perceptively mirrors the conflict of the soul, the moral choices that confront our people, both Negro and white, in these fateful times," King wrote to the entertainer Sammy Davis Jr. King was moved by its social justice themes but also noted it was "so light of touch, entertaining—and thereby all the more persuasive" because "art can move and alter people in subtle ways because, like love, it speaks through the heart." He expressed confidence that "this young man's work will … affect the conscience of

vast numbers with the moral force and vigor of our young people."[8]

In the short term, King's prediction came true. On March 28, 1961, Dave Garroway, host of NBC's *Today Show*, relinquished his entire two-hour television program to Brown to publicize, perform, and raise money for his musical. Many in Chicago "got up earlier than usual yet arrived at work late," noted the *Chicago Defender*, because "thousands of Chicago friends showed their devotion by staying glued to their TV sets." Brown's appearance resulted in a national outpouring too. "Never has any artist," Garroway said, "received as many telephone calls, telegrams, mail and messages after a broadcast." With $400,000 raised and scores of articles, advertisements, and other advance praise, Brown and *Kicks & Co.* seemed destined for success on Broadway.[9]

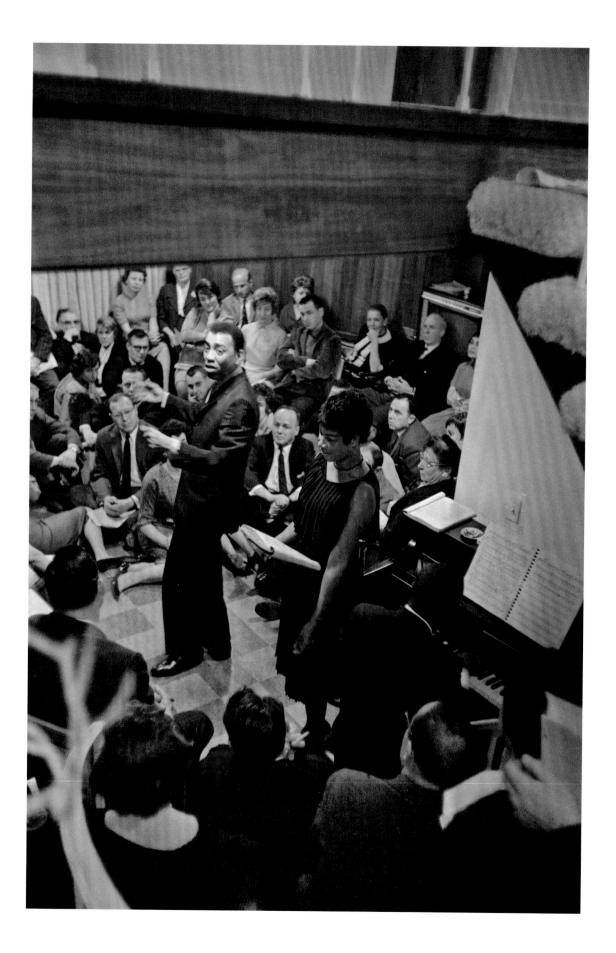

Before performing in New York, Brown returned to Chicago to rehearse and debut *Kicks & Co.*, but the great advance fanfare did not lead to a smash hit. Opening as a benefit for the Urban League at the brand-new 5,000-seat Arie Crown Theater at McCormick Place, *Kicks* won applause from its first sympathetic audience, but mainstream (white) theater critics called it "deadly dull" and likened it to a "hideously costly junior college workshop."[10] African American journalists retorted that some of this venom stemmed from its controversial themes. One *Chicago Defender* critic posited that the "thumbs down" from critics came partially from "Oscar Brown, Jr.'s attack on segregation [that] is all too true." Another critic even suggested malfeasance, its Chicago debut "deliberately butchered because some people are not ready to open their eyes."[11] Although Black and white critics reviewed the show differently, they tended to agree that it had problems. Producers had demanded too many revisions and miscast as Kicks the established actor Burgess Meredith instead of Brown Jr. himself (who played the role to much acclaim in preview performances). The cavernous McCormick Place's Arie Crown Theater had acoustic and lighting problems.[12] The musical shut down in Chicago after only four performances; a revival in New York also stalled.

The high expectations then cancellation of *Kicks* paralleled the great anticipation and then devolution of the northern freedom movement in the early 1960s. Chicago activists, like Brown's characters, struggled to enact their principles amid preexisting obstacles and mounting resistance. The Chicago Urban League earned money from the benefit, but it also seemed unable to do much about the city's growing inequalities. The Independent Voters of Illinois sponsored a cocktail party in advance of the opening performances, yet Richard J. Daley's Democratic machine was in firm control of the city's politics, and when faced with viable challengers, it offered its own "kicks" to co-opt them. And in the midst of the fight for an integrated housing project in Deerfield, Morris Milgram encouraged his liberal allies to attend its opening performances, especially given Brown's support for the American Freedom of Residence Fund. But this campaign for limited interracial housing was also blocked.[13]

To many in Chicago and its suburbs, civil rights and the problems it addressed appeared as a southern phenomenon. But the musical also depicted inequality and corruption in Chicago, reflecting Brown's experiences in radical politics, civil rights, labor organizing, and antiwar activism. Thus, *Kicks* may have looked south, but it also portended a northern crisis. The "Call of the City" (the name of one of the final musical numbers in *Kicks & Co.*) would go unanswered in Chicago until new kinds of troublemakers, including a reinvented Oscar Brown Jr., developed their own indigenous freedom movement. This call and its answer thus take the narrative beyond a more typical story of civil rights' success and failure. Instead, it reveals the creative and unexpected ways that Chicagoans declared their own ideas of freedom, changing the terms of the debate and forcing reaction that altered the politics and culture of the city by the mid-1960s.

The first such group emerged in the South Side's Woodlawn neighborhood. Woodlawn's population had shifted from 85 percent white to 85 percent Black in the 1950s. Neighborhood pastors offered a grim assessment of this racial transition's effects. Although it was "situated just South of the city's famed University of Chicago," Woodlawn's "eighty thousand predominantly working-class inhabitants" seemed unable to "prevent a slide into slum." The pastors admitted having "worn out the seats of several good pairs of trousers" in community meetings over the past decade that "have been largely a failure."[14] Not knowing where else to turn, they approached white community organizer Saul Alinsky, who had helped organize the Back of the Yards Neighborhood Council alongside the CIO drive for the packinghouse union in the 1930s. Alinsky had never attempted to organize an African American neighborhood before, but his Industrial Areas Foundation (IAF) had worked with Woodlawn's Puerto Rican population in 1954, only to divert its attention when many of these residents moved away. In 1958 the IAF noted that only 7 percent of the remaining population was Puerto Rican. Alinsky called on his Catholic Church allies to fund a larger neighborhood-wide project, noting it was "rapidly becoming one of the worst slum districts."[15]

Meanwhile, the IAF kept tabs on Woodlawn as accounts of crime, police brutality, and terrible housing conditions piled up at the office of the maverick Fifth Ward Alderman Leon Despres, whose appeals to Mayor Daley and the city council fell on deaf ears. The IAF's Nicholas von Hoffman studied the possibilities of an organizing project there, noting how West Woodlawn remained somewhat stable, anchored by middle-class African Americans who owned their homes and formed block clubs. East Woodlawn, by contrast, was disorganized and had few organizations to build upon.[16]

In 1960 the IAF nonetheless reentered Woodlawn by targeting its wealthy neighbor, the University of Chicago. Scholar and activist Jane Jacobs called the University's Hyde Park neighborhood an "example of how we are deliberately building unsafe cities." She challenged how the city and university "removes these chunks of blight and replaces them with housing projects designed, as usual, to minimize use of the streets" for "extraneous" people who lived nearby.[17] The IAF followed up by recruiting fifty neighborhood residents to a routine city zoning meeting where the university sought urban renewal funding to build on vacant property next to campus. Unaccustomed to such attention, zoning officials postponed the decision, giving these residents a sense that small victories might be possible. By the next year, a *Chicago Defender* headline promised to tell "How University of Chicago Was Stopped by a Fighting Community." The "how," organizers explained, stemmed from the basic yet radical demand that residents had "established the right of people to participate in the planning of their own community."[18]

The Temporary Woodlawn Organization (TWO) was a different kind of neighborhood group. In 1961 IAF hired its first Black organizer, Bob Squires, who worked with local residents to recruit volunteers and neighborhood associations. The "Temporary" piece of its name was key to its development. Alinsky and others advised and participated, but they believed that such community organizations had to develop organically. Alinsky thus sought to combat what he called "civic-sclerosis," a condition of passivity and obedience to larger structures of authority. This disease

came not from ignorance, he claimed, but from the magnitude of the problems that kept poor residents busy just trying to survive. Developing indigenous leadership was also crucial because the IAF's own understanding of African American culture was laced with stereotypes. While denouncing the "fad" of "race relations experts" and noting the structural forms of racial inequality, the IAF deemed the "matriarchal" nature of African American families a problem that caused a "distended and thwarted culture" that in turn stymied Black adjustment to city life.[19] But even if the IAF's white organizers bore preconceived notions about African Americans, their cultivation of local people as leaders neutralized these assumptions; also, their early work with TWO no doubt helped to undermine them.

Some of the most dramatic early TWO confrontations came in housing. Firetraps and other landlord violations had continued unaddressed over the past decade, and TWO decided upon more confrontational tactics. This fight paralleled TWO's sparring with the University of Chicago over urban redevelopment. As such, activists avoided demanding redevelopment of so-called "blighted" housing because they knew that such urban renewal, if not under neighborhood control, would lead to "Negro removal." Instead, they pressured landlords to make their buildings livable. Reverend Arthur Brazier of the Apostolic Church of God in Woodlawn described a typical situation of a "young mother of three small children living in a one-room apartment" whose "heat is turned off or the plumbing collapses or the plaster falls off the walls," but who "has no power to correct the situation."[20] To address these neighborhood-wide complaints, TWO organized tenants in several buildings. The tenants confronted local bankers to reveal the names of landlords who owned buildings in nameless trusts. Once they identified the owners, the tenants embarrassed them. As one "TWO: Greet a Slumlord" flyer explained, the organization invited residents to pressure a specific landlord to "inspect his hellhole." They picketed landlords' suburban homes and packed courtrooms when they appeared to face charges of building violations. And when all of these tactics did not bring compliance, TWO held rent

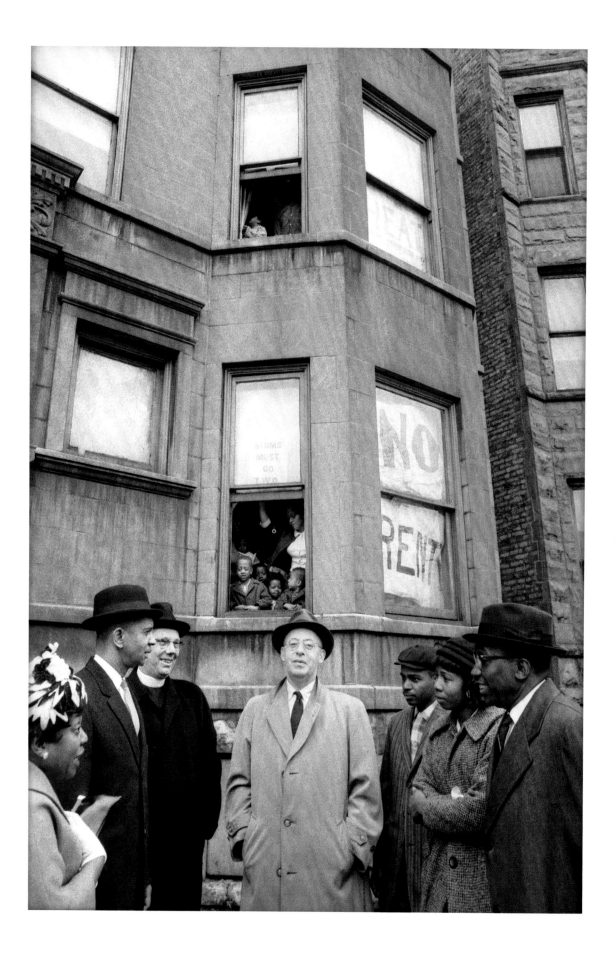

strikes.[21] Art Shay photographed this early group of organizers, including the IAF's Saul Alinsky and TWO's Reverend Brazier. But as important as this leadership was, it was the background scene in this photograph that the organization sought to foreground. Residents looked down favorably on the TWO organizers and "NO RENT" and "SLUMS MUST GO" signs appeared in their windows.

Despite the success of several rent strikes, TWO moved on to other campaigns and targets. Even as tenants won millions of dollars of improvements, TWO organizers realized that building-by-building organizing was not an efficient way to reverse the neighborhood's pervasive housing problems. Just a single square-mile section of Woodlawn housed 60,000 people, making it one of the most overcrowded sections in all of Chicago.[22] But this early

housing activism politicized neighborhood residents. As sociologist Charles Silberman explained, "What makes The Woodlawn Organization significant is not so much what it is doing for its members as what it is doing to them."[23] In June 1961 Reverend Brazier, who had emerged as a neighborhood leader, announced membership in TWO by over twenty neighborhood groups that kept its office buzzing with activity. That same month, TWO held a meeting at Snyril Church featuring veterans of the southern Freedom Rides who had courageously sought enforcement of desegregated interstate transportation. The organizers had expected a few dozen residents, but 700 showed up. This indicated both the new sense of pride TWO had helped galvanize and northerners' desire to harness the southern movement's en-

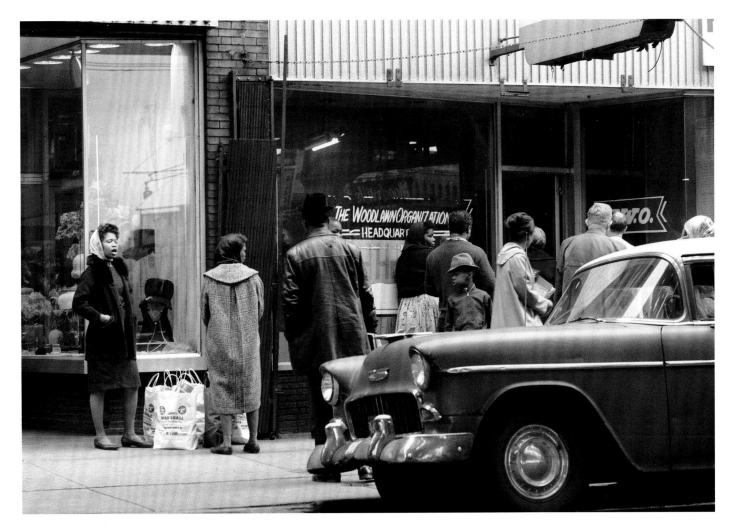

ergy and methods. Adopting the Freedom Riders' tactics, TWO staff rented buses to drive 2,000 residents to City Hall to stage a Vote-In Campaign. By the spring of 1962, TWO had officially formed (changing its name from the Temporary Woodlawn Organization to The Woodlawn Organization). Its convention featured 1,200 representatives from ninety-two community groups, revealing it as a force in Chicago politics—even Mayor Daley made an appearance. In just two short years, TWO had shown to many in Chicago that a neighborhood could trade powerlessness for self-determination.[24] TWO caused a worsening headache for Daley, but the city's power brokers comforted themselves that it was a form of troublemaking contained in a single neighborhood. Unless other movements emerged to coordinate citywide, TWO's threat was isolated.

One such citywide protest network did coalesce—the peace movement—though it emerged in fits and starts, and at first it seemed to be a world apart from Woodlawn's Black activists. The peace movement had waned in the 1950s due to the early Cold War politics of conformity. A handful of committed Quakers, most notably those in the American Friends Service Committee (AFSC), attempted to spread their beliefs in Chicago. At one 1958 demonstration against "Pacific Bomb Test Season," AFSC members organized a demonstration in the Chicago downtown business Loop and on the Northwest Side, expecting no more than a hundred people. Given their small numbers, AFSC members attended Fourth of July demonstrations and other patriotic citywide events, as in a scene photographed by Shay of the U.S. Navy holding a mock amphibious landing on Montrose

Beach on the North Side of Chicago. This event, they believed, "afforded an unusual opportunity for the public witness of our peace concerns." They passed out flyers reading "The Men May Live: An Alternative to Atomic Death." AFSC organizers contested the escalation of the nation's nuclear arsenal, which grew from 6,000 to 18,000 weapons in the late 1950s. Most prominently, they attracted a few hundred people in the spring of 1959 for a downtown Chicago rally marking a "Week for World Peace." But its other events that week showed that peace protestors were marginal in Chicago. Only a handful of people attended its Grant Park vigil, as one protestor's sign confirmed: "We Work for Peace, If More Would, We'd Have it."[25]

By the early 1960s, new peace activists began to contest the Cold War model of security in Chicago. Quaker students Kenneth and Ele Calkins and the AFSC's Peace Education director, Bradford Lyttle, created a student group at the University of Chicago that had a dozen chapters in the Midwest and about a hundred committed

members by the fall of 1959. Calling themselves the Student Peace Union (SPU), they urged every member to act for peace while staking out a "third camp" position separate from the U.S. and the Soviet bloc, which they deemed locked in a dual militaristic foreign policy agenda. The prominence of nonviolent direct action in the southern student sit-in movement—and the overlap between pacifists and civil rights activists—suggested that justice could be achieved with nonviolence, making these peace activists and their tactics appear less strange. In April 1961 they participated in a multi-day march led by adult pacifists in the AFSC and the National Committee for a Sane Nuclear Policy (SANE) that began at the Great Lakes Naval base and ended with 1,500 people marching into downtown Chicago.[26]

Student activists also gained sympathetic allies in their opposition to local civil defense efforts. One 1962 study among 1,600 college students on sixteen campuses showed that only 54 percent dismissed pacifism as "not a practical philosophy in the world today," and 17 percent believed that

war violated their moral principles. These and other measures made the longtime peace group Fellowship of Reconciliation optimistic. Even the *New York Times* noted that demands for "later dating hours or making a panty raid on the girls' dormitory" had given way to "sitting-in" for civil rights and "Ban the Bomb" demonstrations. "The 'silent generation,'" the article concluded, "has found a voice." That same year, the SPU had grown to 2,000 members, thanks to a merger with the East Coast College Peace Union and recruitment efforts. The national headquarters in Chicago served as a "halfway house" for students and transients, a precursor to the collectives that emerged later in the decade. The office was located just south of the University of Chicago in the Woodlawn neighborhood, although at first the students had no formal collaboration with African Americans in TWO. As such, local interracial alliances seemed lacking, even as the burgeoning civil rights movement of the South impacted the SPU and college students more generally. In addition to southern influence, SPU also thought internationally, adopting the "chicken scratch" logo of the British Campaign for Nuclear Disarmament that would become the most prominent symbol for peace in the years to come.[27]

Meanwhile, a second and seemingly isolated group of older women and mothers suddenly became immersed in peace activism. In 1961 Dagmar Wilson, a children's book illustrator and mother in the suburbs of Washington, DC, and three of her neighbors decided to act out against the growing climate of militarization. They organized Women Strike for Peace and subsequently gathered thousands of women on November 1 for a one-day peace march in the capital with simultaneous rallies of 50,000 women in fifty-eight cities. In Chicago, Mayor Daley received a caravan of women from "all sections of the city and suburbs." These activists declared themselves uniquely qualified as women and mothers to speak on the survival of humanity. They demanded a Test-Ban Treaty, disarmament, and a moratorium "on name-calling on both sides." One woman who answered this call to action was Chicagoan Shirley Lens. She was no ordinary housewife. Shirley, along with her husband, Sidney, had been involved in all kinds

of socialist democratic protest activity since the 1930s. She formed and led a local Chicago chapter of Women for Peace (WFP). This WFP chapter, as well as a northern suburban outpost formed in Winnetka, pursued peace under the motto "End the Arms Race, Not the Human Race."[28]

Chicago's WFP challenged the city's irrational approach to civilian defense. Shay's photographs documented these initiatives, from Daley showing off supplies in an underground facility, to missiles set up on the lakefront, to a single-family bomb shelter (which *Life* magazine noted had already sold out). WFP asked parents and school principals to stop air raid drills and food drives to stock fallout shelters. "We are blinding ourselves to the realities of the nuclear age by thinking there can be an adequate survival program against such attacks," WFP explained, noting a 1959 congressional study that concluded that just one megaton bomb would destroy eight miles of housing and cause thirty miles of fires, "in addition to its vast radioactivity." The group also argued that "the anxiety aroused in our children by constant exposure to such preparations ... block[s] normal avenues of learning."[29] In March 1962, WFP sharpened its message when members hosted a meeting at the University of Chicago featuring two survivors of the atomic bomb dropped on Hiroshima, Japan. These survivors humanized the 200,000 deaths. The audience learned that

"17 years after, radiation sickness lingers and takes a heavy toll on their lives." Shirley Lens next attended an international women's peace conference in Geneva, Switzerland, which inspired her to organize public meetings with Chicago medical experts who could describe the dangers of domestic nuclear testing. WFP also confronted the American Dairy Association, which "made no effort to refute charges about the strontium-iodine danger" in cows that could taint milk and other dairy products consumed by children.[30]

But it was the real threat of nuclear war from the revelation of Soviet missiles in nearby Cuba that fused the two strands of peace activists in late October 1962. At its headquarters in Chicago, SPU organized hundreds of volunteers from various cities to caravan to Washington, DC, for protests, held an all-night vigil in New York outside of the United Nations, and attended demonstrations in seven other cities. Shay's images of several hundred Chicago demonstrators showed the range of participants. WFP's suburban housewives and SPU's students picketed, leafleted, and marched

together downtown along State Street and Michigan Avenue. Their signs of "No Bases East or West" and "All Hands Off Cuba" made clear that both the Soviet Union and the United States were to blame. The protestors urged both sides to "Accept U Thant's Proposals," referring to the Burmese diplomat and secretary-general of the United Nations who sought a world peace treaty. Another sign read "The Pope Has Called for Peace," prefiguring Pope John XXIII's official *Pacem in Terris* (announced the following April), a peace message that spoke to Chicago's large Catholic population. This demonstration was best summed up by one WFP marcher's sign that simply stated: "Peace in the World or the World in Pieces."[31]

Chicago's coalescence of peace movement activists built notable power but fell short of its ultimate goals. President Kennedy had suffered through an embarrassing set of foreign policy blunders in 1961 that began with the botched Bay of Pigs invasion of Cuba by 1,500 anti-Castro exiles. Kennedy's subsequent summit in Vienna led Soviet leader Nikita Khrushchev to construct

the Berlin Wall and both sides to violate the nuclear test ban. But Kennedy's last-minute defusing of a nuclear war in October led to a strange relief among Americans and renewed faith in his leadership. As a result, candidates who ran in the November 1962 midterm election "Voters for Peace" party, including Sidney Lens and two others in the Chicago area, suffered crushing electoral defeats.[32] In addition, Chicago peace activists butted up against a political elite that defined support for U.S. foreign policy as a patriotic duty. Shortly before the downtown protest, SPU members at the University of Chicago managed to pass a student government resolution condemning the blockade, 16–9, but thereafter campus supporters of Kennedy's Cold War foreign policy presented a petition bearing the signatures of more than 1,000 students who accurately assessed the resolution as representing a mere fraction of the student body.[33]

WFP faced similar obstacles. One 1962 Chicago WFP report explained that "private citizens frequently taunt the peace marchers." As an example, one counterdemonstrator at the October march, as photographed by Shay, held the sign "Nikita Loves You: Better Dead than Red." Middle-class WFP members were shocked when donors attending a local Democratic Party fund-raising dinner dismissed their pamphlets and disparaged them. WFP concluded that Chicago politicians cared only about the arms race in "the awarding of government contracts." They noted that even liberal Illinois Democrats such as Senator Paul Douglas opposed their efforts, saying that peace activists could become a threat to national security.[34] Then in December, WFP faced pressure from Washington as the House Un-American Activities Committee (HUAC) subpoenaed nineteen of its members for hearings to investigate Communist influence. HUAC hoped to splinter the organization on the issue of whether to ban Communist participation, as they did in 1960 to another peace group, SANE.[35] But their plans backfired. Refusing to buckle, national leader Dagmar Wilson treated the prosecuting attorney "as if he were a rather tiring dinner partner," and explained, "We're all leaders." Pressured by further questions about WFP motives, she admitted, "I find it very difficult to explain to the masculine mind."[36] Overall, while the peace movement grew in size and influence, and some in their ranks celebrated the partial test ban treaty ratified by the U.S. Senate in September 1963, most lamented their ineffectiveness. "We came near being blown up," student activist Jack Newfield wrote in December 1962, and "our almost total impotence to avert the crisis had its effect on all of us."[37]

As peace activists began to comprehend the limits of northern Democratic liberalism, so, too, did civil rights activists. They targeted the racial disparities in Chicago's education system and were met with school general superintendent Benjamin Willis's complete denial that any problem existed. Willis's 1954 employment as head of the Chicago Public Schools (CPS) coincided with the U.S. Supreme Court's *Brown v. Board of Education* ruling that segregated schools were "inherently unequal." But Willis interpreted this ruling as correcting a southern problem. Throughout the 1950s, he denied that race was a factor in CPS and refused to collect any data on the racial composition of schools in Chicago. He willfully ignored figures that showed a net gain of approximately 500,000 African Americans with a loss of 400,000 whites in Chicago between 1940 and 1960 while the school-aged population increased by 180,000 children between 1953 and 1966. This new school-aged population was largely African Americans whom housing discrimination had forced into particular South and West Side neighborhoods. But Willis stuck his head in the sand and instead promoted himself as "Ben the Builder," constructing seventy-five new schools by 1960 that he evenly distributed across Chicago rather than concentrating on the places of school overcrowding.[38]

By the early 1960s, African American civic groups sought to expose CPS's denial of institutional racism. The NAACP sponsored "Willis Must Go" and "Project Transfer" campaigns in 1961. The board of education responded by voting to renew Willis's contract, raising his salary to $42,000 (making him the fourth highest-paid city official), and denying all 160 parent requests for transfers to less-crowded schools in white

areas. But mounting pressure also led some school board members to defect. For example, the board voted 8–2 for Willis to devise a plan to relieve the now crisis-level school-overcrowding problem and authorized $100,000 for an independent study of CPS. Willis reluctantly complied in late 1961 by releasing a long-awaited report on vacant classrooms, proposing a limited transfer plan, and requesting the purchase of 150 mobile classroom units. All of these policies sidestepped desegregation as a solution. The Chicago Urban League (CUL) found in its own study 1,117 overcrowded classrooms in African American schools, 13,330 unused seats in white schools, and at least a 20 percent disparity in funding between white and African American schools. In response, Willis called the CUL's findings "invalid, erroneous, and misleading." Further, he sought to control the forthcoming "independent" CPS study by naming himself as one of three experts to conduct it.[39]

Frustrated by this back-and-forth and double-talk, parents took matters into their own hands in early 1962. At the Burnside School on the Far South Side, seventeen mothers and two dozen students staged a sit-in in early January to protest the fact that their transfer applications funneled them into the all-Black and overcrowded Gillespie School rather than the nearby white Perry School. For two weeks, they effectively shut down the elementary school. The police eventually arrested the parents, and the school board ignored the situation, which helped ignite other forms of organizing and civil disobedience. In April the Coordinating Council of Community Organizations (CCCO) formed to try to bring together protest activities from upstart neighborhood groups—such as TWO, the Chatham-Avalon Community Council, and the Englewood Council for Community Action—with established civil rights organizations such as the NAACP and the CUL. The CCCO, according to one study of Black youth in CPS, "revitalized the school desegregation movement."[40] This coalition succeeded in pressuring the Chicago school board president to resign and lobbying at the state level to secure passage of the Armstrong Amendment, which restricted school boards from perpetuating de facto segregation through new

construction and redistricting. Further, they pejoratively deemed the mobile classroom units "Willis Wagons." By early 1963 two organizations known for their militant, grassroots southern activism joined the CCCO: the Chicago Area Friends of the Student Nonviolent Coordinating Committee (CAFSNCC) and the Congress of Racial Equality (CORE). Both ostensibly formed to raise funds and support the movement in the South but became more and more distracted by Jim Crow in Chicago.[41]

These northern and southern constituencies came together in July when NAACP delegates from across the country convened for their annual convention, "Free by Sixty-Three," in Chicago. Governor Otto Kerner and Mayor Richard Daley both claimed to support civil rights when they addressed its opening session at the Progressive Baptist Church in Chicago's South Side Bronzeville neighborhood. Art Shay photographed the scene, focusing especially on Mayor Daley as he recounted the city's great record on civil rights to the gathering of 1,500. Daley praised Congressman William Dawson, the well-known Black leader in his Democratic submachine, for achieving excellent voter turnouts, implicitly contrasting Chicago to the South as a land of Black disenfranchisement. He went on, in a statement that would become infamous, to declare that Chicago had no ghettos.[42]

Daley's speech drew polite applause, but a subsequent speaker challenged his account. "I don't agree with anything our great mayor just said," claimed Joliet dentist and state NAACP president L. H. Holman. "We know there are slums in Illinois and we know there are more segregated schools in Illinois than the state of Mississippi." Roy Wilkins, national head of the NAACP and keynote speaker, tried to walk a fine line between the two positions. Wilkins consciously framed his talk in terms of national civil rights and scorned southern Democrats and northern Republicans for their opposition to the civil rights bill in Congress. "It is fitting that Chicago, rough, tough, and disdainful of empty protocol and impatient with forms of rituals," he said, "should be the scene of our 1963 demand for the end to the ritual of racial

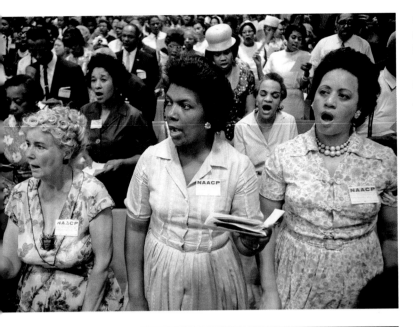

segregation, exploitation, and other sundry forms of discrimination between the citizens of the United States of America."[43]

While the audience at Progressive Baptist Church received mixed messages, the *Chicago Defender* made clear that a confrontation was brewing. The paper broadcast Daley's denial that discrimination existed in Chicago and Holman's courageous defiance of the mayor that "electrified the audience." But the *Defender* also predicted that the upcoming Freedom March, sponsored by the NAACP and co-led by Mayor Daley, would be more parade than protest. "Mayor Richard J. Daley," columnist Lillian Calhoun wrote, "is proving again why he's considered one of the most astute politicians," because "the NAACP may be planning a parade of 100,000 on July 4, but by golly, Hizzoner is going to lead it, which means it will hardly go anywhere he doesn't want to take it."[44]

At first, Calhoun's prediction seemed accurate. With Daley front and center, the Freedom March began as both celebratory and solemn, with NAACP leader Wilkins, its president Arthur Spingarn, Alabama civil rights activist Reverend Fred Shuttlesworth, and Alderman Claude Holman flanking the mayor as the procession moved down State Street before a crowd of 10,000. Shay captured the leaders but, as important, he documented the optimism and pride of NAACP members and others who marched with American flags that simply read "FREEDOM." Bringing seriousness to the celebratory atmosphere was the family of Mississippi NAACP leader Medgar Evers, who had been murdered only a month earlier in Jackson, Mississippi. His widow, Myrlie, and their three-year-old son Van Dyke rode just behind the front of the march in a convertible, while Charles Evers walked with his slain brother's two older children. Much of the event's symbolism focused on the southern movement, but a few signs scattered among the official procession targeted education ("Jim Crow Harms All Our Children: NAACP") and Ben Willis in Chicago in particular ("Mr. Willis Away with your Segregated Wagons" and "This is 1963 Mr. Willis"). But these signs blended into a larger festive theme of progress, depicted by a permanent sign posted on the Elevated train station: "*Chicago*: City of Tomorrow, *Today*."[45]

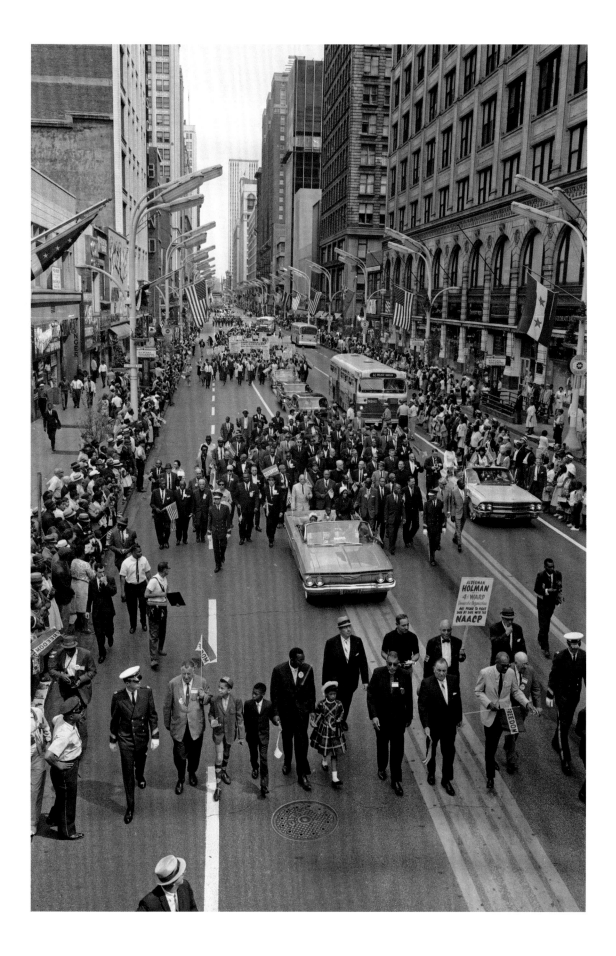

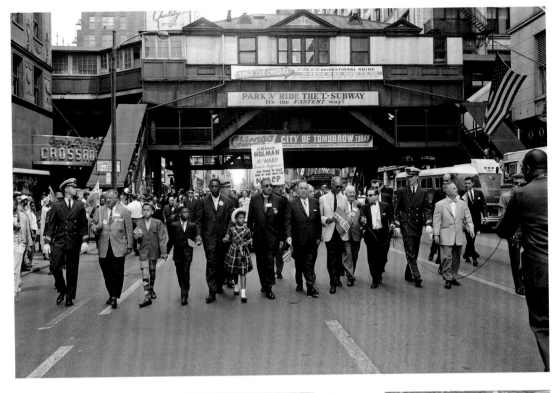

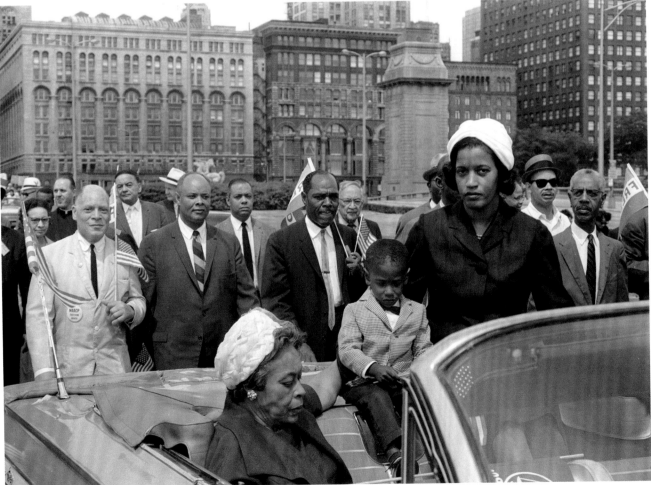

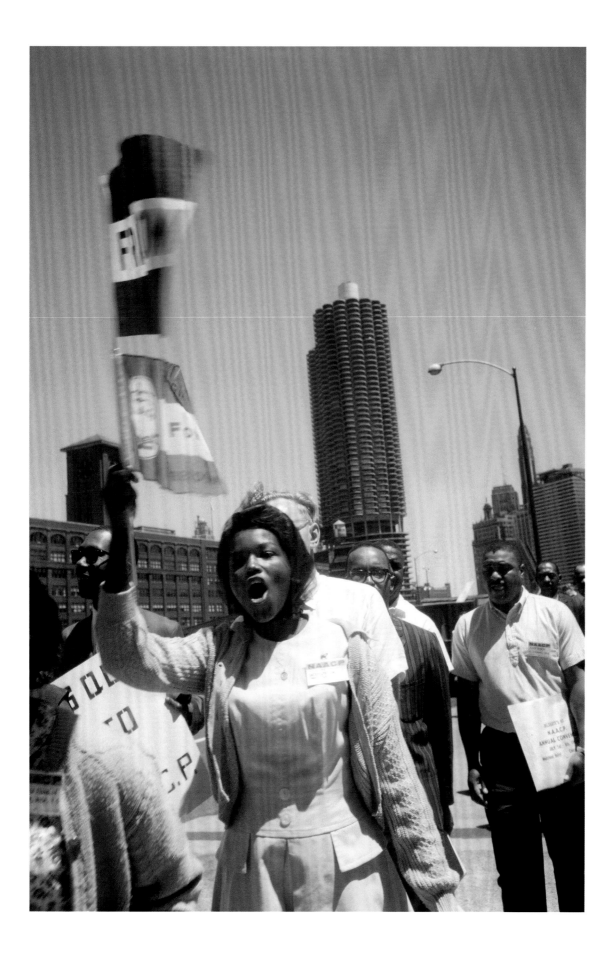

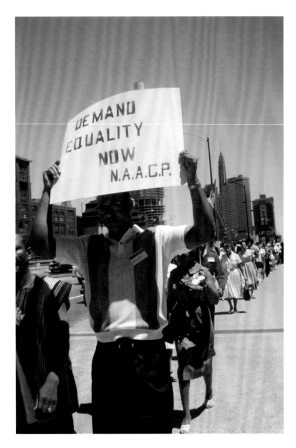 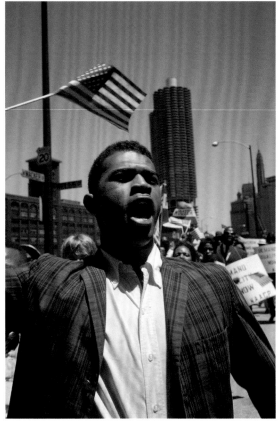

Once the marchers arrived in Grant Park for a rally at the Band Shell, however, another group was waiting to challenge "Hizzoner" and declare July 4, 1963, their own Independence Day. First, signs appeared in Grant Park by a few dozen demonstrators who openly upended the premise of the celebration. They emphasized racial discrimination in housing, jobs, and especially education in Chicago, signifying that their nascent homegrown movement would redress it. "N.A.A.C.P.: Ask Mayor Daley about Segregated Schools," one sign read, and another more specifically demanded, "Ask Mayor Daley about Washburn Trade School," the massive West Side apprenticeship school that symbolized white privilege in education and training in the lucrative and unionized building trades of Chicago. Perhaps most direct, a huge banner posed the question, "Mr. Mayor, How about a Freedom of Residence Ordinance?" while other signs simply asked, "Why Should Mayor Daley Lead A Freedom March?"[46]

Counterdemonstrators made these sentiments audible as Mayor Daley approached the podium to give brief welcoming remarks to the 30,000 people assembled there. A crowd of approximately one hundred white and Black hecklers made their way to the front, booing and chanting, "Daley Must Go!" and "Tokenism Must Go!" Daley never got beyond the second sentence of his prepared remarks, as NAACP officials could not quiet the interrupters. They offered to stop if one of them could give a speech at the microphone. This deal was rejected, and instead the NAACP struck up the choir to try, unsuccessfully, to drown them out. For eleven minutes, Daley stood there "flushed but occasionally attempting a smile" until finally saying into the microphone, "We recognize the contingent from the Republican Party in front of us." He then exited the rostrum and sped away from the park in his limousine. "Youths cheered his departure lustily and then dispersed," but then returned when Joseph Jackson, the African American

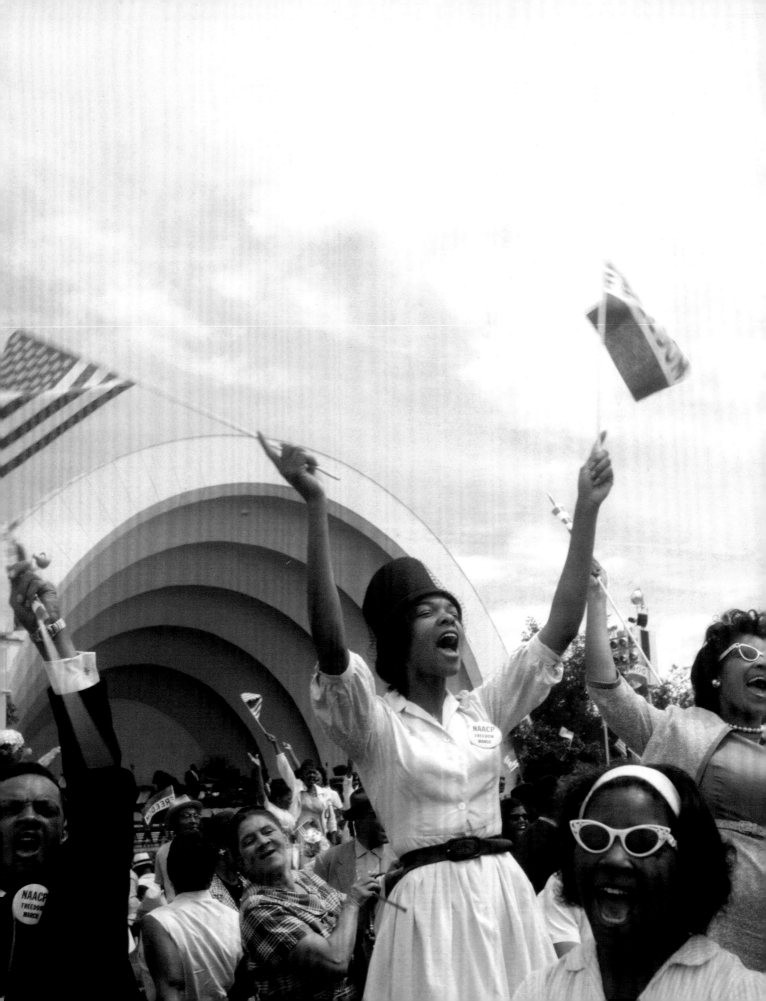

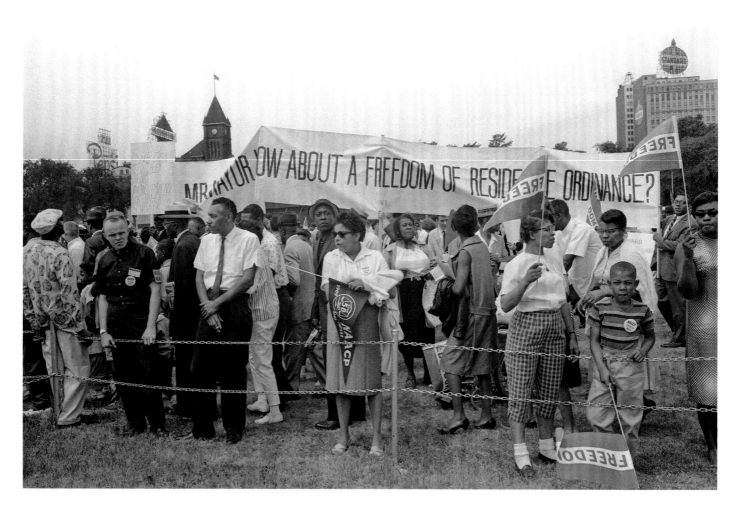

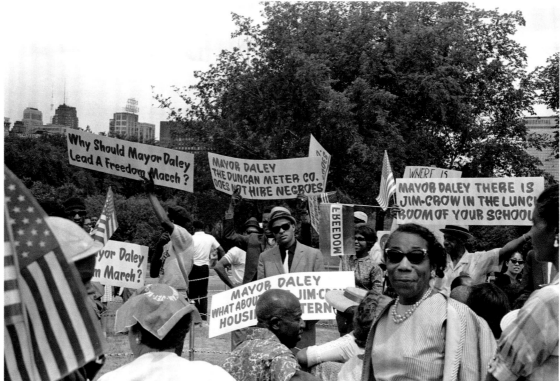

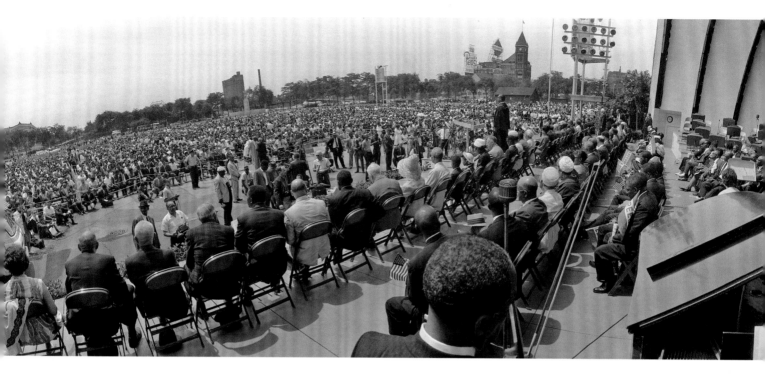

president of the National Baptist Convention, took the stage. This time police blocked the trouble-makers' path to the front, but the motley group still got their message across as they booed and denounced him as an "Uncle Tom." Since 1941 Jackson had been the minister at one of the most established South Side churches, Olivet Baptist, and had recently called for a moratorium on civil rights demonstrations. The hecklers shouted down Jackson in support of the many NAACP signs that stated, "Status Quo Has Got to Go." They made clear that they now saw the liberal alliance of the Democratic Mayor Daley and Republican Jackson as an impediment to freedom.[47]

Reactions to this melee included condemnation by the press, denials by civil rights groups, and some outright approval. The white press probably would have noted this Freedom March in passing if not for the disruption that made it front-page news in Chicago and nationwide. The *Chicago Tribune* noted Daley's political motivation in "improving the living conditions of Chicago Negroes," but then denounced the demonstrators by decrying their use of "the street" as a "concerted mob action uninhibited by law or reason." Chicago's *Sun-Times* also attacked the hecklers, calling

them "immature," suggesting their "un-American demonstration" set back the cause of civil rights, and noting their behavior was "embarrassing to Chicago." Wilkins denied that any NAACP members were among "the people who interrupted our meeting." But the national board, after a ninety-minute heated closed-door meeting the next day, refused to apologize, which reversed the previous conciliatory attitude and apology of Chicago NAACP leader Reverend W. N. Daniel. Others such as Edwin "Bill" Berry of the CUL backed the NAACP decision, saying to the press, "I cannot say I regret the action." And when asked if the demonstrators embarrassed the Evers family, Charles Evers quipped, "I would have been embarrassed if they hadn't demonstrated." The press circulated rumors that militants in new civil groups such as SNCC and CORE must have organized it, or perhaps Black Muslims. Charles Fisher of CAFSNCC declared it "an ad-hoc deal"; perhaps a few members of SNCC and CORE joined in, but they did not plan it.[48]

Only one group, the National Afro-American Organization, led by Roosevelt University student leader John Bracey, took credit for the disruption. Fifteen of its members next picketed the Antioch

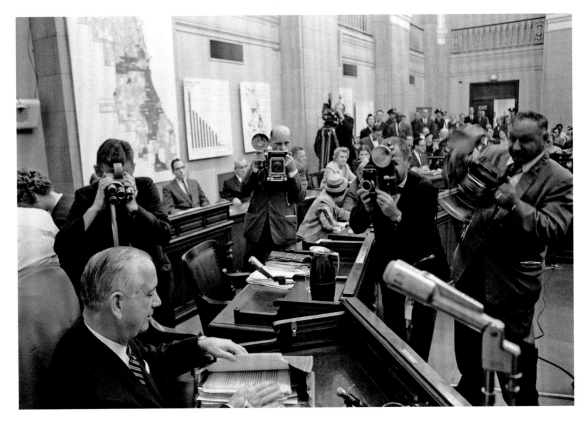

Missionary Baptist Church to protest the apologetic reaction of its reverend, Wilbur Daniel, to the Daley fracas. According to Bracey, who grew up on the city's West Side, the group demanded "No More Tokens or Toms." Reflecting the new tone of militancy in Chicago, he said, "We must organize people where they are ... on a local level" and no longer pursue "middle class goals by middle class methods."[49] Two weeks later, an article in *Jet* detailed the adult collaboration in the July 4th interruption. Timuel Black, a Negro American Labor Council leader and local schoolteacher, admitted that he and Baton Rouge NAACP leader Albert Jelks took part in planning the disruption.[50] This range of opinion exposed the tension brewing on all sides. But one thing was now clear to all: Chicago had its own Freedom Movement.

After this declaration of independence from Democratic machine–style liberalism, the Chicago movement intensified its organizing, especially in the realm of education. The local chapter of CORE initiated a series of pickets to prevent the installation of more Willis Wagons and organized sit-ins at the Chicago Board of Education. They demanded that Willis resign and that a new integration and transfer plan be implemented. Meanwhile, the CCCO expanded to more than one dozen groups, with an especially catalytic and collaborative group of activists in CORE, CAFSNCC, the Negro American Labor Council, and Teachers for Integrated Schools. In late August a legal challenge to the integration plan settled the transfer issue in the activists' favor, and white Chicagoans protested. At Bogan High School, for example, more than 2,500 parents met with the local alderman to dispute the idea that the top 5 percent of students in CPS schools that lacked honors programs could transfer into schools that had them. Willis responded to these whites' complaints by reducing the transfer schools from twenty-four to a mere nine. CORE responded with another sit-in. Police arrested thirty-seven people, including dragging more than one dozen from the second-floor offices down the back stairwell and out a side door into a police wagon. Facing this immediate pressure and an Illinois appellate court order to

implement the plan, the school board overruled the superintendent. Rather than comply, Willis resigned and left town to go fishing on a 42-foot yacht. This series of events led Chicago's education activists to believe that victory was in sight and Willis would be finally cast out to sea.[51]

Only three days later, the school board reversed its position and voted 6–2 to reject Willis's resignation. "Chicago had a new joke last week," a journalist from *Newsweek* reported. "It concerned the school-board doll. 'You wind it up, say boo, and it reverses itself.'" Willis said "boo," the article explained, and now board members were "beseeching the jowly sixty-one-year-old superintendent to remain at his $48,500-a-year post—the best paying job in American education." Chicago's civil rights activists were outraged. Sylvia Fisher of CAFSNCC fired off a press release that they were "shocked" by the school board's decision, declaring that it "can only be interpreted as approval of his segregationist policies." Activists also invoked the telegram sent by twenty-three prominent Loop businessmen urging that Willis be immediately reinstated. This was hypocritical, they said, because the businessmen's children did not attend CPS. "I think our basic need for education right now," Bill Berry of the Urban League said, "is for the thick-skulled whites who live in the suburbs and run everything in the city to become aware of the problem." Nonetheless, Willis returned as a hero to the white Chicagoans who cheered his staged return. "Smiling like a Cheshire cat," Willis accepted the plea from the CPS board to remain in charge.[52]

On the day the school board rejected Willis's resignation, CCCO activists met in Bill Berry's apartment to plan a school boycott. Showing their strength beyond a few dozen committed protestors, the CCCO's constituent organizations got to work educating people about the boycott, passing out "Willis Must Go!" and "Freedom Day" flyers, and urging parents to keep their children home from CPS classrooms on October 22, 1963. Lawrence Landry—who, according to the *Defender*, "personifies the New Breed of Negro leadership"— led the campaign alongside fellow CAFSNCC leader Roberta Galler and a number of other organization leaders. They privately expected 75,000 students to join the effort, but their organizing

instead produced a remarkable result: 224,770 out of 536,000 students (47 percent) stayed home from school. While most students simply enjoyed the unusually warm fall day away from their classes, others attended freedom schools, and between 8,000 and 10,000 people participated in a massive rally downtown.[53]

Shay photographed the energetic urban scene. Activists marched in the afternoon sunlight from City Hall to the Board of Education Building, which "jammed" rush-hour traffic downtown. Sound trucks played recordings of a song to the tune of Woody Guthrie's famous "This Land Is Your Land" with lyrics "These schools are your schools / These schools are my schools" and "The Board is a one-man rule board / He [Willis] makes like a fool

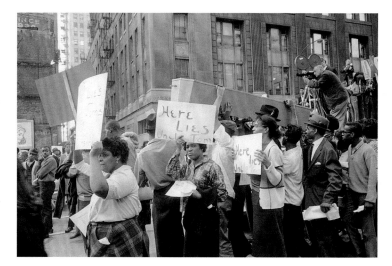

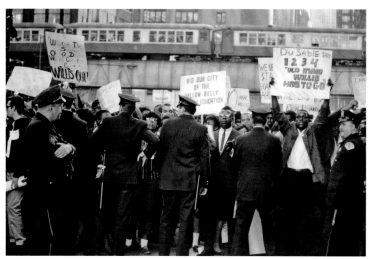

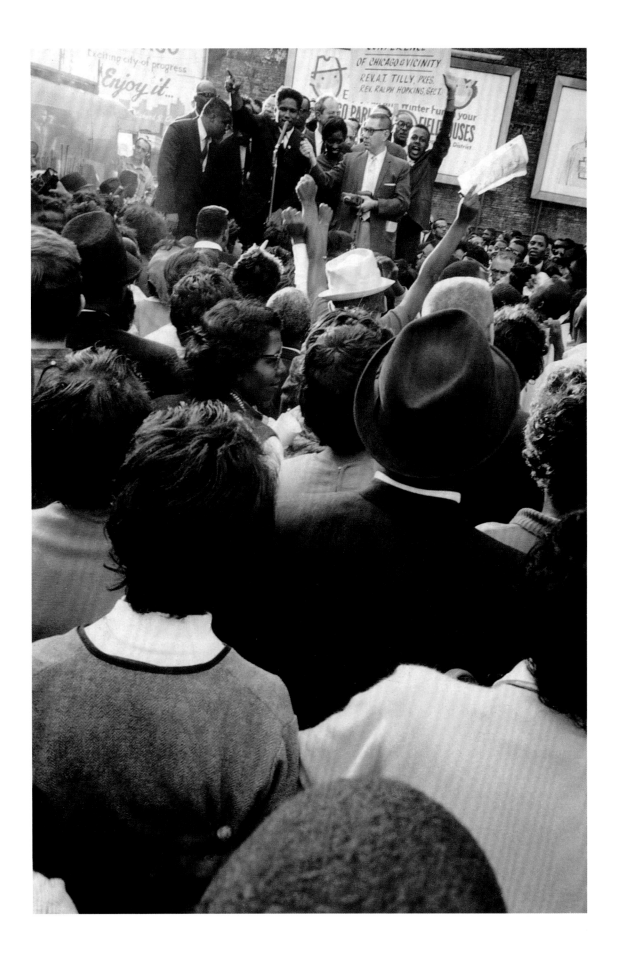

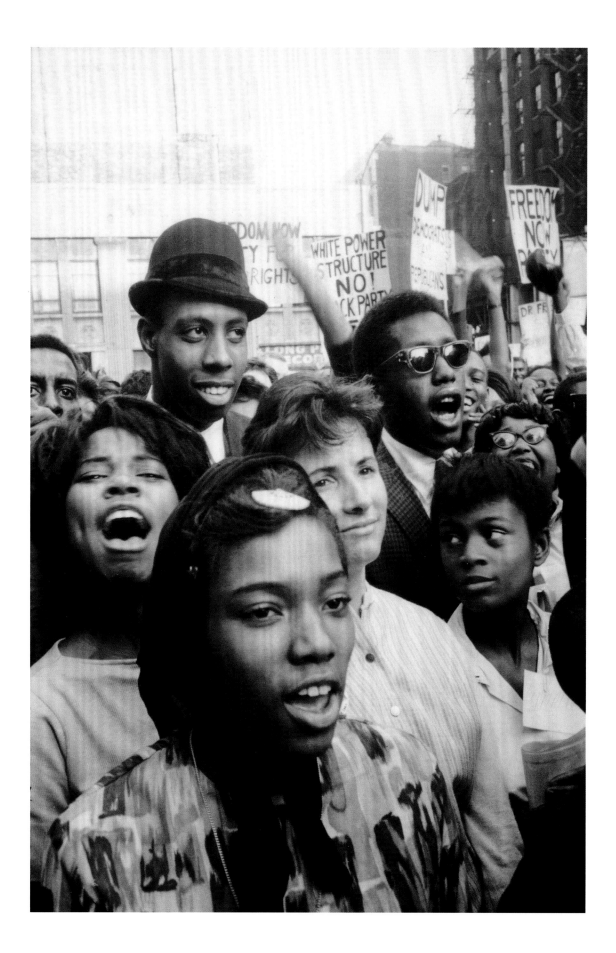

board," as marchers sang along. The demonstration remained orderly and celebratory, with even the usually critical *Tribune* reporting on the marchers' discipline, noting, "Police had little to do except keep traffic moving." Thousands congregated at Lake and LaSalle Streets, where they heard speeches from a group atop a parade float. Speakers included Lawrence Landry, Chicago-based comedian and activist Dick Gregory, the national SNCC executive secretary and former Roosevelt University student James Forman, and Reverend Carl Fuqua of the NAACP. Fuqua's speech revealed that the CCCO coalition had fostered militancy even in the NAACP. He highlighted the comparison to the southern Black Freedom struggle. "The Time for victory is here in Chicago, as well as in Birmingham," Fuqua said. Then he drew a parallel between Superintendent Willis to Governor Wallace of Alabama as segregationist anti-democratic leaders. Protestors' signs demanded better public education in the city, ranging from the curriculum ("HISTORY IS NOT ALL WHITE") to Willis's leadership and specific board of education members. They called for an independent "Freedom Now" political party and staged a mock funeral procession surrounding a coffin and bearing signs reading "Here Lies Uncle Tom." This boycott also "hit the board's pocketbook." CPS lost an estimated $470,000 in state funds that were tied to attendance. Overall, the event turned out to be one of the largest one-day boycotts in American history.[54]

More creative activism followed, but it did not produce concomitant reforms. CCCO activists launched a holiday boycott of downtown stores in December and organized a second school walkout. In the February 1964 boycott, 172,350 students stayed home. But sympathetic school board member Clair Roddewig resigned. Further, the NAACP and Urban League did not support the second boycott, revealing a fissure in the CCCO between moderate middle-class groups and increasingly militant ones. There were more disappointments for activists. Superintendent Willis remained in office, and the two major reports issued on CPS confirmed racial segregation and inequality but did not generate action. The findings of the first report, authored by sociologist Philip Hauser

and prompted by the settlement in the *Webb v. Board of Education* case, were released on March 31. It revealed that 84 percent of Black children attended segregated schools that featured overcrowding, poor facilities, and inexperienced teachers. Yet the report's recommendations called for only a modest open-enrollment plan. When pressed on this resolution, Hauser said that more deliberate integration would push whites out entirely, leaving CPS with "nothing left to integrate." Months later, when nothing at all had changed, even he spoke out against the lack of reform.

Similarly, the CPS-commissioned report, written principally by education professor Robert Havighurst, was modest in scope. The report warned against any policy that would make Chicago an undesirable place to live, implying that whites would flee in larger numbers to the suburbs if CPS attempted significant desegregation. The $185,000 report was presented at the November CPS board meeting and then never brought up again. By the end of 1964, the CPS board dropped integration from its agenda, and Willis once again focused on new school construction. While espousing integration publicly, Willis and the board proceeded to cut funding for library services, reading clinics, and other after-school programs, meanwhile concentrating on reversing white flight at all costs.[55]

In 1963 Chicago activists had boldly declared their own resistance campaigns. Over the next two years, their actions created a nascent mass movement in the urban North. But the experiences of these activists also revealed notable opposition and internal tensions. By early 1965, one *Chicago Daily News* article concluded that the "super group" CCCO "still meets occasionally, but for all effective purposes it has expired." This obituary was premature, but it did capture this moment of transition. Moderate groups such as the NAACP retreated, instead holding voting registration drives and other forms of negotiation. The Chicago Area Friends of SNCC worried that their local work distracted from their priority of supporting the southern Black Freedom Movement. Others searched for national allies, while still others

sought out broader local coalitions. Looking for new points of pressure, Lawrence Landry of CAFSNCC wrote a letter to Martin Luther King Jr. imploring him to come to the city. "Here in Chicago," he wrote, "we feel the time has come to bring some National pressure to bear on a problem that is really National in scope."[56] King eventually responded to this call, seeing the city's activist energy as having potential to bring the nation's attention to racial inequality in the urban North.

Meanwhile, grassroots activists debated how to bring national leverage to bear on Mayor Daley's machine control over Chicago's schools, employment, and other institutions. They looked to Lyndon Johnson's Great Society programs, which seemed to promise more than abstract forms of freedom of opportunity. They also began connecting domestic and international issues, bridging the class, racial, and even generational divides that previously had assigned civil rights, peace, and economic demands to separate Cold War–era categories. Their experiences prompted some to deepen and widen their commitments to community organizing and activism; others changed course; and still others drifted off into self-fulfilling "Kicks." As a result, by 1965 Oscar Brown's "Call of the City" had been heard but not yet redressed as protestors regrouped for a second phase of activity.

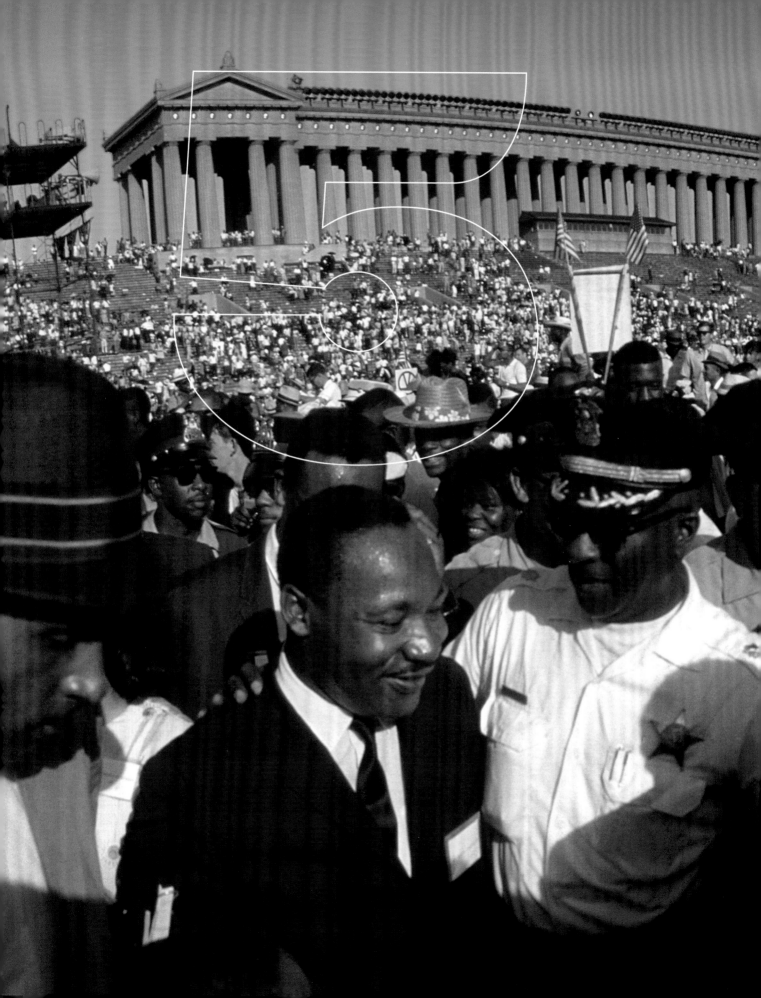

HUMAN RIGHTS AND FREEDOM MARCHES

In 1966 Junior Wells and his band performed the song "Vietcong Blues" to audiences in Chicago, around the United States, and, most controversially, on a six-week European tour that included a stop in East Berlin.[1] Backed by Buddy Guy on guitar, Wells's lyrics describe receiving a letter from a younger brother away at war. "Don't you know the boy's laying down in Vietnam," he sang. "Lord they say, you don't have no reason to fight, baby, but / Lord knows you think you're right / but you got to be wrong, don't you hear me, you got to be wrong." In the next verse, he compared his brother's plight to his own poverty at home, complaining about "nothing to eat" and "can't buy yourself no clothes, baby," then later exclaiming, "I'm about to go out of my God-darned mind." Wells dedicated the song to "all the mothers, all the wives, / All the fathers, that have sons, in Vietnam," and asked the rest of the audience, "How would you feel if it was your brother over there?"[2]

"Vietcong Blues" expressed the new culture of resistance emanating from mid-1960s Chicago. While "jazz ambassadors" had earlier criticized American Cold War foreign policy abroad, and folk and rock musicians would later pen more explicit antiwar songs, Wells and his band occupied a unique cultural position as creators and performers of Chicago-style blues.[3] This music proved so popular that by the mid-1960s Wells's band was no longer confined to playing small clubs in Black neighborhoods; "Vietcong Blues" reached a wider national and even international audience in concerts and on LP records. "Vietcong Blues" even caught the FBI's attention. Once Wells returned to the United States after the 1966 tour, an agent confronted him at the airport, reading him a letter that forbade him from playing the song without the State Department's consent. This seemingly innocent blues man had become a subversive cultural figure, his music highlighting hometown activists who increasingly criticized racial discrimination, poverty, and war.[4]

This new resistance sprung up in several places in Chicago, including struggles to control federal funding for the largest anti-poverty program of any city in the nation. President Lyndon Johnson's 1964 State of the Union address declared an "unconditional war on poverty," and Congress soon passed the Economic Opportunity Act of 1964, which authorized funding for a new Office of Economic Opportunity (OEO). Policy makers' rhetoric—especially Section 202 (a)(3) of Title II of the bill, which called for "maximum feasible participation" of the poor—revitalized local working-class activists. These Chicagoans sought to use federal resources to challenge the inequalities produced by the city's Democratic machine. Activists hoped "maximum feasible participation" would mean placing poor and working-class people, not middle-class social workers and politicians, in leadership roles. The Chicago activist Jane Addams had earlier anticipated this problem when she opined, "May I warn you against doing good to people, and trying to make others good by law? One does good, if at all, *with* people, not *to* people." Social workers and government programs rarely followed Addams's dictum in the Progressive and New Deal eras, but new circumstances in the mid-1960s offered a chance to empower rather than pity the poor. Chicago community organizer Saul Alinsky saw this potential but expressed reservations about control in a government-sponsored "war." Declaring Johnson's War on Poverty "political pornography," Alinsky predicted it would become a "huge political pork barrel" that would "suffocate militant independent leadership." Certainly, Sargent Shriver, chosen to lead the federal anti-poverty crusade, had no intention of undercutting big-city mayors like Richard Daley. In fact, Shriver had dreams of becoming governor of Illinois and

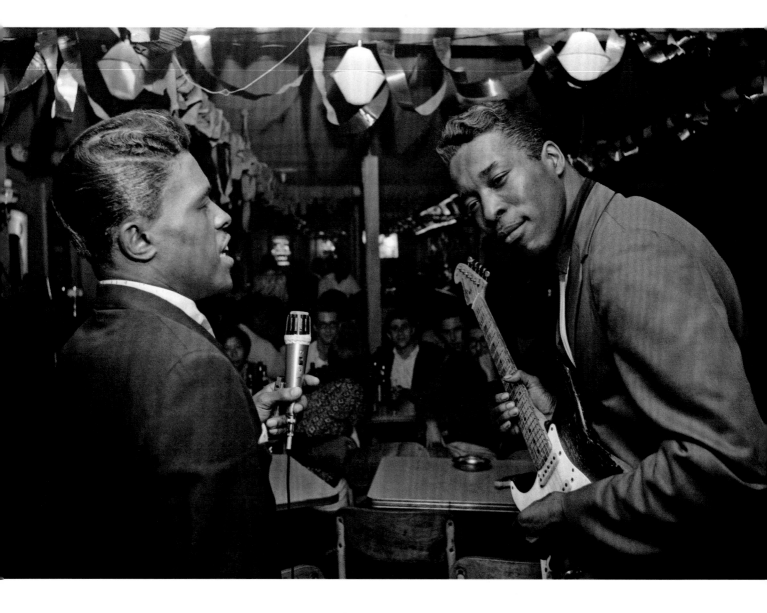

would need Daley's support down the road. But that would not stop others from wielding the War on Poverty as a weapon for that very purpose. By the mid-1960s, civil rights groups developed community action programs to wrest away the welfare apparatus and erode the "you can't fight city hall" mentality that had long buttressed the Daley machine's control of the city.[5]

As Alinsky predicted, Chicago's war over the War on Poverty began as a "pork barrel," but that soon became contested. At first Daley skillfully used community action programs and other federal resources to expand his own patronage fiefdom. He established the Chicago Committee on Urban Opportunity (CCUO) with a steering committee of two dozen and a blue-ribbon board of fifty-four more. Then he appointed Deton Brooks, an African American sociologist and former Cook County official, to head the CCUO and set up Urban Progress Centers, which would ostensibly place ordinary Chicagoans in OEO programs. But these centers, according to one journalist, were among the many "facades behind which agencies conduct welfare business as usual," improving little more than employees' patronage salaries. Many women in these neighborhoods found that at the Urban Progress Centers they were "putting themselves right back into the hands of the welfare workers, whose grip on their lives they were feebly trying to break." And Chicago received more than $5 million for Youth Corps employment training, but unlike any other city, made fingerprinting and checking police records a prerequisite, thereby eliminating many young people from eligibility. The Woodlawn Organization (TWO) had other ideas and sought to expose these facades all the way to Washington. Reverend Lynward Stevenson, a Kentucky-born and Morehouse-educated pastor at Bethlehem Covenant Baptist Church in Chicago, had become TWO's president the previous year. Declaring that the War on Poverty was a way to "back up our program of self-determination with deeds," he submitted two grant proposals to Brooks's office to supplement a Department of Labor grant that provided job training. After nine months of silence, and thanks to series of articles written by Lois Wille in the *Chicago Daily News*, he began to

broadcast his criticisms of Chicago's undemocratic implementation of the War on Poverty.[6]

These headlines caught the attention of the African American congressman Adam Clayton Powell Jr., who called on both Chicagoans to testify before an ad hoc committee of the House Committee on Education and Labor. Powell, in his own battle with the mayor of New York over War on Poverty funds, hoped to spotlight Chicago as an example of how in "many areas ... the people who have kept the poor impoverished are now running the war on poverty." Stevenson did not disappoint. He combed the list of committee members for the CCUO and explained that "not one of these persons live in the poverty belt for whom the program is designed." Thirty-one were "tied to city hall as salaried or members of a commission," and local people were told someone from the political machine must "recommend you" for any position. He blamed Deton Brooks, whom he said addressed them with "meaningless sociological drivel designed not to lift people up but keep them dependent." Stevenson concluded by outlining two paths for the future of the War on Poverty. Chicago could stay the course where "there is no war on poverty, there is only more of the ancient, galling war against the poor ... when the great ideas of two Presidents and Congress are twisted into cheap political slogans to benefit local politicians." Or this "nightmare" of "northern-style emasculation" could be thwarted if the federal government would allow for real participation of poor people. "We will train ourselves," he concluded, and promised, "We will lift ourselves into the mainstream of America."[7]

In his rebuttal the next day, Brooks declared Stevenson's statement "one of the most scurrilous personal attacks I have ever experienced." He next confirmed his loyalty to Daley's machine. "For myself, I can take it, but when one of the greatest mayors of the United States ... is maligned in an irresponsible way ... then I am appalled." Brooks thereafter defended the program, but in further questioning he could not name a single person on the CCUO board who represented the poor or other specific evidence to refute Stevenson's charges. And at the end of his testimony, Roman Pucinski, the Chicago congressman and Daley loyalist, jumped in to defend and laud Brooks, which

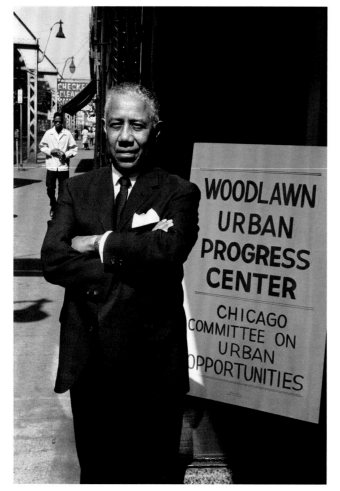

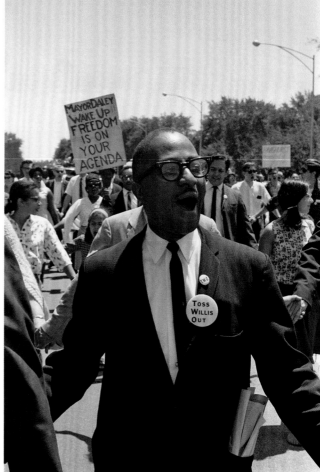

probably only further convinced many in the gallery that the Chicago machine controlled the War on Poverty.[8]

During that summer, local activists tried to expose these tensions within the Democratic Party and the Great Society programs. On assignment for *Fortune* magazine, Art Shay captured the main protagonists on each side. He photographed Stevenson during a June march from Soldier Field to City Hall to address educational inequality. This context highlighted how working-class activists tended to see the War on Poverty as a new opportunity to organize the unorganized into a broad coalition for jobs and justice. Meanwhile, Shay photographed Brooks standing alone at one of the CCUO's offices—a leader without followers. Put together, the photos contrasted the community versus individualist approaches, and

the grassroots versus city hall, that each man represented. "The 'war,' which six months ago was bathed in a warm glow of Lyndon Johnson's 'great consensus,'" Charles Silberman's accompanying article explained, "is now engulfed in bitter controversy." But he also noted that this war had "broken complacency that has blinded most Americans to the fact that poverty remains." Most Americans agreed that the federal government should wage a war on poverty, but "the question is how." With the direction far from predetermined, the powerful and the powerless alike laid claim to these federal resources, debating in City Hall and across Chicago's neighborhoods.[9]

As Stevenson's "Oust Willis" button suggested, and his hand clasped with Coordinating Council of Community Organizations head Al Raby confirmed, Chicago activists thought the "how"

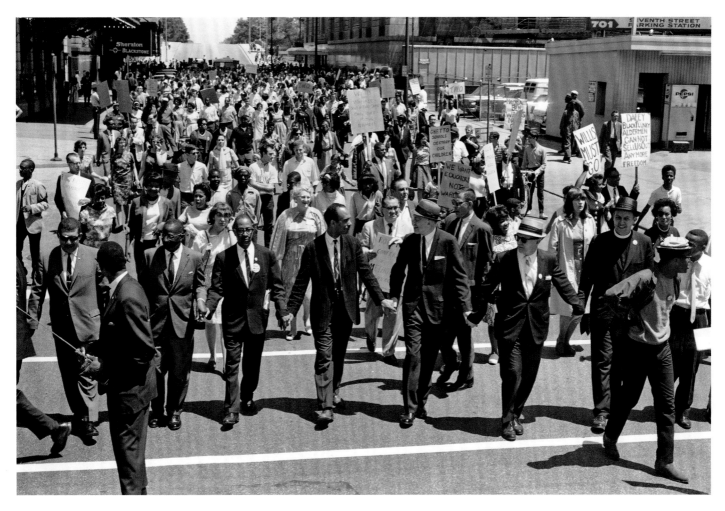

should be a multi-pronged movement. TWO and other CCCO groups fought for federal leverage through control over the War on Poverty, but they also ramped up their fight against inequality in the streets. When the second downtown march on June 11, 1965, ended with a mass sit-in, police clubbed many of the demonstrators and arrested over 250. In response, Dick Gregory announced daily demonstrations, telling the participants, "Don't come with no cute shoes, because we're going to march."[10] They made good on their vow for the rest of the summer. By late July, they had shifted their destination to "Chicago writ small": Bridgeport.

The bold choice of Daley's home neighborhood capitalized upon the mayor's own campaign narrative that his neighborhood was typical. These activists agreed—it represented the city's rampant racism. They defined Bridgeport as "the hotbed of antagonism to Negroes." Settled by Irish and other immigrants in the nineteenth century, Bridgeport had been an epicenter of machine politics since the 1930s. Several decades later, the neighborhood epitomized the machine's uneven patronage that rewarded the "melting pot" of ethnic residents based on their whiteness and political loyalty. The CHA's Bridgeport Homes, built in 1943, remained lily-white even as the African American population grew just east in Bronzeville and demand for public housing increased. The director of CHA rentals explained in 1964 that Black applicants "say they would rather be near their friends and neighbors." But another CHA official admitted that the agency kept segregated waiting lists for applicants, which violated Title VI of the 1964 Civil Rights Act.[11]

127

John Walsh, a white high school English teacher and leader in Teachers for Integrated Schools, decided to integrate Bridgeport himself. He bought a building at 3309 South Lowe and found two young Black men willing to move there in October 1964. Their move ignited so much white mob activity that police ordered round-the-clock protection near the property (including Mayor Daley's home two blocks away). The press focused as much attention on Walsh as the white mob violence, emphasizing Walsh's intent to "embarrass the mayor" and asking Walsh, "You're a troublemaker, aren't you?" In the meantime, residents, with the cooperation of police and local precinct captains, moved out the two tenants' belongings, and a local real estate agent quickly rented it to two white tenants. Walsh sued to evict these tenants, but the judge also ruled against him. With this level of coordinated white resistance in mind, Dick Gregory and others argued that Bridgeport should be the focus of activists' daily protests because the neighborhood's segregated housing connected to their ongoing citywide economic and education campaigns.[12]

The marches into Bridgeport peaked in August 1965. As Gregory led a motley group of demonstrators near Daley's home at 3536 South Lowe Avenue, Shay was one of the few photographers who documented them, both during the day and at night. He also captured the opponents who emerged from their homes to support the mayor and defend their territory. The marchers walked quietly, double-file on the sidewalk, as Bridgeport residents heckled them and threw stones, eggs, and tomatoes. Police arrested a few residents for disorderly conduct, but more often "officers joked with many of the onlookers." Residents held mass-produced signs in front of their homes that read: "We Love Our Mayor" and "Daley is for Democracy and Pickets are for Publicity." But other homemade signs emerged, stating "Klu [sic] Klux Klan Forever" and "Nig, You have Every Thing. What Else You Want?" These signs removed any doubt about white supremacist intent, with the latter sign suggesting that African Americans had unearned rights at whites' expense. The confrontation escalated on August 2 when local law enforcement "broke down." Police arrested sixty-

five civil rights demonstrators "for their own protection," sparing the antagonistic white mob. The next day, Gregory led a march from Buckingham Fountain downtown to the South Side "snake pit," where in pouring rain hundreds of local police officers managed to contain a mob of whites waiting for them in Bridgeport.[13]

With animosity escalating, politicians and police sought to curb further negative publicity. Daley criticized these marches, saying, "Surely a man in public office shouldn't be subjected to this sort of thing." He defended his "neighbors" as "fine people, working class, middle income." Police Superintendent Orlando Wilson called for a meeting with twenty religious leaders in an effort to halt the demonstrations. The representatives rebuffed Wilson, unanimously agreeing that the demonstrators' demands for justice superseded the police superintendent's call for "order." Fewer hecklers appeared the next week. Some applauded precinct captains for convincing residents to stay home and avoid further violence. Others credited Wilson for using restraint and even protecting the civil rights demonstrators, much to the displeasure of Daley, who, according to one alderman, would "sit there blowing his stack and shouting that Wilson was a dumb son-of-a-bitch," because the mayor wanted to see the activists punished. Still others credited the civil rights activists' nonviolent behavior and persistence in wearing down the opposition. On television that week, Raby used a mortal metaphor to explain the Bridgeport marches' significance. Chicagoans needed to diagnose their racism as the cancer it was, he claimed, and treat it before it was too late.[14]

The CCCO also attacked the disease of racism on the other side of the color line. On the afternoon of the fifty-fourth daily march, TWO's Reverend Stevenson rebuked the "silent six," the Black aldermen in the machine who were "Mayor Daley's house Negroes." Stevenson charged them with obstructing democracy in Chicago's Black neighborhoods. Warring over the War on Poverty, TWO demanded the right to choose the representatives for Woodlawn's Urban Progress Center. Daley conceded but cleverly increased the board's size so that neighborhood representatives were in the minority. Undeterred, 200 TWO

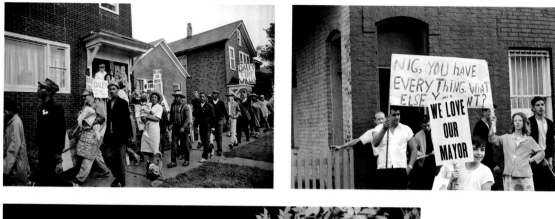

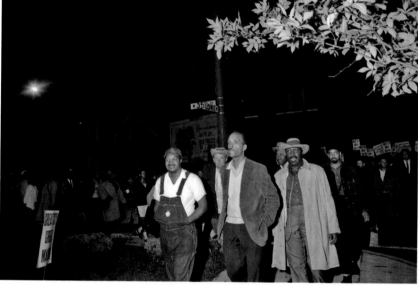

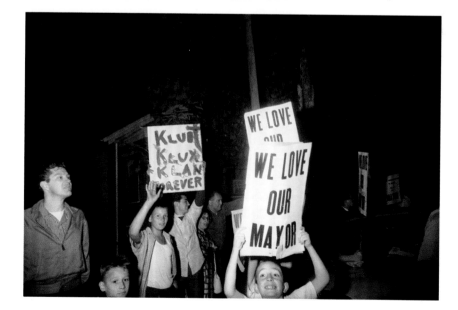

members crashed a War on Poverty conference at the Sherman House hotel, staging a sit-in in the lobby as Sargent Shriver spoke to the 1,700 delegates there. They succeeded in embarrassing Daley, who supposedly remarked, "They're kicking the hell out of us." In December 1965, TWO managed to pass some of its proposals at an Urban Progress Center meeting, but James Clardy, a Woodlawn precinct captain and advisory board member, reversed the decision. The Democratic machine next sponsored a neighborhood signature campaign in support of its own proposals to suggest that TWO did not represent the neighborhood. TWO countered by dismissing the Urban Progress Center as a fraud. By early 1966, in his "State of the Community Speech," Stevenson explained that "we are in the center of American history right now," and "TWO must set an example for America and Chicago that democracy CAN work and poor people can take part in the decisions of their city." TWO vowed to keep anti-poverty efforts at the center of their agenda. It continued to demand direct federal aid as well as rely on its own meager resources, with self-determination increasingly translated into conceptions of Black Power.[15]

Absent from the early debates about the War on Poverty was the military conflict in Southeast Asia. In April 1965, the antiwar movement began to shift gears after Students for a Democratic Society (SDS) organized a march of 25,000 people in Washington, DC. After the march, SDS surprised many by surrendering its new mantle of leadership in favor of community projects such as the anti-poverty campaign "Jobs or Income Now" in Chicago's Uptown neighborhood. But many individual SDS members worked with civil groups such as the Chicago Area Friends of SNCC to build new antiwar networks. They concentrated on local college campuses and hosted "teach-outs" for the general public at two major downtown intersections each Friday and Saturday.[16] But they still had little visibility when President Johnson visited Chicago in early June to speak to 6,000 people at a $100-a-plate Cook County Democratic fund-raising dinner. Along the route to the venue, a few civil rights activists, led by Dick Gregory and Al Raby of the CCCO,

came out to protest, but they concentrated on their education campaign, bearing signs such as "Keep Chicago Clean, Get Rid of [Ben] Willis." It was actually Johnson, not these protestors, who had the undeclared war in Vietnam on his mind that night; he used the Chicago appearance to speak on foreign policy and how to achieve peace with the Soviet Union.[17]

Later that summer, however, the Black Freedom struggle and the antiwar movement began to interact and overlap, both ideologically and in personnel. The left-wing Chicago W. E. B. Du Bois Club, for example, helped organize a demonstration at the downtown Federal Building on July 20, 1965, that posed the question: "Why Are American Troops in South Viet Nam and Not in Mississippi?" Rather than protecting civil rights activists, the government sent troops "halfway round the world" at the expense of $1.5 million a day "to drop napalm on women and children in the name of 'freedom.'"[18] Other rallies displayed the diversity of the mounting coalition. One August gathering featured Carl Oglesby, the president of SDS, and Shirley Lens of Chicago Women for Peace, with student activists noting how "the rally will include spokesmen for the civil rights movement who will show the connection between the war in Vietnam and the civil rights struggle of this country."[19] But the civil rights coalition's liberals rejected this new comparison, even convincing Dr. Martin Luther King Jr. to refrain from further calls for a negotiated settlement in Vietnam. Seeking to merge these movements were a diverse group of pacifists, Quakers, community organizers, poverty workers, students, and various New Left sectarian radicals. They coalesced in Washington for the Assembly of Unrepresented People in August and thereafter formed the National Coordinating Committee to End the War in Vietnam (NCC), a new association that sought to coordinate a broad and non-exclusionary coalition for "International Days of Protest" to take place in October 1965.[20]

As one of eighty participating cities, Chicago's Committee to End the War organized a series of demonstrations, campus educational activities, and rallies during the weekend of October 15–17. On the first Friday, Shay photographed a rally of

several hundred at Buckingham Fountain. Their signs outlined their demands for immediate withdrawal and draft resistance. One sign compared the war to the recent racial insurrection in Los Angeles ("I Didn't Kill in L.A. and I Won't Kill in Vietnam"), while another raised the question "Are We Still 'Part Of The Way' with Elbie Jay [LBJ]?"—suggesting that not all of these activists were ready to take the more radical step of departing from the president's Great Society policies. The park's atmosphere grew tense when a larger group of pro-war demonstrations arrived, singing "My Country, 'Tis of Thee." This group had its own bold message: "Victory in Vietnam," "We Back Our President," and "We Support US Policy in Vietnam." Shay's images documented several heated debates, where aside from their signs and buttons, one group of young people was hardly distinguishable from the other. The crowd heard speeches from NCC leaders Earl Silbar and Steve Baum, as well as some antiwar poetry from Industrial Workers of the World member Carlos Cortez and "well-known anarchist" Joffre Stewart. Then they marched through downtown to the U.S.

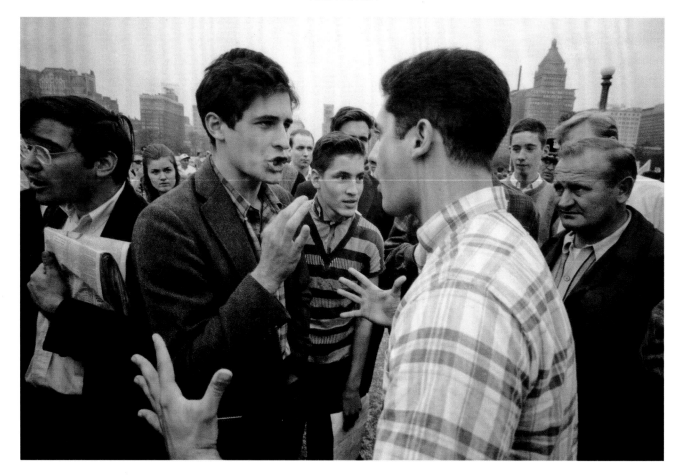

Army induction center at 615 West Van Buren Street, where police isolated the pro-war demonstrators on Van Buren and funneled the antiwar pickets to the Jefferson Street side of the building. The young antiwar participants concluded their "days of protest" by combining forces with Chicago Peace Council activists, a new local coalition of older peace groups modeled on the NCC's nonexclusion principle. This closing "Rally for Peace in Vietnam" assembled the diverse new coalition to hear speeches from a range of people, including Dick Gregory and longtime pacifist David Dellinger.[21]

The International Days of Protest exposed a new era of antiwar movement activism as well as its formidable opposition. Sidney Lens noted that "a new mood of resistance was already in evidence, very much different in previous years." He cited Rennie Davis, a Chicago SDS leader

who described the new strategy as "creative discord": an attempt through confrontation to force average citizens to think about the war and bring about a national dialogue that would turn public opinion against it. But inside the new antiwar coalition, discord was sometimes anything but creative. Sectarian tensions and internal "fiefdoms" cost the NCC its leadership in the antiwar movement by the next spring. And discord did not inevitably lead to sympathy from those outside the New Left. Lens remembered how some Chicagoans admitted they "hated the war" but were also "furious at the people who actively opposed it." William McMillan, who identified himself as a leader of the pro-war counterdemonstrators during the October march, said, "More than 75 percent of the student body is with President Johnson and his Viet Nam policies." Opinion polls showed he was largely correct. Even as 1,350 Americans died in combat

in 1965, 67 percent of all Americans favored the war in a September poll. A December poll revealed that one-third of all Americans believed U.S. citizens did not have the right to speak out against the war at all.[22]

Government officials and the mainstream press worked together to shape public opinion, castigating antiwar activists as immature and Communist-influenced. A *Life* magazine reporter called the antiwar activists at the October demonstrations "chronic showoffs" whose "annoying clamor" had "little chance of succeeding in changing public opinion." Locally, the *Chicago Tribune* critiqued "red diaper babies," including NCC leader Frank Emspak, whose father, Julius, had been a left-wing leader of the United Electrical Workers union. These young activists, the *Tribune* concluded, have "been taught from infancy that

anything which creates dissention in the bourgeois ranks" should be undertaken "no matter what the subject." But more ominous, local and federal government officials vowed to strike back. Attorney General Nicholas Katzenbach came to Chicago to confer with local U.S. Attorney Edward Hanrahan and the "heads of the police intelligence units." They announced that they would investigate the groups behind the anti-draft protests, specifically mentioning SDS, whose headquarters were in Chicago. They, as well as local police chief Orlando Wilson, agreed that there was "no question" that Communists influenced the student movement. These denunciations made Mayor Daley look moderate in comparison. "You are bound to have Communists feeding on this line," Daley told reporters, "but I don't want to be misunderstood and reported to be in the position that all demonstrators are Communists."[23]

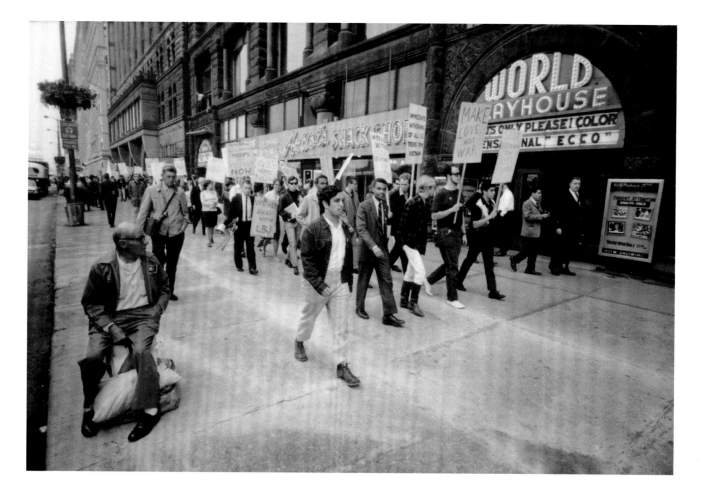

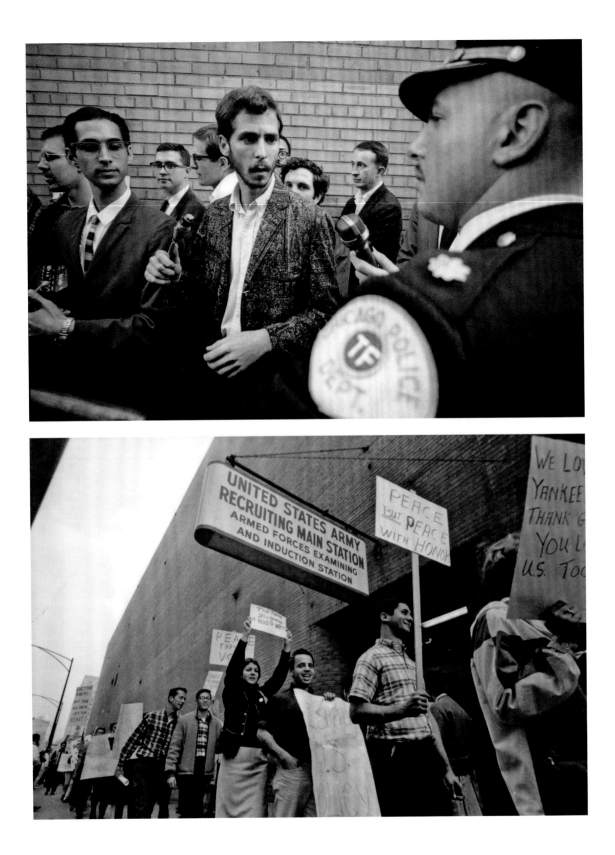

Under new scrutiny, the antiwar movement regrouped and expanded on college campuses in the first months of 1966. There, students concentrated on "ranking" as the "most loathsome aspect of the draft." First used during the Korean War, the Selective Service of the U.S. government planned to draft students according to special test scores and class rank. Students formed an ad hoc Students Against the Rank (SAR) on several campuses, and over 150 faculty signed a petition against the practice of testing as interfering with higher education. In March a group of Roosevelt University students marched to the Science Research Associates office, the corporation that created and administered Selective Service tests; nine students got arrested, including Sandra Drake, the daughter of the prominent African American intellectual and Roosevelt sociology professor St. Clair Drake. On test day, May 15, students at area campuses picketed outside the classroom building, including two dozen photographed by Shay at Roosevelt. These students did not disrupt the actual test, but they handed leaflets to test-takers and others that denounced the draft system as "catering to a privileged student class." Roosevelt President Rolf Weil had told the press, "We tolerate all views and want to give our students the right to discuss and freely debate the issue." But when students engaged in a sit-in on the eighth-floor administration offices, Weil instructed police to arrest them for trespassing and remove them by force if necessary. Over faculty objections, police arrested several dozen students at their own university.[24]

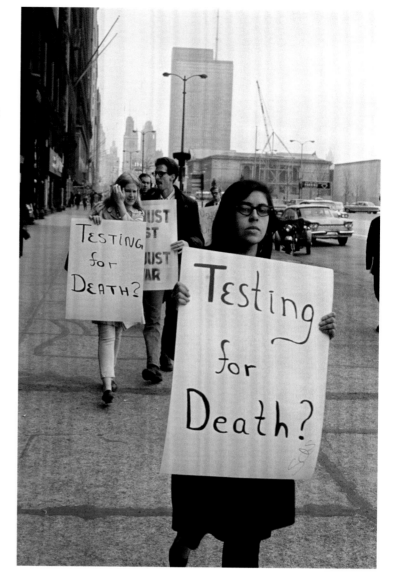

While Roosevelt University had become a key incubator of antiwar activity, it was at the University of Chicago that local students shocked the nation when 450 took over the administration building for five days. Shay's photographs showed students listening to music and speeches, debating, studying, and sleeping. One emblematic photo of the scene featured former Berkeley Free Speech leader and then–Chicago graduate student Jacqueline Goldberg leading students in a dialogue with a sign behind her making clear their demand: "Don't Use My Grades to Murder Students." The students

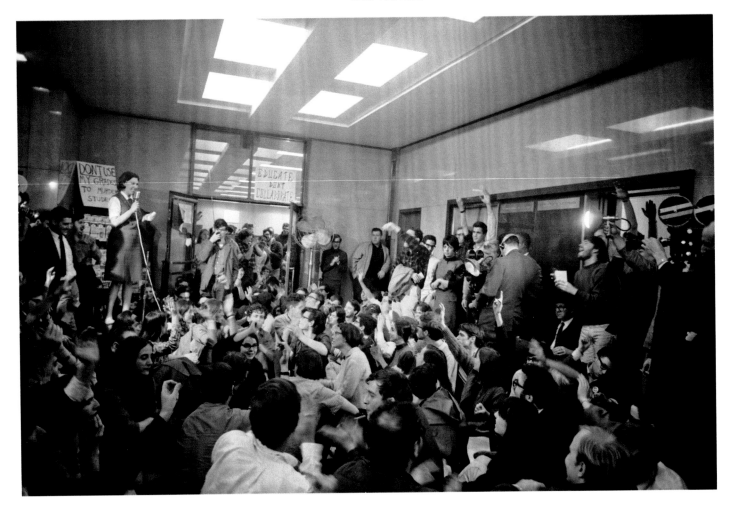

demanded that the administration stop testing and sending male students' class ranking data to the Selective Service. Their very elitism proved their unselfishness, they claimed. "Any U of C student, having survived a highly selective admissions policy," their petition outlined, "could obtain a student deferment by simply taking the selective services aptitude test." Several other students argued that the entire deferment system should be abolished. Assistant professor of sociology Richard Flacks, a former SDS member (shown holding a class in solidarity during the occupation), explained that many students saw it as a caste system that "sends disadvantaged kids to the Army while privileged kids take refuge in the university." Predictably, university officials did not condone these new acts of civil disobedience. President George Beadle called the students' tactics "coercive," and other admin-

istrators stressed that the protestors represented only a minority of the campus's 8,000 students. And while more than ninety faculty signed a petition to postpone testing and ranking until the university as a whole could discuss the issue, one week later the faculty council voted to discipline those responsible, which eventually led to over a hundred expulsions. A *Tribune* editorial summarized the opposition. The Selective Service policy was "reasonable," it declared; what was "intolerable" was "when a handful of young punks take over an institution such as the University of Chicago." The student "punks" succeeded in ending the use of class rank and test scores as major criteria for the draft, even if that did not lessen their larger critique about the vulnerability of less privileged young people, especially young men of color, who would increasingly be conscripted.[25]

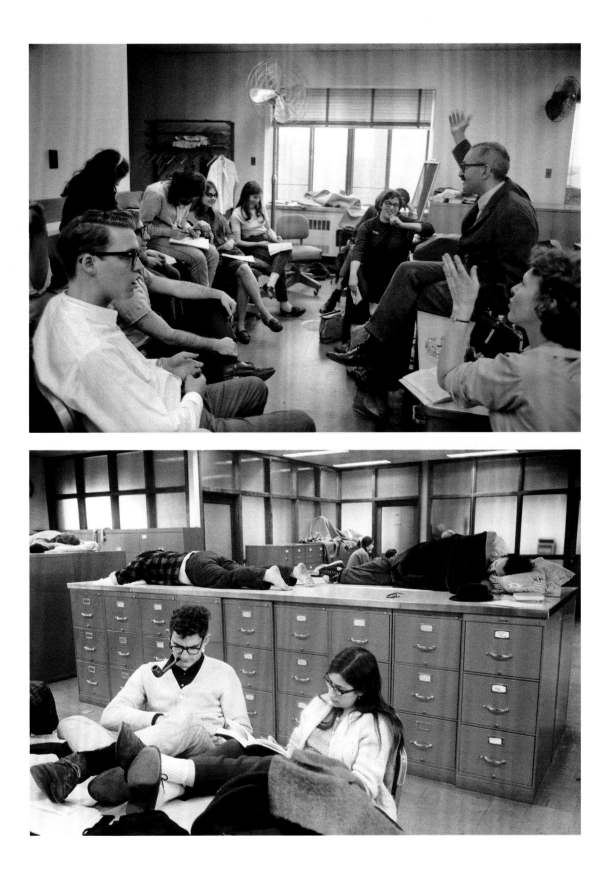

Amid the draft ruckus on campuses, President Johnson visited Chicago to defend his handling of the war. In the past months, many Americans perceived the situation in Vietnam as more opaque than righteous. South Vietnam's government seemed unstable and undemocratic under Prime Minister Nguyễn Cao Kỳ's military rule. These new circumstances also drew opposition from members of the president's own party, most notably Arkansas Senator J. William Fulbright, who began to interpret the war as part of America's mistaken "arrogance of power" foreign policy. Public opinion

polls "slipped," putting Johnson on the defensive. In town for another Cook County Democratic fund-raiser, Johnson planned to trumpet his administration's Vietnam agenda. Meantime, Chicago's homegrown and burgeoning antiwar movement prepared its loudest possible dissent.[26]

LBJ was scheduled to address a sympathetic audience of thousands of local Democrats, and once again Mayor Daley mobilized to display the city's support. Shay was careful to portray this connection. His photographs documented the large police presence, which turned out to be a record-setting 1,545 local officers reassigned for the president's visit. Shay also captured Streets and Sanitation workers discreetly unloading hundreds of mass-produced signs that were part of the Daley machine's own version of street theater. Across from the Conrad Hilton Hotel, these supporters held signs—"Chicago Backs L.B.J. All The Way" and "Chicago Beautiful Welcomes Mrs. Johnson." But reporters also noted a lack of even manufactured enthusiasm. "Crowds were thin" along the motorcade route from O'Hare Airport, one reporter noted, while another noticed

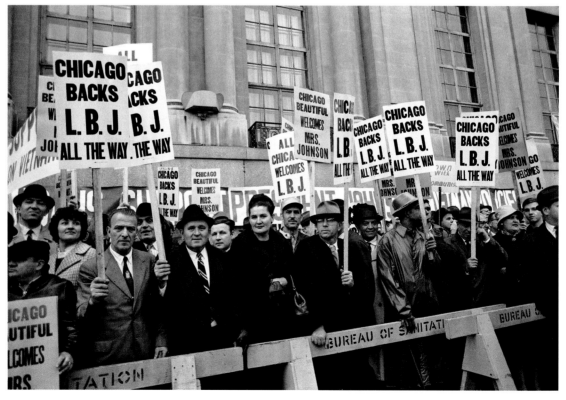

many "signs reading 'Plumbers Support President Johnson' were lying in the rain awaiting use," suggesting that a large turnout of pro-war unionists did not materialize. But most notable, reporters concluded that former LBJ supporters had become dissenters. While the president had earned universal praise on a previous visit to Chicago for his vision for a "Great Society of the highest order," this time he was "plagued by peace pickets."[27]

Shay's photographs captured these diverse antiwar demonstrators outside the downtown hotel and McCormick Place. These images belied assumptions that dissent on the war came only from white middle-class and elite college students. Beside them were veterans, people of color, and young and old alike whose signs and speeches indicated the movement's breadth. While one spokesperson for the Near North Side Civil Rights Organization expressed disagreement with the antiwar protestors, most did not distinguish among civil rights, the War on Poverty, and antiwar concerns, signified by several antiwar signs that read: "War in Viet Nam / Chicago Slums: Who Profits?" Connecting the war to a larger debate

over American imperialism at home and abroad, they compared U.S. human rights abuses in Vietnam to Nazi concentration camps.[28]

Inside the fund-raising dinner, LBJ confirmed these links between local, national, and international issues. He began his speech by praising Chicago's "progress," emphasizing its developed lakefront and modern office buildings, houses, schools, and thruways. Johnson attributed these accomplishments to the city's "steadfast," "courageous," and "hard working" mayor. Johnson even departed from his script to declare Daley "the number one mayor in all of the United States." Party leaders had seen Daley as a kingmaker since Kennedy's election in 1960. LBJ's over-the-top praise burnished Daley's reputation,

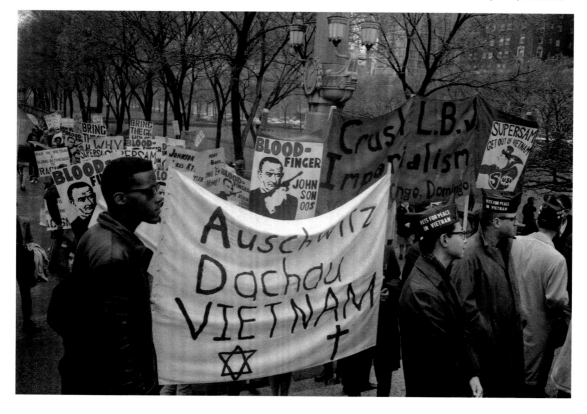

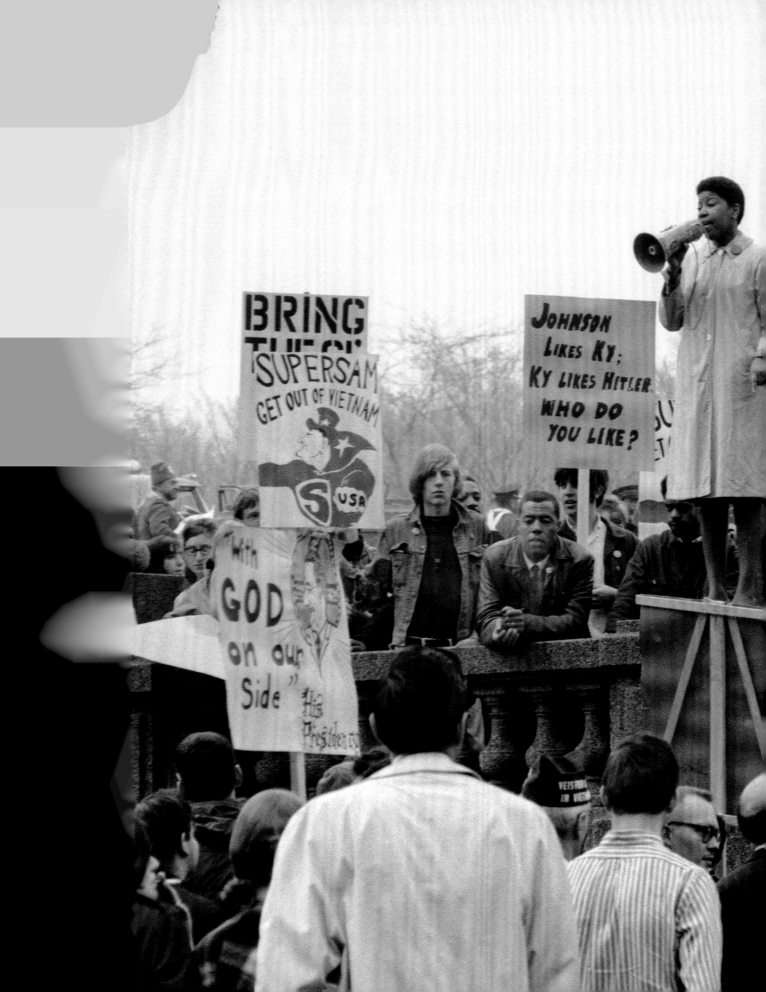

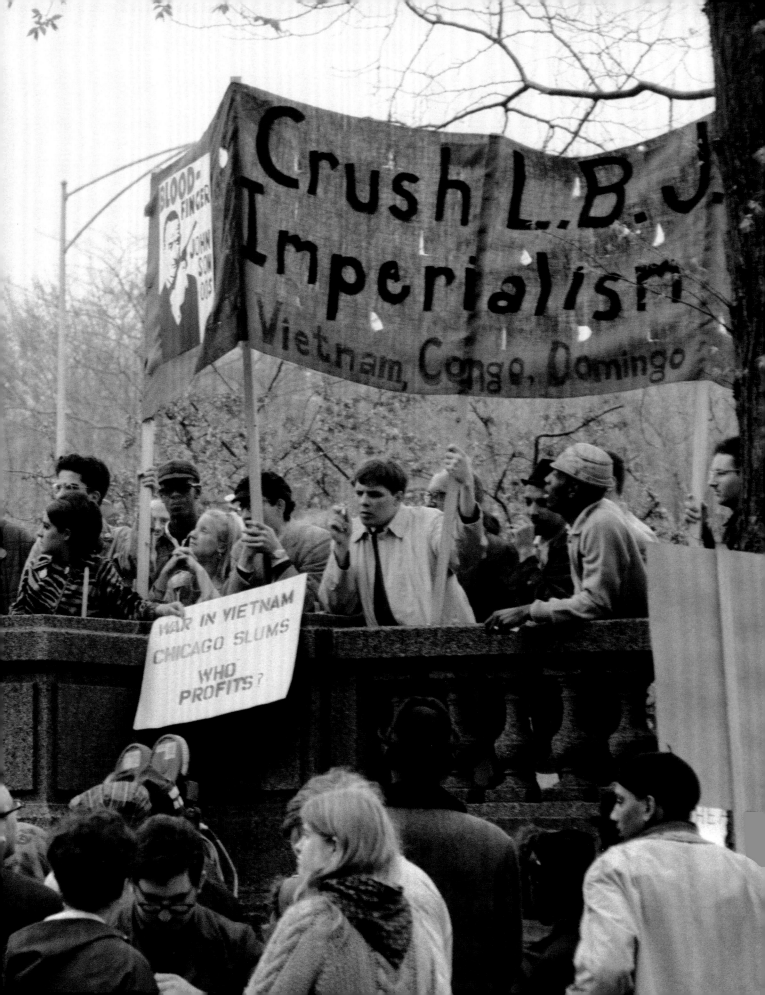

as did the $500,000 he raised for the Cook County Democratic machine that night. Johnson next placed his Great Society programs in tension with the international situation. "I want to join hands with others to do more in the fight against hunger, disease and ignorance," he declared, "but we know from hard won experiences that the road to peace is not the road of concession and retreat." To make his point, Johnson referenced the coming of the Second World War and the famous "Quarantine the Aggressor" address that President Franklin D. Roosevelt made in Chicago on October 5, 1937. Despite Roosevelt's warning, "the country failed to back him," Johnson said, "and then we saw what happened when the aggressors felt confident they could win." He did not seek to enlarge the war, he said, "but we shall not pull out."[29]

Johnson next launched into what the *New York Times* called "his most outspoken attack on his opponents of his Vietnam policy." He deemed them "nervous Nellies" who "break ranks under the strain and turn on their own leaders, their own country, and their own fighting men." LBJ called on Americans to "put away all childish and divisive things" and "stand united." This was not the optimistic and warm LBJ from previous years.[30] Shay's images of the event—including a close-up of an advance copy of the speech on paper and the Orwellian portraits of Daley and LBJ—evoked a scripted and gloomy atmosphere that seemed to reflect the president's own mood. "The road ahead is going to be difficult," he conceded, and one reporter noted that the president delivered the speech "rapidly and flatly." The loyalist audience responded with "respectful but not wildly enthusiastic applause," and following the speech those in attendance wondered whether the "controversies over the Viet Nam war are causing a loss of support for the Democrat Party." Mayor Daley answered these murmurs with an emphatic "no," telling the press that the possibility of such doubts was only Republicans' "wishful thinking." One month later, local Democratic primaries seemed to back the mayor's assessment, but in

a private phone call, Johnson and Daley shared concerns that political opponents could use the war against them and that the growing civil rights campaign could hurt them in Chicago.[31]

Not just a national hub of antiwar activity, Chicago was also becoming a major node of the civil rights movement. During the summer of 1965, Al Raby had hosted Dr. Martin Luther King Jr. for a whirlwind speaking tour and a downtown demonstration. "I think I've talked more in the past three days," King said after, "then I have any time in my life."[32] Meetings in more than a dozen West and South Side neighborhoods deepened King's understanding of the enormity of Chicago's urban landscape and the scourge of racial segregation. Returning to Atlanta, he conferred with his colleagues in the Southern Christian Leadership Conference (SCLC), and they made Chicago the site of a new attack on discrimination above the Mason-Dixon Line. They had been especially impressed by Raby and

the CCCO South Side network, as well as recent efforts by their own staffer James Bevel. Over the past months, Bevel had served as program director of the West Side Christian Parish, organizing in one of the city's poorest sections. They also noted that the Chicago machine could be turned to their advantage if Richard J. Daley, Chicago mayor and Cook County chairman of the Democratic Party, were forced to use its streamlined power for sweeping reforms. SCLC staffers were also touched by the similarities between these Black urbanites and those they knew in the Deep South, especially in Mississippi. After all, most Black Chicagoans had migrated over the past several decades, forming a diaspora between the two places.[33]

Civil rights leaders hoped they could leverage outside pressure to transform Chicago. In May 1965, Chicago Public Schools Superintendent Benjamin Willis announced that he would retire by the end of the following year. Meanwhile, the CCCO used its summer 1965 marches to demand that federal authorities address housing, jobs, and educational inequalities. In September, Mayor Daley called President Johnson to protest that "two rabble-rousing ministers" had sent a letter to the U.S. Department of Housing and Urban Development that might delay funding for a half dozen public housing projects due to charges of racial discrimination. Daley asked, "Does this mean all of our projects are going to get held up? We're trying to carry out your programs." The president reassured Daley that he would call HUD and straighten it out. The next month, another previously filed CCCO complaint seemed to gain traction when a six-person investigative team from the Office of Education in the Department of Health, Education, and Welfare (HEW) found that educational segregation in CPS placed it in "probable non-compliance" with Title VI of the 1964 Civil Rights Act. Its staff worried that if HEW did not at least threaten to hold the $32 million pledged to Chicago through the new Elementary and Secondary Education Act, southern cities would follow Chicago's lead in undermining civil rights legislation through noncompliance.

While the CCCO was elated by this news from

Washington, local Democrats responded with consternation and coordinated opposition. Roman Pucinski, for example, said Congress "won't appropriate another nickel for education programs" after such "dictatorial acts." Seeing this political defiance as a way to avoid civil rights implementation, southern Democrats joined their Chicago colleagues, and then Mayor Daley raised the matter in person with President Johnson, who promptly summoned HEW officials to give them "unstinted hell" in private while instructing them to "be sure that there is no mention of the White House being in this thing at all."[34]

This attempt to permit noncompliance showed the CCCO and SCLC that a similar coordinated local and national counterattack could expose and undermine this embedded racism. In early 1966, Dr. King took up residence in a West Side "slum" apartment in North Lawndale to dramatize the terrible housing conditions, but overall the SCLC's first few months of the Chicago campaign did not grab national headlines. This was partially intentional, as the SCLC and CCCO tried to coordinate plans, and SCLC strategist James Bevel and other organizers took a methodical approach to forming West Side tenants' unions. Based at Warren Avenue Congregational Church in East Garfield Park, West Side organizers established the Union to End Slums. But by the spring, the SCLC and CCCO grew impatient, instead looking for another way to draw the nation's attention away from other concerns such as the escalating Vietnam War.[35]

Activists began their new "action phase" with a massive rally at Soldier Field. Under a "blazing sun" on July 10, 1966, the Chicago Freedom Movement (CFM) drew 30,000 people—many fewer than the anticipated 100,000 and also at least 20,000 fewer than a similar rally at Soldier Field two years earlier. Some organizers blamed the weather, but Shay's photographs suggest other reasons for the limited attendance. These include marked racial, class, and other divisions among the crowd—from the United Automobile Workers contingent holding a banner that read, "Not Black, Not White, But People's Power," to Black ACT militants holding signs such as "Black Lackeys Must Go," to a young man in a shirt with "Black Power" written across his back. The event began with three artists who had long supported and even led Chicago's Black Freedom Struggle: Mahalia Jackson, Oscar Brown Jr., and Dick Gregory. Then, as the Andrew McPherson Quartet played "John Brown's Body," a group of about fifty Black teenagers leapt onto the field and ran around holding a Black Power banner as well as a sign that proclaimed "Freedom Now" alongside a drawing of a submachine gun. Revealing their class as much as ideological differences from these youths, some displeased spectators cried, "Call the police!" This prompted the interlopers, some of whom reportedly were gang members of the South Side's Blackstone Rangers and the West Side's Gangster Disciples, to run off the field, up the bleachers, and out of the stadium.[36]

Following this outburst, a motorcade entered the stadium to great fanfare, but these men's speeches suggested a strained unity. James Meredith, whose shooting and subsequent civil rights march through Mississippi had delayed the Chicago rally by three weeks, drew applause until he launched into praise for the controversial Reverend Joseph Jackson. Echoing the response from three years earlier at the march in Grant Park, the crowd booed him for his support of the Black Baptist Convention leader and vocal critic of the civil rights movement. Unlike Meredith, Al Raby was direct in demanding a broader and more confrontational movement that connected civil rights and peace demands. "I would rather suffer and if necessary die here in Chicago to end the slave psychology and the pathology of racism

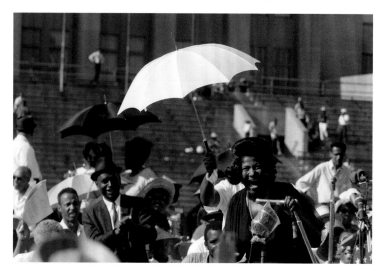

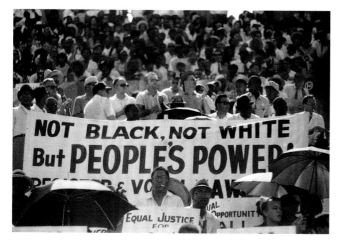

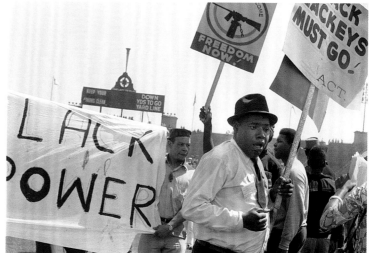

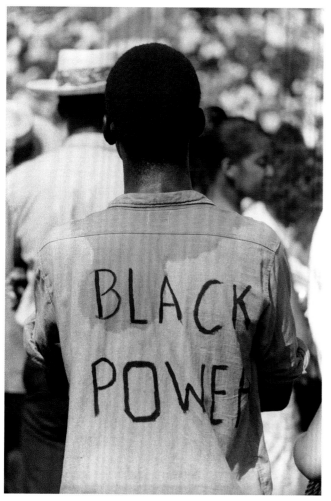

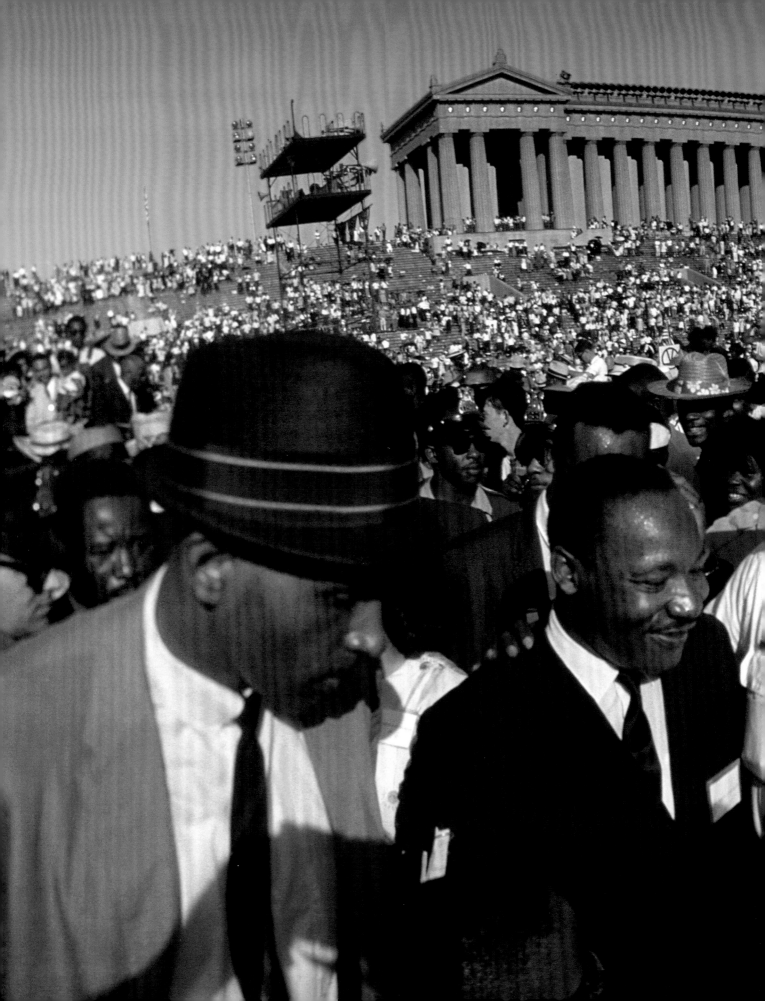

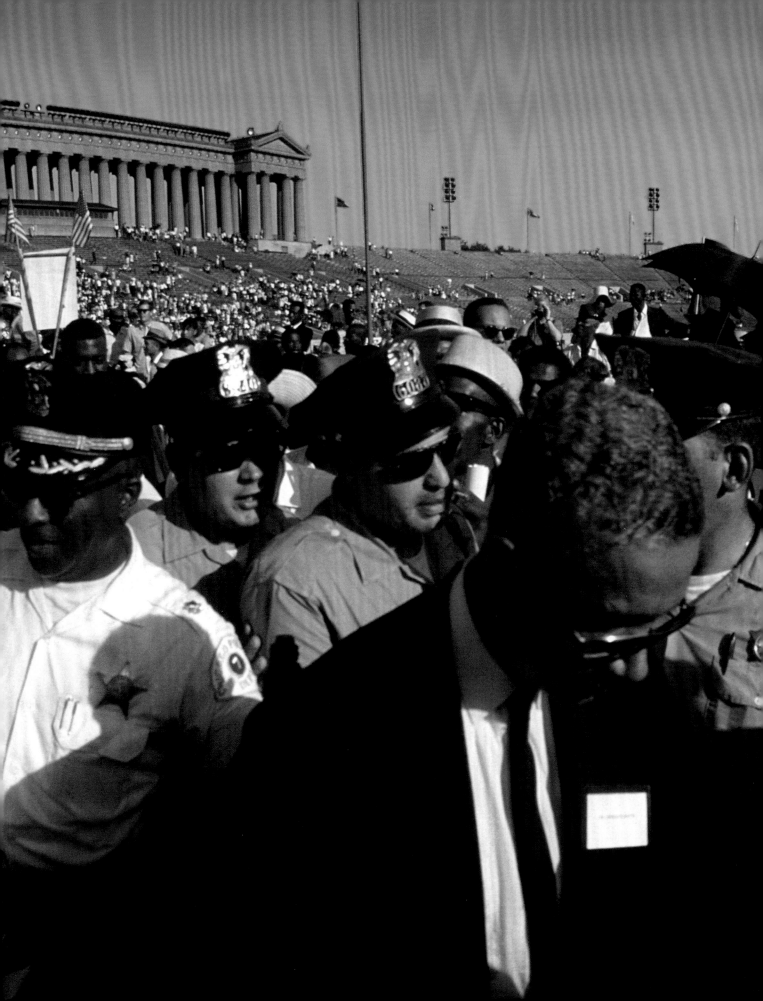

that is at the root of most war," he said, "than to be a hero in some foreign land fighting against a faceless enemy in support of a dubious democracy." This rhetoric, as well as the presence of antiwar demonstrators that day, departed from SCLC staffers' and King's plans. King had agreed to scale back his criticism of the war and was instead preoccupied with how to deal with the resurrection of Black nationalism and the Black Power slogan. This chant had sprung up in the Meredith march, voiced by SNCC and CORE activists, and was voiced in the Chicago rally, too. Floyd McKissick, the national director of CORE, spoke in defense of Black Power. It "does not mean violence," he explained, but Blacks unifying as a means of "gathering power with their money and votes." King next argued against the "romanticized call for black separatism," declaring the "doctrine of black supremacy as evil as the doctrine of white supremacy." Press accounts noted that these speeches drew equal applause, revealing the ideological and tactical divisions brewing in Chicago that might require further reconciliation.[37]

Dr. King also referenced the need to make new demands at both the local and federal level rather than be satisfied by the Civil Rights and Voting Rights Acts of the previous two years. "We will be sadly mistaken," he said, "if we think freedom is some lavish dish that the federal government and the white man will pass out on a silver platter." Then he echoed the great abolitionist Frederick Douglass: "Freedom is never voluntarily granted," but "must be demanded by the oppressed." In an explicit challenge to Mayor Daley, he told Chicagoans that "this day we must decide that our votes will determine who will be the Mayor of Chicago next year." He next announced the CFM's future direction. "We shall begin to act as if Chicago were an open city," by focusing on housing discrimination in all-white neighborhoods. Thereafter, about 5,000 of the most spirited participants marched and rode on cars from Soldier Field downtown, where King, invoking his namesake who had nailed demands on a church door in 1517, affixed the movement's long list of demands to City Hall's LaSalle Street door.[38]

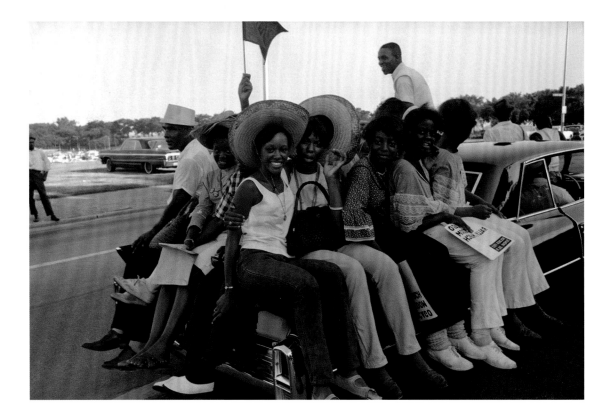

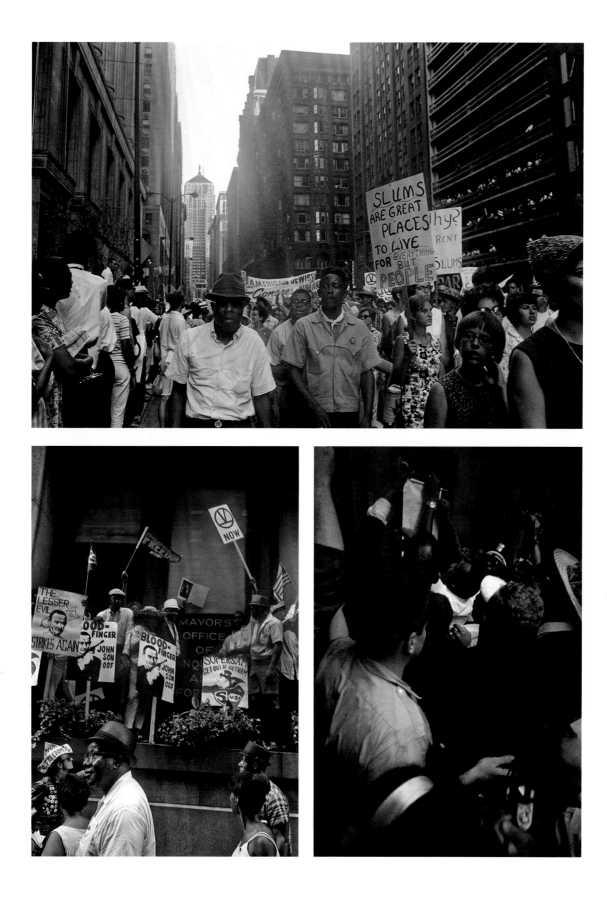

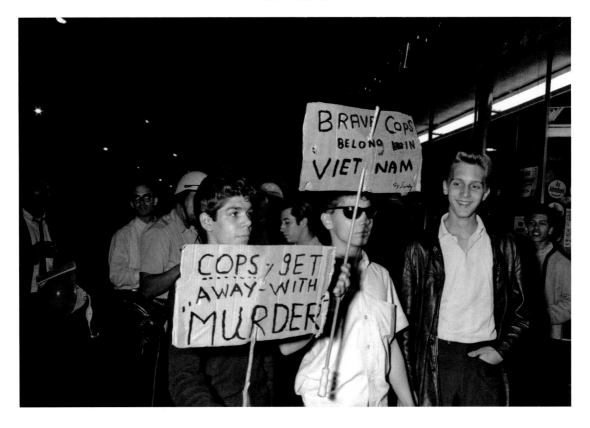

Before the CFM could begin this "open city" action phase, two uprisings broke out that summer, highlighting both the inequality that activists sought to expose and their lack of reach into these neighborhoods. The Division Street riot happened in a burgeoning Puerto Rican area on the Near West Side. Between 1960 and 1970, the Puerto Rican population in the West Town and adjacent Humboldt Park neighborhoods grew from 8,000 to 40,000 residents. This increase also led to a rise in complaints to the district police station of harassment and brutality, especially about officers who spoke no Spanish. The previous summer, for example, officers had beaten several young men who had opened fire hydrants to cool off on a hot day. The violence that began on June 12, 1966, ironically occurred on the final evening's celebration of Mayor Daley's official Puerto Rican Week. Responding to a call about young men fighting, police entered Humboldt Park, chasing a few young men out of the park and into neighborhood alleys until Officer Thomas Munyon shot twenty-year-old Arcelis Cruz. Munyon claimed Cruz had

drawn a gun, but witnesses disputed the claim. Word spread among the already assembled crowd, and hundreds of residents took to Division Street in protest, facing off with hundreds of officers who arrived on the scene. For the next two nights, police shot seven more men and arrested over one hundred people, including the wounded Cruz. Shay arrived just after the initial uprising, documenting the arrests and jailings along Division Street and the neighborhood outrage, signified by a photograph of two young men. One held a sign, "Cops Get Away with Murder," while the other's sarcastic sign connected this violence to the war abroad: "Brave Cops Belong in Viet Nam."[39]

The Soldier Field rally had occurred after this uprising and just before another one. Raby had Division Street on his mind as a warning and an opportunity. He highlighted the "unfortunate but predictable kind of incident" that sparked a "revolt" in Chicago's "Latin American" community, suggesting that "the grievances of our Spanish-speaking amigos are the same as ours." King and the SCLC, who had previously worked in southern

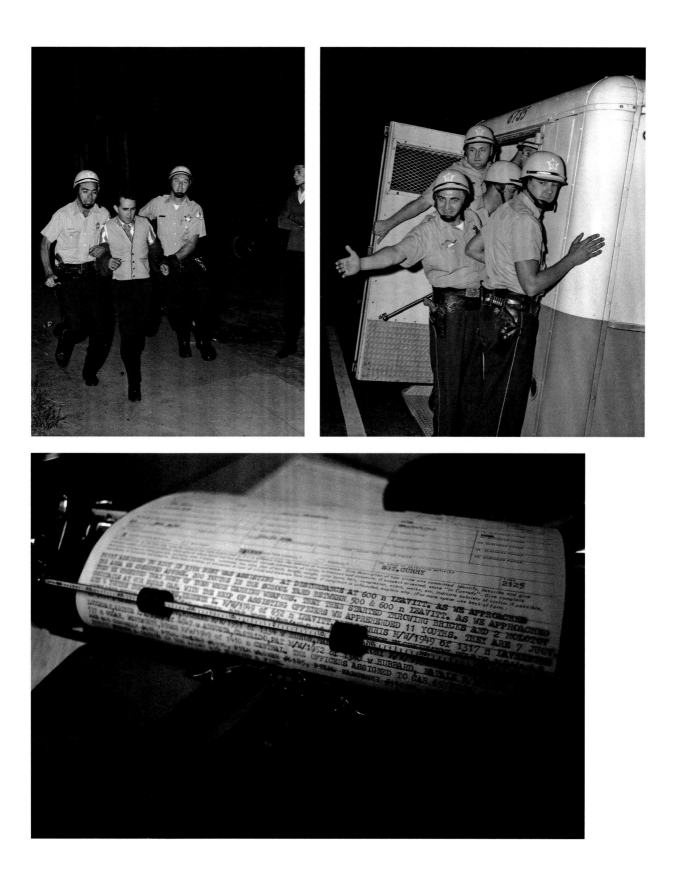

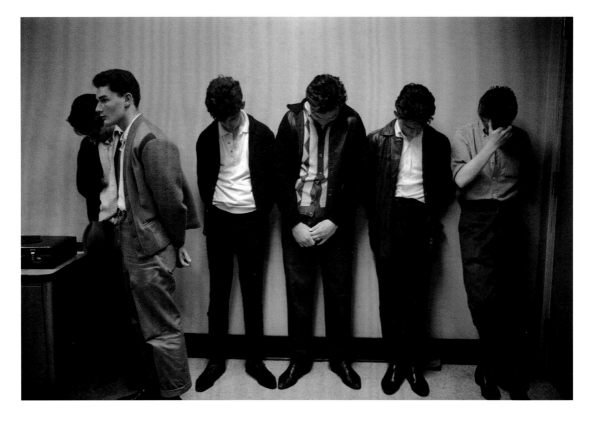

cities without a significant Latin American presence, tended to see race in more binary terms. In his own speech on July 10, King had warned, "There is great bitterness in the Negro community and feeling of no way out." These fears came to fruition just two days after the Soldier Field rally when police shut down an open hydrant on the Near West Side. Technically a city ordinance forbade using hydrants to cool off, but young people across Chicago had long made this a summertime tradition. This action, not unlike a similar one along Division Street the previous summer, ended with police beating several youths. When a crowd gathered on the Near West Side corner of Throop Street and Roosevelt Road, police cleared the area and clubbed five teenagers "bloody" in attempting to reclaim this urban space. But residents fought back, throwing rocks at police and engaging in vandalism, including looting white-owned businesses along Roosevelt Road.[40]

City Hall responded by denying the gravity of what was happening. Mayor Daley refused to call

this a "riot," instead minimizing it as a "juvenile incident." Subsequent meetings between police and residents bred further anger when officers lectured people and ignored evidence of police brutality. This police denial was endemic, with Superintendent Wilson blaming "elements in the community which seem intent on destroying the effectiveness of the police by charging police brutality." Wilson declared that he had "the matter under control" even as the uprising spread to West Madison Avenue and then as far as two miles west to North Lawndale and East and West Garfield Park. Meantime, Dr. King and other activists tried in vain to stop the violence, admitting that only the West Side Organization (WSO) had a calming influence among neighborhood residents. By that Friday, police admitted they had also lost control as officers cordoned off a large section of the West Side and evacuated firemen and other personnel. Mayor Daley reluctantly called a press conference to announce that he asked Governor Otto Kerner to summon more than 4,000 National Guardsmen

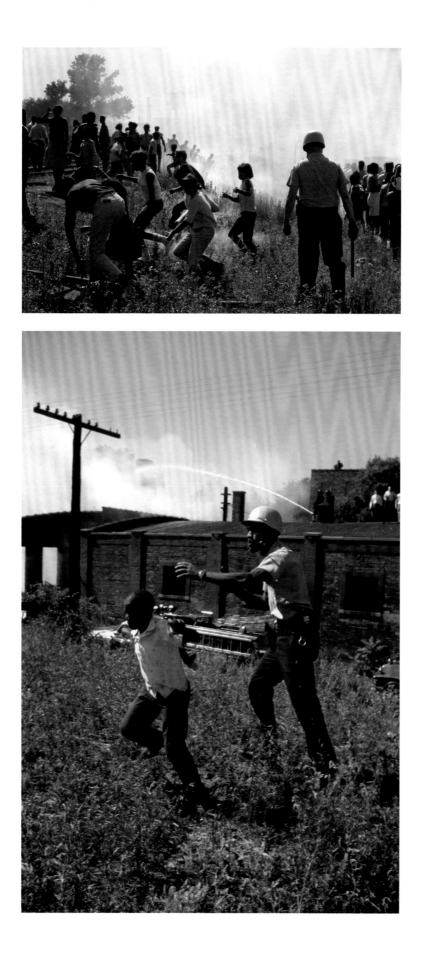

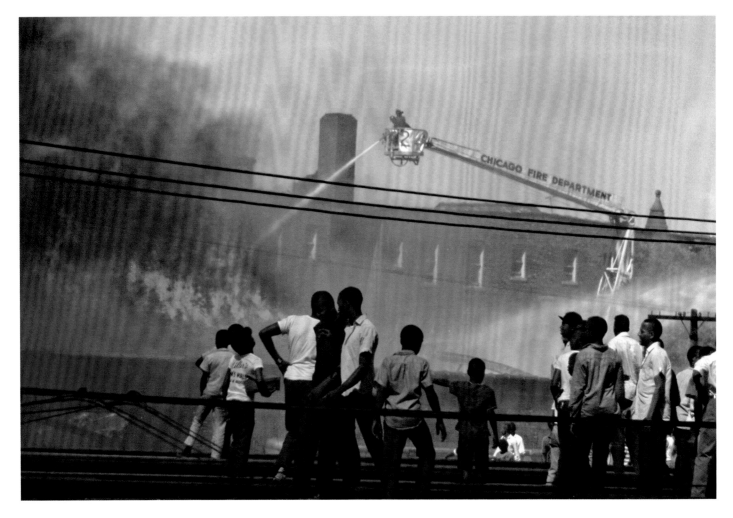

to end the uprising. Daley also used the opportunity to cast blame on the CFM. "I think you cannot charge it directly to Martin Luther King, but surely some people came in here and have been talking for the last year in violence.... They are on his staff. They are responsible." Following Daley's lead, the *Chicago Tribune* and other newspapers overlooked the decades of racial and economic inequality that had plagued the West Side. Instead, journalists blamed King and the CFM for importing trouble from the outside. The *Tribune* instructed judges to sentence participants "to get out of the city within thirty days and never come back," and even urged police to "pick up known rioters whenever and wherever they are seen, making life so unpleasant for them they will be forced to leave town."[41]

Determined not to let these uprisings divert their nonviolent movement, CFM activists redoubled their efforts to create an "open city." Turning away from economic justice organizing such as Operation Breadbasket's jobs campaigns and West Side attempts to organize hospital workers, they held demonstrations at realty company offices in white neighborhoods, hoping to draw attention to widespread discriminatory housing practices. They also targeted Southwest Side working-class neighborhoods such as Gage Park and Marquette Park, where many African Americans could afford to live. CFM leaders hoped that this strategy would create more drama by confronting white Chicagoans and speeding the passage of the 1966 Civil Rights Act—just as

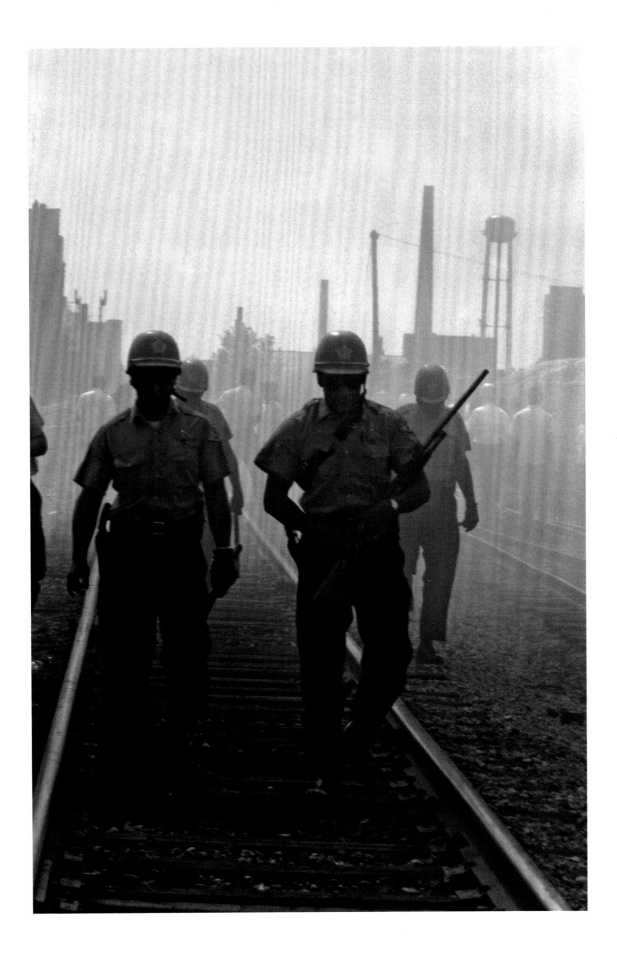

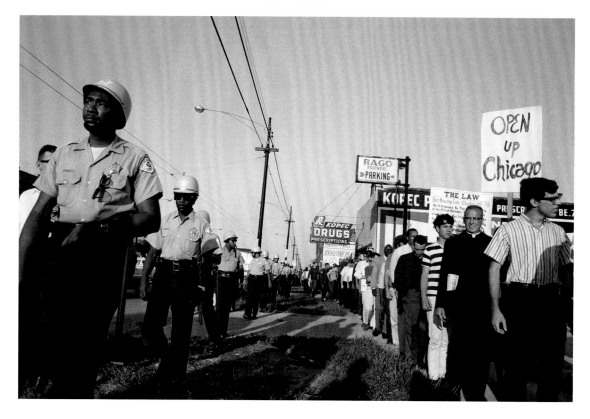

the Selma campaign the previous year had done for the Voting Rights Act. And at the state level, Democratic Governor Kerner, as part of an effort to secure a lucrative federal atomic accelerator project to Weston, Illinois, recently signed an executive order that banned discrimination in selling or renting homes in the state, effective July 23. "We want to turn that thin paper," King said of Kerner's order, "into thick action." They began marching daily into several neighborhoods.[42]

CFM leaders knew they would encounter some resistance from real estate agents and residents of these neighborhoods, but nobody expected the visceral hatred and unapologetic racism they met. Shay captured these shocking scenes at Northwest Side demonstrations in the largely Polish and Italian American Belmont Cragin area. These skirmishes have received relatively little attention from scholars, with one historian concluding that Northwest Side residents "lacked a sharp and palpable community-wide fear of racial transition" compared to the people on the Southwest Side neighborhoods of Marquette

Park and Gage Park, where full-scale white rioting occurred (and Dr. King was infamously hit on the head with a brick).[43]

Yet these images from Belmont Cragin in early August belie the notion that visceral white supremacy was limited to Southwest Side whites. The CFM targeted the Northwest Side Realtors Parker-Finney at 5041 West Fullerton for a nonviolent demonstration. That office was one of many area Realtors that discriminated against African Americans, as more than sixty testers had confirmed, by refusing them service and steering them elsewhere. About 250 people marched from Hanson Park down Central Avenue (alongside police protection on the north sidewalk) to Parker-Finney, where an interracial group of laypeople and clergy, including SCLC organizers James Bevel and Jesse Jackson, knelt and prayed on the sidewalk in front of the office. This action created a spectacle that drew a rowdy crowd across the street. Following Superintendent Wilson's "strict" orders to protect the demonstrators, one police commander admitted that they had to choose

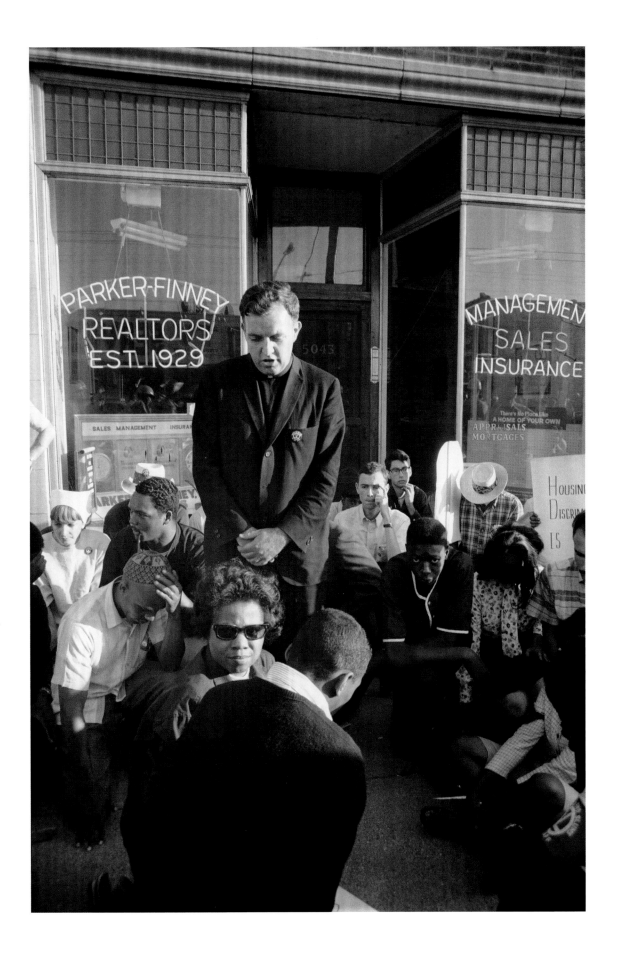

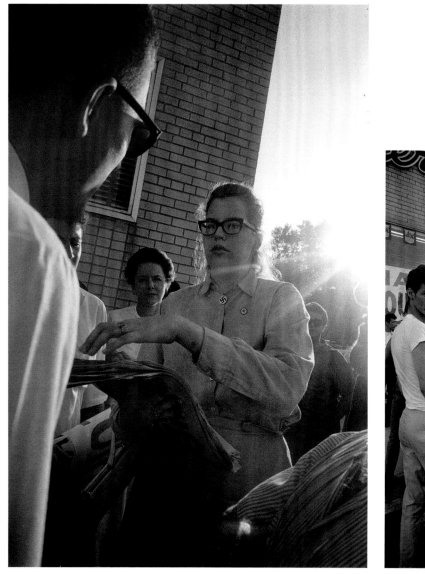

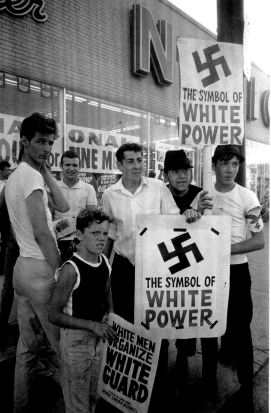

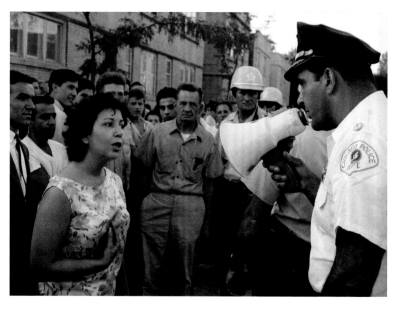

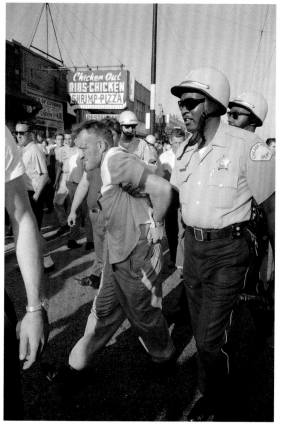

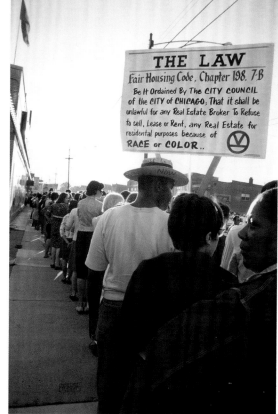

"to protect people or property." Selecting the former, they restrained the crowd from violence and permitted damage to over fifty demonstrators' vehicles back at the park. The crowd hurled bottles and bricks, tried to set a grass fire, shouted obscenities, and then turned their anger against the police—especially the Black policemen on the scene. In all, seventeen men, one woman, and two juveniles were arrested, bringing the total to twenty-four arrests there over two days. Whites displayed Nazi swastikas and signs reading "White Power" and even "Only Good Nigger is a Dead Nigger," revealing their proud white supremacy. But unlike the earlier Bridgeport protests that featured racist signs alongside messages of support for the mayor, this crowd openly backed the segregationist George Wallace for president. Their pro-Wallace signs worried Daley and Johnson that working-class whites might defect in the 1966 midterm election or, worse, from the 1968 Democratic Party presidential ticket.[44]

This series of marches into white neighborhoods created a citywide crisis but once again led to only superficial reforms. Real estate brokers did not wear swastikas, but their lobbying message clearly expressed their intent. "All we are asking," the vice president of the Illinois Association of Real Estate boards said, "is that the brokers and salesmen have the same right to discriminate as the owners." They won an injunction in late July from a Springfield judge that exempted 154 brokers, including 22 in Chicago, from Kerner's executive order on the basis that the governor had usurped legislative authority and violated the right of contract.[45]

The local press sympathized with these real estate agents, admitting white "hysteria" but blaming the CFM for it. The *Tribune* called Belmont Cragin a "community of modest but good homes" and families that "ordinarily would be enjoying the chance to sit on the front porch ... or to go to the park or beach." Instead, they were "confronted by

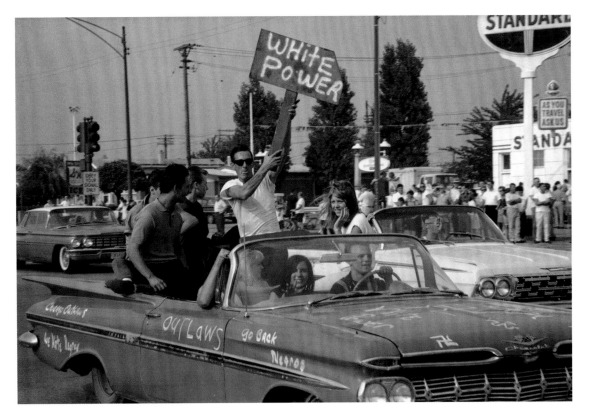

a shuffling procession of strangers carrying signs and posing as martyrs." Its editors deemed King's tactics as being "designed to incite crowd fury," dismissed the demonstrations as "phony," and called upon Black Chicagoans to expel "King and his imported troublemakers." Beyond the increasingly reactionary *Tribune*, other press outlets raised concern about white behavior, only to equivocate about the white supremacists and civil rights marchers. An editorial on the local CBS affiliate WBBM, for example, noted that the "salt of the earth" people in these neighborhoods showed they "were willing to adopt the methods of Hitler's Nazis to keep" the "Negro [from] living next door." But editorial director Carter Davidson said there existed "even less excuse for the demonstration marches that provoked" this response, calling them "useless" because real estate spokesmen had been willing to meet and because the marches had diverted 1,200 CPD officers from protecting city residents "from a rising crime rate."[46]

In addition, CPD Superintendent Wilson helped Daley's cause by privately defying him. He contin-

ually rejected the mayor's call to arrest and punish the civil rights activists; this limited activists' ability to use claims of police brutality and jail crowding as a strategy to get support for their cause, which had aided their previous campaigns in places like Birmingham. In this unsympathetic context, Daley convened negotiations that led to the signing of a mid-August "Summit Agreement" of largely unenforceable housing discrimination pledges. King and other SCLC leaders vowed to resume marches if the agreement was not upheld, but behind the scenes they began to withdraw from Chicago for other campaigns.[47]

Why did the CFM fall short of its civil rights goals? Shay's photographs reveal a lack of synchronicity between national civil rights leaders and Chicago troublemakers. By the mid-1960s, many local activists had broken from the liberal consensus to treat foreign wars as threats to democracy abroad and at home. Organic working-class activists, already engaged in anti-poverty and civil rights work, thus became a crucial new part of the city's peace movement. Yet national movement

leaders ultimately decided to focus on housing in "slum" neighborhoods and then shifted this focus to desegregating white and largely working-class neighborhoods. This housing strategy certainly exposed both individual and structural racism in the urban North. But at no time did the CFM engage more than 3 percent of Chicago's African American population.[48] In addition to a lack of Black participation, the national leaders who built the CFM did not seize upon the opportunity to foster alliances across the city. They did little to form a coalition with Mexican and Puerto Rican residents in Chicago.

Further, when the CCCO-SCLC appointed an action and agenda committee to lead the CFM, they relied upon gendered assumptions about leadership to assemble an all-male cast. When West Side women presented their grievances to James Bevel, Molly Martindale recalled, "he accepted the logic of what we were saying, but afterward, we noticed he didn't change his behavior." The decision to march into all-white working-class neighborhoods also changed the movement's composition from West Side working-class Blacks to a largely middle-class and interracial group that prioritized integration over the self-determination of groups like TWO or WSO.[49] SCLC staffers and the CCCO acted strategically in narrowing their goals to focus on housing. But this decision also seemed intended to protect their carefully built coalitions among civil rights activists, the Democratic Party, and organized labor.

The coalition that the SCLC and others in the CFM sought to preserve had already come apart. Many Chicago activists had arrived at this conclusion before the CFM of 1966; others learned of it after the results came in. Neither Johnson nor King spoke at all during the summer of 1966. That year's civil rights bill was defeated by a coalition of northern and southern Democrats who linked up with Republicans. And while Paul Douglas and other Democrats lost midterm elections in

1966, Daley's landslide reelection the next April by more than a half million votes (compared to only 140,000 votes four years before) reflected increasing white support for his home rule of Chicago. This freed Daley to be more aggressive in his control over funds for the War on Poverty and other federal programs. When the president's top domestic aide, Joseph Califano, called the mayor in 1967 and asked him to meet with HEW and OEO officials, Daley declined, saying he would not meet with federal bureaucrats who were trying to "take over the City of Chicago and run it." President Johnson, upon seeing the memorandum that summarized this call, sided with Daley, writing a stern note to Califano in the margin, "Joe: Don't do things like this without clearance."[50] While the Great Society policies might have empowered the poor and created new forms of class mobility for Chicagoans, the Johnson-Daley relationship took precedence, and the CFM did not challenge that key aspect of the urban status quo.

By sidestepping Chicagoans' class- and race-based critique of domestic and foreign policies, national movement leaders sidelined the chance for a broader working-class and multiracial campaign for peace, jobs, and justice for little gain in return. It was only after leaving Chicago that King and the SCLC developed an outspoken critique of the war, emphasized poverty and jobs, and reached out to Chicano and white allies to launch a broader Poor People's Campaign. Indeed, King returned to Chicago in March 1967 to help lead a peace rally. "The war is hurting us in all our programs to end slums and to end segregation in schools," he told Chicagoans, and "we need a radical reordering of our national priorities." This came one year too late. "Chicago," Al Raby concluded, "was an education for Martin." The CFM experience thus profoundly shaped Dr. King, but the tragic lack of synchronicity in 1966 narrowed a human rights movement into a largely ineffectual civil rights campaign.[51]

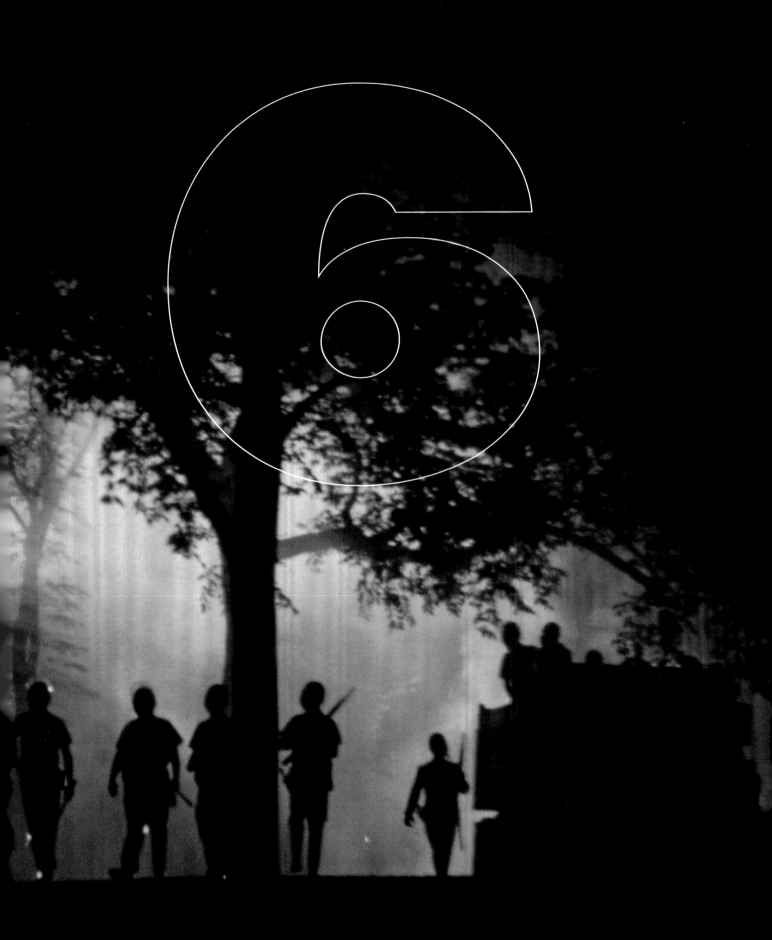

WELCOME DEMOCRATS AND BLACK POWER

In February 1967 the Nation of Islam (NOI) gathered at the Chicago Coliseum for its annual convention. NOI leader Elijah Muhammad was the featured speaker, but Art Shay also documented one of the most celebrated and controversial attendees: twenty-five-year-old boxer Muhammad Ali. Born Cassius Clay, Ali had changed his name after becoming the heavyweight-boxing champion three years earlier. In this photograph, Ali is not in the expected center of the frame, nor did Shay depict him in the context of the sport that had made him famous. Rather, Ali stands in solidarity with a faith movement that embraced its own form of Black Power. While some African Americans joined Ali in converting to Islam, many more respected his bravado and defiance of white authority. His fame and unapologetic Blackness drew controversy in 1966 when his draft status was inexplicably changed from 4-F (ineligible based on a low induction test score) to 1-A (available for unrestricted military service). Ali expressed disbelief to reporters that a man once classified as a "nut" could suddenly become a "wise man." He hinted that he would resist this new classification, saying, "I ain't got no quarrel with the Viet Cong." His attorneys soon filed paperwork appealing for reclassification as a Conscientious Objector (CO) on religious grounds.[1]

Ali's unwillingness to serve in the military grabbed international attention. As government officials and journalists condemned him as unpatriotic, antiwar activists venerated him as a symbol of resistance. A Selective Service spokesperson said that no Black Muslim had ever been classified as a CO, dismissing the NOI as a "militant sect."[2] In Chicago, where Ali lived, Mayor Richard Daley made several behind-the-scenes maneuvers to ensure that the Illinois Athletic Commission would keep Ali from fighting his upcoming bout in Chicago; the match was moved to Toronto, Canada.[3] Ali and others began to notice people watching his South Side home at Eighty-Fifth

and South Jeffery Boulevard as both Chicago's Red Squad police division and the FBI scrutinized his every move.[4] Major Chicago newspapers and, perhaps more surprising, the Black-owned *Chicago Defender* joined the national press in criticizing Ali. A *Defender* sports reporter asked four Black Chicagoans, all male and three of them policemen, whether Ali should enter the armed forces. All believed he should enlist.[5]

But those in the antiwar and Black Power movements rejoiced that Ali, the embodiment of Black pride and masculinity, might inspire others to join the growing chorus of dissent. They now had a louder megaphone from which to criticize the imperialist and militaristic ideology that suppressed freedom movements at home and escalated the war abroad. Activists exposed how the Selective Service reclassified the previously ineligible. This seemed to happen mostly to poor or working-class men of color. Black men, for example, made up 10 percent of the population but would account for 22 percent of battlefield deaths in the war.[6] After Ali refused induction, he was found guilty and sentenced to jail. He appealed to the Supreme Court. During the lengthy court battle (which Ali won in 1971), public opinion shifted, especially in Black communities. In May 1967, for example, the *Chicago Defender*'s editors condemned the World Boxing Association for stripping his title, admitting that Ali represented "an increasing number of young men [who] believe that the war in Vietnam is unjust" and "have the option of going to jail based on their moral convictions."[7] Ali's embrace of Black Power and refusal to serve symbolized the rising movements for peace and racial justice that brought a crescendo of street theater, activism, and violent repression to late 1960s Chicago.

The first stirrings came from Democrats who gathered in Chicago in December 1967, though their protests felt more like a cocktail party that featured an academic lecture than a true

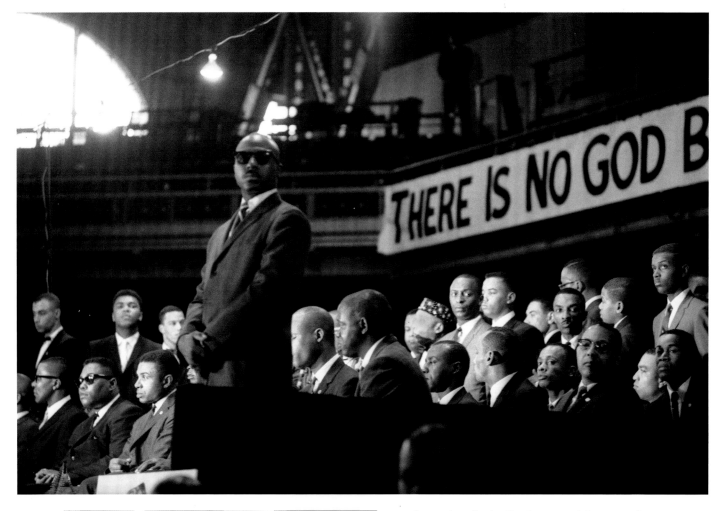

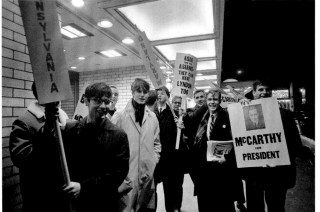

confrontation. At the Conference of Concerned Democrats, a mix of college students and middle-class professionals mingled in the ballrooms of the Sheraton-Blackstone Hotel and adjacent Conrad Hilton Hotel. Shay captured the scene, affirming in his photographs what reporters noted: "Few, if any, delegates were Negroes," and the well-groomed young men attending had an "absence of beards." Asked if they meant to "make trouble for President Johnson," an official statement implied that the delegates only sought to "change the policies of the leadership of the Democratic Party, or to change that leadership." Many of them had backed Johnson's ticket in 1964, but they now believed "his actions in Viet Nam and their consequences at home are leading the nation to disaster." The 400 delegates looked favorably upon Minnesota Senator Eugene McCarthy, who had

recently announced he would challenge the sitting president in the primaries. As keynote speaker, McCarthy called the Vietnam conflict "morally wrong" and said he would look "for an honorable, rational and political solution to this war."[8]

McCarthy's remarks and the entire convention drew conflicting reviews. One reporter noted that the speech was "greeted with less than over-whelming enthusiasm." McCarthy's "flat delivery" and "good sentences" were not "spellbinding," he claimed, but at least the audience "found a man whom they can live with as an anti-LBJ candidate." The majority of other delegates adopted a compro-mise permitting them to vote as individuals rather than endorsing McCarthy as a group. But another observer commended the delegates by contrasting them to other peace activists. "The aura of political professionalism was strong," he wrote, claiming that this was not "just another 'new left' debacle" such as the previous summer's fractious New Politics Convention in Chicago. Overall, the con-vention itself did not cause much drama. Mayor Daley publicly ignored it, but he and other power-ful Democrats fretted that so many middle-class, clean-cut whites now opposed President John-son. Democratic National Committee chairman John M. Bailey ridiculed conference co-chairman Allard Lowenstein as a fatalistic "Chicken Lit-tle." Such mockery of respectable dissenters portended something much less civil on the hori-zon, especially after the following month's Tet Offensive by the North Vietnamese army showed many Americans that the U.S. government's opti-mistic assessments about the progress of the war were exaggerations and even lies.[9]

The sky did fall on April 5, 1968, at least in Black neighborhoods across America. A day ear-lier, the world had learned of the assassination of Martin Luther King Jr. in Memphis. While some Black Chicagoans had criticized King's leadership of the Chicago Freedom Movement, most re-spected and admired him, and many on the West Side had met him when he resided in Chicago in 1966. King had recently taken more radical posi-tions, condemning the war, focusing on economic justice in Memphis, and planning for a national Poor People's Campaign. This more militant vision aligned him with many Chicago civil rights and

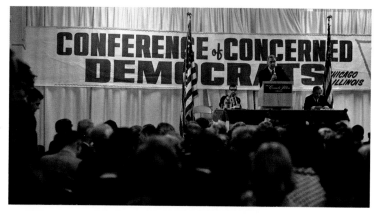

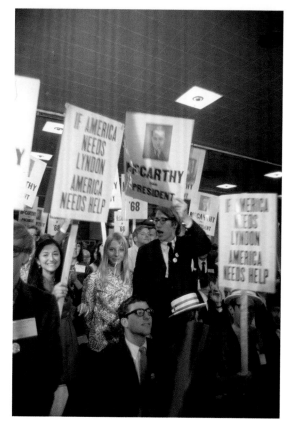

antiwar groups. But, as American Civil Liberties Union attorney Kermit Coleman explained, "King was only the immediate catalyst that activated a lifetime of frustration and inhibition" for Black West Side residents. *Life* dispatched Shay to Memphis, where he was one of the first photogra-phers to capture the murder scene, but he quickly returned home to capture what would become the largest "riot" in Chicago's history.[10]

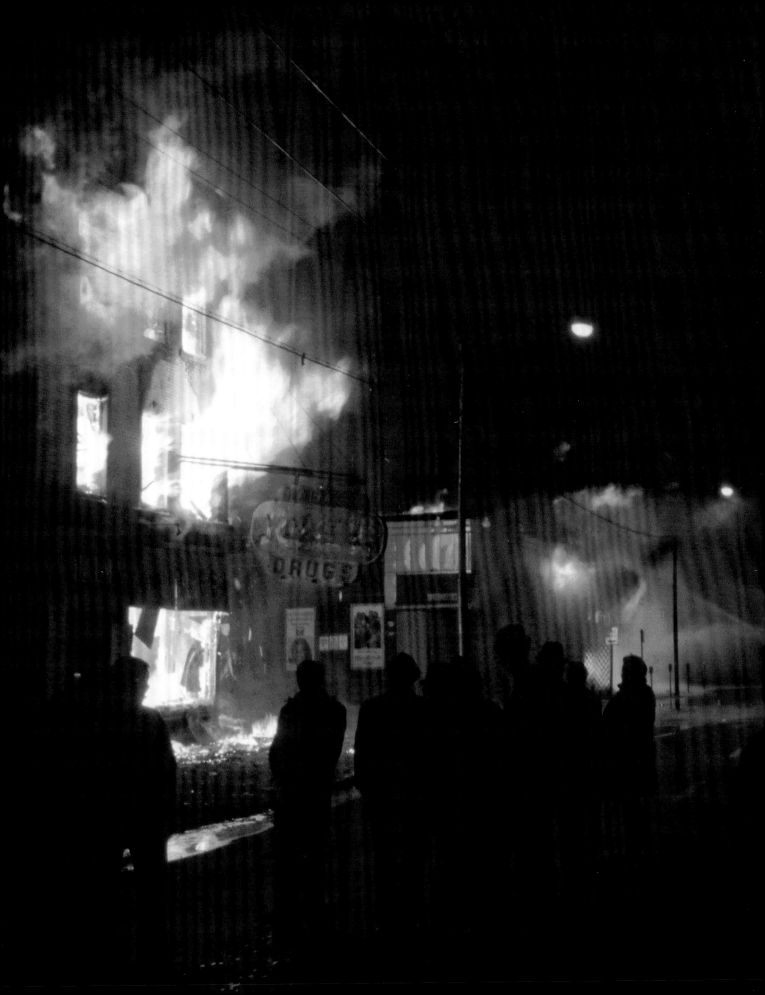

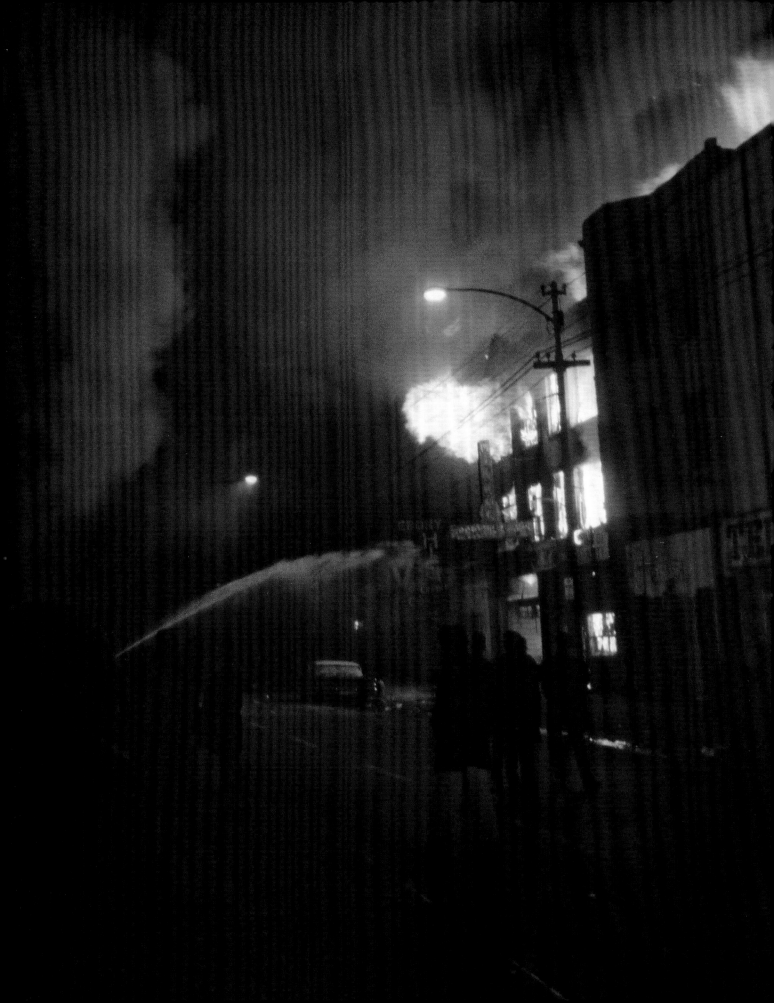

and other property. By late afternoon, the first fire broke out at 2235 West Madison Street, which prompted Mayor Daley to request 7,000 men from the Illinois National Guard.[11]

Fires and looting defined the weekend. State troops arrived late Friday night to join more than 2,000 CPD officers and 2,000 firemen in the conflict zone, working in twelve-hour shifts. By then the main east–west thoroughfares—Madison Street and Roosevelt Road—were ablaze. Shay chose color film to highlight the destruction and the residents and firemen looking on in fear and wonder. The fire chief declared it "the worst fire in the history of the fire department since the great fire of 1871." The uprising continued overnight, and Shay photographed the rubble in daylight. Overwhelmed, the new Police Superintendent James Conlisk requested the help of the U.S. Army. These 5,000 troops, many of them Vietnam veterans, occupied the West Side while the CPD enforced a curfew, sweeping the streets and arresting everyone in sight. By the end of the weekend, at least 175 buildings had burned to the ground. Tragically, ten people died—all Black and male, ranging in age from a ten-month-old baby to a thirty-two-year-old man—and more than 500 suffered injuries.[12]

The West Side uprising of 1968 deeply affected Chicago's citizens, politicians, and police officers. In the immediate aftermath, many journalists and even some Black Chicagoans commended the police and fire department for their restraint. Former Police Superintendent Orlando Wilson had retired the previous year. He appealed to his deteriorating health, but his disagreement with Mayor Daley over how to handle activists in the streets likely played a part. Wilson handed the reins to his protégé James Conlisk Jr., a very different type of leader. Conlisk came from a police family in Chicago—his father was on the CPD and a friend of the mayor—and he lacked his predecessor's national reputation and independent judgment.[13] Even so, Conlisk largely followed his mentor's playbook during the April insurrection. Police knew they were prohibited from firing into crowds or buildings unless an officer above the rank of captain authorized it and they could see their target. As a result, one reporter concluded, any police officer "could be forgiven for keeping the safety on his pistol."[14]

Teenagers began the uprising that soon spread to several West Side neighborhoods. Black students at five Chicago public schools had already been planning walkouts over unaddressed poor conditions when they heard the news of Dr. King's death. The next morning, Friday, April 5, a group of angry students walked out of Farragut High School, moving westward from school to school until police at the farthest west high school in Austin turned them back eastward, where they then converged with employees (dismissed early from their jobs) and neighborhood residents. Some began looting white-owned businesses

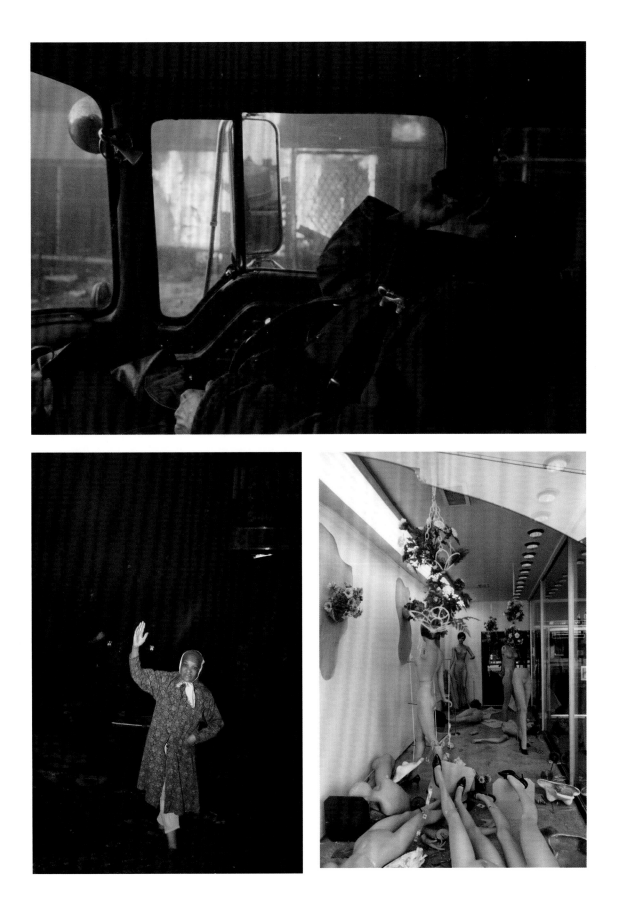

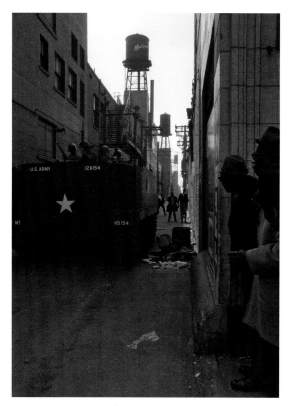

Despite at least seven deaths by police shooting, restraint became the consensus interpretation even as Conlisk followed Wilson's more subtly aggressive police policies. During the April uprising, regular CPD officers were supplemented by at least 300 Task Force officers, who had become notorious for their stop-and-frisk tactics and other civil liberties abuses. Wilson had openly criticized recent Supreme Court decisions that provided more rights to defendants and had lobbied for an Illinois stop-and-frisk law (which only cleared the state legislature in 1968, one year after he retired). Using this approach, the CPD injured more than 500 and arrested nearly 3,000.[15] More abusive yet less visible was the fate of these Black Chicagoans after their arrests. Many of those arrested were merely standing in doorways or on sidewalks as police used broad discretion in clearing the streets. From there, "the administration of justice bogged down," according to an ACLU attorney. This was quite an understatement, as several months later many had yet to post bond or even get a hearing that listed the charges against them.[16]

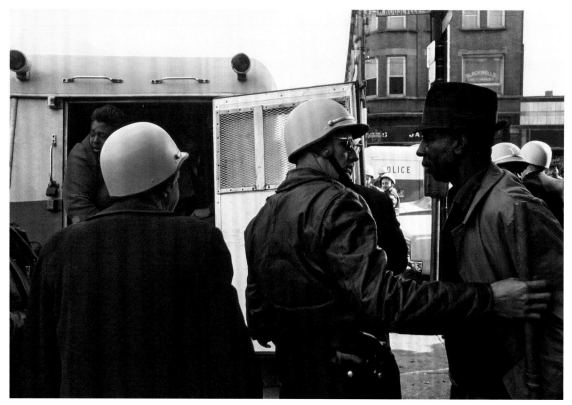

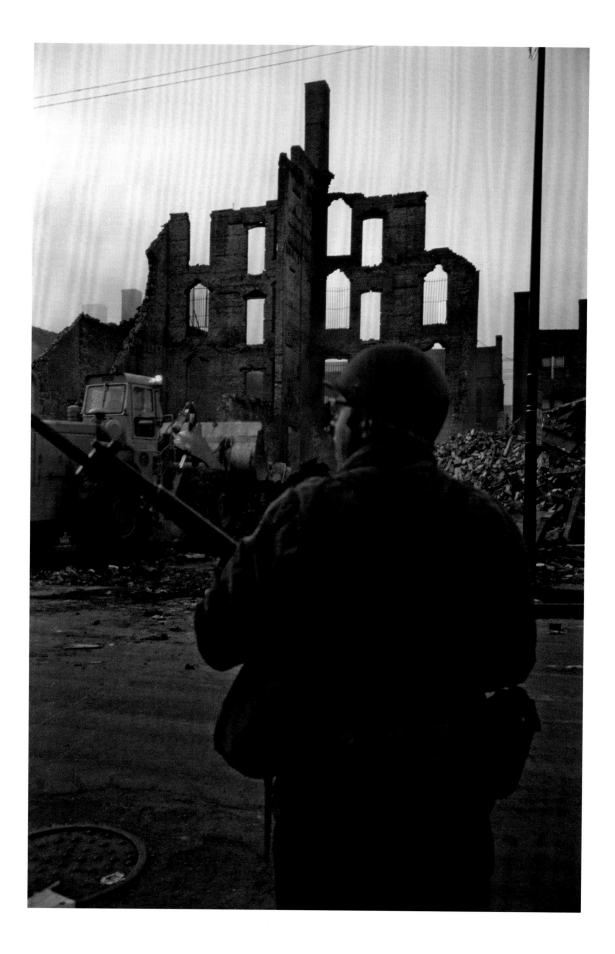

Many West Siders endured their purgatory in the Cook County Jail, where 75 percent of detainees were awaiting trial or court action. Shay got access to the jail once more, and his photographs show overcrowded, dreary conditions for a population of largely young Black men. A 1967 investigation by the Cook County grand jury confirmed these conditions. The fact that twenty-one out of thirty-two tiers had no sink or toilet in their cells meant that many cells had to remain open to allow for bathroom access after the ten p.m. lockdown. This permitted inmates to roam around at night "beating and sexually assaulting other prisoners." Guards routinely spat, threw hot water, and struck inmates, and they delegated power to "barn bosses," who controlled the flow of contraband and meted out abuse in each tier. Eight people had died the previous year in the fights that commonly broke out between inmates. Survivors had no way to complain; the medical treatment facility offered insufficient privacy for victims to explain their injuries, and barn bosses could access the complaint boxes in each tier. The jail had also begun segregating the inmate population by race. This was ostensibly to protect the minority white population, but the report noted that "young Negro inmates" in particular remained vulnerable to abuse. The grand jury condemned the facility for its "deplorable day to day operations" but pessimistically noted that "public apathy" permitted Cook County Jail Superintendent Jack Johnson and Cook County Republican Sheriff Joseph Woods to operate with impunity.[17]

Richard Daley's infamous call to arms at a press conference ten days after the April "riot" was thus surprising because he had faced only mild criticism for how the CPD had handled it. Daley explained that during the first day of the uprising, he met with Superintendent Conlisk to give him instructions. "I said to him," he told the reporters, "shoot to kill any arsonist or anyone with a Molotov cocktail in their hand in Chicago to fire a building because they're potential murderers." Black leaders, clergy, white allies, the ACLU, and even the relatively conservative board of the City Club of Chicago all condemned the mayor's comments. Many concluded that the mayor either did not care, was completely out of touch

with the city's Black population, or both. "He *has* visited the black ghetto," radio personality and journalist Studs Terkel later recalled about Daley's response to this uprising. "He flew over the areas in a helicopter. Like an American colonel surveying a Vietnamese village. He was contemplating pacification." The mayor's comments also made international headlines that "brought down a storm of criticism upon [Daley's] head," especially when U.S. Attorney General Ramsey Clark spoke out. "I do not believe deadly force is permissible, except in self-defense or when it is necessary to protect the lives of others," Clark told a convention of newspaper editors. "We need to be constructive," he said, and to "resort to deadly force" would cause a "dangerous escalation of the problem."[18]

Daley tried to soften his comments in a carefully crafted statement to the city council, but he remained far from apologetic. Moreover, he felt validated by ordinary Chicagoans' praise for his caustic rhetoric. He claimed that mail he received after the press conference supported his policy by 15–1. These letters, as well as conservative newspaper editorials and letters written to the attorney general, do indicate that many white Americans backed Daley's extreme law-and-order approach. "I am glad to say we have a champion in Mayor Daley," one typical letter from a posh North Lake Shore Drive address stated. This letter was accompanied by twenty-eight signatures of "friends," many of whom who listed suburban Chicago addresses. Others were more blunt, "You are Wrong and Daley is Right on these SAVAGES BURNING AND LOOTING," Bill Valeski from Cicero, Illinois, wrote. He ended his rant by telling Clark he would do his part to vote Democrats out of Washington and signing off, "[George] Wallace for President." City employees got the message, too. On April 11 the city council passed several new ordinances that gave officers more leeway for stopping disorderly conduct, trespassing, and resisting arrest, including "any unreasonable or offensive act, utterance, gesture or display" an officer perceived as a "breach of the peace." Police Superintendent Conlisk answered Daley's charge by requiring all police stations to read these new rules at roll call each of the next four days. He then followed up with new general orders of his own that authorized

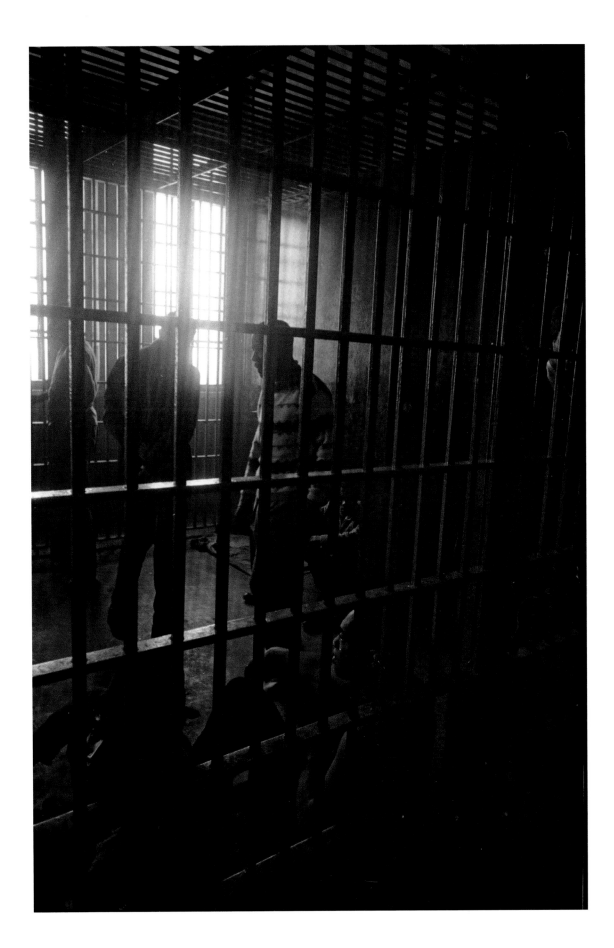

riot helmets, chemical Mace, and a shotgun in each squad car.[19]

Several journalists related Mayor Daley's visceral reaction to the April 1968 West Side insurrection to his hosting of fellow Democrats in August. "He was terribly upset," one *Washington Post* reporter discovered, "at the prospect that Chicago might lose the Democratic National Convention to another city." The previous October, Democratic Party officials informed Mayor Daley that they would hold their convention in Chicago, but Daley believed that was contingent upon his muting protestors. As Daley's communications with the White House confirmed, he advised Johnson to "develop a better way of explaining what's going on" in Vietnam because "we are losing people on this issue." Johnson's response was to announce in late March that he would not seek reelection, which surprised the nation and depressed Daley, who hoped that he would reconsider.[20]

Three days later, an antiwar demonstration seemed to confirm what one historian called "the mayor's darkest nightmare": Black Power and antiwar advocates were planning to unify for mass demonstrations at the upcoming convention. Several months earlier, the notorious comedian and activist Dick Gregory told President Johnson in an open letter that selecting Chicago for the convention was "a cruel insult" to "millions of deprived citizens" there. He threatened to demonstrate unless the mayor met a list of civil rights demands. But after the April uprising, Gregory reconsidered, holding a press conference to explain that the situation in Chicago was too "combustible" to ensure nonviolent demonstrations. This retreat and intelligence reports on the disorganized planning for convention protests seemed to indicate this "nightmare" would not come true. But then the police department's Red Squad intelligence unit and advertisements for a planned protest on April 27 suggested these dissenters could get together. Advertisements emphasized that protesting would "Honor Dr. King" and linked "self-determination for Black Americans" with "self-determination for the Vietnamese." This march also threatened Mayor Daley politically, as the Chicago Peace Council announced that the main speaker would

be A. A. "Sammy" Rayner Jr. The previous year, the Black undertaker had won as an independent candidate in the Sixth Ward alderman race. He became one of Daley's fiercest critics in the city council, providing what the *Defender* called the "most adamant" rebuke of Daley's "shoot to kill" comments. Calling Daley a "fascist racist" and his comments "inflammatory," Alderman Rayner said the mayor's rhetoric would "make even the best non-violent person mad as hell," adding, "I guess he's trying to muster support for the Democratic Convention here."[21]

The CPD's actions during this downtown "March Against Racism and War" confirmed officials' new intolerance for the rights of assembly and free speech. The city refused to issue a permit until a lawsuit forced a reluctant compromise that allowed demonstrators to march on sidewalks only. The Parks Department was supposed to provide sound equipment, but it failed to do so, which meant the participants could not hear instructions from organizers or from Rayner and the other featured speaker, Roosevelt University sociology professor St. Clair Drake. When between 5,000 and 6,000 demonstrators wound their way through the downtown Loop to the Civic Center Plaza, they ignored some temporary construction barriers because no construction work was happening and another event had used the plaza the week before. Police took this as a sign of disobedience and began to push confused people into side streets and away from the plaza except for about 250 people who staged a sit-in. Police told demonstrators to drop their signs and placards, sprayed them with their newly issued Mace, and began beating protestors and anyone else along the sidewalk. While one officer called this "textbook crowd control," others later admitted they knew this was an expected and aggressive response against a peaceful demonstration. "The widespread crapolla that took place after King got killed," one officer surmised, "bled into the Civic Center thing. Sure. We were on notice. And I don't think it was a secret." Another confirmed, "Daley was pissed in April," and that certainly "led to what happened during that peace march" because "the word was out that officers were gonna get a few free swings—it was good for their jobs to do it."[22]

As important as the confrontation itself was the newspapers' weak coverage. The *Chicago Defender* ran advertisements and stories leading up to the event but overlooked the violent result. The conservative *Tribune* gave the most extensive coverage, but the headline read "Anti-War Protestors Battle Police" and featured a photograph of injured Police Commander James Riordan, whom a woman had hit on the head with a protest sign when he commanded her to discard it. Shay was not there to document this melee, but photographers who were present suffered injuries by police who also broke their cameras and exposed their film. Despite this official silence, local activists and concerned citizens responded. The ACLU wrote an open letter containing evidence of "threatened violence" by police officers "before any disorder was apparent"; the NAACP's West Side branch filed a lawsuit on behalf of four young Black men who were beaten; and others wrote in protest, including one woman who complained to Daley of the "Hitler tactics" meted out by the "so-called guardians of law and order." Edward J. Sparling, president emeritus of Roosevelt University, formed a nonpartisan committee that studied the demonstrations and issued dispassionate recommendations that outlined how the city and police had mishandled the situation. Mayor Daley ignored it all, letting the CPD's actions speak for themselves.[23]

The police response to the April disorders told those planning to come to the Chicago convention to expect violence. When Soviet-led Warsaw Pact troops marched into Czechoslovakia to crush the Prague Spring reform movement, Mayor Daley called it a "dastardly act of suppression of freedom and liberty," but his own preparations for the convention suggested a similar containment of civil liberties. In the months before it, the mayor's office stonewalled all requests for permits or to use the city's parks at night. Worried that people would come to Chicago and find a hostile police department and no place to sleep, the Chicago underground comic the *Seed* warned its readers that "Chicago may host a festival of blood." Students for a Democratic Society (SDS), which would later participate, hesitated to build coalitions with liberals; it did little to help organize even as many

individual members and founders—such as Rennie Davis, Tom Hayden, and Carl Oglesby—supported it. Moderate peace activists were also told to stay home. After conferring with Daley, peace candidate Eugene McCarthy dissuaded his supporters from coming to the convention. The Coalition for an Open Convention did the same when Judge William Lynch, Daley's former law partner, ruled against their appeal for a permit to assemble in Soldier Field.[24]

The only political news that saved the demonstration from outright cancellation was activists' vitriolic response to Hubert Humphrey entering the race. The vice president had refused to denounce Johnson's foreign policy and was predicted to win a first-ballot nomination for president at the convention without having won a single primary. To the Yippies, a group of self-proclaimed politicized hippies, Humphrey was the perfect candidate to combat with absurd antics: he made the Democrats look "fat, ugly and full of shit." To New Leftists, he represented the opposite of participatory democracy. And the relatively modest McCarthy supporters viewed Humphrey as unprincipled by comparison to their own candidate. Many of them defied the warnings and went to Chicago.[25]

Before protestors arrived in Chicago and the official convention began, the credentials committee hearings featured significant challenges to the Democratic Party. These debates were overshadowed by the subsequent activity in the streets, then and in later accounts, but Shay photographed them. Julian Bond, the former SNCC leader turned Georgia politician, made a strong case for seating an integrated delegation rather than the all-white group handpicked by segregationist Governor Lester Maddox. The credentials committee was somewhat sympathetic, agreeing to split the Georgia delegation. It also seated the entire Mississippi Freedom Democratic Party delegation and demanded that the Alabama delegates swear an oath of allegiance to support the nominee rather than third-party candidate George Wallace. The convention rules committee denied McCarthy delegates' other efforts to "wrest the nomination away from Vice President Humphrey," but the challenges it did accept foreshadowed a shift as

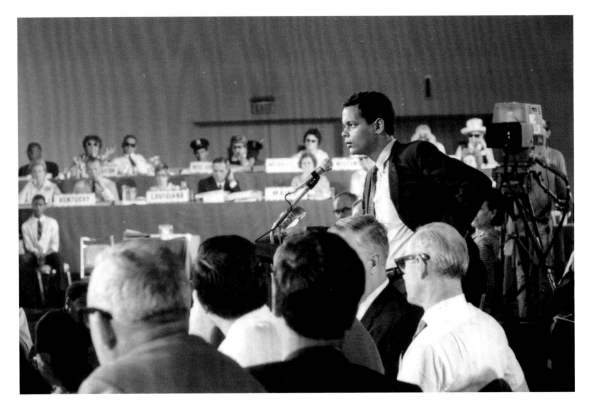

Democrats began to embrace more democratic primaries in the South. These new delegates then voted for the Vietnam peace plank that ultimately was defeated by votes from states like Illinois, whose selected delegates voted overwhelmingly against it. This seemed unrelated to the host city of Chicago, but at least one journalist noted that while Blacks could vote in Illinois, they "have little say in the patronage-dominated machine of Cook County" due to Daley's "iron grip on the political process" and support from "business and financial interests, often apparently with Republican backing." While the "iron grip" tightened through law-and-order politics at the local level, pundits wondered whether Daley represented the Old Guard of a party on its way out, suggesting his power as a presidential kingmaker was declining. And these mutterings came *before* the convention and concomitant protests even began.[26]

Once the convention opened, the Yippies and the Mobilization Committee to End the War in Vietnam (Mobe) had to make the most of the hand that they were dealt. Expecting 100,000 people, only 2,000 people came from out of town.

Their ranks swelled to 10,000 by midweek. Further complicating their convergence that Saturday, each group viewed the other with suspicion. The Yippies, formed earlier that year by a few New Yorkers with allies at the Chicago *Seed* underground newspaper, wanted to use the counterculture to redefine radical politics. As Abbie Hoffman described it, the "Yippie idea" of "blending pot and politics" for a "gigantic get together" might just lead to the "development of a model for an alternative society." Their tactics included "revolutionary action-theater items" and a "Festival of Life in Chicago" to contrast the Democrats' "National Death Party." Mobe's chairman, David Dellinger, found the Yippies hedonistic and irresponsible. The fifty-two-year-old statesmen for a younger group of New Left activists, Dellinger had spent three years in jail for refusing the draft in World War II. To him, activism was serious business. But he was open-minded about New Leftist ideas in Mobe that might "forge a creative synthesis of Gandhi and guerilla" for the upcoming convention.

Mobe leader Dellinger coordinated with a third key, if underappreciated, group: activist networks already in Chicago. Its local coordinator was Rennie

Davis, who had moved to Chicago to work with SDS's Economic Research and Action Project in the Uptown neighborhood. Davis argued for a massive demonstration to show "escalation of militancy" by the peace movement, pressure the Democrats to revise their war policies, and radicalize and pull together the deeply divided peace and racial justice movements. He did not want to disrupt the convention, but like other radicals in the Mobe coalition, he believed that the days of parades or lobbying for a peace plank within the Democratic Party were over. New tactics and ideas were needed to produce lasting, systemic social change.[27]

Assigned to cover all aspects of the convention for *Time* magazine, Shay hinted at the differences between the official convention and the circus-like sideshow in his earliest photographs. They also jumbled preconceived notions of these two concurrent happenings. His black-and-white photograph of the International Amphitheatre showed its isolation in the old packinghouse district, more than forty blocks south of downtown. Fifteen hundred police guarded and patrolled its barbed-wire perimeter. Delegates called it "Fort Daley" since it felt more like an enemy compound than a patriotic venue. Shay also took seemingly innocuous photos of electricians installing equipment in the Amphitheatre, whose unionized workers had just settled their strike against the City of Chicago. The press speculated that this backroom deal might have been why electricians refused to hook up any live relay or color television equipment to be used outside. This refusal, much to the mayor's approval, limited television producers from filming anything beyond the official proceedings.[28]

Reversing the city's emphasis on the convention and blackout of the demonstrators, Shay's staid black-and-white images of the venue contrasted with colorful images of the protestors in Lincoln Park. Some of these photographs may have confirmed stereotypes about hippies, including drug use ("LSD Line"), another with Beat poet and guru Allen Ginsberg chanting "om" in a meditation circle, as well as one of two longhaired young men kissing on the grass. But Shay also captured an interracial drum circle, people gathering around poster-sized newspapers to get the latest news,

and even some local working-class "greasers" embedded in the crowd. Meanwhile, his photos of the official Democratic Party welcoming committee revealed a different kind of circus, including an older man dancing on the top of a float with two women and a group of men in kilts playing bagpipes to greet Hubert Humphrey's arrival. Shay also infused some humor into a photograph of Mayor Daley at a press conference, lining him up with an arrow on the wall for a fire extinguisher. These photographs asked whether the "freaks" in the park were any more absurd than the people inside the official convention.[29]

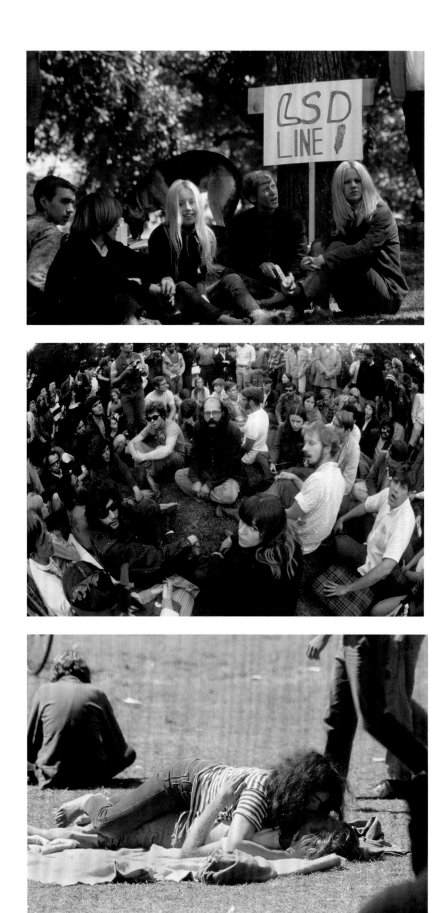

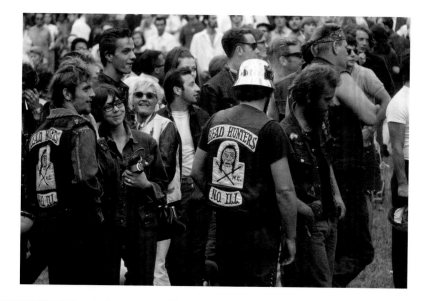

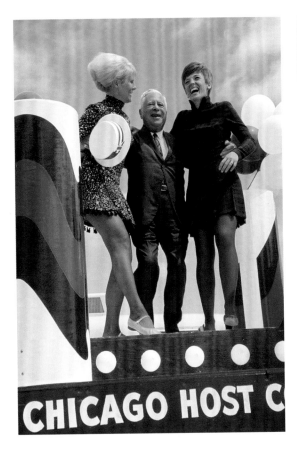

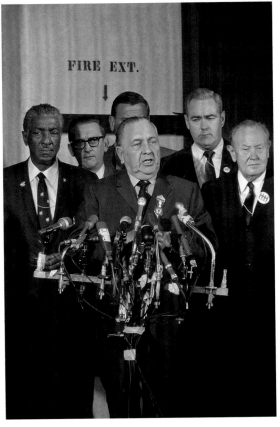

The spectacle in Lincoln Park drew attention, but it certainly was not newsworthy until the CPD got aggressive with the people there. Chicago law enforcement more than doubled its presence, with approximately 12,000 CPD officers, 1,000 FBI officers, 5,000 Illinois National Guard troops, and 5,000 U.S. Army troops on standby. "Never before," Chicago journalist Mike Royko quipped, "had so many feared so much from so few." The first stirrings of trouble began on Sunday night when police forbade the Yippies from using a flatbed truck as a stage for their "Festival of Life." The only band that showed up, Detroit's brash MC5, had played a raucous set on the grass until the electricity went out. At dusk a scuffle over the truck grew into a series of confrontations. Many police removed their nameplates and clubbed their way through parts of the park, drawing energy from the crowd's taunts. Officers went after several Yippies and Mobe leaders, but others got hurt, too. One witness saw a medic hit by a police club. When he

said, "I'm a medic," the policeman said, "Excuse me," and hit him again. Once the eleven p.m. curfew hour arrived, police cleared the park. The night before, police had allowed demonstrators fleeing the park to gather in the adjacent North Side "hip" Old Town neighborhood only to be "reamed out" when they returned to the station.[30]

On this night and subsequent ones, police not only clubbed people to clear the park, but continued to harass and beat them and other bystanders. A group of clergy tried to mitigate the violence, hauling an eight-foot wooden cross into the park for a prayer and song service there. Violence escalated after a group of demonstrators erected a 35-foot-long barricade and tried to hunker down after the curfew. Police lobbed smoke bombs and, using an army-issued dispenser rigged to a sanitation truck, sprayed the entire park full of tear gas. With Task Force officers leading the way and apparently chanting, "Kill, kill, kill," the police marched into the park with weapons raised, and

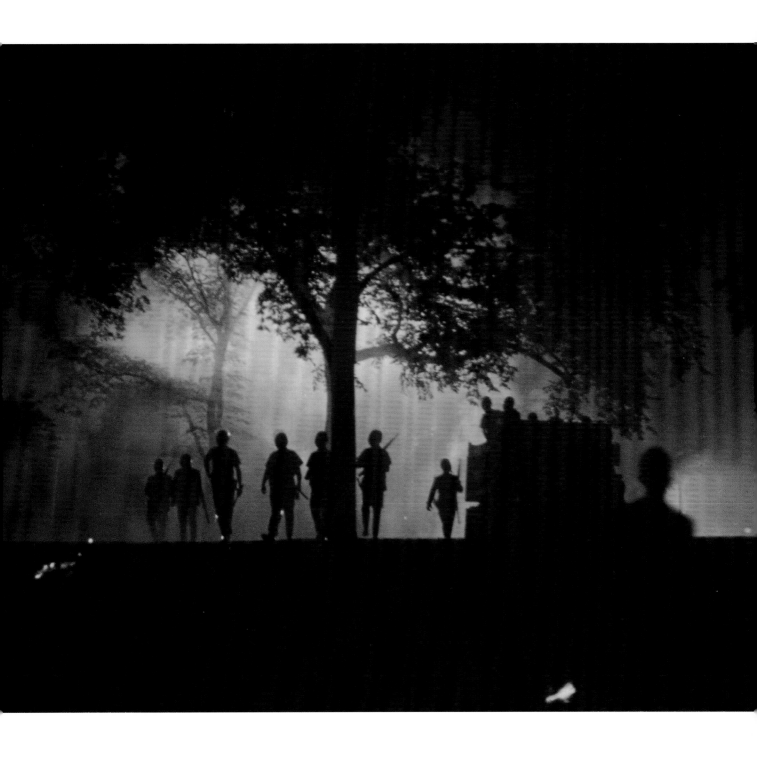

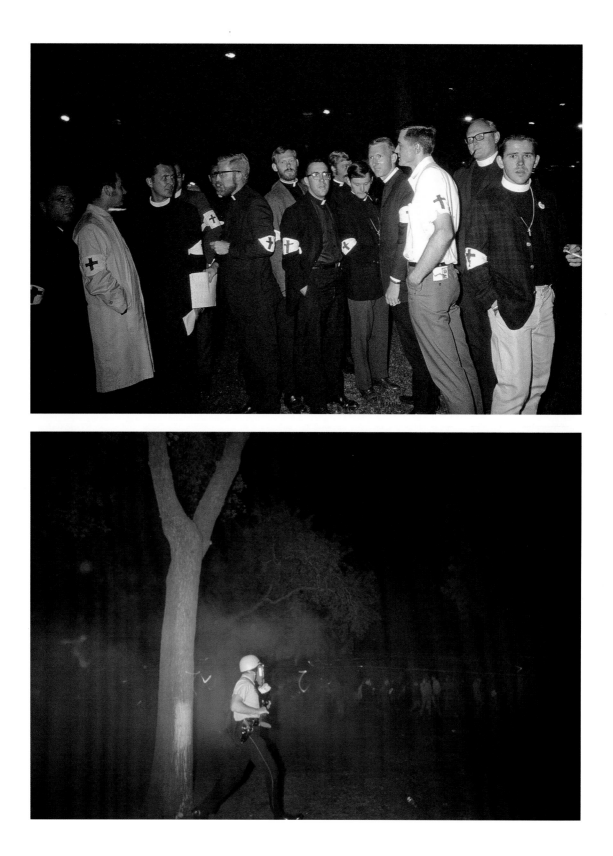

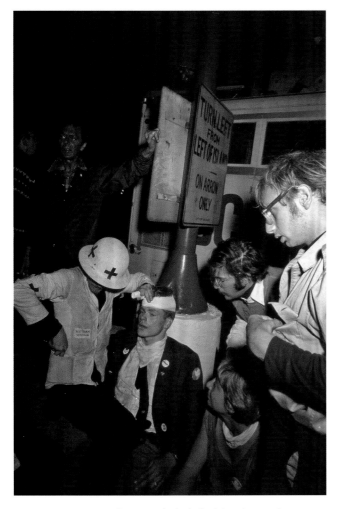

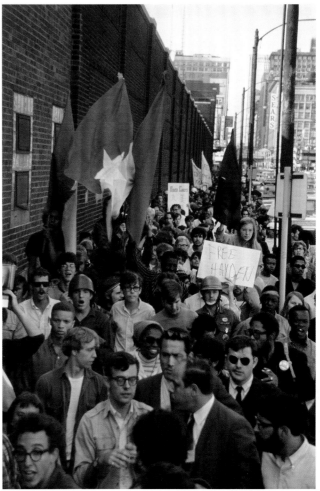

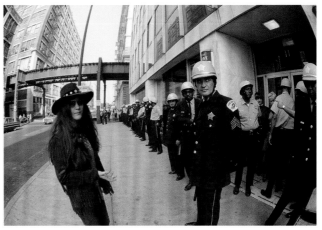

everyone, clergy included, fled for their safety. Shay captured the smoky scene, taking photographs on the run out of the park and into the combative side streets of the neighborhood. "No one could accuse the Chicago cops of discrimination," a *Time* magazine reporter concluded, since they "savagely attacked" everyone.[31]

"The streets are for the people," demonstrators chanted, as they made their way beyond the Near North Side and into the city's other urban spaces. Earlier on Monday, Rennie Davis and others had marched from Lincoln Park to the CPD headquarters just south of downtown to protest the arrest of Tom Hayden and another New Left leader. Between 500 and 1,000 people joined, and Shay captured the enthusiastic faces of a racially diverse group of self-defined revolutionaries who waved the Viet Cong flag. They also marched in

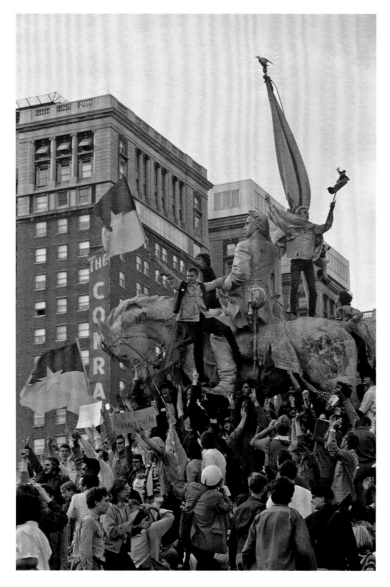

than simply ignore them, police took back the statue, scuttling people into the park except for one young man who refused to dismount. Several police dragged him from the statue, breaking his arm and beating anyone else nearby, including a "hippie girl," whom Shay tried to rescue. An officer clubbed his right hand, giving Shay a "crooked finger"—a lifelong memento of the convention.[32]

The violence continued on Tuesday, when New Left demonstrators put forth political visions of their own. Yippie leader Jerry Rubin introduced Black Panther Party chairman Bobby Seale, who gave an impassioned speech about the need for self-defense in Lincoln Park. This Black Power rally drew many young African Americans to the North Side. Rubin next led a march of several hundred people to a nearby Chicago Transit Authority bus barn. They demonstrated there in solidarity with the Concerned Transit Workers, a group of African American bus drivers who had called a wildcat strike demanding a more democratic and militant union. A massive Black Power and white leftist alliance did not materialize at the convention, but this demonstration proved that all African Americans, in the words of one Black activist, did not dismiss the convention as a "white folks' thing."[33]

Later that night, several thousand made their way to the Chicago Coliseum, where they had an emotional evening of speeches, poetry, music, and more. The gathering was intended to celebrate President Johnson's sixtieth "Un-Birthday." He had not only dropped out of the presidential race but decided not to appear that evening at the Democrats' official birthday party for him in Chicago. The crowd voiced some anti-LBJ chants and staged their own countercultural event. Inside the venue, Shay photographed people burning their draft notices and cheering the speeches of a wide-ranging group, including the Yippie Abbie Hoffman and folksinger Phil Ochs, whose protest songs "The War Is Over" and especially "I Ain't Marching Anymore" had become part of the counterculture. When Ochs sang, "Call it 'Peace' or call it 'Treason,' / Call it 'Love' or call it 'Reason,' / But I ain't marchin' anymore," the crowd cheered, chanted, and some people even wept. Thanks to the Yippie ally Ed Sanders of the Fugs rock band, local underground bands performed as well. One

a single column as Mobe marshals ensured that they stayed on the sidewalk and obeyed traffic signals. The marchers arrived at the station to find it ringed with police. Davis and others saw danger in trying to confront them there and led the people back to Grant Park across from the Conrad Hilton Hotel. This space was significant because the delegates stayed in that hotel and it was one of the few locations where mounted television cameras were permitted. There, exclaiming, "Take the hill," they ran up a small mound and swarmed the park's statue of Civil War General John A. Logan for a spontaneous and photogenic rally. Rather

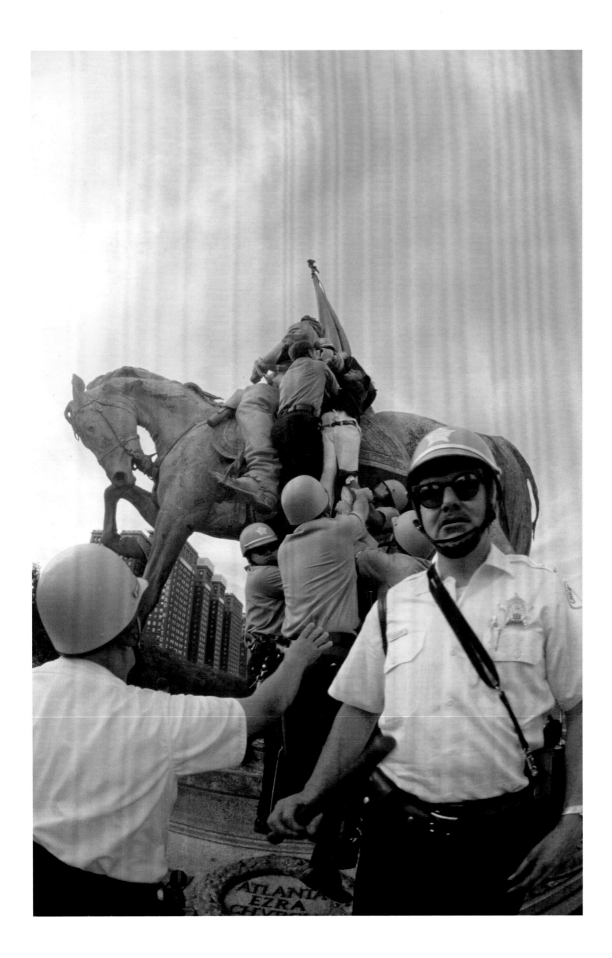

attendee declared that the Coliseum event felt like a religious "revival meeting." Both this event and the earlier Black Power gathering in Lincoln Park convinced activists that their purpose was far greater than protesting the Democratic Party's policy on Vietnam. Rather, they were imagining a more meaningful and peaceful democratic society. About 2,000 people ended the evening by marching from the Coliseum back to Grant Park, where the police—relieved by the National Guard at two a.m.—allowed them to stay overnight.[34]

By Wednesday both activists and the police engaged in street theater for the convention's climatic scenes. During the day, more than 10,000 people congregated in Grant Park, where they listened to speeches at the Band Shell in the only permitted event of the week. The police department stationed several hundred uniformed officers and many more in plainclothes throughout the park. Based on the assumption that people in the park would be kinder to Black officers, they were made to hand out flyers that warned they would stop any march to the convention site. The large crowd listened to an array of serious political

speeches, but there were moments of levity too, such as when Allen Ginsberg placed a flower in the pocket of Dick Gregory (with Bobby Seale looking on in the background) or when Pigasus, the Yippies' 145-pound hog and nominee for president, made a surprise return appearance. They also listened to their transistor radios to learn that the peace plank was voted down at the convention, which led many disillusioned McCarthy workers to join the crowd in Grant Park. That afternoon would have remained pleasant except for police officers' overreaction to a person who climbed the flagpole and lowered the flag to half-mast—supposedly to signify the defeat of the peace plank at the official convention. His capture and arrest led others to take the flag down and replace it with a red T-shirt. That prompted police to break into the large crowd and begin beating people in broad daylight. The crowd responded by throwing objects back at the police line. When Rennie Davis ran over to the area to try to organize Mobe marshals to protect bystanders, police yelled, "Get Davis!" and beat him unconscious. The event resumed, but Tom Hayden lost his temper after seeing his friend Davis and many others get injured. "Let us make sure that if blood is going to flow," he said, "let it flow all over the streets of the city."[35]

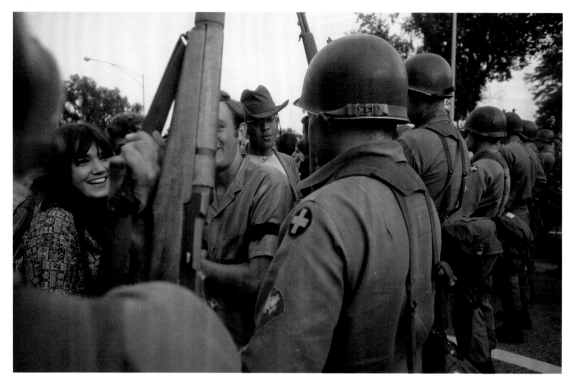

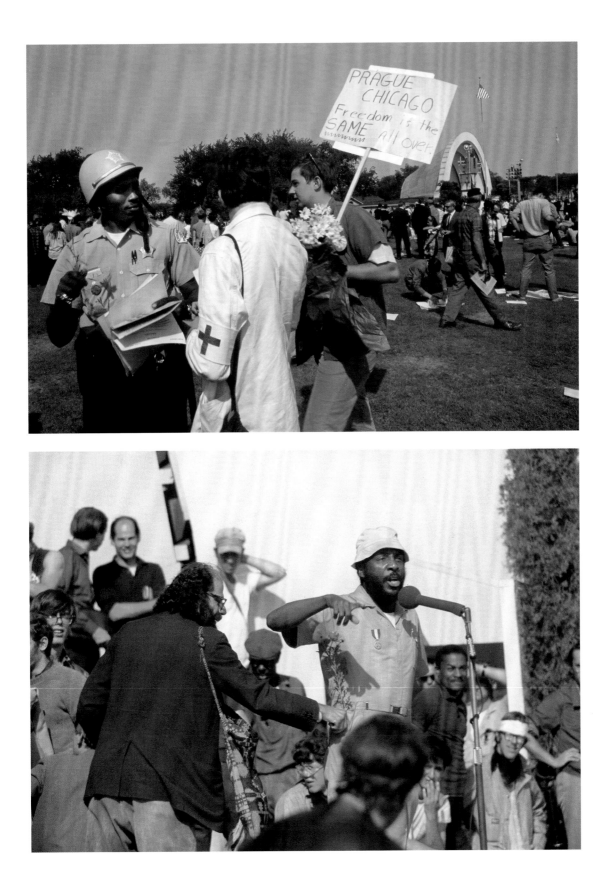

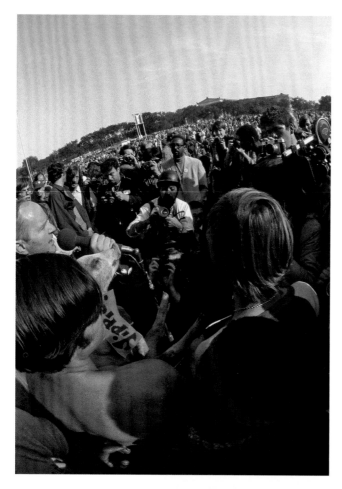

Blood did flow that night, but just in one downtown area. The master of ceremonies, David Dellinger, tried to calm the crowd and told them to assemble along the sidewalk at Columbus Drive and attempt to march to the Amphitheatre. He stressed they would be nonviolent, declaring, "If you're looking for trouble don't come with us." At least 5,000 people sat idle and frustrated on the Columbus Drive sidewalk, including French poet Jean Genet and the American Beat poet William Burroughs, who had earlier praised the crowd for "doing something workable about an unworkable system." But police refused to let them march, and National Guard and army troops blocked the bridges leading out of the park (over the Central Illinois Railroad tracks). Many assembled back in the park across from the Hilton, but others felt trapped and eventually found a way to cross the street at the Jackson Boulevard overpass, gathering on the corner of Balbo Drive and Michigan Avenue in front of the hotel. Adding to the crowding and confusion, the SCLC Poor People's Campaign Mule Train arrived in front of the Hilton on a police-sanctioned march. The Mule Train, symbolizing rural poverty and accompanied by Black demonstrators in farm clothes, was allowed to pass, but it further excited the crowd and hemmed it in between Michigan Avenue and the hotel's windows.[36]

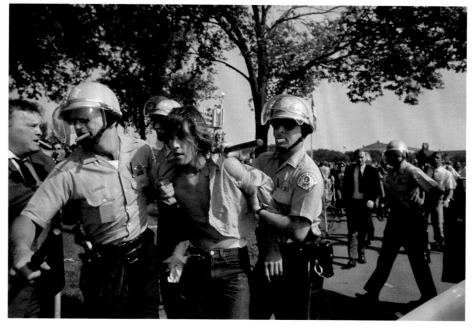

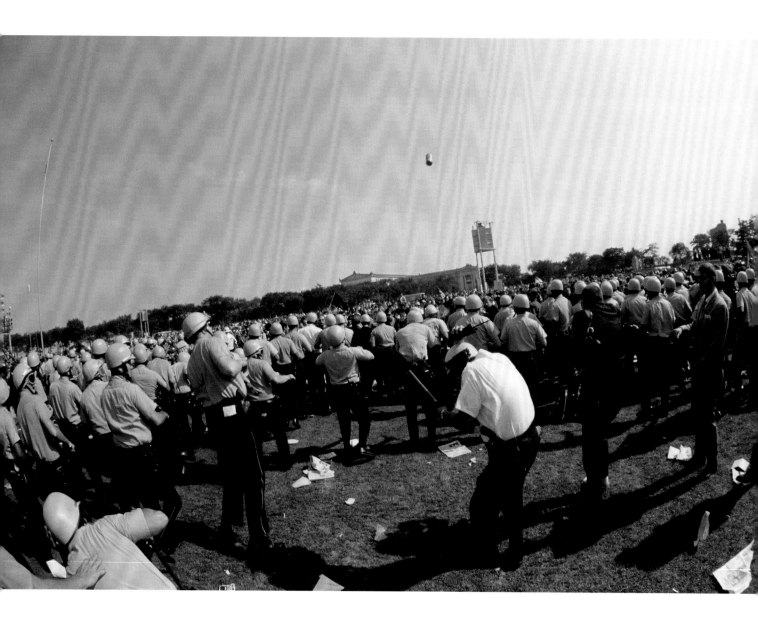

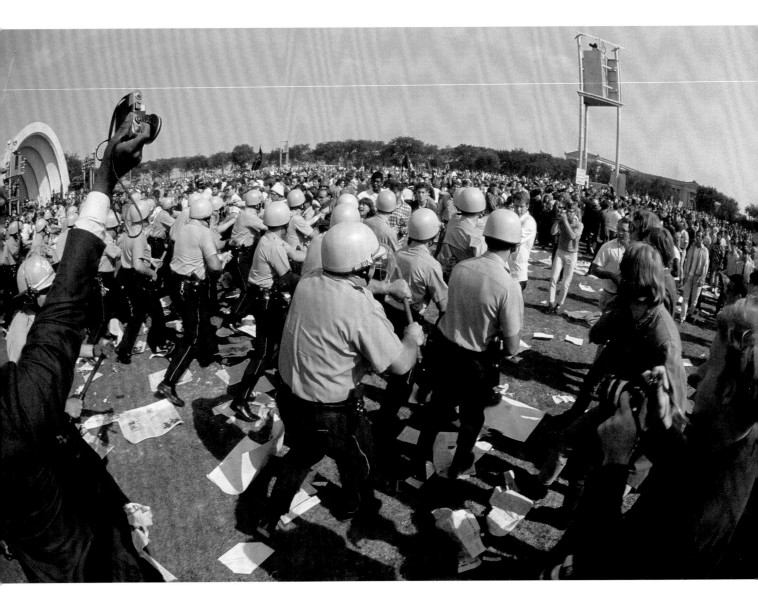

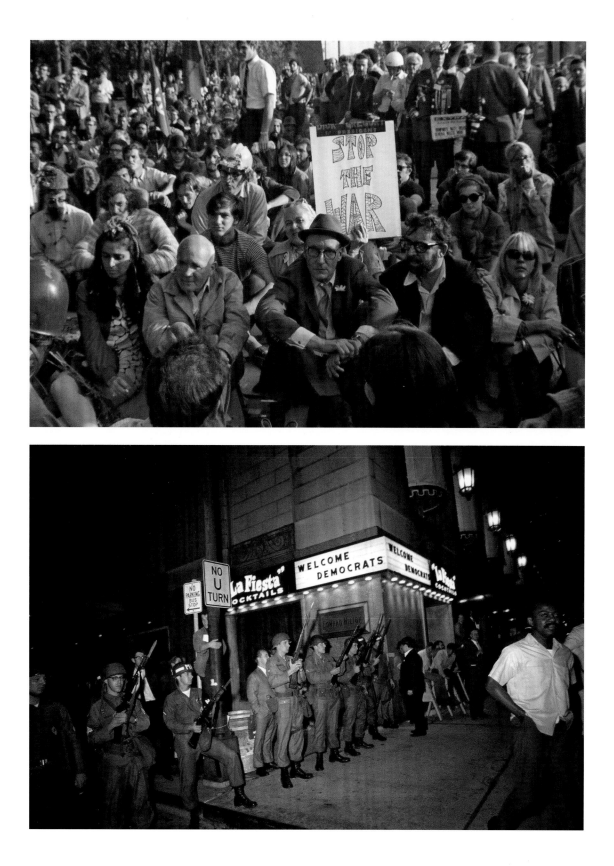

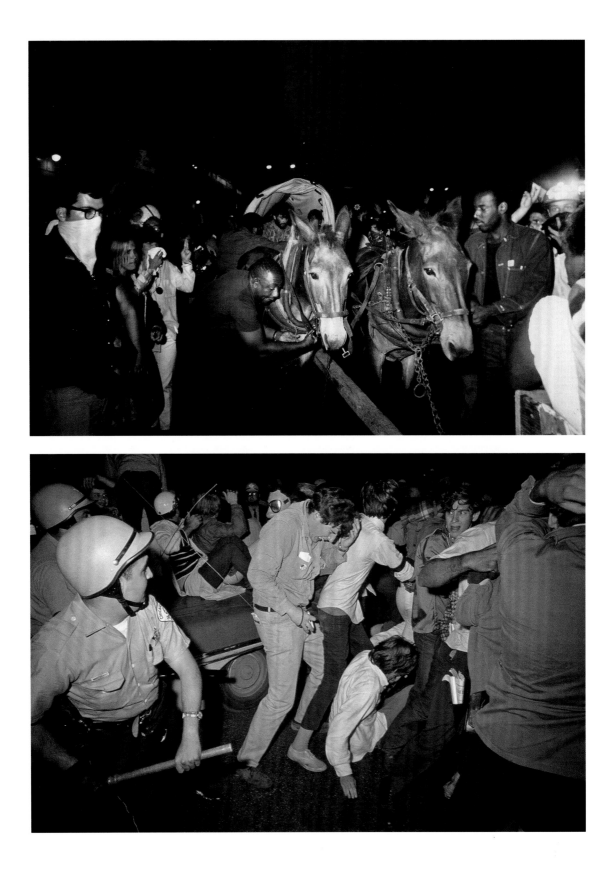

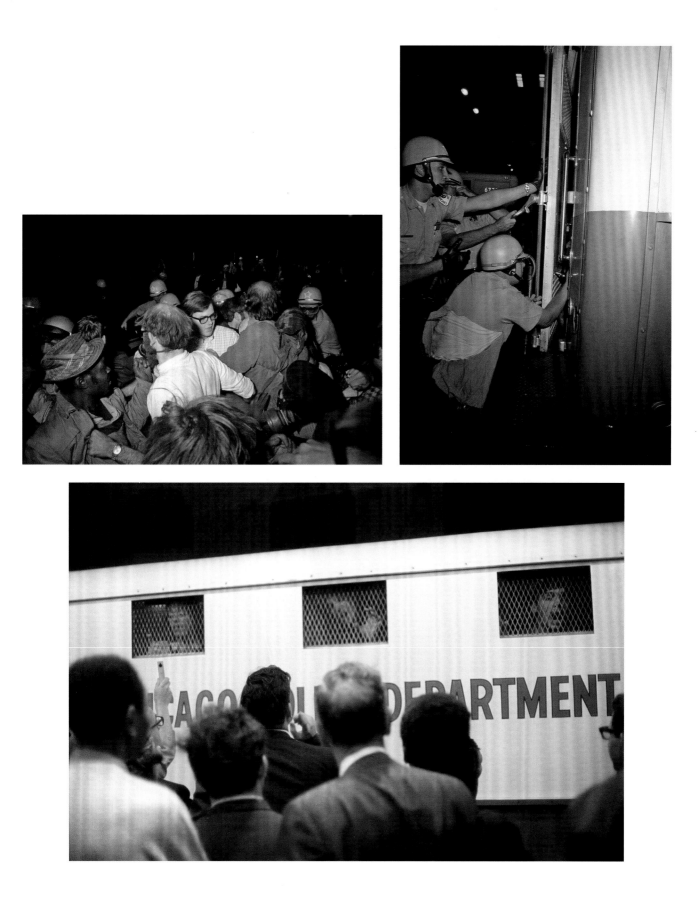

The protestors hoped to stay there, but police had other intentions. Police reinforcements arrived just before eight p.m. with orders to clear the intersection. With the massive lights shining down, television cameras captured CPD officers inflicting violence upon the crowd. Protestors were trapped up against the plate-glass windows of the Hilton's Haymarket Lounge restaurant—a name that alluded to Chicago's turbulent late nineteenth-century protest movement and bombing that killed seven policeman and four civilians. The crowd buckled and then smashed the glass. People got cut as they fell into the restaurant, only to be beaten by police in front of diners and hotel guests. During these seventeen minutes of bedlam, people across the street began to chant, "The whole world is watching," and indeed, this footage, famously replayed an hour later on national television, was viewed worldwide. But back at the convention, "the Hump" was not dumped. Although 80 percent of 7.5 million Democrats had voted for peace candidates in the state primaries, Daley and other party regulars ensured that Hubert Humphrey won the nomination over McCarthy by 1,760 to 601 on the first ballot. The convention adjourned.[37]

The Yippies did concoct a new American mythology in Chicago, but it was not entirely of their own making. "What the 'whole world was watching,' after all," the subsequent Walker Report on the convention concluded, "was not a confrontation but a picture of a confrontation, to some extent directed by a generation that had grown up with television and learned to use it." Shay's still images from the week captured a less composed narrative. He traveled widely around the city with four cameras, and at times a gas mask, photographing subjects who did not always anticipate his presence. Shay's images thus help separate the history from the mythology, with the former serving as a corrective but the mythmaking itself no less important. The Chicago demonstrators felt empowered and vindicated, but subsequent polls revealed that most Americans did not share their opinion. More people (25 percent) said they thought the police used too little force than the slim minority (19 percent) who thought they used too much. The antiwar movement's leaders became reviled even as more ordinary Americans doubted the aims of the Vietnam War itself. As a result, the convention was something of a self-fulfilling prophecy for many Yippies and New Leftists. The subsequent 1969 SDS convention in Chicago splintered into a walkout, with the dissenters holding a second gathering at the First Congregational Church, signaling how their meetings grew more isolated from the very people they might have convinced to join them.[38]

The mythology created before, during, and after the convention has also held that white middle-class hippies descended upon Chicago and encountered CPD officers who went "berserk" with hatred against them. Shay's photographs reveal that demonstrators were diverse in age, race, and political affiliation. Arrest records show that 41 percent of those arrested had Chicago addresses, revealing Daley's mythmaking in deeming the troublemakers as outsiders. And while police violence was abhorrent, nobody died. Police arrested only 668 people over the course of the week (compared with ten dead and almost 3,000 arrests during the Black West Side insurrection four months before). Photographs and subsequent oral histories reveal that many police were angry at the demonstrators, but other evidence suggests that they also knew that the convention was a media show. Many demonstrators were put into police vans and dropped off quietly a few miles away, and very few people complained about being abused when in police custody. "It was a show—a sham for Conlisk and Daley—that we were not going to let this generation and the Negroes run around free and embarrass the city," one officer said, and "many of us were happy to oblige." Activists such as Dick Gregory and Tom Hayden agreed, saying that police officers should not be blamed for following the mayor's directives. In fact, police not only seemed to be following Daley's new orders, but also longer-standing policies, as indicated by the Task Force's leading role in charging into Lincoln Park. The fact that nobody was killed does not excuse these officers from misconduct, but it does suggest that the Walker Commission's "police riot" conclusion contributed to the reigning mythology. "If we really lost control of ourselves," reasoned one officer, "there would have been a lot of dead hippies."[39]

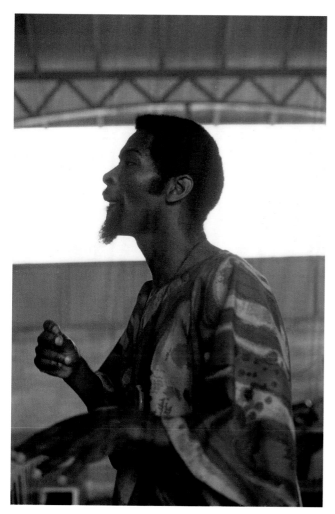

that we intend to take over our own destinies, to be our own agents, and to play our own music." Shay's images from this same year depict AACM members as individuals—with Abrams conducting and Malachi Favors on bass—as well as a collective, as represented by the saxophone section of the larger ensemble. The accompanying *Chicago Tribune Magazine* article deemed their sound "perplexing" because it "confuses those who like a little order in life," which reflected a parallel lack of understanding of Black Power in Chicago by the newspaper's columnists. But unlike the numerous editorials that criticized and dismissed local Black Power activism, this article expressed appreciation of the AACM's collective vision that emphasized creativity and community (composition for its members,

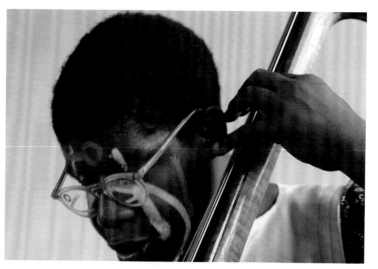

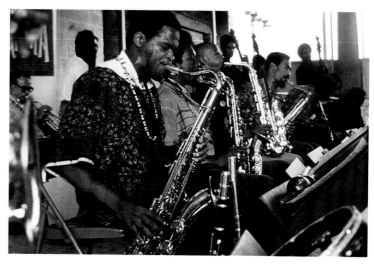

After the convention, the potential for revolution came not from the fragmented white Left but from the myriad forms of Black Power that emerged on the city's South and West Sides. After the 1966 Chicago Freedom Movement, national and local chapters of civil rights groups such as SNCC, CORE, and the Association for Community Teams (ACT) retooled their ideology and leadership in line with Black Power. But, as Shay's documentation of this movement attests, cultural production went hand in hand with political action.

This creative outpouring included the 1965 formation of the Association for the Advancement of Creative Musicians (AACM). When asked whether the AACM had "anything to do with Black Power," cofounder and composer-pianist Muhal Richard Abrams explained in 1968, "It does in the sense

free concerts for the public, and music lessons for neighborhood kids) over the "star system" and commercial success. These photographs suggested AACM members' search for freedom in making "Great Black Music" as individuals who nonetheless gave primacy to the process of their collective endeavor.[40]

The AACM also emphasized the visual arts, fostering connections with artists in the Organization of Black American Culture (OBAC), who transformed the South Side corner of Forty-Third Street and Langley Avenue into the *Wall of Respect*. Dedicated in October 1967, the mural served as an urban monument to Black Power and inspired

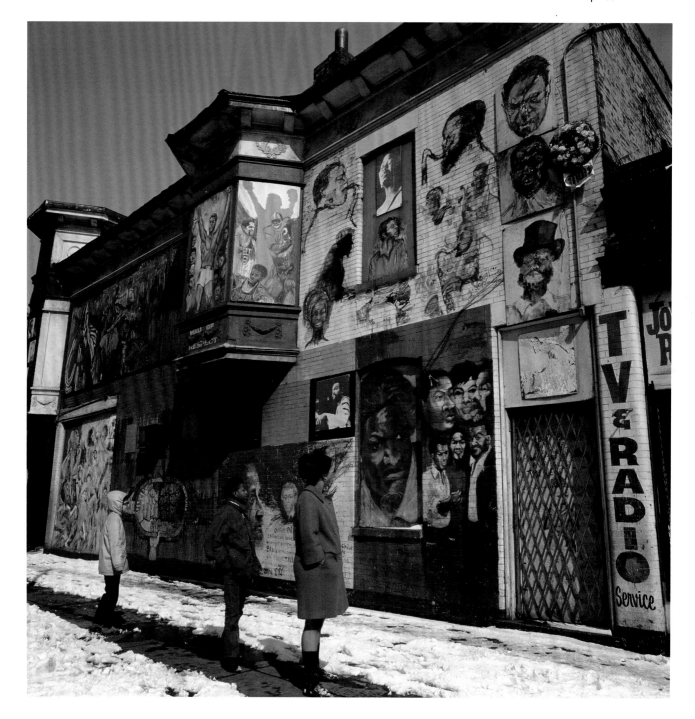

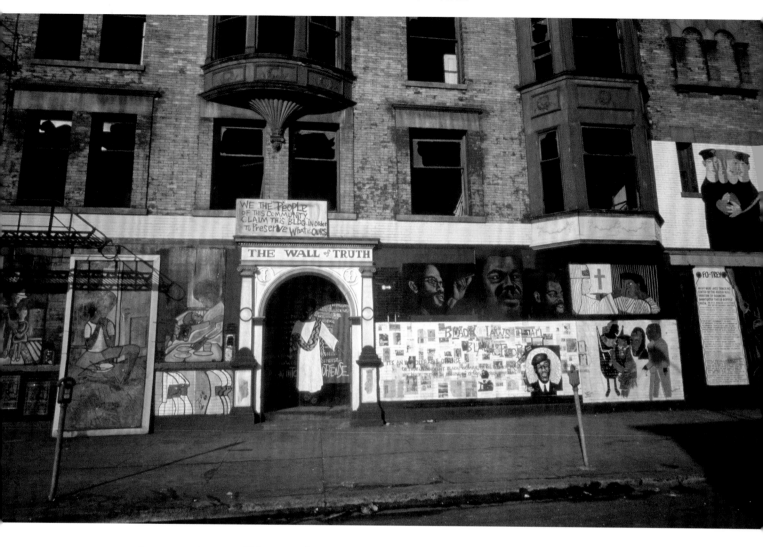

a new mural movement across Chicago and elsewhere. "Dominating the 40-foot high mural," the *Chicago Defender* noted, "is a painting of a clenched-black-fist & the black-power salute." The group of designers, painters, and photographers who created the *Wall of Respect* chose a wide range of Black "heroes" who embraced Black pride and nationalism, grouping them in sections of statesmen, people of faith, writers, actors, and musicians. While national in scope, Chicagoans were well represented on the *Wall*, which included musician Muddy Waters, theater talent Oscar Brown Jr., boxer Muhammad Ali, and writer Gwendolyn Brooks, who wrote a poem for its dedication. Similarly inspired by this shrine, the AACM and other musicians, writers, poets, and dancers performed in front of the mural, and community

members looked after it. Two years later, William Walker and other artists returned to paint the *Wall of Truth* across the street. According to Walker, by 1969 these artists intended to "get away from the hero type thing" to instead focus on "the reality of things that we felt the community should deal with." This second mural reflected that the Black Power movement had changed to become more collective and political than it had been two years before.[41]

Another less conspicuous battlefront for Black Power in Chicago involved educating Black youth. In 1968 a group of Chicago teachers formed the Association of Afro-American Educators (AAAE) to apply "BLACK POWER thru EDUCATION." Stymied in their previous desegregation campaigns,

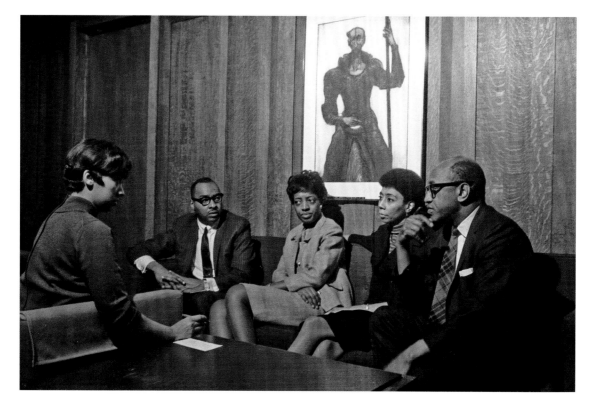

they embraced community control to stem the tide of worsening educational inequality. The AAAE claimed to seek "better ways to educate 'black students' even if it means radical departures from today's half-hearted, failing attempts," and organized a national conference of 500 Black educators that took place in Chicago in June "to understand the crisis" and "prepare black people mentally and psychologically to survive." The conference featured an array of top Black educators, as well as OBAC poet Ebon Dooley and Muhammad Ali.[42] While factionalism hampered the AAAE on a national level by 1969, its Chicago contingent (photographed by Shay—left to right, Myrna Adams, Arnold Jones, Clara Anthony, Mildred Gladney, and Timuel Black) continued working in the trenches on community-based education and training. Gladney, for example, pioneered literacy curricula that embraced Black linguistic differences, while Jones organized Cook County job-training centers and then joined Adams and students in the Black Student Alliance to transform Crane Junior College into Malcolm

X College and to devise new curricula and job-placement programs (including the formerly incarcerated). Meantime, teacher, labor and civil rights activist, politician, and general troublemaker Timuel Black was at the forefront of several Black Power efforts in the late 1960s.[43]

These educators and other Black Power activists were alarmed that the failing education system and concomitant decline in industrial work created unprecedented unemployment, especially for Black youth. Shay's portrait of Addie Wyatt, taken a few years later for *Time*'s "Women of the Year" issue, summed up the paradoxical situation: just as Black leaders like her had worked their way into positions of leadership to promote further Black and female liberation through the union, the jobs disappeared, the culmination of deliberate corporate decisions that produced runaway shops and automation that had begun decades earlier. In her case, Wyatt became a national leader just as the progressive United Packinghouse Workers of America merged in 1968 with the more conservative Amalgamated

Meat Cutters and Butcher Workmen, which one scholar concluded, "dealt a significant blow to Chicago's progressive labor movement." One way these educators tried to ameliorate this crisis was by looking to their own union as a source of new labor movement strength and testing new federal and state regulations involving the right of public-sector workers to bargain collectively and strike. In September 1968, Shay photographed an American Federation of Teachers' strike in nearby East Chicago, Indiana, and Chicago teachers followed suit with a successful strike of their own in May 1969 to achieve better salaries. As important, they bargained for limits on the number of students in each classroom and adding more African American history into the curriculum.[44]

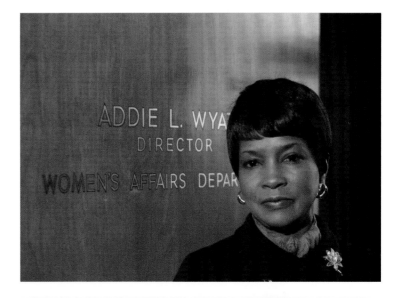

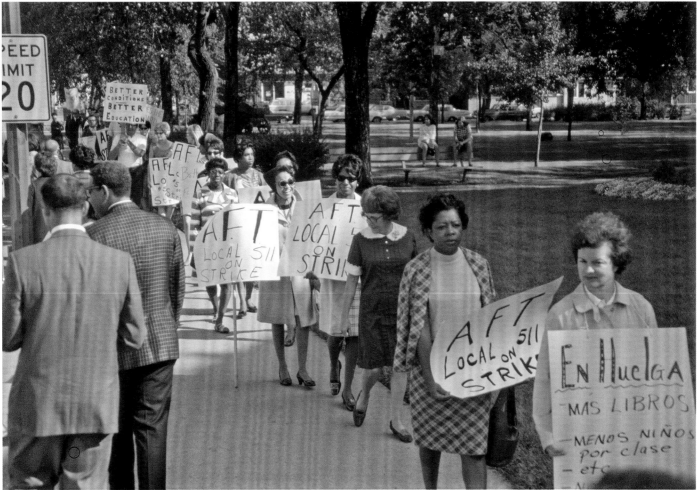

Problems with accessing education and jobs led other young Black men to join gangs for identity and empowerment. Earlier in the decade, Chicago gangs began as peer groups at local high schools and juvenile detention centers, offering protection against interracial incidents during the years when many western and southern Chicago neighborhoods shifted from white to

Black.[45] But as they grew and consolidated, gangs increasingly fought each other for members and especially for urban territory. In the mid-1960s, the Chicago Freedom Movement worked with gang members, especially on the West Side, and other members served in crucial marshal positions during dangerous marches into white Southwest and Northwest Side neighborhoods.[46] Within Black neighborhoods, organizations such as the Woodlawn Organization (TWO), the West Side Organization (WSO), and the Kenwood Oakland Community Organization (KOCO) devised ways to incorporate, educate, and create jobs for gang-affiliated youth. TWO, for example, had secured some War on Poverty funding, including almost $1 million from the federal Office of Economic Opportunity. Previous programs in Chicago, controlled by the local political machine, always demanded that gang members renounce their affiliation as a precondition for receiving services. This grant differed because Reverend John Fry and TWO's Reverend Arthur Brazier sought to engage the existing gangs, adapting their tightly knit structures toward more progressive applications.[47]

By the late 1960s, African American gang affiliation in Chicago had grown to over 50,000, and members engaged in a variety of criminal, business, cultural, and activist enterprises. There were three dominant African Americans gangs in Chicago: the Conservative Vice Lords, an amalgam of West Side gangs; the Black P. Stone Nation, formerly the Blackstone Rangers of the South Side; and the Black Disciples, formerly the Devil's Disciples, another South Side gang. All three managed contradictory impulses as they engaged in turf wars and other violent and criminal activity while they also formed legitimate businesses and programs to improve their communities. Shay documented this activity in its most regressive and progressive forms. His photographs of rival gang graffiti symbolized the violence between them, as did his photograph of the burial of fifteen-year-old Roy Vaughn, who was reportedly shot for refusing to join the Disciples. Shay also talked his way into a ride-along with a member of the Black P. Stones, whose Black Power salute with someone

on the sidewalk evoked the mix of pride, fear, and solidarity these gangs inspired. This photo also referenced the Blackstone Rangers' control over several South Side neighborhoods. During the uprising of April 1968, reporters and politicians noted with astonishment that the South Side largely "stayed cool." Instead of rioting, the Blackstone Rangers posted signs in local businesses that read: "DO NOT TOUCH—MAIN 21" in their windows, and several hundred Rangers and Disciples formed a

truce to march through the streets and "save their neighborhood from fire and gunplay."[48]

Shay also documented other Black youth activity, showing them as multidimensional rather than irredeemable thugs. The Conservative Vice Lords on the West Side had opened a restaurant called Teen Town at 3700 West Sixteenth Street in the Lawndale neighborhood, complete with a "beautification" mural project on the side of the building. He also visited another CVL business

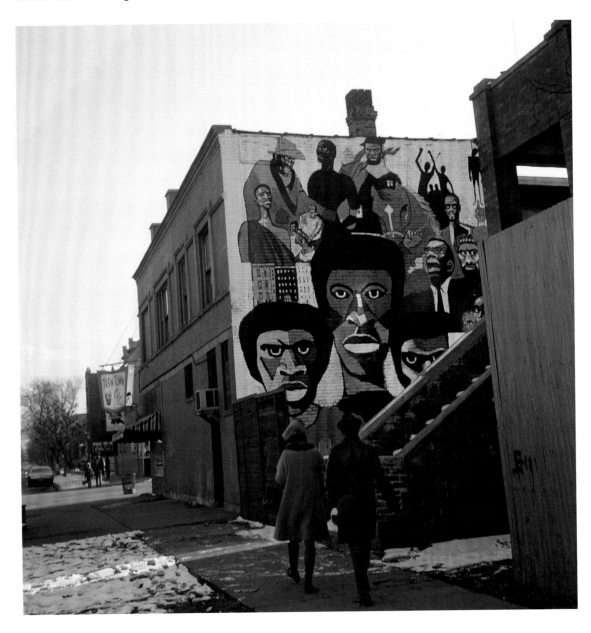

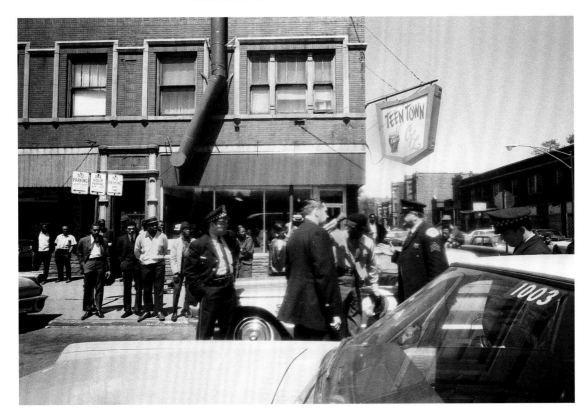

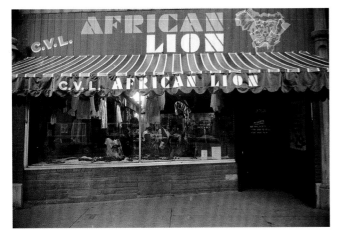

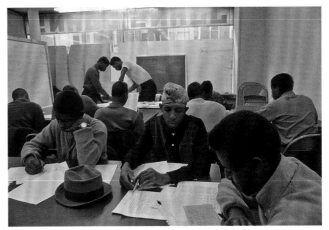

venture, the African Lion store. Just three blocks east of Teen Town, the store featured Afrocentric clothing and jewelry that reflected some of the stylistic hallmarks of the Black Power era. Last, for a *Fortune* magazine story called "Upward Bound," Shay documented members of the Rangers and Disciples in TWO's job-training program as part of "one of the most exciting periods of educational experimentation in history," as well as another gang member reading James Baldwin's *Notes of a Native Son*. Despite harassment from the Democratic machine and local police, TWO's program still put 105 "hard core unemployable" young men to work, revealing the possibility that gang members could be turned into a disciplined and thoughtful army for Black liberation.[49]

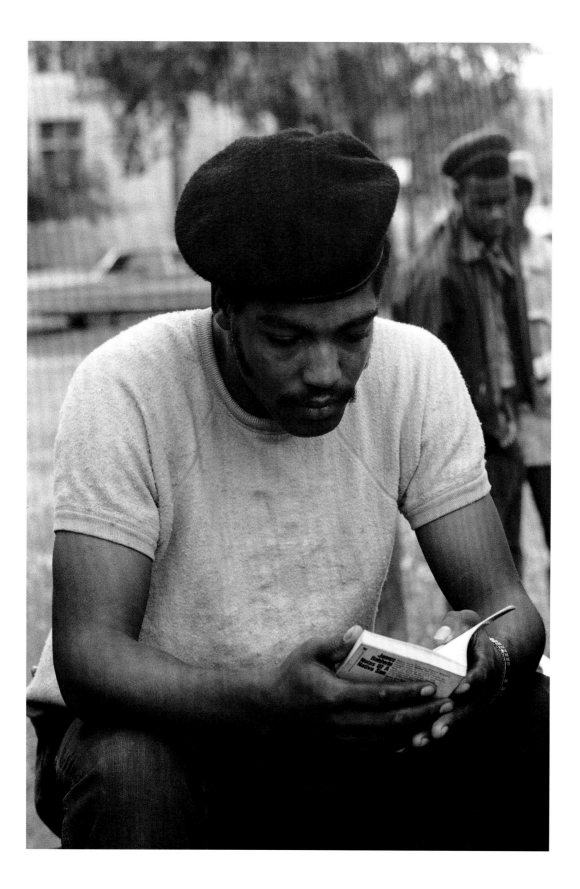

The main group that tried to harness these gang networks was the 1968 Coalition for United Community Action (CUCA). Comprised of sixty-one community organizations and spanning Chicago's Black neighborhoods, CUCA focused on reclaiming economic power. In addition to the automation and deindustrialization that had made job prospects dire for African Americans, Chicago lost 48,000 jobs between 1957 and 1966 while the suburbs gained 276,000. Young Black males were most affected; their unemployment rate during the summer of 1969 was 31 percent, three times the national average.[50] After an initial experiment in campaigning for employment at Red Rooster supermarkets in Black neighborhoods, CUCA expanded to take on the entire building trades industry. These contractors, unions, and political allies had blocked African Americans from working in lucrative construction jobs. Their demands, CUCA leaders believed, would open up the institutions that had excluded African Americans for the past half century, renew poor neighborhoods, and put young Black men to work. But first, several of the community organizations affiliated with CUCA had to convince gang members to join their coalition. The head of the coalition, SCLC leader C. T. Vivian, said, "Because culture has closed [young Blacks] out," they needed "to find a way to get in, and … rebuild their own community." This multi-neighborhood campaign eventually convinced gang members to form "LSD." Standing for Lords, Stones, and Disciples, it fused three rival Black gangs into a single organization for CUCA's campaign.[51]

The street gangs, one CUCA leader concluded, put the "troops in the field." In the summer and fall of 1969, they deployed to dozens of construction sites across Chicago, where they shut down several hundred million dollars' worth of federally financed construction projects.[52] Shay captured one of many confrontations, as hundreds of young Black men showed up to take over a construction site. They coerced white workers and foremen to leave the site, making threats but avoiding violence. Citing President Johnson's 1965 Executive Order 11246, they declared that all nineteen of Chicago's building trades and its principal training facility, the Washburne Trade School, maintained racially exclusive barriers to unions and jobs. They sought to pressure the Office of Federal Contract

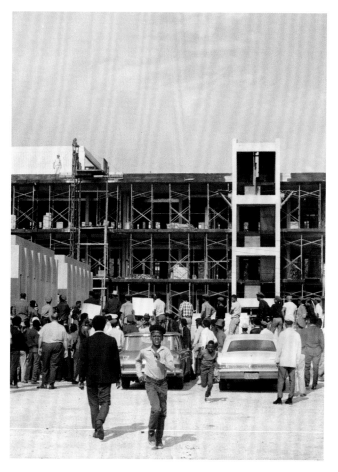

Compliance to hold accountable firms that received these federal dollars but did not practice "affirmative action."[53] As CUCA's protests spread, Chicago representatives of a dozen federal agencies responded by forming the Federal Ad Hoc Committee Concerning the Building Trades, whose research confirmed Blacks' blatant exclusion from every Chicago building trade union except three. Nine of the unionized industries had labor shortages, it found, but they nonetheless continued to discriminate.[54] To many observers inside and outside of CUCA, a revolutionary restructuring of institutional racism in employment seemed possible. "In the summer of 1969," one federal official remarked, "the black community in Chicago was better organized than anywhere in the country."[55] *Chicago Defender* editor John Sengstacke agreed, declaring there was "more compact unity behind [CUCA] on this issue then there was behind Martin Luther King in the struggle for integrated housing in Chicago."[56]

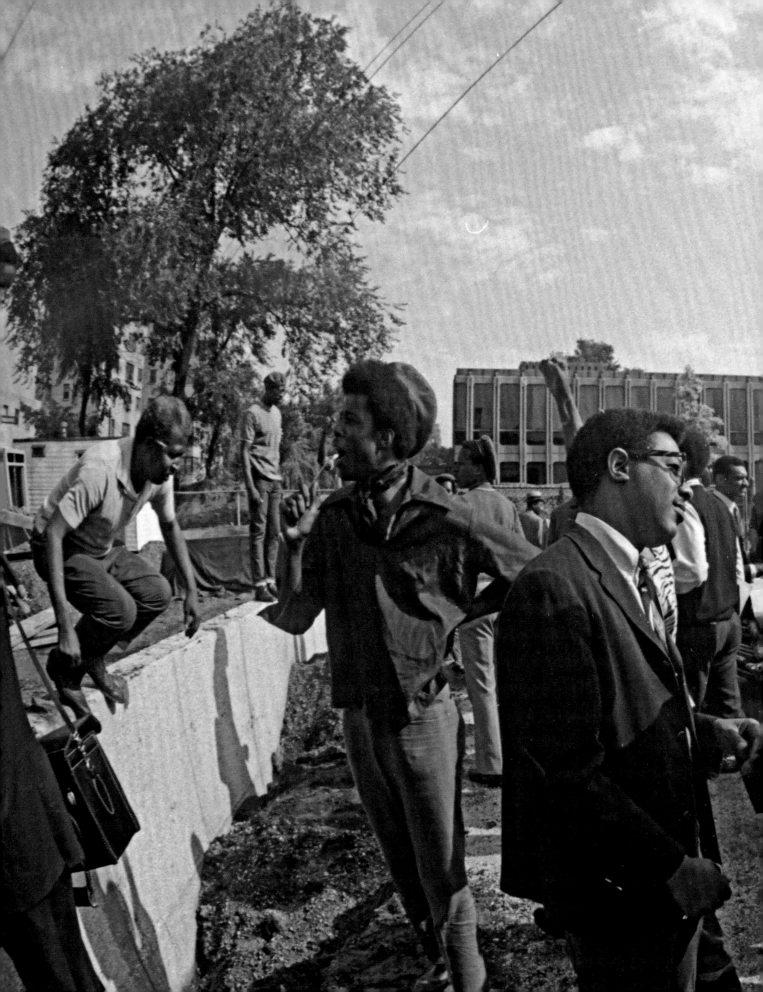

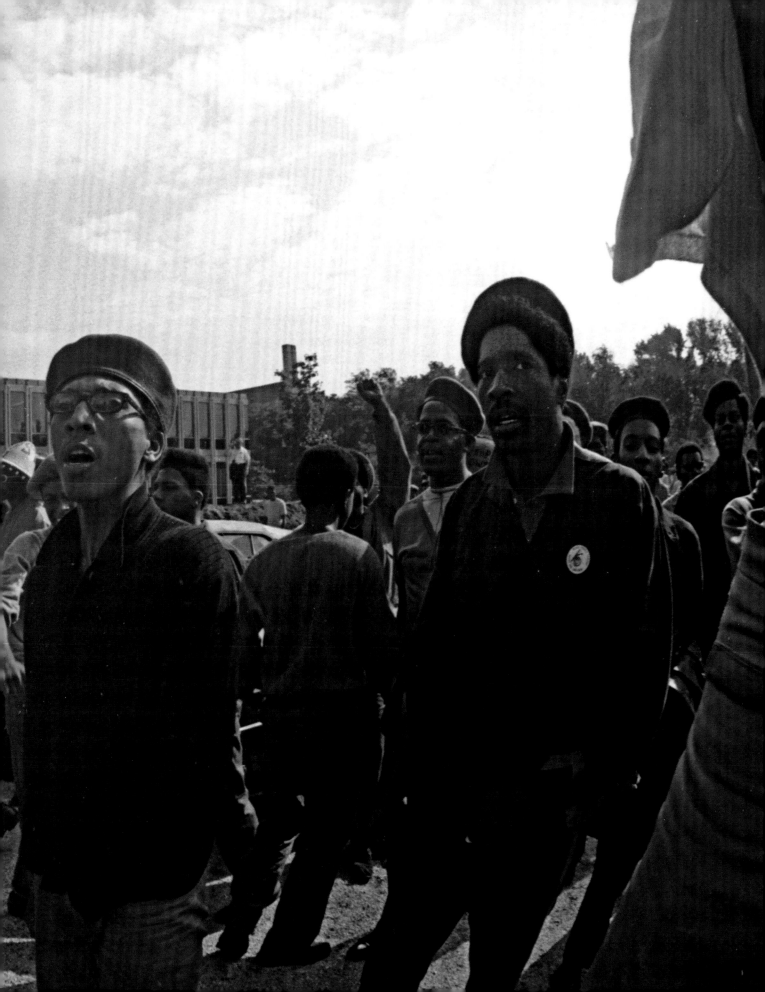

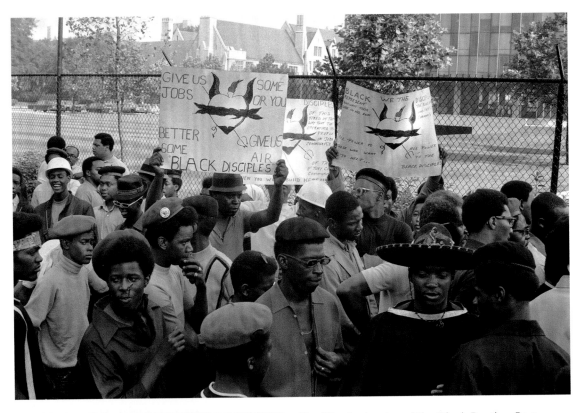

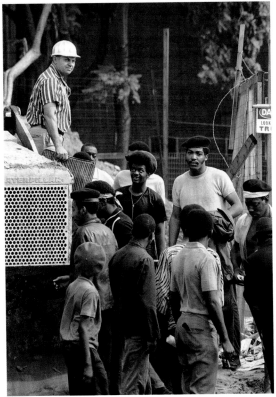

The Illinois chapter of the Black Panther Party (BPP) rose to prominence during this same apex of activity. At the Democratic National Convention, Bobby Seale spoke for the national BPP because no Chicago chapter existed. But by November 1968, two upstart factions (one South Side and one West Side) merged to form an Illinois chapter. The Panthers opened a Near West Side headquarters at 2350 West Madison Street, in the center of the "riot" zone from earlier that year. Under the leadership of twenty-one-year-old Fred Hampton, the BPP cultivated its own form of Black Power that emphasized "observation and participation" as an approach to day-to-day community engagement. They opened a breakfast program for children and later a health clinic, while condemning the "avaricious businessman," the "demagogic politician," and the "fascist, pig cops" who exploited their community.

As Hampton's speeches indicated, the chapter emphasized Black solidarity alongside a socialist class struggle. Hampton criticized people whose "hair's long and you got a dashiki on" who thought the style alone would make them revolutionaries.

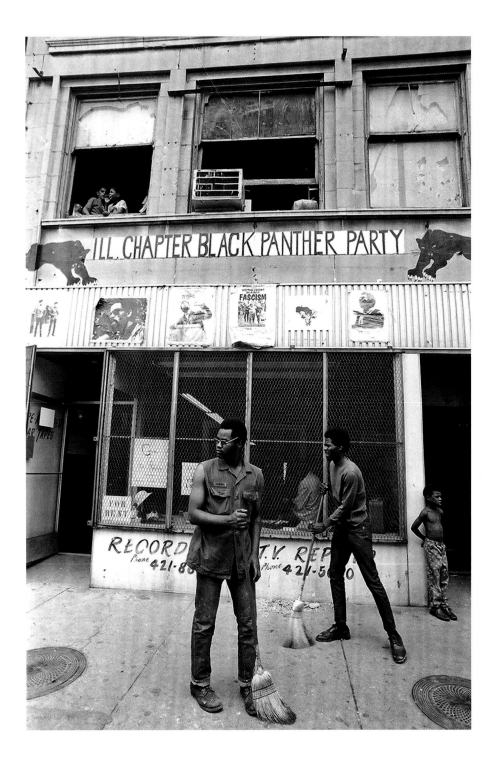

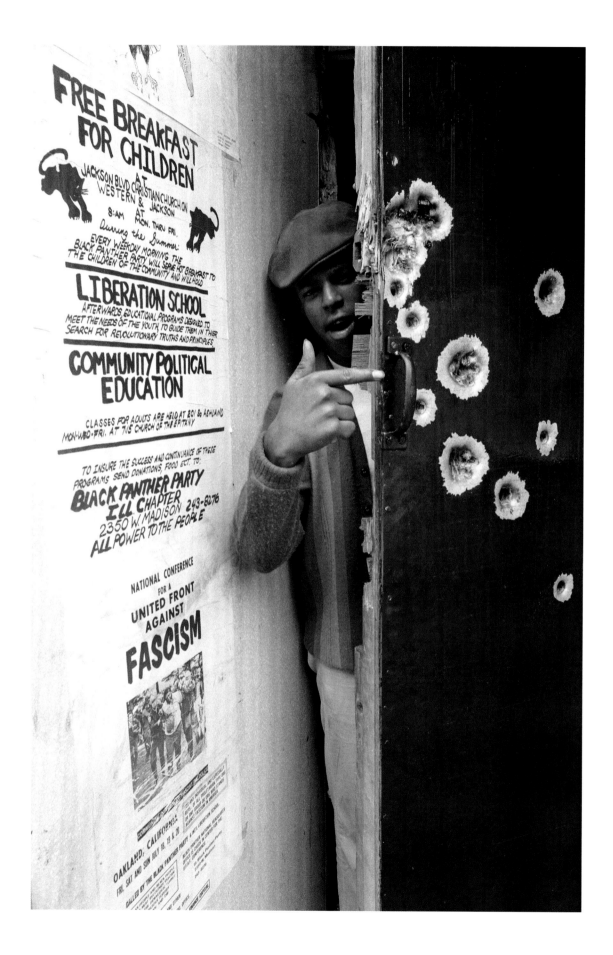

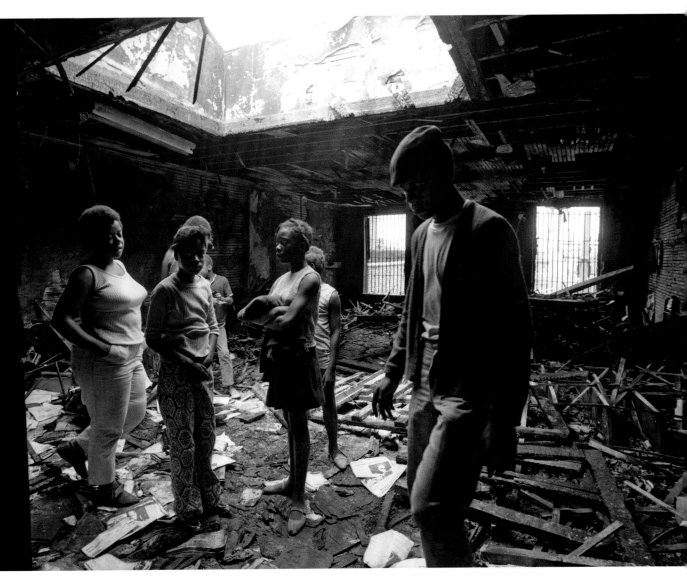

He also condemned those who defined Black Power as getting a share of capitalism because, as he said, "It's kind of hard to burn up on Tuesday what you bought on a Monday." And he also quarreled with activists who wanted peace in Vietnam; he wanted victory in Vietnam to get the "imperialists" and "Wall Street warmongers" to be "driven out of there." The Chicago BPP also sought to politicize gang members, forming a coalition with the Disciples, working with members of the Vice Lords, and engaging in a series of meetings in attempted coordination with the Blackstone Rangers. Meantime, Hampton, Bob Lee, and other Panthers

began to organize a broader "Rainbow Coalition" with groups including white Appalachian migrants in Uptown (the Young Patriots) and Puerto Rican and Mexican American Chicagoans in the Young Lords in Humboldt Park and elsewhere.[57]

Police resented the BPP calling them "pigs," but the BPP grabbed the attention of Chicago's law enforcement and other power brokers because of its potential to politicize gangs and create a broad citywide coalition. "We've been attacked three times since June," Hampton said in 1969, concluding, "We know what the pigs don't like." Shay photographed the aftermath of one of these

attacks. On the last day of July, police officers broke into the Panthers office. A shoot-out ensued that injured several officers. Police arrested three people, ransacked the office, and set fire to the second floor. As Shay's photographs show, bullet holes riddled the door of the Panther office, and upstairs the fire destroyed newspapers, food, and other supplies. Holding an impromptu press conference, Bobby Rush of the Panthers doubled-down on their intent to organize a "united front" composed of people of "any color" because "America is gravely threatened by fascism, and this latest incident is a clear and present warning of the new danger."[58]

Such harassment was just one part of a larger coordination between the Chicago police, its local subversive units, and the Federal Bureau of Investigation to harass, infiltrate, and destroy Black Power organizations. The Red Squad, the powerful intelligence unit of Daley's police department, had begun as an anti-Communist unit following the Palmer Raids in 1919 and 1920. By the 1960s, it had widened its scope to include extensive surveillance files on any opponents of the status quo or threats to the local Democratic machine.[59] The Red Squad also had a new Gang Intelligence Unit. Its mandate was to eradicate "gangs," broadly defined, but the GIU's funding depended upon the proliferation of gangs as an urban menace. The Panthers were squarely in its purview.[60] During the summer of 1969, these agencies escalated their activity and waged a war on gangs, as evidenced by Shay's photograph of a police map of targets. Mayor Daley called a meeting with Attorney General Edward Hanrahan, Circuit Court head Judge Eugene Wachowski, and other civic officials to establish a special judicial branch, approvingly deemed a "terrorist" court by the *Chicago Tribune*. This renewed focus on eradicating gangs permitted the GIU to justify huge increases in funding and resources; between 1967 and 1969, the division grew from 38 to 200 officers.[61]

What followed in the summer and fall of 1969 was a full-scale war on gangs and anyone who sought to work with them. During the summer of 1969, police arrested BPP members 111

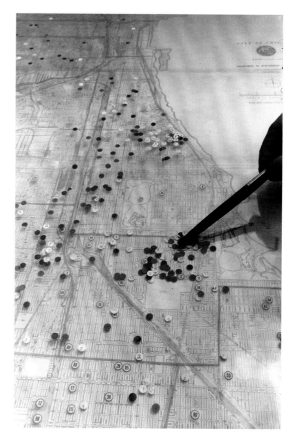

times—mostly on minor charges that were later dropped. CUCA representatives charged police with the nighttime assault of gang members who participated in demonstrations, the arrest without cause of scores of gang members in Washington Park, and the arrest and imprisonment of Leonard Sengali, a key bridge between the Blackstone Rangers and CUCA, on a trumped-up murder charge (photographed by Shay in front of the KOCO office). The FBI's fabricated rumors, which it disseminated through its covert action program, COINTELPRO, failed to turn the Black Panther Party, the Rangers, and the Disciples against each other. But on December 4, 1969, the CPD-, GIU-, and FBI-coordinated nighttime raid of the BPP apartment that killed Panther leaders Fred Hampton and Mark Clark demonstrated the lengths that the city would go to in its war on gangs.[62] These assassinations were part of a much broader campaign of repression; CUCA documented sixteen cases between June 1969 and May 1970 in which "black

youths [were] murdered by the police." Under these pressured circumstances, CUCA hastily signed the "Chicago Plan" in January 1970, which promised thousands of construction jobs on "good faith" that never materialized. As a result, groups like CUCA and the BPP enervated and fragmented, the Art Ensemble of Chicago of the AACM went to Paris, and the City of Chicago even destroyed the *Wall of Respect* in 1971 for the sake of "urban renewal." Even more disastrous, with "all but shattered communications between the gang and the community," LSD broke apart, and gang members began to fight each other again, to attempt to extort Black Freedom Movement leaders, and to prioritize criminal enterprises above Black Freedom struggles.[63]

Some organizations did survive and take Black Power in a different direction. Operation Breadbasket's Chicago chapter was formed during the 1966 Chicago Freedom Movement and achieved what Dr. King called "undramatic victories" by organizing a group of ministers who threatened boycotts against companies if they did not sign

"covenants" to hire, train, and promote African Americans. Three years later, under the leadership of Jesse Jackson and with a strong supporting cast of ministers and advisors doing the trench work, Breadbasket became a hub of activity and touted 8,000 new jobs won through its campaigns. Its weekly meetings in 1969 certainly brought drama, featuring a host of speakers, celebrity guests, and a 200-voice choir and 20-piece orchestra. They were also attended by thousands of "stunning young women in Afro hairdos, hippies with peace beads, gang members, successful businessmen, students, nuns, welfare mothers, and a generous sprinkling of whites."[64]

Shay photographed one of these weekly meetings in mid-December 1969. It was an auspicious moment: just a week and a half after the murders of Hampton and Clark and days after Jesse Jackson arranged for the public surrender to police of surviving Panther leader Bobby Rush. The photograph inside the Mount Pisgah Church on the South Side shows a continued spirit of rebellion, but Jackson's response to Hampton's

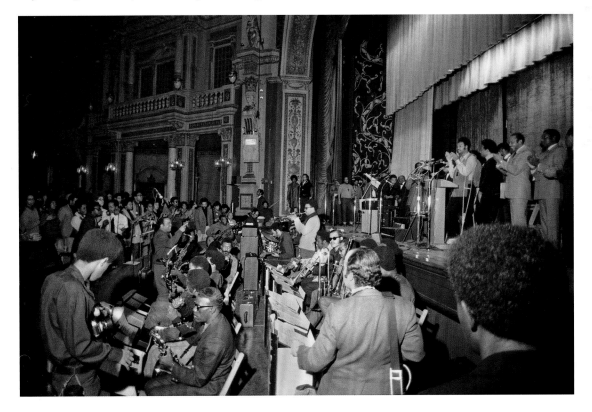

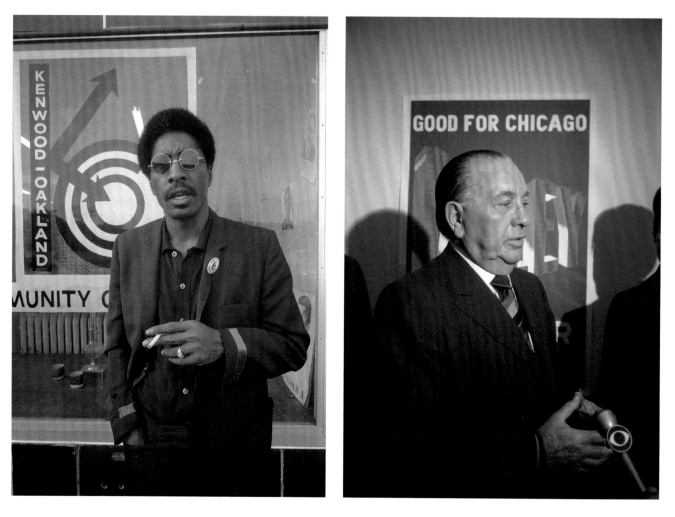

murder also indicated a different vision. "It is up to us to see that his precious blood shall not have been shed in vain," Jackson declared. But he believed the way to make it "pay dividends in our race's freedom" was to focus on voter registration and the hiring and promotion of more Black police officers. Hampton and the BPP viewed such goals as secondary. In fact, Hampton had previously criticized Jackson and others for embracing forms of capitalism, traditional party politics, and police reforms that sought to replace white faces with Black ones rather than transform the system. On the matter of the police, Hampton had previously appealed to GIU head, the African American Captain Edward Buckney, as a prime example. "Did you think," he asked his audience, "Buckney was white?"

If this was the new Black leadership, the BPP considered its outcome a nightmare. Similarly, leaders in CUCA thought Jackson arrived late and then tried to misdirect their campaign, helping to defuse what CORE and community activist Bob Lucas called "a real revolutionary moment there" in favor of negotiations that went awry. While Jackson insisted in 1969 that he focused on "black capital" to make a "rich community" rather than "black capitalists" to make a "few people rich," over the next years he would increasingly promote his own leadership over that of the previous cast of ministers who worked with him. He formally separated from the SCLC to form People United to Save Humanity (PUSH) in 1971, even finding some pragmatic ground with Richard Nixon's notion of Black capitalism. This form of

WELCOME DEMOCRATS AND BLACK POWER

Black Power seemed more resilient, but other activists who survived the decade wondered what they had sacrificed.[65]

"Daley and Chicago," one journalist wrote in August 1968, "seemed to symbolize America; he was ours, for better and for worse, in sickness and health."[66] Indeed, the world watched with sympathy and disgust as troublemaking peaked in Chicago at the end of the 1960s. Amid unprecedented violence that was more heavily applied against citizens of color, social movements sought to fundamentally transform the city and make it more democratic. While the New Left's presence at the convention became more theatrical then substantive, young people nonetheless revealed their potential to demand participatory democracy. They also created mythology about Chicago 1968, whereas the actual 1969 peak of activism among Black communities in Chicago has largely been forgotten. Economic, political, and cultural forms of Black Power took different yet overlapping approaches to eradicating institutional racism. They sought to improve Chicago for all of its residents—especially those who were not enriched by the Democratic machine's spoils.

This revolution did not happen, but it took an unprecedented level of police surveillance, harassment, and even murder to defuse it. Mayor Daley went on to defy the pundits who thought he would retire by running and winning reelection in 1971–72 with a slogan captured by Shay: "Good for Chicago." Daley would continue to rule the city until he died in office in 1976; he was but one powerful man in a crowd of brokers and hustlers whose definitions of urban order and disorder privileged financial extraction and deepened inequalities and feudal relations of loyalty and dependence. But democratic political and cultural forms of troublemaking also persisted. In a different and hostile political and economic climate, they, too, would challenge this form of a naturalized urban order in Chicago into the next century.

CONCLUSION

As this book's photographs and history convey, the postwar decades were especially vital years in urban America. Chicago, often defined as the nation's "social laboratory," became an engine of economic and cultural activity as well as a place of deepening inequality. Chicagoans made sense of these changes in different ways. Some put forth robust visions of urban democracy; others found new ways to justify these imbalances. The latter group tended to win out as the climate for the American Left became relatively less hospitable.[1] Many of the defining features of the urban crisis—hyper-segregation, economic exploitation, "renewal" that benefited the privileged, and street violence—became entrenched in the last century's middle decades.

Scholars and pundits have sought to understand these urban transformations. Decades ago, the pathbreaking historian Arnold Hirsch described them as the "second ghetto." He argued that policy makers' deliberate choices, not an abstract "Negro problem," degraded the American social contract through racialized public and private partnerships that advanced whites alone.[2] This narrative, while powerful, sorts urbanites into beneficiaries or victims of changes they could not control while "naturaliz[ing] public failure as the master narrative of urban history," in the words of another scholar.[3] From this perspective, resistance to omnipotent forms of urban capitalism and governance has been reactive and ultimately futile.

Troublemakers offers a different perspective on urban America's bypassed possibilities. Art Shay's photographs and the history they illustrate reveal how activists generated volatile yet productive energy, making trouble in the name of justice. As Chicagoans adapted to the Second Great Migration, "white flight," neighborhood and street activism, cultural and racial politics, and the evolving Democratic political machine that extended from politicians to the city's police, courts, and jails, they also responded to national and international politics—from the southern civil rights movement and the War on Poverty to the early Cold War that escalated into a protracted military campaign in Vietnam. This activism crossed social and geographic boundaries, continued to accelerate even after national civil rights and antiwar movement leaders abandoned the city in the late 1960s, and grew increasingly threatening to the city's power brokers. It took an equal countermovement to shore up inequality, corruption, and bigotry. This reaction was not led by a Republican backlash but by a Democratic mayor and a host of allies who deployed strategic violence and significant tax dollars to will this version of the city into existence.

Chicago's diverse postwar activists believed that rising urban inequality could extinguish American democracy. The notion that maintaining democracy requires energetic grassroots participation has deep roots. In the 1830s, for example, the French writer Alexis de Tocqueville defined it as uniquely American.[4] In the modern metropolis, ordinary people translated this vigilance into disruptive collective action, exposing the veneer of order and civility that covered an unjust status quo. But rather than simply create disorder, they collaborated to try to transform predatory institutions into fair ones. In the language of the 1960s, these Chicagoans exercised "democracy in the streets." These were the public spaces where Shay trained the lenses of his cameras.

As Shay discovered, these activists saw culture as an incubator of social change. They created new forms of art that breathed life into older traditions. Beginning in the 1920s, this cultural innovation persisted through the Cold War and transformed in unexpected ways throughout the 1960s. This Black Chicago Renaissance informed

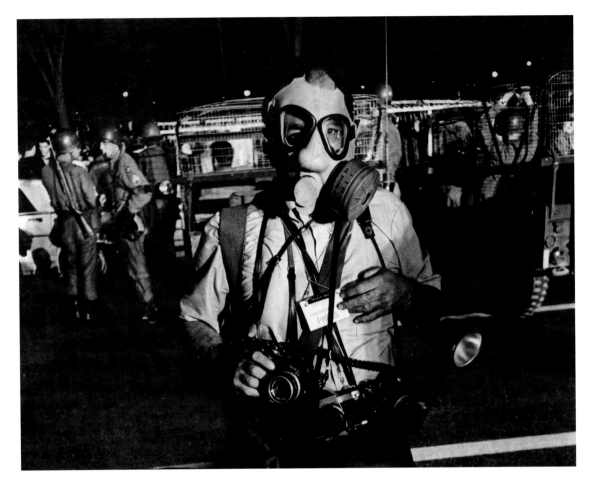

and inspired protest politics, and its notions of citizenship and identity crossed the city's color lines, molding the city's urban culture.[5] It was artists and activists, not politicians and urban planners, who protected what journalist and urban theorist Jane Jacobs saw as the promise of modern cities. In the 1960s she observed that "conformity and monotony" would not lead to "economically vigorous cities." But cities do "contain the seeds of their own regeneration." The people who performed the "ballet of a good city sidewalk," according to Jacobs, could remake urban spaces into "lively, diverse, intense cities."[6]

Shifting class identities shaped this history as well. In the immediate postwar, the labor movement fought for a democratic city, attempting to build upon its prewar success in organizing progressive interracial industrial unions in Chicago. But even as labor unions claimed their highest

membership in history—35 percent of American workers—this democratic urban vision faltered in the 1950s. Some in the working class moved right politically, especially white men, who took refuge in their race and gendered privilege. Others literally moved to suburbs like Deerfield, disengaging from urban life. But other working-class Chicagoans looked beyond unions for new pathways to democratic power. Anti-poverty staffers, peace activists, and even gang members advanced urgent economic demands, seeing social movements as new vessels for older visions of industrial democracy.[7] By the late 1960s, broader political forces aligned with segments of the working class to foreclose that possibility. Many working-class urbanites had grown frustrated with the promise of liberalism. Some became more conservative, while others, particularly in the Black Power movement, directly challenged the institutions—

unions included—that excluded and divided them. A white segment of this racially defined working class ultimately aided the rebirth and entrenchment of an older model of machine politics that consolidated local and national power against ordinary Chicagoans' interests.[8]

As Shay's images reveal, ordinary people's activism could be messy and unpredictable. In the early 1960s, for example, resistance to racial inequality in education felt powerful but resulted in no immediate substantive changes. Not until activists shifted to community control did they gain some access to resources. Meanwhile, peace activism seemed futile at first but developed into a broader movement. Troublemaking could also backfire, creating unanticipated reactions, such as when antiwar activists in the late 1960s galvanized more opposition to the Vietnam War while also creating foes out of potential allies. Thus, this history reveals no one right way to make trouble. But the cumulative effect of democratic troublemaking created oxygen for democracy, allowing its adherents spaces to breathe where they

envisioned and acted out alternatives for their city and society.

The two decades of movement continuity and rupture that Shay captured were also the golden age of photojournalism, but editors used his work to tell certain kinds of stories. Print, not television, was still Americans' main news source, but not for long. *Life*, for example, had 32 million weekly readers in the mid-1960s, but by 1972 it had ceased weekly publication.[9] Shay made a living by publishing some of his images, and that work gave him a journalistic and artistic platform. But his version of a story often butted up against magazine editors' more commercial goals. Shay's employers tended to choose images depicting African Americans as passive victims of racism, peace activists as overgrown and hedonistic children, and northern militant activists as inherently violent.[10] Where editors could not discern a marketable story, they sometimes declined to publish Shay's images at all. This editing process flattened the ideas that activists generated and performed in public. The Chicagoans Shay captured wanted to

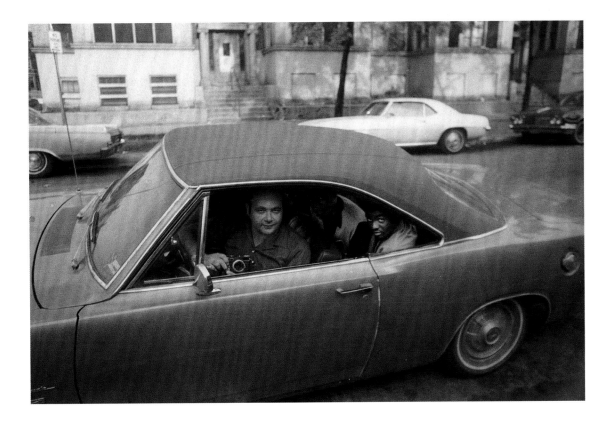

transform the normative society that *Life* and other mainstream magazines conveyed, not be typecast within it.

Fortunately, Shay kept a voluminous archive of all of his negatives. Those images help us see past a liberal framing of activism in these years, opening up a messier history. With sophistication and wry humor, Shay captured Chicago's troublemakers—high-minded ones and hustlers alike—embedded in a drama that was far truer than a simple morality tale. Fusing these photographs with archival sources and the vast urban history scholarship, this book has sought to balance dynamic creativity with passivity, and contingency with declension.[11] In so

doing, it attempts to "capture the balance between collective agency and state power" that one historian calls the "crucial challenge for a new narrative on urban history."[12]

But Shay's photographs are more than historical artifacts—they are compelling documents of humanity. They show us the ecstasy and pain, satisfaction and frustration, and freedom and repression that sprung up in Chicago a half century ago. They invite us to reexamine their historical context to gain new insights into our contemporary urban environment. They may even inspire us to engage in that American tradition of making trouble of our own.

ACKNOWLEDGMENTS

This book came about by accident and thereafter anchored my last years in Chicago. A few years ago, my Roosevelt University colleague Lynn Weiner connected me with Amy Likover, a longtime friend of the Shay family. Soon I was sitting at lunch with Art Shay himself, his assistant Erica DeGlopper, and my close colleague and Gage Gallery director, Mike Ensdorf. I had long admired Shay's portraits of Marlon Brando, Simone de Beauvoir, Elizabeth Taylor, and especially his photographs of the writer Nelson Algren in Chicago. But I was stunned to learn that Art Shay had hundreds of thousands of unpublished images from the decades he spent roaming the city with his camera. Every week DeGlopper discovered more negatives and contact sheets in Art's basement archive, a space that *Home Office Computing* magazine once declared the messiest in America. Shay invited me to see it for myself, and I could not believe the depth and scope of his work. Like Woody Allen's fictional character Leonard Zelig, Shay seemed to have been everywhere. He witnessed nearly every protest movement in the city and captured powerful everyday scenes as well.

Our initial vision for an exhibition of a few of Shay's photographs at the Gage Gallery turned into an all-consuming dive into Chicago's visual culture. Mike Ensdorf encouraged me to think big, educating me on photography and guiding me on how to curate a more ambitious exhibit. Erica DeGlopper, far from a gatekeeper to Shay's work, became an essential ally. She energetically tracked down images, provided sage advice and sharp ideas, and gave me free reign to wander the rows of metal filing cabinets and Shay's old darkroom in his Deerfield basement. Most important, though, was that Art Shay tolerated me. I had been warned that Shay was demanding, unpredictable, and irascible; this was one reason why he had been a life-long freelancer and not taken steadier work. I saw only flashes of this personality. Sometimes he was warm and talkative, and other times he seemed indifferent to me. When I surfaced from the basement, he often shared stories and filled in key details. But he never told me which photographs to choose or what they meant, instead granting me remarkable freedom to mine and interpret his life's work. As our collaboration deepened, a modest exhibition grew massive. More than three hundred images took up almost every inch of available space in the Gage Gallery for our fall 2015 exhibition, which used Shay's work to illustrate social movements in recent Chicago history.

Over one thousand people saw the exhibit, including University of Chicago Press editor Tim Mennel. We walked through the gallery together at a quieter moment. As I guided him around the gallery, I could tell that he understood my goal in trying to balance history and photography, allowing each to inform the other. He suggested that an expanded version of this exhibit could become a book whose photographs drove a new narrative of Chicago's postwar urban history. As important, Mennel agreed that while Shay himself was a fascinating figure, the book should center upon his work, not his life.

This book was born in that meeting, and it took shape through my conversations with a passionate group of archivists and librarians. I was fortunate during the early research and writing stages to serve as the vice chair of the Black Metropolis Research Consortium. As the only professor on its board, I felt honored to participate in conversations among Chicago-area archivists. In particular, conversations with Steve Adams at Northwestern University, Valerie Harris at University of Illinois at Chicago, Aaisha Haykal at Chicago State University, Julie Wroblewski and Lesley Martin at the Chicago History Museum, and the entire staff

at the Carter Woodson Library's Vivian G. Harsh Research Collection directed me to new sources, advised me on those I had already found, and generally helped me piece together this history. In addition, Donald Davis at the American Friends Service Committee archives, Joellen ElBashir at Moorland-Spingarn Research Center at Howard University, and the staffs at the Historical Society of Pennsylvania and the LBJ Presidential Library archives expertly addressed my targeted research inquiries.

Meantime, I became steeped in conversations and scholarship on Chicago. Before this project, Adam Green and Jim Grossman hosted a series of conversations with a group of scholars on the 1945 study *Black Metropolis*. While a sequel to that famous text by St. Clair Drake and Horace R. Cayton did not emerge, these dialogues deepened and refocused my interest in Chicago's postwar history, connecting me with scholars from other disciplines such as Mary Pattillo, who has since written a brilliant foreword to *Black Metropolis*. Then, once this book project was underway, conversations with and reading the work of Megan Adams, Richard Anderson, Davarian Baldwin, Simon Balto, Ron Cohen, Lilia Fernandez, Rick Halpern, Jeff Helgeson, Brad Hunt, Devin Hunter, Lionel Kimble, Gordon Mantler, Amy Mooney, Melanie Newport, Liesl Orenic, Chomingwen Pond, Christopher Reed, Amanda Seligman, Ian Smith, Elizabeth Todd-Breland, and Catherine Weidner proved invaluable. I am also grateful to all of the participants at the Newberry Library Seminar in Labor History, and specifically the comradeship of Peter Cole, Tobias Higbie, Jack Metzgar, Jim Wolfinger, and the crucial mentorship of Leon Fink. Not a historian of Chicago but a historian in Chicago, Martha Biondi, has provided essential guidance over the years as well as that of James Thwinda. Thanks, also, to Lisa Oppenheim, the director of the Chicago Metro History Fair and behind-the-scenes fount of Chicago knowledge. Her collaborative spirit connected me to scores of secondary school teachers, whose probing questions and comments became a way of learning, and then in turn, these teachers, such as Emily Hinz of Grayslake High School, introduced me to students whose reactions and comments surprised and helped me.

As I turned to writing the book, a Public Scholar grant from the National Endowment for the Humanities freed me to leave Chicago for a time and deepen my thinking about the city. Much of the book's framing came together as I gazed out the window at deer in the woods of a Chatham County, North Carolina, house. From this vantage point, I was fortunate to connect with scholars who were not focused on Chicago—in particular Bob Cantwell, Bill Ferris, John Kasson, and Susan Pennybacker—who inspired and provoked me to think about the relationship between culture and protest politics. Most important, my steadfast mentor for the past two decades, Nancy MacLean, hosted a meaningful dialogue with Jacquelyn Dowd Hall, Bob Korstad, and Bruce Orenstein at a key moment when I needed direction and encouragement.

Filmmakers and photographers also helped me think about how to select and analyze the photographs in this book. Given his similar interest in Chicago history but his different approach as a documentary filmmaker, Orenstein's advice was important. Two other practicing photographers—Scott LaPierre and Jason Reblando—helped me think through the images in this book (and the 100,000s more that did not make the cut), as both documents and art. Similarly, the ongoing dialogue with photo and design experts Mike Ensdorf and Kathy Pilat proved vital. In addition, filmmaker Bryan Simpson bolstered my approach to the Deerfield chapter, and the documentarians working on a feature-length film on Art Shay—Jack Davidson and Ken Hanson—provided me with key information about Art Shay's life and career.

It turned out that my 2016 move to North Carolina was not temporary. I was honored to be asked to join the incredible history department at the University of North Carolina at Chapel Hill. Returning to Chicago, my home for nearly two decades, for one last year (while living on Bittersweet Place no less), made writing this book difficult yet more meaningful. Most of all, I savored my last year at Roosevelt University, a place that inspires collaborations, new forms of learning, and the kinds of connections that led to this book. Special thanks to Chris Chulos, Heather Dalmage, David Faris, Sandra Frink, Bonnie Gunzenhauser, June

Lapidus, Mike Maly, Laura Mills, Margaret Rung, and at least two dozen others for creating this intellectual and social justice environment. I also thank my students at RU over the past decade for educating me as I sought to educate them, especially Simon Balto (now an essential colleague and collaborator), Earnest Bickerstaff, Gigi Davis, Tracy Drake, Josh Evans, Brandon Glynn (who served as a part-time research assistant), Dan Such, and the late Doria Johnson.

Beyond Roosevelt, contact with historic Chicago troublemakers catalyzed the book in many creative directions. These activists, artists, and intellects included Timuel Black, Maggie Brown, Martin Deppe, Sylvia Fischer, Susan Fison, Melody Heaps, Sally Johnson, Jim Keck, Fannie Rushing (and all of the Chicago SNCC project participants), Helen Shiller, Earl Silbar, C. T. Vivian, Jane Shay Wald, and Stan Willis. Among this group I have been blessed to have two associates develop into mentors and friends—Calvin Morris and Paul King—whose spirited counsel has been essential.

Institutions have also provided key assistance for this project. Aside from the NEH, Roosevelt University's Gage Gallery and the University of North Carolina's Office of Research Development have provided essential financial support for this publication. Thanks also to Sue Rutsen for inviting me to present a chapter of this book at the Nelson Algren Museum of Miller Beach in Gary, Indiana, and to Dylan Zavagno for a similar invitation to the Deerfield Public Library, and to Richard Shay for his general promotion of this project. And everyone at the University of Chicago Press deserves praise for their handling of this manuscript. Conversations and cogent comments from Tim

Mennel have continued to prove essential. I also thank Rachel Kelly Unger for her assistance, Erin DeWitt for her expert copyediting, and Michael Honey and an anonymous reader for their helpful comments.

My family, old and new, was supportive and patient over these last few years. My parents, George and Bodil Gellman, and brother, Ken Gellman, understood when I needed to work instead of visiting and followed the book's progress with interest. So, too, were all the members of the Turk family: Mary Lee, Beth, Charlie, Emily and Ed Miller, and Kareen Gray. Most of all, I thank my incredible partner in everything, Katherine Turk. Conversations with her about this project occurred from its inception to the very end, and she helped shape each draft of every chapter. Reverend Calvin Morris married us in the midst of this project, and our daughter was born in North Carolina in the same week I somehow managed to present this work to fifty soon-to-be-colleagues at UNC.

On the morning of April 28, 2018, I received word from Erica DeGlopper that Art Shay had died. This was the very day I moved away from Chicago. Since I settled in North Carolina, my relationship with Art has come to mean even more to me. My appreciation for Erica has deepened as well, as she redoubled her efforts on this project and mourned the end of her own fifteen-year collaboration with Art. I would dedicate this book to Art and Erica, but both would object in favor of the "book baby," whose photo Shay posted next to his breakfast table and whom he came to ask me about more than the status of the book itself. As such, this book is dedicated to the littlest troublemaker, Vivian Jontz Gellman.

IMAGES

Art Shay photographs, in order of appearance.

NOTES

Introduction

1. This phrase refers to the Chicago School of Sociology but also the attention Chicago received as a quintessential postwar American city. One of the most crucial texts in this regard focused on Black Chicago. See St. Clair Drake and Horace R. Cayton, *Black Metropolis: A Study of Negro Life in a Northern City* (1993; repr., Chicago: University of Chicago Press, 1945).

2. This framing is influenced by the classic study of civil rights and civility in a southern city (Greensboro). See William H. Chafe, *Civilities and Civil Rights: Greensboro, North Carolina, and the Black Freedom Struggle* (New York: Oxford University Press, 1980). Mayor Richard Daley adamantly preferred calling his Democratic political apparatus an "organization" rather than a machine. See Mike Royko, *Boss: Richard J. Daley of Chicago* (New York: Dutton, 1971).

3. Nelson Algren, *Chicago: City on the Make* (1951; repr., Chicago: University of Chicago Press, 2011).

4. Recent notable and model exceptions include Mark Speltz, *North of Dixie: Civil Rights Photography Beyond the South* (Los Angeles: Getty Publications, 2016); Martin A. Berger, *Seeing Through Race: A Reinterpretation of Civil Rights Photography* (Berkeley: University of California Press, 2011); and especially Leigh Raiford, *Imprisoned in a Luminous Glare: Photography and the African American Freedom Struggle* (Chapel Hill: University of North Carolina Press, 2007).

5. Susan Sontag, "Looking at War: Photography's View of Devastation and Death," *New Yorker*, December 9, 2002. See also Susan Sontag, *On Photography* (1973; repr., New York: Farrar, Straus and Giroux, 1977), 167–69. Art Shay's body of work does not replicate Henri Cartier-Bresson's "decisive moment"; nor does it reduce photographs to mathematical rules for successful framing of an image; nor does it conform to photojournalism clichés of protests. See also Teju Cole, "Perfect and Unrehearsed," *New York Times Magazine*, November 11, 2015; and Berger, *Seeing Through Race*.

6. Stan Holden, "Free Lance and Survive!: About Art Shay," *Art Photography* 6, no. 8 (February 1955): 47; Shay quoted in Holden, "Free Lance and Survive!," 4.

7. See Raiford, *Imprisoned in a Luminous Glare*, 77–78; Sontag, "Looking at War"; Michael Denning, *The Cultural Front: The Laboring of American Culture in the Twentieth Century* (New York: Verso, 1996); and Linda Gordon, *Dorothea Lange: A Life Beyond Limits* (New York: Norton, 2009).

8. For more on Shay's life, see his somewhat autobiographical work: Art Shay, *Album for an Age: Unconventional Words and Pictures from the Twentieth Century* (Chicago: Ivan R. Dee, 2000).

9. Shay quoted in Holden, "Free Lance and Survive!," 8.

Chapter One

1. St. Clair Drake and Horace R. Cayton, *Black Metropolis: A Study of Negro Life in a Northern City* (1993; repr., Chicago: University of Chicago Press, 1945), 377, chaps. 23–24.

2. James Gregory, "The Second Great Migration: A Historical Overview," in *African American Urban History since World War II*, ed. Kenneth L. Kusmer and Joe W. Trotter (Chicago: University of Chicago Press, 2009), 36.

3. Wallace D. Best, *Passionately Human, No Less Divine: Religion and Culture in Black Chicago, 1915–1952* (Princeton, NJ: Princeton University Press, 2006), 38–39.

4. Carl Wiegman, "City Tackles Race Problem: Here Is Story!," *Chicago Tribune*, December 28, 1949, 1.

5. Roi Ottley, "Why Negroes Flock to North," *Chicago Tribune*, April 29, 1956, 1. This series consisted of ten articles with the last one appearing on May 8, 1956. Historians have tended to reinforce these conclusions by emphasizing the first wave of the Great Migration to Chicago's South Side and by taking a pessimistic view of the second wave of migrants who settled on the city's West Side. See, for example, Nicholas Lemann, *The Promised Land: The Great Migration and How It Changed America* (New York: Knopf, 1991).

6. Fannie M. Brown, "Migration Bugaboo," in "The People Speak," *Chicago Defender*, daily edition, May 10, 1956, 11. Interestingly, other Black Chicagoans, including the labor leader Willard Townshend, wrote to the *Tribune* to commend its publishing of Ottley's articles. See "Voice of the People," *Chicago Tribune*, May 9, 1956, 20.

7. Gregory, "The Second Great Migration," 35–36; Gregory, "Two Sinister Objectives," *Chicago Defender*, national edition, June 22, 1957, 10.

8. Robert Gordon, *Can't Be Satisfied: The Life and Times of Muddy Waters* (New York: Little, Brown, 2002), 67, 82–84; Adam Green, *Selling the Race: Culture, Community, and Black Chicago, 1940–1955* (Chicago: University of Chicago Press, 2007), 74–78.

9. Muddy Waters, as told to Alfred Duckett, "'Got a Right to Sing Blues'—Muddy Waters: Something That Troubles Gets Needed Airing," *Chicago Defender*, national edition, March 26, 1955, 6.

10. Mike Rowe, *Chicago Blues: The City and the Music* (Boston: Da Capo Press, 1975), 217–18; Gordon, *Can't Be Satisfied*, 84, 115; Green, *Selling the Race*, 74–78.

11. Leslie F. Orear and Stephen H. Diamond, *Out of the Jungle: The Packinghouse Workers Fight for Justice and Equality* (Chicago: Hyde Park Press, 1968); Rick Halpern, *Down on the Killing Floor: Black and White Workers in Chicago's Packinghouses, 1904–54* (Urbana: University of Illinois Press, 1997); Erik S. Gellman, *Death Blow to Jim Crow: The National Negro Congress and the Rise of Militant Civil Rights* (Chapel Hill: University of North Carolina Press, 2012), chap. 1.

12. Marcia Walker-McWilliams, *Reverend Addie Wyatt: Faith and the Fight for Labor, Gender, and Racial Equality* (Urbana: University of Illinois Press, 2016), 40; Rick Halpern and Roger Horowitz, *Meatpackers: An Oral History of Black Packinghouse Workers and Their Struggle for Racial and Economic Equality* (New York: Monthly Review Press, 1999), 2; Dennis A. Deslippe, *Rights, Not Roses: Unions and the Rise of Working-Class Feminism, 1945–80* (Urbana: University of Illinois Press, 2000), 36.

13. Roger Horowitz, *"Negro and White, Unite and Fight!": A Social History of Industrial Unionism in Meatpacking, 1930–90* (Urbana: University of Illinois Press, 2000), 223.

14. Walker-McWilliams, *Reverend Addie Wyatt*, 86.

15. Orear and Diamond, *Out of the Jungle*; Walker-McWilliams, *Reverend Addie Wyatt*, 68–69; Cyril Robinson, *Marching with Dr. King: Ralph Helstein and the United Packinghouse Workers of America* (Santa Barbara, CA: Praeger, 2011), 62–63.

16. Len De Caux, "A Mission That Failed," *March of Labor* 4, no. 10 (October–November 1952): 6–8, 30.

17. Joseph McCarthy, speech broadcast on Mutual Broadcasting Association, March 17, 1954, Irish Fellowship Club meeting, Grand Ballroom, Palmer House, Chicago, as heard from Gordon Skene Sound Collection, www.crooksandliars.com/gordinskene/historys-wingnuts-sen-joe-mccarthy-chi.

18. Nelson Algren, *Chicago: City on the Make* (1951; repr., Chicago: University of Chicago Press, 2011), 39; Art Shay, *Album for an Age: Unconventional Words and Pictures from the Twentieth Century* (Chicago: Ivan R. Dee, 2000), 250.

19. Editorial, "Wilson's Hunting Dog," *Chicago Daily Tribune*, October 13, 1954, 24; "Wilson's 'Thru' as Political Speechmaker," *Chicago Daily Tribune*, October 15, 1954, 8; Kevin Boyle, *The UAW and the Heyday of American Liberalism, 1945–1968* (Ithaca, NY: Cornell University Press, 1995), 97–98; Solon Simmons, *The Eclipse of Equality: Arguing America on "Meet the Press"* (Stanford, CA: Stanford University Press, 2013), 213–14.

20. This plant was located at 12600 South Torrence in Chicago. See "Ford Prepares for Strike," *Chicago Tribune*, June 5, 1955, 1; "Union Men Leave Jobs as Parlay Continues," *Chicago Tribune*, June 6, 1955, 1; "Walkout Ends Here," *Chicago Tribune*, June 7, 1955, 2; Boyle, *The UAW and the Heyday of American Liberalism*, 93–97; Reuther quoted in Nelson

Lichtenstein, *The Most Dangerous Man in Detroit: Walter Reuther and the Fate of American Labor* (Urbana: University of Illinois Press, 1995), 284, 285–87.

21. Dominic A. Pacyga, *Slaughterhouse: Chicago's Union Stock Yard and the World It Made* (Chicago: University of Chicago Press, 2015), xi; Ethel Payne, "Idle Workers, Cutbacks Sure Depression Signs," *Chicago Defender*, national edition, October 30, 1954, 12; "Percy Says Gregory's Effect Potent," *Chicago Defender*, national edition, February 13, 1965, 1; Charles Watman, "Says Negro Losing Ground in New AFL-CIO," *Chicago Defender*, national edition, January 4, 1958, 9; Walker-McWilliams, *Reverend Addie Wyatt*, 92.

22. Arvarh E. Strickland, *History of the Chicago Urban League* (1966; repr., Columbia: University of Missouri Press, 2001), 132; Jeffrey Helgeson, *Crucibles of Black Empowerment: Chicago's Neighborhood Politics from the New Deal to Harold Washington* (Chicago: University of Chicago Press, 2014), 99–101; Lionel Kimble Jr., *A New Deal for Bronzeville: Housing, Employment, and Civil Rights in Black Chicago, 1935–1955* (Carbondale: Southern Illinois Press, 2015), 49; Gellman, *Death Blow to Jim Crow*, 49.

23. Alice Martin, "What the People Say: Labor Relations League," *Chicago Defender*, national edition, August 2, 1941, 14; Steering Committee, "What the People Say: Negro Labor League Answers Critic," *Chicago Defender*, national edition, August 9, 1941.

24. "17 Banks Face NLRL Picketing," *Chicago Defender*, national edition, June 7, 1958, 2; Bob Hunter, "Daley Seeks List of Snubbed Contractors," *Chicago Defender*, national edition, March 15, 1962.

25. Lewis A. H. Caldwell, "Commentary," *Chicago Defender*, national edition, March 19, 1958, 8; "Blackmail Charge Denied by Chicago Job Group," *Jet* 24, no. 46 (October 17, 1963): 23; "Southside Pair Convicted on Race Shakedown Rap," *Chicago Defender*, daily edition, July 20, 1965, 5.

26. Scott Newman cited in Victoria W. Wolcott, *Race, Riots, and Roller Coasters: The Struggle over Segregated Recreation in America* (Philadelphia: University of Pennsylvania Press, 2012), 219n110.

27. "Historical Loop-the-Loop: Riverview," *Chicago Tribune*, July 28, 1963, G22.

28. In 1935 Mattie Taylor and the Chicago NAACP successfully sued Riverview for failing to serve African Americans at the Bowery Restaurant in the park. See "Riverview Loses 'Rights' Suit," *Chicago Defender*, national edition, July 6, 1935, 5.

29. David Crowder, "What the People Say: Riverview Park Exhibit Disgusting," *Chicago Defender*, national edition, July 1, 1944, 12.

30. F. Richard Ciccone, *Royko: A Life in Print* (New York: Public Affairs, 2001), 97.

31. Provisional Committee, "What the People Say: Rap Riverview Park," *Chicago Defender*, national edition, July 8, 1950, 6.

32. Mike Royko, "The Dip Gets 'The Business' at Riverview,"

Chicago Daily News, May 21, 1964, 16. While the game disappeared, its underlying racial problems remained, evoked by the Black men who got fired as a result. See Mike Royko, "Tossing Dwarfs Raises Bigger Issue" (July 17, 1989), in Royko, *The Chicago Tribune Collection* (Chicago: Agate Digital, 2014). Mayor Daley ordered Riverside closed after the 1966 riots. No evidence of riots or increased crime existed in Riverview, but the owner claimed that the "rising problems of violence and disorder" contributed to the sale of the park's land, which no doubt was a racially coded message. This move to the hinterland became part of a national trend of urban amusement parks' relocation to areas that were only accessible by automobile and away from the perceived dangers of the city. See Wolcott, *Race, Riots, and Roller Coasters*, 219–20.

33. Chicago Urban League, "Fog over Chicago: An Urban League Editorial," *Chicago Urban League Newsletter* 3, no. 2 (April–May 1958), copy in box 73, folder 8, Morris Milgram Papers (Collection 2176), the Historical Society of Pennsylvania, Philadelphia, hereafter Milgram Papers.

34. "Housing Opportunities Program," reports on visits to community leaders, Chicago Regional Office, 1952, box 19, and general report, Chicago Regional Office, 1954, box 21: both AFSC Regional Office Files, AFSC Archives, Philadelphia, hereafter AFSC Papers.

35. Chicago Urban League, "Fog over Chicago."

36. "Jury Sees New Fire Trap," *Chicago Tribune*, September 10, 1953, 1; "Find Building Has Ignored 14 Fire Warnings," *Chicago Tribune*, September 11, 1953, 1; Clayton Kirkpatrick, "Wiring Never Tested by City Where 18 Died," *Chicago Tribune*, September 15, 1963, 10.

37. Editorial, "Fires in the Slums," *Chicago Tribune*, September 12, 1953, 12; "Alderman O.K. 3 Ordinances on Firetraps," *Chicago Tribune*, September 19, 1953, A7; "Firetrap Quiz Finds 23 Live in Old Store," *Chicago Tribune*, September 23, 1959, B10; "Coroner Plans Unit to Work on Fire Laws," *Chicago Tribune*, October 16, 1953, B8.

38. Judy Miller, report on Trumbull Park, January 3, 1957, Chicago Regional Office, box 25, folder "Housing: Trumbull Park Staff Visits," AFSC Papers.

39. See Arnold R. Hirsch, *Making the Second Ghetto: Race and Housing in Chicago, 1940–1960* (New York: Cambridge University Press, 1983), chap. 2.

40. "Night Watch: It Guards Negroes in a Chicago Housing Project against Violence," *Life* 35, no. 19 (November 9, 1953): 57, 59–60.

41. Frank London Brown, *Trumbull Park* (Chicago: Henry Regnery Company, 1959), 27, 97–98, 427–31. For an excellent analysis of the novel as a means to "reevaluate black Cold War literary production," see Mary Helen Washington, *The Other Blacklist: The African American Literary and Cultural Left of the 1950s* (New York: Columbia University Press, 2014), chap. 5.

42. Judy Miller, reports on Trumbull Park, September 12, 1957, Chicago Regional Office, box 25, folder "Housing: Trumbull Park Staff Visits, Chicago R.O. 1957"; May 1, 1958,

Chicago Regional Office, box 27, folder "Housing: Trumbull Park Staff Visits, Chicago R.O. 1958"; and July 14, 1959, Chicago Regional Office, box 28, folder "Housing Opportunities Program—Trumbull Park CRO 1959": all AFSC Papers.

43. Megan Adams, "The Patrolmen's Revolt: Chicago Police and the Labor and Urban Crises of the Late Twentieth Century" (PhD diss., University of California, Berkeley, 2012), 2, 6–9, 15.

44. See Karen J. Johnson, *One in Christ: Chicago Catholics and the Quest for Interracial Justice* (New York: Oxford University Press, 2018), 137–39.

45. This point appreciates and responds to Arnold Hirsch's definitive account of race and housing in postwar Chicago and his call for "further research" of "the rediscovery of ethnicity" among whites as "an effective new tactic in fending off advances made by politically aggressive blacks." See Hirsch, *Making the Second Ghetto*, chap. 3 and quote above from 258.

46. "Trumbull Park: A Progress Report," April 1959, Chicago Regional Office, box 28, folder "Housing Opportunities Program, General, Chicago R.O, 1959," AFSC Papers.

47. David Fison, "How to Stop Riots in Chicago," article clipping from unknown periodical, n.d. [1959–60], box 24, folder 403, Industrial Areas Foundation Records, Special Collections and University Archives, University of Illinois at Chicago, hereafter IAF Records.

48. Gregory, "The Second Great Migration," 30.

49. Hirsch, *Making the Second Ghetto*, 238. See also D. Bradford Hunt, *Blueprint for Disaster: The Unraveling of Chicago Public Housing* (Chicago: University of Chicago Press, 2010).

50. "Challenge for a Machine," *Life* 38, no. 8 (February 21, 1955): 53–54; Adam Cohen and Elizabeth Taylor, *American Pharaoh: Mayor Richard J. Daley—His Battle for Chicago and the Nation* (Boston: Little Brown, 2000), 115, 123–25, 134, 139–41.

51. "Go Forward," Daley pamphlet, n.d. [1954], box SIIss1B28, folder 8; and Ben Sacks, Jeweler's Association of Chicago to Daley, February 4, 1955, box SIIss1B28, folder 1: both Richard J. Daley Collection, Special Collections and University Archives, University of Illinois at Chicago, hereafter Daley Collection.

52. "FOR ALL THE PEOPLE: Elect Richard J. Daley, Democratic Candidate for Mayor," pamphlet, n.d. [1955], box SIIss1B28, folder 10, Daley Collection.

53. Cohen and Taylor, *American Pharaoh*, 82. Note here, too, that Daley "squeezed [Hugh "Babe"] Connelly out," even though Connelly had been so influential in promoting Daley's early Democratic machine career.

54. Paul Welty to Daley, January 25, 1955, box SIIss1B28, folder 1, Daley Collection.

55. Daley Telecast script, WKBW, February 23, 1955; James Anderson to Matthew Danasher, Administrative Assistant, Cook County Building, February 15, 1955; and Robert A. Platt Agency, "All Chicago Citizens Committee for Richard J. Daley for Mayor," WKBW advertising schedule: all box SIIss1B28, folder 1, Daley Collection.

56. William Lee and Earl McMahon, "AF of L Labor Committee for Daley to All Unions and District Councils," n.d. [1954–1955]; William Rocco, Chairman CIO Cook County PAC to Ward Committee, January 28, 1955; "Statement of the CIO to the Nominating Committee of the Democratic Party of Cook County," December 16, 1954; AFL Flyer, "The Man Who Will Lead ALL Chicagoans to Their Greatest Destiny," n.d. [1954–55]: all in box SIIss1B28, folder 9, Daley Collection.

57. Ernest DeMaio, President, District 11, United Electrical Workers to Daley, n.d. [late 1954, early 1955], box SIIss1B28, folder 9, Daley Collection.

58. "Challenge for a Machine," 53–54; Cohen and Taylor, *American Pharaoh*, 115, 123–25, 134, 139–41; Edward Welters, People's Welfare Organization of Chicago, to Daley, December 22, 1954, box SIIss1B28, folder 5, Daley Collection.

59. Some sources date Jackson's move to Chicago in 1927 rather than 1928 and her beauty salon as opening during World War II rather than 1939. After evaluating the sources, the years 1927 and 1939 seem more precise. See Mahalia Jackson, as told to Evan Wylie, "I Can't Stop Singing," *Saturday Evening Post* 232, no. 23 (December 5, 1959): 19–21, 98–100; Clay Gowran, "Gospel Singing Queen Lonely, Sad as Child," *Chicago Tribune*, July 31, 1955, 12; Clay Gowran, "Mahalia's Rise to Fame Rapid," *Chicago Tribune*, August 7, 1955, 9; untitled article, *Chicago Defender*, January 3, 1948, 9; Miss Wright, "What the People Say: Raps Al Benson," *Chicago Defender*, February 21, 1948, 14; Mahalia Jackson, as told to Alfred Duckett, "My Love Life: Why I Became a Gospel Singer," *Chicago Defender*, June 19, 1956, 8; and Jules Schwerin, *Got to Tell It: Mahalia Jackson, Queen of Gospel* (New York: Oxford University Press, 1992). For more on gospel music's denunciation and popularity in the 1920s, see Davarian L. Baldwin, *Chicago's New Negroes: Modernity, the Great Migration, and Black Urban Life* (Chapel Hill: University of North Carolina Press, 2007), 181–92.

60. "Progressives Open 4th Ward Campaign at Party Tuesday," *Chicago Tribune*, April 4, 1948, S4; Conrad Clark, "Gospel Queen Threatens to Sue Leftists," *Philadelphia Tribune*, August 5, 1952, 1; Richard Orr, "'Mahalia Sings' Is TV Magic," *Chicago Tribune*, March 17, 1955, 9G; "Our Opinions: TV Ain't the Thing," *Chicago Defender*, March 19, 1955, 9; "Mahalia Jackson Backs Boycott: 'It's for My Folks,'" *Chicago Defender*, daily edition, February 4, 1964, A1; Green, *Selling the Race*, 62–66; Schwerin, *Got to Tell It*, 63–65, 84–86.

61. Jackson, "I Can't Stop Singing," 99–100; "Two Homes Fired; Cops on Guard," *Chicago Defender*, April 26, 1956, 1; "Great Confusion: Case of Mahalia Jackson," *Philadelphia Tribune*, December 5, 1959, 4; "Burglars Get $2,000 in Cash from Mahalia," *Chicago Tribune*, January 6, 1959, C6; Jackson quoted in "Mahalia's Fans to Fill Carnegie," *New York Amsterdam News*, October 11, 1952, 27.

62. "Through with Pacifier, Says Abernathy at Rally," *Chicago Defender*, May 28, 1956, 5; "Non-Violence Seminar Dec. 3," *Chicago Defender*, November 24, 1956, 8; "Mahalia Rocks Walking Folks," *Baltimore Afro-American*, December 15, 1956, 12; "Mahalia Jackson Approves Sitdowns," *Baltimore Afro-American*, April 16, 1960, 5.

Chapter Two

1. Art Shay, *Chicago's Nelson Algren* (New York: Seven Stories Press, 2007), xxvi, 120, 131.

2. Nelson Algren, with Art Shay, "One Man's Chicago," *Holiday* 10, no. 4 (October 1951): 72–73, 75–78, 80–89, 117. On the electric chair in Cook County Jail, see Melanie Newport, "Jail America: The Reformist Origins of the Carceral State" (PhD diss., Temple University, 2016), 79–80.

3. Alfred Ames, "Algren Pens a Distorted, Partial Story of Chicago," *Chicago Tribune*, October 21, 1951, J5; Helene Washer, "Whose Chicago?," *Chicago Tribune*, letters to the editor, November 18, 1951, B16; Algren, "One Man's Chicago." In the sixtieth anniversary edition of *Chicago: City on the Make*, David Schmittgens and Bill Savage point out that Algren substantially revised the article into a book because he thought it "had been butchered by the magazine's editors." Also, in the 1961 edition, Algren added a preface, in part to comment upon "the book's initial reception and its cultural milieu." See the preface and publishing history sections in Nelson Algren, *Chicago: City on the Make* (1951; repr., Chicago: University of Chicago Press, 2011), vii–viii, 130.

4. "Chicago Candidate Shot," *New York Times*, February 7, 1952, 28; "West Side Bloc: How It Decides Laws, Elections," *Chicago Tribune*, February 9, 1952, 6; "Widow Asserts Gross Died for Clean Politics," *Chicago Tribune*, February 11, 1952, 10; "2 Chicago Groups Get Under Way in Fight on Crime," *Washington Post*, February 17, 1952, M8; "Gross Slaying Forgotten in Probe Uproar," *Chicago Tribune*, February 2, 1953, B7; "New Quiz on Cops' Incomes," *Chicago Tribune*, February 27, 1953, 1; Richard C. Lindberg, *To Serve and Collect: Chicago Politics and Police Corruption from the Lager Beer Riot to the Summerdale Scandal, 1855–1960* (New York: Praeger, 1991), 280–81.

5. "Push G.O.P. Purge," *Chicago Tribune*, February 12, 1952, 1; "Demand Purge of Hoodlums by Democrats," *Chicago Tribune*, March 6, 1952, 2; "Erickson Calls Democrats Big Bosses of Bloc," *Chicago Tribune*, February 14, 1952, 3; "Cops Doing Fine Job, Crime Quiz as Told by Cops," *Chicago Tribune*, June 5, 1952, 3; "Gross Assassinated Three Years Ago," *Chicago Tribune*, February 6, 1955, 42; "Cop Income Quiz Dropped!" *Chicago Tribune*, October 5, 1955, 1.

6. Mike Royko, *Boss: Richard J. Daley of Chicago* (New York: Dutton, 1971), 108.

7. Dora Jane Hamblin and Art Shay, "Chicago's Traffic Terror," *Life* 29, no. 17 (October 24, 1955), 2, 61; Howard Earle, "The Real Jack Muller," *Chicago Tribune*, October 16, 1955, G30.

8. Hamblin and Shay, "Chicago's Traffic Terror"; "Arrest

Judge and Wife in Traffic Row," *Chicago Tribune*, August 8, 1954, 1; Editorial, "Have We a Ruling Class?," *Chicago Tribune*, August 11, 1954, 16; "$6 Traffic Fine Paid for Judge's Wife," *Chicago Tribune*, August 19, 1954, 1.

9. "Outspoken Patrolman Jack Muller Gets a Beat in Chicago's Siberia," *Life* 39, no. 24 (December 12, 1955): 157; Patricia Bronte, "Meet Chicago's Toughest Cop!," *Chicago Tribune*, January 17, 1954, C18; "Letters from Readers," *Chicago Tribune*, February 28, 1954, F4; "Muller Loses His Night Life Beat," *Chicago Tribune*, October 10, 1955, 1; Earle, "The Real Jack Muller"; "Policeman Muller Gagged, but He Keeps on Talking," *Chicago Tribune*, November 23, 1955, 1; "Muller Sets Mayor to Drumming," *Chicago Tribune*, August 7, 1957, 7; "The People Speak: Honest Jack Muller," *Chicago Defender*, August 16, 1958, 10; "Victory for Democrats!," *Chicago Tribune*, November 5, 1958, 1; "Jack Muller to Be Investigation Suspect," *Chicago Tribune*, December 27, 1967, 16; "Cop Hired as Killer: Muller," *Chicago Tribune*, March 14, 1968, A10.

10. "Work Papers on Courts Serving Children and Youth," part 12 of Mayor's Advisory Committee on Youth Welfare and the Welfare Council of Metropolitan Chicago, "Community Mobilization for Youth: Work Papers prepared by the sub-committees of the sponsoring organizations for the First Report Meeting," 1957, 3, box 13, folder 4, Harvey Lawrence Long Papers, Special Collections and University Archives, University of Illinois at Chicago, hereafter Long Papers.

11. Hans Mattick, Youth Bureau memorandum, "Re: Five Year Comparison of CPD," Juvenile Statistics, February 14, 1961, box 1, Hans W. Mattick Papers, Chicago History Museum Research Center, hereafter Mattick Papers; "Area of Concern of the Conference," section 1 of Mayor's Advisory Committee on Youth Welfare and the Welfare Council of Metropolitan Chicago, "Community Mobilization for Youth: Work Papers prepared by the subcommittees of the sponsoring organizations for the First Report Meeting," 1957, 3, box 13, folder 4, Long Papers.

12. Charles Schwanitz, "Schurz High Pupils Have Fine Record," *Chicago Tribune*, March 27, 1955, NW23.

13. Kathleen Winsor, *Forever Amber* (1944; New York: Signet, 1950); Dawn B. Sova, *Banned Books: Literature Suppressed on Sexual Grounds*, rev. ed. (New York: Facts on File, 2006), 79–81.

14. Chicago Youth Commission, "A Report on Legislation as It Affects Youth," part of Mayor's Advisory Committee on Youth Welfare and the Welfare Council of Metropolitan Chicago, "Community Mobilization for Youth: Work Papers prepared by the subcommittees of the sponsoring organizations for the First Report Meeting," 1957, 3, box 13, folder 4, Long Papers.

15. Norma Lee Browning, "Good and Bad Teen-Agers," *Chicago Tribune* series, March 4–10, 1956.

16. For examples, see "Seize 5 in Stolen Car Chase," *Chicago Tribune*, February 15, 1954, 1; "Seize 4 Teen-Agers as Extortion Gang," *Chicago Tribune*, August 16, 1955, 1; "Hit-Run Driver Surrenders in Death of Mother of Four," *Chicago Tribune*, December 23, 1958, 3; and "Two Boys and Girl Injured by Auto; Pupil, 15, Seized, " *Chicago Tribune*, April 3, 1959, 1.

17. Browning, "Good and Bad Teen-Agers," *Chicago Tribune*, March 5, 1956, 6.

18. Andrew J. Diamond, *Mean Streets: Chicago Youths and the Everyday Struggle for Empowerment in the Multiracial City, 1908–1969* (Berkeley: University of California Press, 2009), esp. chap. 4.

19. Barbara Ehrenreich, *Fear of Falling: The Inner Life of the Middle Class* (New York: Random House, 1989), 91–96.

20. Diamond, *Mean Streets*, 154, 155, chap. 4 *passim*; Arnold R. Hirsch, *Making the Second Ghetto: Race and Housing in Chicago, 1940–1960* (New York: Cambridge University Press, 1983), 208.

21. "Causes of Delinquency, Bias Are Same; Carey," *Chicago Defender*, national edition, July 23, 1955, 1.

22. Gunnar Myrdal, *An American Dilemma: The Negro Problem and Modern Democracy*, 2 vols. (New York: Carnegie Corporation, 1944); David W. Southern, *Gunnar Myrdal and Black-White Relations: The Use and Abuse of "An American Dilemma," 1944–1969* (Baton Rouge: Louisiana State University Press, 1987); Erik S. Gellman, *Death Blow to Jim Crow: The National Negro Congress and the Rise of Militant Civil Rights* (Chapel Hill: University of North Carolina Press, 2012), 262–65.

23. Editorial, "Police Brutality Again," *Chicago Sun-Times*, June 13, 1958, copy in box 20, folder 321, series 1, IAF Records.

24. Richard J. Daley quoted in Mayor's Advisory Committee on Youth Welfare, "Statement of Purpose," pamphlet, October 22, 1957, box 13, folder 4, Long Papers.

25. Chicago Youth Commission, "A Report on Legislation as It Affects Youth," Long Papers.

26. See "Police Brutality—clippings, 1958–1963," box 20, folder 321, series 1, IAF Records.

27. Hans Mattick, "Some Comments on Chicago Police Department Statistics Related to Younger Offenders," July 15, 1960, box 94, Mattick Papers.

28. U.S. Senate Report 1593, "Juvenile Delinquency: Report of the Committee on the Judiciary, United States Senate, 86th Cong., 2d Sess.," June 15, 1960, US Government Printing Office, copy in box 94, Mattick Papers.

29. Mattick, "Some Comments on Chicago Police Department Statistics Related to Younger Offenders."

30. Simon Balto, *Occupied Territory: Policing Black Chicago from Red Summer to Black Power* (Chapel Hill: University of North Carolina Press, 2019), 124; "Here's What Man on Street Thinks of Chicago Police," *Chicago Defender*, national edition, November 30, 1957, 5.

31. Illinois Institute for Juvenile Research and Chicago Area Project, "Drug Addiction among Young Persons in Chicago," October 1953, box 3, Mattick Papers; Hans Mattick, "1,086 Offenses for Which Men Were Sentenced to Cook County Jail by the Municipal Court," October 31, 1955, box 159, Mattick

Papers; Hans Mattick to A. G. Geocaris, Esq., June 7, 1955, box 159, Mattick Papers; Balto, *Occupied Territory*, 139–44.

32. "Work Papers on Correctional Services," part 13 of Mayor's Advisory Committee on Youth Welfare and the Welfare Council of Metropolitan Chicago, "Community Mobilization for Youth: Work Papers prepared by the subcommittees of the sponsoring organizations for the First Report Meeting," 1957, 3, box 13, folder 4, Long Papers.

33. George Bliss, "Tell High Pay Costs at Juvenile Home," *Chicago Tribune*, February 16, 1964, 17; "Work Papers on Correctional Services," Long Papers.

34. Mrs. Doramai Allent to Charles Farrell, Superintendent, Illinois Industrial School for Boys, received December 13, 1958, box 20, folder 1, Long Papers.

35. "Reformatory Boss Is Fired for Brutality," *Chicago Tribune*, February 21, 1961, 3.

36. Robert Wiedrich, "Boys' Prison Riot! Guard Beaten," *Chicago Tribune*, October 17, 1960, 1.

37. Commission to Visit and Examine State Institutions, Penal Division, "Special Report of the Investigation of the Illinois Industrial School for Boys, Sheridan, Illinois," May 21, 1961, copy filed at University of Illinois Library at Urbana-Champaign; "Reformatory Boss Is Fired for Brutality," 3.

38. William Golden, "Impressions of a Juvenile Officer," typescript for article, September 1961, box 19, folder 158, Stephen Bubacz Papers, Special Collections and University Archives, University of Illinois at Chicago, hereafter Bubacz Papers.

39. Fred Farrar, "Story of Reform at Sheridan School: Brutality Gone," *Chicago Tribune*, September 24, 1961, 35; "Howard Group Hits Rehiring of Ray Farber," *Chicago Tribune*, October 7, 1961, B8.

40. John Bartlow Martin, "The Mess at Sheridan," draft 2, "Raw Copy" of two-part article, January 1962, typescript in papers of Art Shay and in author's possession but also in box 191, Speech, Article, and Book file, John Bartlow Martin Papers, Library of Congress, Washington, DC.

41. Lindberg, *To Serve and Collect*, 276–77, 296, 305; "Adamowski Blasts Brass for Police Dept. Scandal," *Chicago Tribune*, January 22, 1960, 2; "8 Cops Lacked Supervision Says Captain," *Chicago Tribune*, January 23, 1960, 3.

42. Robert Wiedrich, "Jury Subpoenas O'Connor, Cohen," *Chicago Tribune*, January 21, 1960, 1; "Experts Find Cops Good Lie Test Subjects," *Chicago Tribune*, January 21, 1960, 5; "Lie Tests Begin in Cop Scandal," *Chicago Tribune*, January 21, 1960, 1.

43. "Extend Police Probe to 4 More Districts," *Chicago Tribune*, January 22, 1960, 1; Daley quoted in Editorial, "Price of One Party Government," *Chicago Tribune*, January 21, 1960, 12.

44. Lindberg, *To Serve and Collect*, 307–9.

45. Seymour Simon quoted in Royko, *Boss*, 118.

46. "Price of One Party Government," 12.

47. "Adamowski Blasts Brass for Police Dept. Scandal," 2.

48. "Adamowski Rips the Tactics of Boss Daley," *Chicago Tribune*, December 1, 1960, 1; Royko, *Boss*, 119.

49. Despres quoted in "Mayor Pledges to Spare None in Cleanup," *Chicago Tribune*, January 21, 1960, 1; Lindberg, *To Serve and Collect*, 310–12, quote from 314.

50. William J. Bopp, *"O. W.": O. W. Wilson and the Search for a Police Profession* (Port Washington, NY: Kennikat Press, 1977), 81–82.

51. Balto, *Occupied Territory*, chap. 5.

52. Balto, *Occupied Territory*, 189; "Cook County Jail: Report of the December, 1967 Grand Jury," box 42, Mattick Papers.

53. Audrey Weaver, "Ben Lewis Story—WPA Laborer to Ward Boss," *Chicago Defender*, national edition, November 4, 1961, 1; Arnold Hirsch, "The Cook County Democratic Organization and the Dilemma of Race, 1931–1987," in *Snowbelt Cities: Metropolitan Politics in the Northeast and Midwest since World War II*, ed. Richard M. Bernard (Bloomington: Indiana University Press, 1990), 80.

54. "Negroes, Whites in Power Struggle over Lewis' Ward," *Jet* 23, no. 22 (March 21, 1963): 5–6.

55. "7,000 Attend Funeral of Ald. Lewis," *Chicago Tribune*, March 5, 1963, 1; Ted Coleman, "'They Got You, Ben,' Amateur Poet Writes as Thousands Pay Mute Tribute to Lewis," *Chicago Defender*, daily edition, March 5, 1963, 4.

56. Ben Burns, "Ben Lewis Murder Shakes Up Chicago," *Chicago Defender*, daily edition, March 5, 1963, 13; "Chi Alderman's Wife Denies Rift with Slain Politician," *Jet* 23, no. 22 (March 21, 1963): 7–11.

57. Betty Edwards, "Lewis Dead, but His Ghost Still Stalks West Side Streets," *Chicago Defender*, March 9, 1963, 1; "Ghost of Ben Lewis Still Haunts City Hall," *Jet* 24, no. 2 (May 2, 1963): 9; Lloyd General, "Month Later: Lewis Gone, Almost Forgotten," *Chicago Defender*, national edition, March 30, 1963, 1.

58. "Negroes, Whites in Power Struggle over Lewis' Ward," 5–6; Jon Rice, "The World of the Illinois Panthers," in *Freedom North: Black Freedom Struggles Outside the South, 1940–1980*, ed. Jeanne F. Theoharis and Komozi Woodard (New York: Palgrave Macmillan, 2003), 43–45.

59. Edwards, "Lewis Dead," 1; Lloyd General, "Ben Lewis Was Slain a Year Ago; Crime Defies Solution," *Chicago Defender*, national edition, February 24, 1964, 3.

60. "Alderman Bar Lewis Quiz," *Chicago Tribune*, March 7, 1963, S1; Ted Coleman, "Negro Vote Won Election for Daley, Experts Agree," *Chicago Defender*, daily edition, April 4, 1963, 1.

61. William J. Grimshaw, *Bitter Fruit: Black Politics and the Chicago Machine, 1931–1991* (Chicago: University of Chicago Press, 1992), 115, 120, 229; Royko, *Boss*, 124–27.

62. "Picket Fillmore Police Station," *Chicago Defender*, daily edition, September 18, 1963, A2; "Friends of Ben Lewis to Hear Rights Lawyer," *Chicago Defender*, daily edition, November 18, 1963, 31; M. Wilson Lewis, "Negroes in 24th Ward Protest Lack of Jobs," *Chicago Defender*, daily edition, April 9, 1964, 3; Rice, "The World of the Illinois Panthers," 43–45.

Chapter Three

1. Baldwin spoke at a similar house party on behalf of the American Freedom of Residence Fund in New York on May 18, 1961, and probably stopped by Deerfield when in Chicago a week later for a fund-raising dinner at the Morrison Hotel for the same organization. See Morris Milgram to Max Weinrib, May 3, 1961, box 73, folder 9, and William vanden Heuvel, President, American Freedom of Residence Fund, to Friends, June 30, 1961, box 74, folder 16: both Morris Milgram Papers.

2. James Baldwin, *The Fire Next Time* (New York: Dial Press, 1963), 69–70.

3. Dominic A. Pacyga, *Chicago: A Biography* (Chicago: University of Chicago Press, 2009), 308–15.

4. Richard Rothstein, *The Color of Law: A Forgotten History of How Our Government Segregated America* (New York: Liveright, 2017), 125.

5. Eleanor Roosevelt and attorney Joseph L. Rauh Jr. were among many to make the Little Rock analogy. See Roosevelt quoted in "The Tragedy of Our Time: But Not Next Door," flyer for forthcoming book on Deerfield, n.d. (1962), folder 1, box 72, Milgram Papers; and Rauh quoted in Henry Hanson, "Assails Deerfield as Little Rock," *Chicago Daily News*, September 13, 1962, clipping, box 72, folder 1, Milgram Papers. For Milgram background, see Thomas J. Sugrue, *Sweet Land of Liberty: The Forgotten Struggle for Civil Rights in the North* (New York: Random House, 2008), 230–36; Ellis Lathers, "From Segregation to Community," box 72, folder 1, Milgram Papers; Milgram to Friends, holiday card, December 1959, box 74, folder 10, Milgram Papers.

6. "Deerfield … Bannockburn and Surrounding Areas STREET DIRECTORY," compliments of Deerfield Commons (Chicago: Lew Merrell, 1959), 2–4; AFSC Report, "Freedom of Resident in Deerfield," November, 1960, box 75, folder 7, Milgram Papers; Max Weinrib, "Information on Building Site," 1959, box 73, folder 6, Milgram Papers; Deerfield Park homes, price list brochure, July 10, 1959, box 73, folder 13, Milgram Papers; Sugrue, *Sweet Land of Liberty*, 236.

7. "Greetings to Race Bigots," letters to editor, *Chicago Defender*, national edition, December 26, 1959, 10.

8. "Underwood, Chi Edit" to "Elliot for Newsfront," *Life*, Teletype, November 25, 1959, copy courtesy of Art Shay, in author's possession.

9. Dorothy Arns, "Deerfield Integration Foes Hoot Teacher," *Chicago American*, November 25, 1959, clipping in the files of Art Shay.

10. "Decision in Deerfield," *Chicago Sun-Times*, reprint of editorial, December 13, 1959, copy in the files of Art Shay.

11. Harold Lewis quoted in "Underwood, Chi Edit" to "Elliot for Newsfront," *Life*, Teletype, November 25, 1959. AFSC Report, "Meeting at Deerfield School," November 24, 1959, box 28, folder "Housing Opportunities Program, Deerfield, Chicago R.O., 1959," AFSC Papers.

12. See Ira Katznelson, *When Affirmative Action Was White: An Untold History of Racial Inequality in Twentieth-Century America* (New York: Norton, 2005). Also, historian Tom Sugrue's work informs this ideology of Deerfield residents. "Whites saw residential segregation not as the result of public policy," he cogently explained, "but rather as a 'natural desirable situation,' the result of separation by class and the sum of individual choices about where to live." See Sugrue, *Sweet Land of Liberty*, 207. On the cultural ideas of the 1950s family, see Elaine Tyler May, *Homeward Bound: American Families in the Cold War Era* (New York: Basic Books, 1988); and Margot Canaday, "Building a Straight State: Sexuality and Social Citizenship Under the 1944 G.I. Bill," *Journal of American History* 90, no. 3 (December 2003): 935–57.

13. Mrs. Robert Hyde quoted from film footage of the November 24, 1959, Deerfield town meeting as used in the film documentary by the Chicago Video Project, *No Place to Live: Chicago's Affordable Housing Crisis*, Chicago Matters: Inside Housing series (Chicago: WTTW, 2002). See also "Integration Plan Discussed at Special Village Meeting," *Deerfield Review*, December 3, 1959, copy in box 77, folder 7, Milgram Papers; AFSC Report, "Meeting at Deerfield School," November 24, 1959, box 28, folder "Housing Opportunities Program, Deerfield, Chicago R.O., 1959," AFSC Papers.

14. For Milgram's past anti-Communism, see Frank McCalister to Morris Milgram, April 27, 1940, and Morris Milgram to Pauli Murray, May 2, 1940, box 338, folder 2, Milgram Papers.

15. Barbara Moffett and Jane Weston, "Deerfield," November 24, 1959, box 28, folder "Housing Opportunities Program, Deerfield, Chicago R.O, 1959," AFSC Papers; Wilma Dykeman and James Stokely, "'The South' in the North: A Racial Conflict over Housing in a Chicago Suburb Points Up Some Difference—and Similarities—Above and Below the Mason-Dixon," *New York Times Magazine*, April 17, 1960, copy in box 79, folder 3, Milgram Papers; "Underwood, Chi Edit" to "Elliot for Newsfront," *Life*, Teletype, November 25, 1959.

16. William Reynolds quoted from film footage of the November 24, 1959, Deerfield town meeting as used in the film documentary Chicago Video Project, *No Place to Live: Chicago's Affordable Housing Crisis*; "Underwood, Chi Edit" to "Elliot for Newsfront," *Life*, Teletype, November 25, 1959; "Integration Plan Discussed at Special Village Meeting," *Deerfield Review*, December 3, 1959, copy in box 77, folder 7, Milgram Papers; "Meeting at Deerfield School," November 24, 1959, box 28, folder "Housing Opportunities Program, Deerfield, Chicago R.O., 1959," AFSC Papers.

17. "Crowd Jeers at Deerfield Homes Parlay," *Chicago Tribune*, November 24, 1959, B11; Jack Willner, "Deerfield Home Prices Unhurt by Racial Issue," *Chicago Daily News*, December 14, 1954, clipping, box 77, folder 7, Milgram Papers.

18. "Rally Backing for Supporter of Integration," *Chicago*

Tribune, November 26, 1959, D18; "Underwood, Chi Edit" to "Elliot for Newsfront," *Life*, Teletype, November 25, 1959.

19. On suburban liberals, see Lily Geismer, *Don't Blame Us: Suburban Liberals and the Transformation of the Democratic Party* (Princeton, NJ: Princeton University Press, 2015).

20. Art Shay, interview with author, December 23, 2016, Deerfield, Illinois.

21. Art Shay, testimony at hearing held before Committee on Commerce, "Nomination of Carl E. Bagge of Illinois, to be a Member of the Federal Power Commission," United States Senate, May 5, 1965 (Washington, DC: Monick-Sullivan, 1965), 2–44.

22. AFSC, "Chronology of Events in Deerfield," January 1960, box 29, folder "Housing Opportunities Program, Deerfield, Chicago R.O., 1960," AFSC Papers; Ellis Lathers, "From Segregation to Community," pro-integration brochure, box 72, folder 1, Milgram Papers; "Deerfield, Suburb of Chicago, Votes Overwhelmingly to Remain Segregated," *Augusta Courier*, January 4, 1960, 1, copy in box 77, folder 8, Milgram Papers; "Urges Deerfield to Defy Mixing," *Chicago Defender*, national edition, February 6, 1960, 13; "Vandals Hack 2 Model Homes in Deerfield Development," *Chicago Sun-Times*, December 18, 1959, 49; "'Klan' Cross to Stay Deerfield Mystery?," *Chicago Daily News*, December 19, 1959, clipping found in files of Art Shay; Editorial, "Good People of Deerfield Won't Tolerate Violence," *Chicago Daily News*, December 19, 1959, 8.

23. Milgram quoted in "Builders Are Going Ahead in Deerfield Despite Poll," *Chicago Daily News*, December 7, 1959, clipping found in files of Art Shay.

24. Deerfield Citizens for Human Rights, "Open Letter to Deerfield Voters," files of Art Shay; AFSC, "Chronology of Events in Deerfield," January 1960, box 29, folder "Housing Opportunities Program, Deerfield, Chicago R.O., 1960," AFSC Papers.

25. "OK Deerfield Bonds in Integration Issue," *Chicago Sun-Times*, December 22, 1959, 1, 16; "King Asks 'Righteous Pressure' in Deerfield," *Chicago Defender*, national edition, December 26, 1959, 3.

26. "Angry Debate on Deerfield," *Chicago Defender*, daily edition, January 7, 1960, A1; "The Pros and Cons of Quotas," *Ebony* 15, no. 5 (March 1960): 108. On the African American home preferences, see Andrew Wiese, "'The House I Live In': Race, Class, and African American Suburban Dreams in the Postwar United States," in *The New Suburban History*, ed. Kevin M. Kruse and Thomas J. Sugrue (Chicago: University of Chicago Press, 2006), 114; Mary Pattillo, *Black Picket Fences: Privilege and Peril among the Black Middle Class* (Chicago: University of Chicago Press, 1999), chap. 1.

27. Fletcher Martin, "Southern Gentleman Judge Is Hearing Deerfield Case," *Chicago Sun-Times*, January 18, 1960, 24; Judy Howard, Jane Weston, and Barbara Moffett, "Deerfield Decision," March 7, 1960, box 29, folder "Housing Opportunities Program—Deerfield, CRO 1960," AFSC Papers.

28. Jane Weston, Minutes of Inter-Agency meeting,

January 5, 1960, box 29, folder "Housing Opportunities Program—Deerfield, CRO 1960," AFSC Papers; Richard Nixon to Kale Williams, February 1, 1960, box 29, folder "Housing Opportunities Program—Deerfield, CRO 1960," AFSC Papers; Dykeman and Stokely, "'The South' in the North"; Jane Weston, "Harassment of the Lemmon Family in Deerfield," July 6, 1961, box 31, folder "Deerfield Controversy, CRO, 1961," AFSC Papers; "Vandals Hack 2 Model Homes in Deerfield Development," *Chicago Sun-Times*, December 18, 1959, clipping, box 77, folder 6, Milgram Papers.

29. Editorial, "Deerfield—A Challenge," *Chicago Defender*, local edition, June 8, 1961, 11.

30. Art Shay, testimony at hearing held before Committee on Commerce, "Nomination of Carl E. Bagge of Illinois," United States Senate, May 5, 1965, 24.

31. Art Shay to "Borgstedt and Schnell," "Herewith first take on Block Busting," May 22, 1962, from the files of Art Shay.

32. Norris Vitchek as told to Alfred Balk, "Confessions of a Block-Buster," *Saturday Evening Post*, July 14, 1962, 15–19. It turns out that the attorney and housing rights advocate Mark Satter provided information and leads to inform "Vitchek's" confession but that Balk also talked to at least one other actual blockbuster for the story. For more on racialized housing policies and practices, see Beryl Satter, *Family Properties: Race, Real Estate, and the Exploitation of Black Urban America* (New York: Metropolitan Books, 2009), 113–14 and *passim*; and Amanda Seligman, *Block by Block: Neighborhoods and Public Policy on Chicago's West Side* (Chicago: University of Chicago Press, 2005), esp. chap. 6.

33. Arthur Falls to Morris Milgram, November 12, 1961, box 73, folder 10, Milgram Papers; AFRF, "Help Fight for the Right to Live Anywhere You Please," January 1962, advertisement in *New Republic* and *Progressive*, box 72, folder 1, Milgram Papers; Elizabeth Freund, "Minutes of the American Freedom of Residence Fund," New York Board meeting, December 15, 1961, box 72, folder 11, Milgram Papers; William J. vanden Heuvel, President, American Freedom of Residence Fund, to Friends, June 30, 1961, box 74, folder 16, Milgram Papers; Ann and Clarence Jones, "We cordially invite you to a reception," March 31, 1963, box 72, folder 1, Milgram Papers; AFRF, invitation to Golden Key Dinner, May 24, 1961, Morrison Hotel, Chicago, box 78, folder 3, Milgram Papers; "Mrs. FDR to Address Fund Dinner," *Chicago Defender*, daily edition, May 24, 1961, 15; Hillard McFall, "View to Uphold Democracy," *Chicago Defender*, national edition, May 27, 1961, 1; AFSC, "Suggested Material for *Trends* article on Chicago," June 1961, box 31, folder "H.O.P., General, CRO, 1961," AFSC Papers.

34. Jane Shay Wald, "Twists and Turns," October 17, 2014, copy of unpublished article shared by the author.

35. Jack Willner, "How Negro Teens Feel about Negroes Living in Town," *Chicago Daily News*, December 21, 1959, clipping in files of Art Shay.

36. Dan Zeff, "Deerfield 'Kneel-In' by 40 Youths Quiet and Second Demonstration Set for Deerfield," *North Shore Life*, an

edition of the *Waukegan News-Sun*, December 27, 1960, 1; Brian Boyer, "Deerfield: On Its Way Up the Economic Ladder, This Young Community Leaves Many Positive Impressions," *Omnibus Magazine*, December 1964, 21–27, in box 79, folder 3, Milgram Papers.

37. Andrew Norman, Chair of Board, and others, MCD statement to all stockholders, June 12, 1961, box 76, folder 1, Milgram Papers; "Appeal Deerfield Case to High Court," *American Freedom of Residence Fund News*, Spring 1962, 1, 4, box 72, folder 1, Milgram Papers; Morris Milgram, "News for Emergency Action in Deerfield," May 11, 1963, box 75, folder 6, Milgram Papers; Morris Milgram to MCD board, n.d. [April 1963], box 72, folder 6, Milgram Papers; List of signers to be added to telegram to Robert F. Kennedy, box 76, folder 8, Milgram Papers; Ian D. McMahan, *The Negro in White Suburbia: Community Power vs. Human Relations* (New York: Freedom of Residence Foundation, 1962); "Deerfield Fight Given Up; Blame Robert Kennedy," *Chicago Defender*, daily edition, May 22, 1963, 4; Robert F. Kennedy, Attorney General, to Morris Milgram, June 23, 1963, box 76, folder 5, Milgram Papers; Burke Marshall, Assistant Attorney General, to Jane Weston, AFSC, June 30, 1963, box 34, folder "Housing Program, Deerfield, IL Controversy, CRO, 1963," AFSC Papers.

38. "'Tent-In Camps in Deerfield to Hit Lily-White Suburban Housing," *Chicago Defender*, daily edition, May 7, 1963, 3; "Deerfield 'Tent-Iners' Talk with Racist Toughs," *Chicago Defender*, daily edition, May 9, 1963, 6; CORE, "Protest Segregation: North and South," flyer, n.d. [1963], box 78, folder 7, Milgram Papers; Ethel Untermyer to Morris Milgram, n.d. [summer 1963], box 78, folder 7, Milgram Papers; "Racial Group Holds Rites in Deerfield," *Chicago Tribune*, May 20, 1963, B10.

39. Morris Milgram, Modern Community Developers, "To the Deerfield Situation," June 1964, box 72, folder 2, Milgram Papers.

40. Jane Weston, "Statement on Deerfield," Housing Opportunities Program, box 32, folder "Housing Program, Deerfield, IL Controversy, CRO, 1962," AFSC Papers.

41. Sherman and Eve Beverly featured in *Deerfield Review*, November 28, 1985, copy in box 76, folder 5, Milgram Papers.

42. "Deerfield Integration," a Deerfield Library and Historic Society presentation, November 1999 (Deerfield: YesVideo, 2005), DVD copy held at Deerfield Public Library.

43. Boyer, "Deerfield: On Its Way Up the Economic Ladder," 27.

44. "Fog over Chicago: An Urban League Editorial," *Chicago Urban League* newsletter, 3, no. 2 (April–May 1958), copy in box 73, folder 8, Milgram Papers; "white noose" quoted in Joseph B. Robison, National Committee Against Discrimination in Housing, New York, to Robert F. Kennedy, April 26, 1963, box 76, folder 5, Milgram Papers.

45. Milgram quoted in David Williams, "No Colour Bar on This Young American's Estate," *Reynolds News*, London, February 12, 1960, copy in box 72, folder 1, Milgram Papers. As Lily Geismer's cogent study of Boston's suburbs puts it,

these liberals favored "campaigns that proposed individualist solutions to rights-related issues, required limited financial sacrifice, and offered tangible quality-of-life benefits." See Geismer, *Don't Blame Us*, 6.

46. *Time* magazine quote from "We Just Can't Afford to Be Democratic," Deerfield Committee for Human Rights release, n.d. [December 1959], box 78, folder 5, Milgram Papers.

Chapter Four

1. See Darlene Clark Hine and John McCluskey Jr., eds., *The Black Chicago Renaissance* (Urbana: University of Illinois Press, 2012); Robert Bone and Richard A. Courage, *The Muse in Bronzeville: African American Creative Expression in Chicago, 1932–1950* (New Brunswick, NJ: Rutgers University Press, 2011); and Brian Dolinar, *The Black Cultural Front: Black Writers and Artists of the Depression Generation* (Jackson: University of Mississippi Press, 2014).

2. For more on Richard Durham, see Sonja D. Williams, *Word Warrior: Richard Durham, Radio, and Freedom* (Urbana: University of Illinois Press, 2015).

3. Oscar Brown Jr. "'Hottest Thing in Show Biz' Tells His Own Story," *Journal and Guide* (Norfolk, VA), April 9, 1966, 2, copy in box 7, folder 50, Oscar Brown, Jr. Papers, Moorland-Spingarn, Howard University, hereafter Brown Papers; "Unusual Appeals Bring Broadway Cash," *Ebony* 16, no. 8 (June 1961): 73–80; *Music Is My Life, Politics My Mistress: The Story of Oscar Brown, Jr.*, a film by Donnie Betts (Aurora, CO: No Credits Productions, 2007), DVD.

4. Brown quoted in *Music Is My Life, Politics My Mistress*.

5. "Kicks & Co.," *Stagebill: Chicago's Theatre Magazine*, Arie Crown Theater, McCormick Place, Week of September 24, 1961, box 8, folder 9, Brown Papers; Oscar Brown Jr., "Mr. Kicks" and "Opportunity, Please Knock," on *Sin & Soul*, Columbia Records, CL 1577, 1960, LP record.

6. Bob Hunter, "World Premiere for 'Kicks' May Be Chicago's Greatest," *Chicago Defender*, daily edition, October 2, 1961, 16; Larry Still, "Oscar Brown Musical Gets Warm Reception in Chicago," *Jet* 20, no. 25 (October 12, 1961): 58–61.

7. Still, "Oscar Brown Musical Gets Warm Reception in Chicago"; Bob Queen, "Oscar Brown, Jr.: The Name That Will Make Them Almost Forget That Other 'Junior,'" *Pittsburgh Courier*, April 1, 1961, A20; "Miss Hansberry to Direct Show," *New York Times*, September 30, 1961, 17.

8. Lorraine Hansberry to Maxine and Oscar Brown Jr., July 29, 1960, box 7, folder 50, Brown Papers; Martin Luther King Jr. to Sammy Davis Jr., December 20, 1960, in *The Papers of Martin Luther King, Jr.*, ed. Clayborne Carson, vol. 5: *Threshold of a New Decade, January 1959–December 1960* (Berkeley: University of California Press, 2005), 582–83.

9. Val Adams, "Garroway Plans Musical Preview," *New York Times*, March 20, 1961, 59; 22; A. L. Foster, "Other People's Business," *Chicago Defender*, national edition, April 8. 1961, 4; Garroway quoted in "Unusual Appeals Bring Broadway Cash."

10. "Urban League to Benefit from 'Kicks & Co.' Opener," *Chicago Defender*, daily edition, August 9, 1961, 11; Al Monroe, "'Kicks and Co.,' in Business to Stay: 5,000 Cheer Kicks & Co.; Hail Oscar Brown, Jr.," *Chicago Defender*, national edition, September 30, 1961, 1; Claudia Cassidy, "On the Aisle: Of All 'Kicks' Ailments This One Is Lethal: It's Deadly Dull," *Chicago Tribune*, October 12, 1961, D13; Ban Burley, "Burley's Pearls: The Critics Got No 'Kicks' and "Kicks and Co.' Got the Boot!," *Philadelphia Tribune*, November 14, 1961, 4; Roger Dettmer, "Amateur Night about Dixie," *Chicago American*, n.d. [1961], box 8, folder 9, Brown Papers.

11. Bob Hunter, "'Kicks' Too Modern for Most," *Chicago Defender*, daily edition, October 16, 1961, 16; Al Monroe, "So They Say," *Chicago Defender*, October 23, 1961, 16. As just one example of this perceived racial bias, *Tribune* critic Claudia Cassidy wrote, "And ugly as the manifestations of segregation can be, it proves nothing theater-wise to label those who practice it as stupid, filthy, and lecherous in a rabble-rouser called 'Turn the Other Cheek.'" See Cassidy, "On the Aisle: Of All 'Kicks' Ailments This One Is Lethal."

12. One of the most objective accounts of *Kicks & Co.* comes from one of the dancers in the production. See Donald McKayle, *Transcending Boundaries: My Dancing Life* (New York: Routledge, 2002), 215–18.

13. "Chicago Urban League Presents the 1st Night of *Kicks & Co.*," flyer, box 7, folder 50, Brown Papers; "Urban League, Voters Group Plan Benefits," *Chicago Tribune*, September 10, 1961, part 8, p. 5; Morris Milgram to Max Weinrib, September 12, 1961, box 72, folder 9, Milgram Papers.

14. Ulysses Blakeley and Charles T. Leber Jr., "The Great Debate in Chicago," *Presbyterian Life* 14, no. 12 (June 15, 1961): 35–38; John Hall Fish, *Black Power/White Control: The Struggle of the Woodlawn Organization in Chicago* (Princeton, NJ: Princeton University Press, 1973), chap. 1.

15. IAF, "General Report, Part I: General Report for the Work Done by the Industrial Areas Foundation for the Archdiocese of Chicago, 1958," 47–50, box 4, folder 57, series 1, IAF Records; IAF, "General Report, Part II: The Negro Report, 1958," 82, box 4, folder 58, series 1, IAF Records.

16. For Despres correspondence on Woodlawn, see box 3, folders 47–49, series 1, IAF Records. See also Aaron Schutz, "An Introduction to Nicholas von Hoffman," in *People Power: The Community Organizing Tradition of Saul Alinsky*, ed. Aaron Schutz and Mike Miller (Nashville: Vanderbilt University Press, 2015), 49–54.

17. A reprint of this Jacobs article was filed away in the IAF research files. See Jane Jacobs, "Violence in the City Streets: How Our 'Housing Experts' Unwittingly Encourage Crime," *Harper's Magazine*, September 1961, copy in box 9, folder 135, series 1, IAF Records.

18. Earnestine Cofield, "The Battle of Woodlawn: How University of Chicago Was Stopped by a Fighting Community," *Chicago Defender*, magazine in daily edition, November 21, 1962, 9; Arthur M. Brazier, *Black Self-Determination: The Story of the Woodlawn Organization* (Grand Rapids, MI: Eerdmans, 1969), 57.

19. IAF, "General Report, Part II: The Negro Report, 1958," xxi–xxvii, 8, and *passim*.

20. Brazier, *Black Self-Determination*, 9.

21. "TWO: Greet a Slumlord," n.d. [December 1961], box 21, folder 342, series 1, IAF Records; see articles from *Jet* magazine as well as the *Woodlawn Booster*, *Chicago Defender*, *Chicago American*, and other newspapers in box 21, folder 341, series 1, IAF Records.

22. Fish, *Black Power/White Control*, 52–60; Brazier, *Black Self-Determination*, 10, 43–44.

23. Charles E. Silberman, *Crisis in Black and White* (New York: Random House, 1964), 346.

24. Fish, *Black Power/White Control*, 60, 63.

25. Chicago AFSC, 1958, box 27, folder "Peace Education, Public Witness," AFSC Papers; Chicago AFSC to Executive Committee, "Leaflet Distribution," Montrose Beach, July 4, 1959, box 28, folder "Peace Education Public Witness, Chicago R.O. 1959"; AFSC, "The Mean May Live: An Alternative to Atomic Death," flyer, box 28; AFSC, report on "A Week for World Peace," March 23–29, 1959, AFSC Papers. And statistics on armament from Charles DeBenedetti with Charles Chatfield, *An American Ordeal: The Antiwar Movement of the Vietnam Era* (Syracuse, NY: Syracuse University Press, 1990), 49.

26. Aldo Beckman, "1,500 Parade in Loop Asking Disarmament," *Chicago Tribune*, April 2, 1961, 7; AFSC, "Week for World Peace," brochure, March 26–April 1, 1961, and Erica Enzer, "Week for World Peace—a Very Partial Evaluation," n.d. [April 1961], box 31, folder "Public Witness, Week for World Peace, CRO 1961": both AFSC Papers; DeBenedetti with Chatfield, *An American Ordeal*, 41–44; Lawrence S. Wittner, *Rebels against War: The American Peace Movement, 1941–1960* (New York: Columbia University Press, 1969), 271–73.

27. Nan Robertson, "Campuses Show New Interest in Political and Social Issues," *New York Times*, May 14, 1962, 1; Wittner, *Rebels against War*, 267; Dawn Lander of SPU to Sidney Lens, September 11, 1962, box 30, folder 5, Sidney Lens Papers, Chicago History Museum, hereafter Sidney Lens Papers.

28. Rosemary Kaye, "Women for Peace—Age One," November 12, 1962, box 12, folder 9, Women for Peace Papers, Chicago History Museum, hereafter WFP Papers; Wittner, *Rebels against War*, 276.

29. "A Shelter in Time Save Thine," *Life* 51, no. 5 (August 4, 1961): 44; Edith Gurspan, "Women for Peace to all parents and principals of schools designated as fall-out shelters," n.d. [1961–62], box 10, folder 7, WFP Papers.

30. "A-Bomb Survivors Visit City," *Hyde Park Herald*, March 21, 1962, copy in box 11, folder 1, WFP Papers; Kaye, "Women for Peace—Age One."

31. "Students March Today in Capital in Protest over Cuban Blockade," *New York Times*, October 27, 1962, 7; "Women

Strike for Peace in Demonstrations Today," *Chicago Defender*, daily edition, November 2, 1961, 5. A subsequent rally on October 30, 1962, at McCormick Place in Chicago, sponsored by Voters for Peace, gathered 1,800 people, according to Sidney Lens. See Sidney Lens to Laura Godofsky, editor, *Chicago Maroon*, November 2, 1962, box 30, folder 5, Sidney Lens Papers.

32. "End the Arms Race! Sidney Lens: Peace Candidate for Congress, 2nd Congressional District," pamphlet, 1962, box 30, folder 7, Sidney Lens Papers.

33. "Students March Today in Capital in Protest over Cuban Blockade," 7.

34. Kaye, "Women for Peace—Age One."

35. Wittner, *Rebels against War,* 258–60.

36. Women's International League for Peace and Freedom, Chicago Branch, press release, December 6, 1962, and Mary McGrory, "Nobody Controls Anybody," typescript of an article for the *Evening Star*, Washington, December 14, 1959, and other documents in box 2, folder "HUAC 1962," WFP Papers. See also C. P. Trussell, "House Sets Study of Peace Groups," *New York Times*, December 7, 1962, 3.

37. Jack Newfield, "The Cuban Crisis and the Peace Movement," *Common Sense* 4 (December 1962): 2; DeBenedetti with Chatfield, *An American Ordeal*, 41–44.

38. Elizabeth Todd-Breland, *A Political Education: Black Politics and Education Reform in Chicago since the 1960s* (Chapel Hill: University of North Carolina Press, 2018), chap. 1; Catherine Sardo Weidner, "Debating the Future of Chicago's Black Youth: Black Professionals, Black Labor and Educational Politics during the Civil Rights Era, 1950–1965" (PhD diss., Northwestern University, 1989), chap. 4.

39. "Testimony of Edwin C. Berry before the Chicago Board of Education Budget Hearing," December 11, 1962, in folder 252253-029-0718, SNCC files on Chicago Illinois, Subgroup A, Atlanta Office, Series IV, Northern Coordination Department, Friends of SNCC, 1960–1968, in Student Non-Violence Coordinating Papers, Martin Luther King, Jr. Center for Nonviolent Social Change, Inc., Atlanta, accessed via ProQuest Database Black Freedom Struggle in the 20th Century, Organizational Records and Personal Papers, Part 2, MLK Center, hereafter CAFSNCC Papers. See also Weidner, "Debating the Future of Chicago's Black Youth," 248–52.

40. Weidner, "Debating the Future of Chicago's Black Youth," 257.

41. "Face School Segregation Issue," *Chicago Tribune*, August 13, 1963, 10; "Proposed Program," March 28, 1963, Chicago CORE Area Training and Planning Conference for April 26–28, Roosevelt University; and Chicago Area Friends of SNCC, "Rough Draft of Proposal to Coordinate Council to Be Made on Saturday, June 29 [1963]": all in folder 252253-029-0718, CAFSNCC Papers.

42. "Wilkins Hits Dirksen for Rights Stand," *Chicago Tribune*, July 2, 1963, 3.

43. "State NAACP President Scores Mayor Daley on Rights Progress," *Chicago Defender*, daily edition, July 3, 1963, 2; "Wilkins Hits Dirksen for Rights Stand," 3.

44. "State NAACP President Scores Mayor Daley on Rights Progress," 2; Lillian Calhoun, "Confetti," *Chicago Defender*, daily edition, July 2, 1963, 13.

45. James Ritch, "Boo Daley at Negro Rally," *Chicago Tribune*, July 5, 1963, 1; "NAACP Hecklers Upset Daley," *Chicago Sun-Times*, July 8, 1963, 1, and other newspaper clippings in folder 252253-029-0718, CAFSNCC Papers.

46. Kenneth Towers, "Hecklers Cut Daley Talk to NAACP," *Chicago Sun-Times*, July 5, 1963, final edition, B4.

47. Ritch, "Boo Daley at Negro Rally," 1; Towers, "Hecklers Cut Daley Talk to NAACP," B4. For more on Reverend Jackson's complicated relationship to the civil rights movement, see Wallace Best, "'The Right Achieved and the Wrong Way Conquered': J. H. Jackson, Martin Luther King, Jr., and the Conflict over Civil Rights," *Religion and American Culture: A Journal of Interpretation* 16, no. 2 (Summer 2006): 195–226.

48. Georgie Anne Guyer, "Refuse Apology to Daley," *Chicago Daily News*, July 5, 1963, 1; "Outsiders Blamed for Daley Jeers," *Chicago's American*, July 5, 1963, 1; Editorial, "No Service to a Cause," *Chicago Tribune*, July 6, 1963, 10; Editorial, "Hecklers and Responsibility," *Sun-Times*, July 7, 1963. Copies of these and other newspaper clippings on the event are in folder 252253-029-0718, CAFSNCC Papers.

49. "Irate Negroes Picket Church of Rev. Daniel," *Chicago Tribune*, July 15, 1963, 2; Jay Garnett, "Muslim, Socialist, Nationalist, SNCC Views Heard in Chicago," *The Militant*, September 16, 1963, 8.

50. "Teacher, Minister, Lead Protest against Mayor Daley, Minister," *Jet* 24, no. 13 (July 18, 1963): 8–11; Timuel Black Jr., *Sacred Ground: The Chicago Streets of Timuel Black*, as told to Susan Klonsky (Evanston, IL: Northwestern University Press, 2019), 92–94.

51. Chicago Area Friends of SNCC, *Newsletter* 1, no. 4 (July 17, 1963), CAFSNCC Papers; "School Board Sit-In Broken Up; Police Arrest 36 Persons," *Chicago Tribune*, October 12, 1963, 1; "The Man Who Said Boo," *Newsweek* 62, no. 18 (October 28, 1963): 94; Weidner, "Debating the Future of Chicago's Black Youth," 268–75.

52. Sylvia Fisher, CAFSNCC, press release, October 6, 1963, CAFSNCC Papers; Claude Sitton, "Chicago: Racial Tensions Increasing," *New York Times*, August 26, 1963, 1; "The Man Who Said Boo," 94; Weidner, "Debating the Future of Chicago's Black Youth," 268–75.

53. CCCO, "Willis Must Go!," flyer for October 22, 1963 boycott, CAFSNCC Papers; Lillian Calhoun, "Chicago's Lawrence Landry Is Typical of 'New Breed' in U.S. Negro Revolt," *Chicago Defender*, daily edition, November 5, 1963, 6; "224,770 or 47 Pct. of All Pupils Miss Classes," *Chicago Tribune*, October 23, 1963, 1; Alan B. Anderson and George W. Pickering, *Confronting the Color Line: The Broken Promise of the Civil Rights Movement in Chicago* (Athens: University of Georgia Press, 1986), 118.

54. "224,770 or 47 Pct. of All Pupils Miss Classes," 1; Madaline Chafin, "2nd Boycott Weighed If Willis Stays," *Chicago Defender*, daily edition, October 24, 1963, 1.

55. Austin Wehrwein, "Chicago Boycott Draws 172,350," *New York Times*, February 26, 1964, 24; Philip M. Hauser, "Dynamic Inaction in Chicago's Schools," highlights of address at the American Federation of Teachers, August 18, 1964, reprinted in *Equity & Excellence in Education* 2, no. 5 (1964): 44–47, in box 27, folders 3–5, and box 38, folder 7, Philip M. Hauser Papers, Special Collections Research Center, University of Chicago Library; Dionne Danns, *Something Better for Our Children: Black Organizing in Chicago Public Schools, 1963–1971* (New York: Routledge, 2003), 44, 47, 50; Robert Havighurst, excerpts from address to the City Club of Chicago on the Chicago Public Schools, November 16, 1964, box 99, folder 5, Robert J. Havighurst Papers, Special Collections Research Center, University of Chicago Library; and especially Weidner, "Debating the Future of Chicago's Black Youth," 277–93.

56. *Chicago Daily News*, February 20, 1965, quoted in Anderson and Pickering, *Confronting the Color Line*, 151; Chicago Area Friends of SNCC, "Stop! Don't Shop Downtown," flyer and fact sheet, and Lawrence Landry to Martin Luther King Jr., December 30, 1963, folder 252253-029-0718, CAFSNCC Papers.

Chapter Five

1. "18th College Mixer to Salute Students," *Chicago Tribune*, August 6, 1967, 3; "The W. E. B. Du Bois Clubs of America Present an Evening of Music of the New America," advertisement for June 18, 1966, concert at Chicago Coliseum, *Chicago Defender*, daily edition, June 16, 1966, 6; "Junior Wells Touring Europe," *Chicago Defender*, daily edition, October 4. 1966, 11; Ernie Santosuosso, "Seeger 20th Century Pied Piper," *Boston Globe*, February 27, 1967, 24.

2. Junior Wells Chicago Blues Band, "Vietcong Blues," on *Chicago / The Blues / Today! Vol. 1* (New York: Vanguard, 1966), LP record, SVRL-19020.

3. Penny M. Von Eschen, *Race against Empire: Black Americans and Anticolonialism, 1937–1957* (Ithaca, NY: Cornell Press, 1997); Tom Phillips, "Vietnam Blues," *New York Times*, October 8, 1967, SM7.

4. Junior Wells, interview by Jim O'Neal, published in *Living Blues* 119 (February 1995): 384–85; Phillips, "Vietnam Blues," SM7.

5. James Ridgeway, "Poor Chicago: Down and Out with Mayor Daley," *New Republic* 152, no. 19 (May 15, 1965): 17, 20; Jane Addams, address at Rockford College, 1931, quoted in James Weber Linn, *Jane Addams: A Biography* (New York: Appleton-Century, 1935), 387; Saul Alinsky, "The War on Poverty—Political Pornography," remarks prepared for the Institute of Policy Studies, May 26, 1965, reprinted in *Poverty: Power and Politics*, ed. Chaim I. Waxman (New York: Grosset

and Dunlap, 1968): 171–79; Charles Silberman, "The Mixed-Up War on Poverty," *Fortune* 72 (August 1965): 159–60; Nicholas Lemann, *The Promised Land: The Great Black Migration and How It Changed America* (New York: Knopf, 1991), 152; Michael L. Gillette, introduction to *Launching the War on Poverty: An Oral History* (New York: Oxford University Press, 2010).

6. John Hall Fish, *Black Power/White Control: The Struggle of the Woodlawn Organization in Chicago* (Princeton, NJ: Princeton University Press, 1973), 81–83; Silberman, "The Mixed-Up War on Poverty," 223; Ridgeway, "Poor Chicago," 18; Lillian Calhoun, "New TWO Head Rev. Stevenson Man with a Sense of Purpose," *Chicago Defender,* national edition, July 11, 1964, 5; Lois Wille, "TWO Wants to Know: Will We Share in Poverty Funds?," *Chicago Daily News*, April 7, 1965, 68. Other April 1965 articles by Lois Wille in the *Chicago Daily News* reprinted in *Examination of the War on Poverty Program: Hearings, Eighty-Ninth Congress, First Session, Committee on Education and Labor* (Washington, DC: U.S. Government Printing Office, 1965), April 12–15, 1965, 347–57.

7. Adam Clayton Powell and Lynward Stevenson testimony in *Examination of the War on Poverty Program*, April 12, 1965, 3, 357–62; Mary Pakenham, "Blasts City's War on Poverty," *Chicago Tribune*, April 14, 1965, 12.

8. Deton Brooks testimony, *Examination of the War on Poverty Program*, April 13, 1965, 367–89; "Poverty War Jobs Defended by Daley," *Chicago Tribune*, April 15, 1965, 7.

9. Silberman's article ended up using Shay's photo of Stevenson but not Brooks. See Silberman, "The Mixed-Up War on Poverty," 156–61, photo on 161.

10. Brenetta Howell and Skip Bossette, "2,000 Pledge Daily Marches in Chicago," *Chicago Defender*, national edition, June 12, 1965, 1; "Willis March Jams Traffic," *Chicago Tribune*, June 11, 1965, 1; James Ralph Jr. and Mary Lou Finley, "In Their Own Voices: The Story of the Movement as Told by Participants," in *The Chicago Freedom Movement: Martin Luther King, Jr. and Civil Rights Activism in the North*, ed. Mary Lou Finley, Bernard LaFayette Jr., James R. Ralph Jr., and Pam Smith (Lexington: University Press of Kentucky, 2015), 21.

11. "CHA Homes in Daley's Backyard Still Jim Crow," *Chicago Defender*, daily edition, May 14, 1964, 1; Alan B. Anderson and George W. Pickering, *Confronting the Color Line: The Broken Promise of the Civil Rights Movement in Chicago* (Athens: University of Georgia Press, 1986), 144; "Raby Hangs 'Lily White' Label on Bridgeport," *Chicago Defender*, daily edition, August 9, 1965, 1.

12. Lillian Calhoun, "Confetti," *Chicago Defender*, daily edition, October 12, 1964, 11; "Mayor's Home Is Guarded in Chicago after Disorders," *New York Times*, October 7, 1964, 58; Adam Cohen and Elizabeth Taylor, *American Pharaoh: Mayor Richard J. Daley—His Battle for Chicago and the Nation* (Boston: Little Brown, 2000), 321–22, 333–34.

13. "Civil Rights Events in Chicago: Week of August 1 to 8, 1965," draft press release, copy in Chicago Chapter, folder "Gen/Misc. 1946–1966," 252250-004-0022, Congress of Racial

Equality Chapter Papers, Chicago History Museum, accessed through ProQuest History Vault, hereafter Chicago CORE Papers; "Cops Check March to Daley's Home," *Chicago Defender*, daily edition, August 2, 1965, 1; "Daily Trek to See Daley," *Chicago Defender*, daily edition, August 3, 1965, 1; Austin Wehrwein, "Rights Unit Seeks Chicago Parlay," *New York Times*, August 8, 1965, 63.

14. "Civil Rights Events in Chicago: Week of August 1 to 8, 1965," Chicago CORE Papers; "Picket Daley's Home Again," *Chicago Tribune*, August 4, 1965, 1; "Cops Check March to Daley's Home," 1; "Daily Trek to See Daley," 1; "3d Night March on Daley: Mayor Calls Procession 'Invasion' of His Privacy," *Chicago Defender*, daily edition, August 4, 1965, 1; William J. Bopp, *"O. W.": O. W. Wilson and the Search for a Police Profession* (Port Washington, NY: Kennikat Press, 1977), 115–16; "Bridgeport Plays It Cool as the Marches Go On," *Chicago Defender*, daily edition, August 11, 1965, 4.

15. "Politics Laid to Daley in Poverty War," *Chicago Tribune*, July 22, 1965, B3; Fish, *Black Power/White Control*, 86–89; Lynward Stevenson, "The State of the Community," originally published in the *Woodlawn Observer*, April 28, 1966, 2–3, and reprinted in *People Power: The Community Organizing Tradition of Saul Alinsky*, ed. Aaron Schutz and Mike Miller (Nashville: Vanderbilt University Press, 2015), 64–65.

16. Simon Hall, *Rethinking the American Anti-War Movement* (New York: Routledge, 2012), 14–18; Chicago NCC, "Dear Friend," n.d. [September 1965?], flyer, n.d. [September 1965?] with schedule of October 1965 events, box 1, folder 2, Chicago Committee to End the War in Vietnam Records, Wisconsin State Historical Society, Madison, hereafter Chicago NCC Records.

17. Thelma Hunt Shirley, "6,000 Give LBJ Real Red-Carpet Welcome," *Chicago Defender*, daily edition, June 7, 1965, 5.

18. Chicago W. E. B. Du Bois Club, "Why Are American Troops in South Viet Nam and Not in Mississippi?," flyer for July 20, 1965, demonstration, copy in Chicago Chapter, folder "Gen/Misc. 1946–1966," Chicago CORE Papers.

19. Chicago Peace Council, "Viet Nam Visitors to Speak at Hiroshima Observance," press release for August 5, 1965, event, and Chicago NCC, "Chicago Committee (cont.)," n.d. [July 1965]: both in box 1, folder 2, Chicago NCC Records.

20. "Anti-War Protestors Oppose Draft," Roosevelt University *Torch*, October 25, 1965, 1, 7; NCC, "What Is the NCC?," *The Crisis* (NCC newsletter) 1, no. 34 (November 3, 1965): 4, copy in Chicago Chapter Papers, folder "Gen/Misc. 1946–1966," Chicago CORE Papers; Charles DeBenedetti with Charles Chatfield, *An American Ordeal: The Antiwar Movement of the Vietnam War Era* (Syracuse, NY: Syracuse University Press, 1990), 120–21.

21. Douglas Robinson, "Policy in Vietnam Scored in Rallies Throughout U.S.," *New York Times*, October 15, 1965, 1; "Pickets Tussle in Loop over U.S. Viet Aims," *Chicago Tribune*, October 16, 1965, S1; Chicago Peace Council, "Rally for Peace in Vietnam," flyer for October 17, 1965, rally at McCormick Place, Chicago, copy in box 1, folder 2, Chicago NCC Records; Bradford Lyttle, *The Chicago Anti-Vietnam War Movement* (Chicago: Midwest Pacifist Center, 1988), chap. 3.

22. Sidney Lens, *Unrepentant Radical: An American Activist's Account of Five Turbulent Decades* (Boston: Beacon Press, 1980), 301–2, 305, 308–9; DeBenedetti with Chatfield, *An American Ordeal*, 123, 137.

23. John K. Jessup, "The Answer to What the Vietniks Call a Moral Issue" and "Vox Vietnik Fires Volley of Protests," *Life* 59, no. 18 (October 29, 1965): 40; Editorial, "Red Diaper Babies," *Chicago Tribune*, October 16, 1965, S12; Austin Wehrwein, "U.S. Investigates Antidraft Groups," *New York Times*, October 18, 1965, 1; "U.S. Eyes Draft Dodgers," *Chicago Defender*, daily edition, October 18, 1965, 1; "Reds Inciting Draft Foes, 2 Officials Say," *Chicago Tribune*, October 20, 1965, 3.

24. "142 Profs Rap Use of Grades to Set Draft," *Chicago Tribune*, April 21, 1966, 18; Lyttle, *Chicago Anti-Vietnam War Movement*, 59, 62; "400,000 Take Draft Deferment Tests Despite Jeers, Chants," *Chicago Tribune*, May 15, 1966, 1; Robert Nolte, "25 Seized in Roosevelt Sit-In," *Chicago Tribune*, May 20, 1966, 1; "Sit-In Resumes at Chicago College after Arrest of 25," *New York Times*, May 21, 1966, 4; "6 Arrested at Roosevelt Sit-In," *Chicago Tribune*, May 24, 1966, 1.

25. James Yuenger, "U.C. Students Hold Sit-In Second Night," *Chicago Tribune*, May 13, 1966, 3; "California U. Co-ed a Leader of Sit-In," *Chicago Tribune,* May 13, 1966, 3; Gerald Grant, "Sit-In Continues at Chicago U. as Antidraft Drive Intensifies," *Washington Post*, May 15, 1966, A6; "Inquiring Photographer," *Chicago Defender*, daily edition, May 17, 1966, 13; Austin Wehrwein, "Protestors End Chicago U. Sit-In," *New York Times*, May 14, 1966, 10; Austin Wehrwein, "Student Sit-Ins Are Condemned by Chicago University Faculty," *New York Times*, May 27, 1966, 5; "The Midway Rioting," *Chicago Tribune*, May 13, 1966, 16; Lyttle, *Chicago Anti-Vietnam War Movement*, 60.

26. Ernest Furgurson, "Johnson Does Turnabout on Internal Dissent Issue," *Baltimore Sun*, May 19, 1966, A7.

27. "Heavy Guard Set," *Chicago Tribune,* May 17, 1966, 2; John Pomfret, "Johnson Asks U.S. to Unite Behind His Vietnam Policy," *New York Times*, May 18, 1966, 1; "Thousands Greet LBJ at Democratic Rally," *Chicago Defender*, daily edition, May 18, 1966, 1; George Tagge, "Unite on VIET, LBJ Asks," *Chicago Tribune*, May 18, 1966, 1; Cohen and Taylor, *American Pharaoh*, 315.

28. "Thousands Greet LBJ at Democratic Rally," 1; "Ky Is Said to Consider Hitler a Hero," *Washington Post*, July 10, 1965, A12.

29. Tagge, "Unite on VIET, LBJ Asks," 1; "Text of President's Speech at Fund Dinner Here," *Chicago Tribune*, May 18, 1966, 6; on Daley as kingmaker, see Hal Higdon, "A Minority Objects, but Daley Is Chicago," *New York Times Magazine*, September 11, 1963, 182.

30. "Text of President's Speech at Fund Dinner Here," 6.

31. "Text of President's Speech at Fund Dinner Here," 6;

"Johnson Asks U.S. to Unite Behind His Vietnam Policy," *New York Times*, May 18, 1966, 1; Furgurson, "Johnson Does Turnabout on Internal Dissent Issue," A7; "Daley Doubts Viet to Cost Party Votes," *Chicago Tribune*, May 18, 1966, 5. Tagge, "Unite on VIET, LBJ Asks," 1. One month after this event, Daley and Johnson talked about the successful Democratic primaries, but also admitted the opposition used the Vietnam War as an issue against Democratic candidates. "I want to know what you learned. . . . I know the general crowd, but if you have any indication let's have it. It will be between just you and me." Lyndon Johnson, telephone conversation with Richard J. Daley, June 15, 1966, #10240, Miller Center, University of Virginia.

32. "March with Dr. King and Al Raby," flyer for speaking tour, July 24–26, [1965], Chicago CORE Papers; David J. Garrow, *Bearing the Cross: Martin Luther King, Jr., and the Southern Christian Leadership Conference* (New York: William Morrow, 1986), 434.

33. James R. Ralph Jr., *Northern Protest: Martin Luther King, Jr., Chicago, and the Civil Rights Movement* (Cambridge, MA: Harvard University Press, 1993), 42–48; Gordon K. Mantler, *Power to the Poor: Black-Brown Coalition and the Fight for Economic Justice, 1960–1974* (Chapel Hill: University of North Carolina Press, 2013), 53; Garrow, *Bearing the Cross*, 444.

34. Memorandum to Lyndon Johnson, n.d. [1965], summarizing meeting between HEW Assistant Secretary Quigley and Mayor Daley, box 10, WHCF Name, Daley, Richard J., 1966, Lyndon Johnson Papers, LBJ Presidential Library, Austin, TX, hereafter LBJ Papers; Lyndon Johnson, telephone conversation with Richard J. Daley, September 15, 1966, #8870, and Lyndon Johnson, telephone conversation with Joseph Califano, October 28, 1965, #9047: both Miller Center, University of Virginia; Anderson and Pickering, *Confronting the Color Line*, 178–82.

35. Ralph, *Northern Protest*, 101; Ralph and Finley, "In Their Own Voices," 32–33.

36. "Thousands Go to Soldiers' Field Rights Rally," *Chicago Tribune*, July 11, 1966, 1; "30,000 Hear Dr. King at Soldier Field Rally," *Chicago Defender*, daily edition, July 11, 1966, 3; Jon Rice, "The World of the Illinois Panthers," in *Freedom North: Black Freedom Struggles Outside the South, 1940–1980*, ed. Jeanne F. Theoharis and Komozi Woodard (New York: Palgrave Macmillan, 2003), 45–46; Andrew Diamond, *Chicago on the Make: Power and Inequality in a Modern City* (Berkeley: University of California Press, 2017), 191.

37. On the reception to Meredith's speech, see Audrey Weaver, "Confetti," *Chicago Defender*, daily edition, July 14, 1966, 20; Al Raby speech quoted in Ralph and Finley, "In Their Own Voices," 46–48; "Here's What Dr. King Told Vast Thousands," *Chicago Defender*, daily edition, July 11, 1966, 1, 4; Ronald Berquist, "Rights Rally Hears King in Chicago," *Washington Post*, July 11, 1966, A1. On King's move away from antiwar statements, see Garrow, *Bearing the Cross*, 438, 445.

38. Garrow, *Bearing the Cross*, 491. King quoted in Ronald Berquist, "Rights Rally Hears King in Chicago," *Washington Post*, July 11, 1966, A1.

39. Lilia Fernandez, *Brown in the Windy City: Mexicans and Puerto Ricans in Postwar Chicago* (Chicago: University of Chicago Press, 2012), 150–51, 163–67; Mantler, *Power to the Poor*, 55.

40. Raby quoted in Ralph and Finley, "In Their Own Voices," 46–48; "Here's What Dr. King Told Vast Thousands," 1, 4; Janet L. Abu-Lughod, *Race, Space, and Riots in Chicago, New York, and Los Angeles* (New York: Oxford University Press, 2012), chap. 3.

41. Amanda Seligman, "'But Burn—No': The Rest of the Crowd in Three Civil Disorders in Chicago," *Journal of Urban History* 37, no. 2 (2011): 230–55; Abu-Lughod, *Race, Space, and Riots*, 92; Anderson and Pickering, *Confronting the Color Line*, 210–15.

42. Lyndon Johnson, telephone conversation with Richard J. Daley, June 19, 1966, #10415, Miller Center, University of Virginia; Anderson and Pickering, *Confronting the Color Line*, 216–17; King quotes in Ralph, *Northern Protest*, 117, 175; Gil Cornfield, Melody Heaps, and Norman Hill, "Labor and the Chicago Freedom Movement," in *The Chicago Freedom Movement*, ed. Finley et al., 375, 381.

43. Ralph, *Northern Protest*, 134.

44. "Leaders Take Housing Drive to New Area," *Chicago Defender*, daily edition, August 3, 1966, 1; "Mayor and Residents Confer on Marches," *Chicago Tribune*, August 3, 1966, A2; "3,000 Whites Jeer King's Drive," *Atlanta Constitution*, August 4, 1966, 28; Anderson and Pickering, *Confronting the Color Line*, 227; Lyndon Johnson, telephone conversation with Richard J. Daley, August 16, 1966, #10614, Miller Center, University of Virginia.

45. Anderson and Pickering, *Confronting the Color Line*, 216–17, 223.

46. "Why Must We Put Up with Daily Brawls," *Chicago Tribune*, August 9, 1966, 14; Carter Davidson, Editorial Director, WBBM-TV, Standpoint, editorial, broadcast August 15, 1966, transcript in King Center Digital Archive, http://www.theking center.org/archive/document/black-marches-and-white -hysteria.

47. Bopp, *"O.W.,"* 118–20; Under Secretary of State, "Civil Rights Activities in Chicago," memorandum passed from Bromley Smith to Hopkins, White House, box 10, WHCF Name, Daley, Richard J., LBJ Papers; Anderson and Pickering, *Confronting the Color Line*, 269–71.

48. Ralph, *Northern Protest*, 204.

49. Molly Martindale, "Women in the Movement I: The Women of SCLC-WSCP Take Action," in *The Chicago Freedom Movement*, ed. Finley et al., 355; Ralph, *Northern Protest*, 104, 135–36; Anderson and Pickering, *Confronting the Color Line*, 220.

50. Anderson and Pickering, *Confronting the Color Line*, 323; Ralph, *Northern Protest*, 181, 191–92.

51. King quotes in Garrow, *Bearing the Cross*, 549; Raby quoted in Ralph and Finley, "In Their Own Voices," 71.

Chapter Six

1. "Millions of Muslims Are Watching, Cassius Claims," *Chicago Tribune*, February 19, 1966, E1; Muhammad Ali with Richard Durham, *The Greatest: My Own Story* (New York: Random House, 1975), 123–24; Jonathan Eig, *Ali: A Life* (New York: Houghton Mifflin, 2017), 213.

2. "Millions of Muslims Are Watching, Cassius Claims," E1.

3. Ali, *The Greatest*, 138–39.

4. Eig, *Ali: A Life*, 249–50; David Remnick, *King of the World: Muhammad Ali and the Rise of an American Hero* (New York: Random House, 1988), 288–89.

5. A. S. "Doc" Young, "Black Day for Boxing," *Chicago Defender*, daily edition, May 2, 1967, 21; "Inquiring Photographer," *Chicago Defender*, daily edition, April 20, 1967, 19. On the national press condemnation, see Remnick, *King of the World*, 288.

6. Lawrence Allen Eldridge, *Chronicles of a Two-Front War: Civil Rights and Vietnam in the African American Press* (Columbia: University of Missouri Press, 2011), 55–60; Eig, *Ali: A Life*, 211–12; Daniel Lucks, "African American Soldiers and the Vietnam War: No More Vietnams," *The Sixties: A Journal of History, Politics, and Culture* 10, no. 2 (March 2017): 196–220.

7. Editorial, "Cassius Clay's Case," *Chicago Defender*, daily edition, May 15, 1967, 13. For other evidence of Ali's draft refusal swaying opinion, see Eig, *Ali: A Life*, 250, chap. 26; "Chicago Negroes Form National Union to Oppose War and Draft," *Philadelphia Tribune*, February 13, 1968, 7; and "Raps Ali Snub," Views and Opinions, *Chicago Defender*, weekend edition, August 17, 1968, 10.

8. George Tagge, "Sen. McCarthy to Speak Here to Democrats," *Chicago Tribune*, December 2, 1967, 8; Michael McGuire, "Sen. McCarthy Race Boosted by Democrats," *Chicago Tribune*, December 3, 1967, 4; Dennis Wainstock, *Election Year 1968: The Turning Point* (New York: Enigma Books, 2012), 20–25.

9. James Doyle, "Concerned Democrats Not Just Amateurs," *Boston Globe*, December 3, 1967, 14; "McCarthy Hits LBJ's Promised," *Hartford Courant*, December 3, 1967, 12A; Warren Weaver Jr., "McCarthy Denies a Kennedy Plot," *New York Times*, December 3, 1967, 42; David Murray, "New Support Is Pledged to McCarthy," *Washington Post*, December 4, 1967, A1; Rowland Evans and Robert Novak, "McCarthy at Chicago—It Wasn't All Roses," *Boston Globe*, December 6, 1967, 49.

10. Coleman quoted in "The Riot," *Chicago Tribune Magazine*, July 28, 1968, 35; Amanda Seligman, "'But Burn—No': The Rest of the Crowd in Three Civil Disorders in Chicago," *Journal of Urban History* 37, no. 2 (2011): 230–55.

11. "The Riot," 35–38, 43–44; Seligman, "'But Burn—No.'"

12. "Death in Chicago Riot, April 5–6, 1968," memorandum, and Sam Shapiro, Acting Governor, State of Illinois, telegram to President Lyndon Johnson, April 6, 1968, both in box 61, Ramsey Clark Papers, LBJ Presidential Library, Austin, Texas, hereafter Ramsey Clark Papers; "The Riot," 35–38, 43–44;

Janet L. Abu-Lughod, *Race, Space, and Riots in Chicago, New York, and Los Angeles* (New York: Oxford University Press, 2012), 98.

13. William J. Bopp, *"O. W.": O. W. Wilson and the Search for a Police Profession* (Port Washington, NY: Kennikat Press, 1977), 106, 122; Mike Royko, *Boss: Richard J. Daley of Chicago* (New York: Dutton, 1971), 161.

14. "The Riot," 35–38, 43–44; Simon Balto, *Occupied Territory: Policing Black Chicago from Red Summer to Black Power* (Chapel Hill: University of North Carolina Press, 2019), 219–21.

15. Bopp, *"O.W.,"* 110–11; "The Riot," 35–38, 43–44; Balto, *Occupied Territory*, 162–64, 197, 213–14; Christopher Chandler, "Shoot to Kill . . . Shoot to Maim," *Chicago Reader* 31, no. 27 (April 4, 2002).

16. "The Riot," 44, 46.

17. Cook County Grand Jury, report on the Cook County Jail, December 1967, copy in Hans W. Mattick Papers, Chicago History Museum Research Center; Melanie Newport, "Jail America: The Reformist Origins of the Carceral State" (PhD diss., Temple University, 2016), 93–95.

18. "Rights Leaders, Clergy, Call Mayor to Task on 'Shoot to Kill' Stand," *Chicago Defender*, daily edition, April 16, 1968, 1; Studs Terkel, "Jowl to Jowl," in *Law and Disorder: The Chicago Convention and Its Aftermath*, ed. Donald Myrus (Chicago: printed by author, 1968); "Clark Assails Daley Riot Order," *Chicago Tribune*, April 18, 1968, 2; Albert Sehlstedt Jr., "Clark Opposes Force in Riots," *Baltimore Sun*, April 18, 1968, A1; Jean White, "Clark Warns on Use of 'Deadly Force,'" *Washington Post*, April 18, 1968, A1; David Farber, *Chicago '68* (Chicago: University of Chicago Press, 1988), 145.

19. L. A. Pierce to LBJ, April 16, 1968, and Bill Valeski to Ramsey Clark, April 24, 1968, and other letters in reaction to Clark's comments on Daley are in boxes 68–70, Ramsey Clark Papers. See also letters in box 60, folders 8–9, Richard J. Daley Papers, Special Collections and University Archives, University of Illinois at Chicago; Balto, *Occupied Territory*, chap. 6; Farber, *Chicago '68*, 135, 146–47; and Garry Wills, *The Second Civil War: Arming for Armageddon* (New York: New American Library, 1968), 37–38.

20. White, "Clark Warns on Use of 'Deadly Force,'" A1; J. R. Bruckner, "Mayor Daley's Edict," *Los Angeles Times*, April 21, 1968, F1; Mary McGrory, "Mayor Daley Chooses Political Hara-Kiri," *Boston Globe*, April 21, 1968, A5; George Christian, memorandum to President Johnson, March 29, 1968, box 10, WHCF Name, Daley, Richard J., LBJ Papers.

21. Farber, *Chicago '68*, 150; Dick Gregory to Lyndon Johnson, January 1, 1968, box 66, Ramsey Clark Papers; Dave Potter, "'Too Explosive' for Marches, Gregory Junks Demonstrations," *Chicago Defender*, daily edition, April 16, 1968, 1; "March against Racism & War April 27," advertisement, *Chicago Defender*, daily edition, April 25, 1968, 34; William J. Grimshaw, *Bitter Fruit: Black Politics and the Chicago Machine, 1931–1991* (Chicago: University of Chicago Press, 1992), 122–24; Dave

Potter, "Rights Figures Blast Daley on 'Shoot Looters' Order, *Chicago Defender*, daily edition, April 16, 1968, 3; David Potter and Bob Hunter, "Back Office Holders Rap Daley's Shoot, Kill Edict," *Chicago Defender*, daily edition, April 18, 1968, 3; "Aldermen Are Split on Daley Riot Orders," *Chicago Tribune*, April 16, 1968, 2.

22. Warren Bacon, Edward Sparling, and April 27 Investigating Commission, "Dissent and Disorder: A Report to the Citizens of Chicago," August 1968, University Archives, Roosevelt University; Daniel Walker, "The Gathering Forces," in *The Anatomy of a Police Riot, Chicago, U.S.A.: A Concise, Unexpurgated Edition of Rights in Conflict, the Report to the National Commission on Causes and Prevention of Violence* (New York: Universal Publishing, 1968); police officers quoted in Frank Kusch, *Battleground Chicago: The Police and the 1968 Democratic National Convention* (Chicago: University of Chicago Press, 2008), 39–40, 138.

23. "Rayner to Lead Peace March; Solo Speaker," *Chicago Defender*, daily edition, April 23, 1968, 6; "Anti-War Protestors Battle Police," *Chicago Tribune*, April 28, 1968, 1; April 27 Investigating Commission, "Dissent and Disorder: A Report to the Citizens of Chicago"; "N.A.A.C.P. to File Suit for Teens in Peace Rally," *Chicago Tribune*, April 30, 1968, B6; "Hit Cops in Peace Rally," *Chicago Tribune*, May 1, 1968, 7; Florence Weinstein to Richard Daley, copy to Lyndon Johnson, April 28, 1968, box 68, Ramsey Clark Papers.

24. Daley quoted in Adam Cohen and Elizabeth Taylor, *American Pharaoh: Mayor Richard J. Daley—His Battle for Chicago and the Nation* (Boston: Little Brown, 2000), 469; Farber, *Chicago '68*, 97, 153.

25. Abbie Hoffman, "The Yippies Are Going to Chicago," *The Realist*, no. 82 (September 1968): 24; Daniel Walker, *Rights in Conflict: The Violent Confrontation of Demonstrators and Police in the Parks and Streets of Chicago during the Week of the Democratic National Convention of 1968, Report to the National Commission on the Causes and the Prevention of Violence* (New York: Bantam Books, 1968), 91; Farber, *Chicago '68*, 97, 153.

26. *The Presidential Nominating Conventions of 1968* (Washington, DC: Congressional Quarterly Service, September 1968), 88–89, 104, 108, 128; Richard Strout, "When Race Issue Cuts Two Ways," *Christian Science Monitor*, August 27, 1968, 1; William Kling, "First Draft Angers Johnson; Protest Chant Ends Session," *Chicago Tribune*, August 27, 1968, 1; Simeon Booker, "Black Politics at the Crossroads," *Ebony* 23, no. 12 (October 1968): 31–36, 42.

27. Hoffman, "The Yippies Are Going to Chicago," 1, 23–24; Farber, *Chicago '68*, 17, 61–62, 72–73; Walker, "The Gathering Forces," in *Anatomy of a Police Riot*.

28. Farber, *Chicago '68*, 158, 179; Walker, "The Gathering Forces," in *Anatomy of a Police Riot*.

29. Kusch, *Battleground Chicago*, 13, 52–53, 72; Farber, *Chicago '68*, 158, 179; Walker, "The Gathering Forces," in *Anatomy of a Police Riot*.

30. KPFA radio broadcast, "A Day in the Park," recorded August 27, 1968 (80 min.), broadcast April 25, 1969, BB4160; KPFA radio broadcast, recorded August 27, 1968 (60 min.), broadcast December 19, 1968, BB2159; and KPFK radio broadcast, August 28, 1968 (60 min.), BB4550: all Pacifica Radio Archives; Royko, *Boss*, 178.

31. Farber, *Chicago '68*, 177, 185–86, 191; Walker, "Summary" and "Lincoln Park: The Violence Begins," in *Anatomy of a Police Riot*; "Dementia in the Second City," *Time* 92, no. 10 (September 6, 1968): 33.

32. KPFK radio broadcast, BB4550; Farber, *Chicago '68*, 181, 184; Kusch, *Battleground Chicago*, 70; Walker, "Marches and Melees," in *Anatomy of a Police Riot*; John Schultz, *No One Was Killed: The Democratic National Convention, August 1968* (1969; repr., Chicago: University of Chicago Press, 2009), 95; Art Shay, "The Democratic Convention—Chicago '68," *Swans*, commentary for special "Convention Fever Issue," June 2, 2008, http://www.swans.com/library/art14/ashay01.html.

33. KPFA radio broadcast, BB2159; Farber, *Chicago '68*, 190–91; Walker, "Marches and Melees," in *Anatomy of a Police Riot*; Kusch, *Battleground Chicago*, 53; Erik S. Gellman, "In the Driver's Seat: Chicago's Bus Drivers and Labor Insurgency in the Era of Black Power," *Labor: Studies in Working-Class History of the Americas* 11, no. 3 (Fall 2014): 49–76.

34. KPFA radio broadcast, BB2159; Farber, *Chicago '68*, 191; Walker, "Marches and Melees," in *Anatomy of a Police Riot*; Michael Schumacher, *There but for Fortune: The Life of Phil Ochs* (Minneapolis: University of Minnesota Press, 1998), 199–200.

35. Walker, "Wednesday: The Culmination of Violence," in *Anatomy of a Police Riot*; Farber, *Chicago '68*, 196–97.

36. Walker, "Wednesday: The Culmination of Violence," in *Anatomy of a Police Riot*; Farber, *Chicago '68*, 199–200; Gordon K. Mantler, *Power to the Poor: Black-Brown Coalition and the Fight for Economic Justice, 1960–1974* (Chapel Hill: University of North Carolina Press, 2013), 133–34, 214–15.

37. Walker, "Wednesday: The Culmination of Violence," in *Anatomy of a Police Riot*; Clark Kissinger, "Overview," and Arthur Miller, "Eyewitness," in *Law and Disorder*, ed. Myrus; James Green, *Death in the Haymarket: A Story of Chicago, the First Labor Movement, and the Bombing That Divided Gilded Age America* (New York: Random House, 2006).

38. Walker, "The Gathering Forces," in *Anatomy of a Police Riot*; Kusch, *Battleground Chicago*, 155; Hoffman, "The Yippies Are Going to Chicago"; Farber, *Chicago '68*, 243–44; "Badly Split S.D.S. Ends Its Convention," *Chicago Tribune*, June 23, 1969, 7.

39. Walker, *Rights in Conflict*, 356–58; Kusch, *Battleground Chicago*, 121, 138–42; Walker, "Wednesday: The Culmination of Violence," in *Anatomy of a Police Riot*; Balto, *Occupied Territory*.

40. George E. Lewis, *A Power Stronger than Itself: The AACM and American Experimental Music* (Chicago: University of Chicago Press, 2008), ix, 196, chap. 6; Michael Robinson, with photographs by Art Shay, "The Association: The 'New

Thing' Is Their Thing," *Chicago Tribune Magazine*, November 28, 1968, 66–73, 76–77, 79–81.

41. Abdul Alkalimat, Romi Crawford, and Rebecca Zorach, *The Wall of Respect: Public Art and Black Liberation in 1960s Chicago* (Evanston: Northwestern University Press, 2017), 102–5, 173–78, 229–46; Naomi Beckwith and Dieter Roelstraete, *The Freedom Principle: Experiments in Art and Music, 1965 to Now* (Chicago: Museum of Contemporary Art Chicago in association with University of Chicago Press, 2015); "'Wall of Respect' Is Dedicated Here at Black Festival," *Chicago Defender*, daily edition, October 3, 1967, 1; Dave Potter, "Crowds Gather as 'Wall' Is Formally Dedicated," *Chicago Defender*, daily edition, October 2, 1967, 3; "Black Pride Theme for Dedication Festivities," *Chicago Defender*, national edition, September 30, 1967, 3; William Walker, oral history interview, June 12–14, 1991, Archives of American Art, Smithsonian Institute, Washington, DC; Alkalimat, Crawford, and Zorach, *The Wall of Respect*.

42. Russell Rickford, *We Are an African People: Independent Education, Black Power, and the Radical Imagination* (New York: Oxford University Press, 2016), 58–60; Hurley Green, "Confetti," *Chicago Defender*, daily edition, January 15, 1968, 12; "Black Educators to Hold June 6–9 Conference Here," *Chicago Defender*, daily edition, June 3, 1968, 4; photographs of AAAE conference, *Chicago Defender*, June 17, 1968, 14; "Control of Black Schools Is Goal of Teachers Group," *Chicago Defender*, big weekend edition, June 29, 1968, 5.

43. "Group to Organize School Workshops," *Chicago Tribune*, November 28, 1968, S1; Nancy Ciesecke, "Develop New Ways to Teach Inner-City Pupils to Read," *Chicago Tribune*, January 16, 1969, W4; "Gas Station Training Center Moves; Lack of Trainees a Major Problem," *Chicago Tribune*, July 28, 1968, W2; "Welfare Women Join Job Training Program," *Chicago Tribune*, August 17, 1969, SCL6; "County School Program Gives Adult Job Training," *Chicago Tribune*, July 31, 1969, W5; "Educator Made Crane Campus Counselor Head," *Chicago Tribune*, April 20, 1969, W9; "Parolee Aid at Malcolm X," *Chicago Defender*, daily edition, January 15, 1970, 14. For more on community control activism, see Elizabeth Todd-Breland, *A Political Education: Black Politics and Education Reform in Chicago since the 1960s* (Chapel Hill: University of North Carolina Press, 2018), chap. 2.

44. Marcia Walker-McWilliams, *Reverend Addie Wyatt: Faith and the Fight for Labor, Gender, and Racial Equality* (Urbana: University of Illinois Press, 2016), 1–2, chaps. 5, 6, quote from 113; "Women of the Year," *Time* 107, no. 1 (January 5, 1976), cover; "Teachers Back as E. Chicago Strike Ends," *Chicago Tribune*, September 24, 1968, A1; Todd-Breland, *A Political Education*, 125–26; Joseph McCartin, "Bringing the State's Workers In: Time to Rectify an Imbalanced Labor Historiography," *Labor History* 47, no. 1 (January 2017): 73–94.

45. David Dawley, *A Nation of Lords: The Autobiography of the Vice Lords* (Garden City, NY: Anchor Press, 1973), 113; See also "Lawndale Violence Dies Out; 15 Beaten," *Chicago Tribune*,

July 15, 1961, N1; "9 Youths Held at Farragut," *Chicago Tribune*, October 22, 1963, 1; "Coroner Jury Asks Trial in Cicero Death," *Chicago Tribune*, June 3, 1966, C9; and "School Gangs Fight Cops," *Chicago Tribune*, November 22, 1967, 1.

46. "The Talk of the Town: Notes and Comments," *New Yorker* 42 (July 16, 1966): 25.

47. [First Presbyterian Church], "History of Ranger Activity, Summer, 1966," copy in Blackstone Rangers, box 423, folder: volume 1, Chicago Police Department; Special Investigator to Assistant Supervisor in Charge, Enforcement, August 4, 1966, Blackstone Rangers, box 423, folder: volume 2; John Fry, "Eyeball to Eyeball with the Rangers," *Arena One* 1, no. 5 (1967), published by the Division of Youth Activity, American Lutheran Church, Minneapolis, copy in Blackstone Rangers, box 423, folder: volume 3: all in Chicago Police Department, Red Squad selected records, Chicago History Museum; James Alan McPherson, "All Mighty Blackstone: And What Does That Mean? Part I," *Atlantic Monthly* 223, no. 5 (May 1969); "Organization Man," *Newsweek*, June 5, 1967; John Fry, *Locked-Out Americans: A Memoir* (Evanston, IL: Harper and Row, 1973), chap. 6.

48. UPI press release, April 7, 1968, Chicago, copy in box 22, Ramsey Clark Papers; Donald Mosby, "Businessmen Support Gang Efforts to Keep Peace on Southside," *Chicago Defender*, daily edition, April 17, 1968, 2; Ronald Koziol, "Two Business Leaders Defend Rangers, Deny Shakedowns," *Chicago Tribune*, April 17, 1968, 10; Bob Hunter, "Gang Trying to Extort Money from Son: Mom," *Chicago Defender*, daily edition, July 1, 1968, 2; Natalie Y. Moore and Lance Williams, *The Almighty Black P Stone Nation: The Rise, Fall, and Resurgence of an American Gang* (Chicago: Lawrence Hill Books, 2011); Andrew J. Diamond, *Mean Streets: Chicago Youths and the Everyday Struggle for Empowerment in the Multiracial City, 1908–1969* (Berkeley: University of California Press, 2009), chap. 6.

49. "West Side Gang Plans Business Ventures," *Chicago Defender*, daily edition, April 4, 1968, 1; "Upward Bound (A Portfolio)," *Fortune* 77, no. 1 (January 1968): 165–69; McPherson, "All Mighty Blackstone"; Anthony Gibbs, *Final Report: The Woodlawn Organization Youth Project* (Chicago: The Woodlawn Organization, Office of Economic Opportunity, 1968); Fry, *Locked-Out Americans*, 118–19; James Baldwin, *Notes of a Native Son* (1955; repr., New York: Bantam, 1968).

50. See Frank H. Cassell, "Chicago, 1960–1970: One Small Step Forward," *Industrial Relations* 9 (May 1970): 277–78, 282.

51. Faith C. Christmas, "Construction Sites Shut," *Chicago Defender*, daily edition, July 29, 1969, 3; C. T. Vivian, *Black Power and the American Myth* (Minneapolis: Fortress Press, 1970). Bob Taylor, interview by author, April 14, 2005, Chicago; Dawley, *A Nation of Lords*; Faith C. Christmas, "Unions Facing Court Action," *Chicago Defender*, daily edition, July 24, 1969, 1; Fred Frailey, "Tentative Pact Here in Building Jobs for Blacks," *Chicago Sun-Times*, November 7, 1969.

52. See Paul King, interview by Dempsey Travis, July 10, 1981, included in Travis, *An Autobiography of Black Chicago*

(Chicago: Urban Research Institute, 1981), 222–27; C. T. Vivian also refers to the gangs as the troops of the movement. See Don Harris, "Black Coalition Wary of Job Plan Accord," *Chicago Today*, December 3, 1969.

53. See vol. 4, *U.S. Task Force on Building Trades: Minority Participation in Construction Trades*, copy filed at Northwestern University Law Library.

54. Federal Ad Hoc Committee Concerning the Building Trades, "Summary: Labor Shortage Minority Representation Report," in *U.S. Task Force on Building Trades*, vol. 2.

55. Arthur Fletcher, *The Silent Sell-Out: Government Betrayal of Blacks to the Craft Unions* (New York: Third Press, 1974), 69.

56. John H. Sengstacke, "Crisis in the Making," *Chicago Defender*, daily edition, September 11, 1969. For a fuller account of CUCA, see Erik S. Gellman, "'The Stone Wall Behind': The Chicago Coalition for United Community Action and Labor's Overseers, 1968–1973," in *Black Power at Work: Community Control, Affirmative Action, and the Construction Industry*, ed. David Goldberg and Trevor Griffey (Ithaca, NY: Cornell University Press, 2010), chap. 5.

57. Jakobi Williams, *From the Bullet to the Ballot: The Illinois Chapter of the Black Panther Party and Racial Coalition Politics in Chicago* (Chapel Hill: University of North Carolina Press, 2013), 63–64, 127–28, 160–61; Fred Hampton, "You've Got to Make a Commitment," pamphlet of transcripts from three recorded speeches, n.d. [1969], copy in author's possession, 9, 21–23, 40, 47.

58. Hampton, "You've Got to Make a Commitment," 21; Donald Mosby, "$6,000 Lost in Shoot-Out: Cops, Panthers Rap Each Other," *Chicago Defender*, weekend edition, August 2, 1969, 1–2.

59. Frank Donner, *Protectors of Privilege: Red Squads and Police Repression in Urban America* (Berkeley: University of California Press, 1990), 49–52, 90–104, 135.

60. Will Cooley, "'Stones Run It': Taking Back Control of Organized Crime in Chicago, 1940–1975," *Journal of Urban History* 37, no. 6 (2011): 911–32; John Hall Fish, *Black Power/White Control: The Struggle of the Woodlawn Organization in Chicago* (Princeton, NJ: Princeton University Press, 1973), chap. 3; Balto, *Occupied Territory*, chap. 6; Williams, *From the Bullet to the Ballot*, chap. 5; Gellman, "'The Stone Wall Behind.'"

61. "Police Strive to Halt Teen Gang Violence," *Chicago Tribune*, May 9, 1969, B25; Bernard Judge and Patricia Leeds, "Nab Six in Gang Murders: Form a New Court to Try Terrorists," *Chicago Tribune*, May 30, 1969, 1; "Gang Leader Charged with S. Side Killing," *Chicago Tribune*, December 5, 1969, C16.

62. "Fred Hampton Murdered by Fascist Pigs," *The Black Panther* 4, no. 2 (December 13, 1969): 39; U.S. Senate Select Committee to Study Government Operations, *Supplementary Detailed Staff Reports on Intelligence Activities and the Rights of Americans*, book III, final report, April 23, 1976, especially memoranda cited in footnotes 48–52; "F.B.I. Plot to Pit Blackstone Rangers against B.P.P. in Chicago Revealed,"

The Black Panther, December 13, 1975, 3; Jeffrey Haas, *The Assassination of Fred Hampton: How the FBI and the Chicago Police Murdered a Black Panther* (Chicago: Lawrence Hill Books, 2010).

63. Pierre Guilmant, "Buckney May Face Lawsuit," *Chicago Defender*, daily edition, July 5, 1969, 1; Williams, *From the Bullet to the Ballot*, 174; Dawley, *A Nation of Lords*, 160–69; L. F. Palmer Jr., "Blacks OK 9-Point Plan," *Chicago Daily News*, December 17, 1969; Gellman, "'The Stone Wall Behind.'"

64. Alan B. Anderson and George W. Pickering, *Confronting the Color Line: The Broken Promise of the Civil Rights Movement in Chicago* (Athens: University of Georgia Press, 1986), 219; Jean Komaiko, "Pulpit and Power," *Chicago* magazine, 6, no. 2 (Summer 1969): 97–101; Martin L. Deppe, *Operation Breadbasket: An Untold Story of Civil Rights in Chicago, 1966–1971* (Athens: University of Georgia Press, 2017).

65. Faith Christmas, "Bobby Rush Surrenders Before 5,000," *Chicago Defender*, December 8, 1969, 2; Jesse Jackson, "On the Case: On Fred Hampton," *Chicago Defender*, daily edition, part 1, December 13, 1969, 1, and part 2, December 16, 1969, 2; Hampton, "You've Got to Make a Commitment," 29; Marshall Frady, *Jesse: the Life and Pilgrimage of Jesse Jackson* (New York: Random House, 1996), Lucas quote from 250–51.

66. David Halberstam, "Daley of Chicago," *Harper's Magazine* 238 (August 1968).

Conclusion

1. Certainly, Chicago's troublemakers did not disappear in the 1970s, and this more recent history also matters in understanding the twenty-first-century city. As just two examples, Chicago witnessed an increase of activism against police brutality and the growth of anti-machine political challengers in the 1970s, culminating in the election of Harold Washington in 1983. But economic and political shifts in this latter era put activists on the defensive, which led them to regroup with new tactics and participants, and to organize for mere survival (particularly among communities of color). "What collapsed," according to activist and journalist L. A. Kauffman, "was any sense that a grand transformation of the existing political and economic order was possible." While this may be an overstatement, especially given the growth of feminism in the 1970s, Kauffman's account of the latter period does make a cogent case for treating the two eras as distinct. See L. A. Kauffman, *Direct Action: Protest and the Reinvention of American Radicalism* (Brooklyn: Verso, 2017), x, 4–5, 35, and *passim*.

2. Arnold R. Hirsch, *Making the Second Ghetto: Race and Housing in Chicago, 1940–1960*, 2nd ed. (Chicago: University of Chicago Press, 1998). A notable new synthesis by Andrew Diamond examines Chicago over the course of a century. While exemplary in its breadth, it tends to elide historical contingencies. See Andrew Diamond, *Chicago on the Make: Power and Inequality in a Modern City* (Berkeley: University of California Press, 2017).

3. Michael Katz further asserted that "none of what [scholars of urban history] said or wrote … was untrue or unimportant. But they virtually stopped looking for a counter-narrative that would support a different politics." A "crucial challenge for a new narrative on urban history," he argues, must "rehabilitate the role of government" as well as focus on "grassroots social movements" to "capture the balance between collective agency and state power." See Michael B. Katz, "Epilogue: The Existential Problem of Urban Studies," in *Why Don't American Cities Burn?* (Philadelphia: University of Pennsylvania Press, 2012), 157, 159.

4. Alexis de Tocqueville, *Democracy in America and Two Essays on America* (1835–40; repr., New York: Penguin Classics, 2003).

5. A few prominent examples are Darlene Clark Hine and John McCluskey Jr., eds., *The Black Chicago Renaissance* (Urbana: University of Illinois Press, 2012); Davarian L. Baldwin, *Chicago's New Negroes: Modernity, the Great Migration, and Black Urban Life* (Chapel Hill: University of North Carolina Press, 2007); and Ian Rocksborough-Smith, *Black Public History in Chicago: Civil Rights Activism from World War II into the Cold War* (Urbana: University of Illinois Press, 2018).

6. Jane Jacobs, *The Death and Life of Great American Cities* (1961; repr., New York: Vintage, 1992), 50, 448; Jane Jacobs, *The Economy of Cities* (1969; repr., New York: Vintage, 1970), 251.

7. Labor historians have crafted their own accounts of postwar workers that open with its "golden age" and chart its ensuing decline. These narratives often privilege white male industrial workers as they spotlight deindustrialization, the decline of union participation, and the erosion of blue-collar identity as the driving forces of change in these years. They also tend to blame the identity-based movements of the 1960s for fracturing working-class cohesion. But these changes did not so much displace a unified labor movement as compel workers to create new sites to renew their fight to control their lives and reshape the modern city. Shay's photographs reveal sites where the labor movement's energy shifted outside of unions, and examining urban spaces helps explain why certain workers became defensive and hostile, whereas others looked for broader class-based solutions to inequalities.

8. Scholars and popular memory have "whitened" the working class in ways that bear great historical and contemporary significance. As the historian Nell Painter recently remarked, there have been "centuries of historical precedent" of "reluctance to see people of color as … workers," which plays out in a contemporary narrative that "suggests that jobs and financial interests are interests of white voters only." By contrast, Shay's lens captured Black Chicagoans in their neighborhoods, at protests, and at job sites advancing clearly working-class demands. By confining the working class to overly tight boundaries and looking for its members in written sources, we neglect the larger picture of working-class power and the convergence of forces that are stacked against it, historically and today. See Nell Irvin Painter, "The Trump Era: The Politics of Race and Class," *Princeton Alumni Weekly* 117, no. 8 (March 1, 2017): 24–26.

9. Michael DiBari Jr., *Advancing the Civil Rights Movement: Race and Geography of* Life *Magazine's Visual Representation, 1954–1965* (New York: Lexington Books, 2017), 7–8; Leigh Raiford, *Imprisoned in a Luminous Glare: Photography and the African American Freedom Struggle* (Chapel Hill: University of North Carolina Press, 2007), 90, 128.

10. In particular, the scholarship by Martin Berger on civil rights photography proves useful. Berger argues that the photographs of the 1950s and 1960s southern civil rights movement that became disseminated and canonized fed a liberal white "fantasy of black passivity" that cast activists as "acted upon" in order to "foreground white agency." Martin A. Berger, *Seeing Through Race: A Reinterpretation of Civil Rights Photography* (Berkeley: University of California Press, 2011), *passim* and quotes from 19, 22, 23. Similarly, Susan Sontag defined a dichotomy of "privation, failure, misery, pain" in photography between those who suffer and those who observe suffering as "depersonalizing." This applies especially to the liberal northern whites who had supported the civil rights movement when it was a passive southern phenomenon, but who increasingly denied its demands when it became an aggressive Chicago movement. Many of Art Shay's photographs collapse this safe dichotomy for the viewer. But contrary to Berger's argument that northern protest images of "unmediated scenes of black agency in the streets … prevented the emergence of northern white solidarity with blacks," Shay's images emphasize this divide as well as interracial solidarities on Chicago's streets. Susan Sontag, *On Photography* (1973; repr., New York: Farrar, Straus and Giroux, 1977), 167–69; Berger, *Seeing Through Race*, 46, 49.

11. Images alone can be deceptive because photographs can provide a feeling of knowing about the past while "actually using it as a substitute which encourages the atrophy of any such memory." See John Berger, *About Looking* (New York: Pantheon, 1980), 62; and Raiford, *Imprisoned in a Luminous Glare*, 212, 222.

12. Katz, "Epilogue: The Existential Problem of Urban Studies," 161.

INDEX

Page numbers in italics refer to images.